D0207182

who do i lean on?

Other Novels by Neta Jackson

The Yada Yada Prayer Group Series
The Yada Yada Prayer Group
The Yada Yada Prayer Group Gets Down
The Yada Yada Prayer Group Gets Real
The Yada Yada Prayer Group Gets Tough
The Yada Yada Prayer Group Gets Caught
The Yada Yada Prayer Group Gets Rolling
The Yada Yada Prayer Group Gets Decked Out

The Yada Yada House of Hope Series
Where Do I Go?
Who Do I Talk To?

who do i lean on?

BOOK 3

A
yadayada
HOUSE *of* HOPE
Novel

NETA JACKSON

THOMAS NELSON
Since 1798

NASHVILLE DALLAS MEXICO CITY RIO DE JANEIRO

© 2010 by Neta Jackson

All rights reserved. No portion of this book may be reproduced, stored in a retrieval system, or transmitted in any form or by any means—electronic, mechanical, photocopy, recording or any other—except for brief quotations in printed reviews, without the prior written permission of the publisher.

Published in Nashville, Tennessee, by Thomas Nelson. Thomas Nelson is a registered trademark of Thomas Nelson, Inc.

Published in association with the literary agency of Alive Communications, Inc., 7680 Goddard Street, Suite 200, Colorado Springs, CO 80920.

Thomas Nelson, Inc., titles may be purchased in bulk for educational, business, fund-raising, or sales promotional use. For information, e-mail SpecialMarkets@ThomasNelson.com.

Scripture quotations are taken from the following: THE HOLY BIBLE, NEW INTERNATIONAL VERSION®. © 1973, 1978, 1984 by International Bible Society. Used by permission of Zondervan Bible Publishers.

The Holy Bible, New Living Translation, © 1996. Used by permission of Tyndale House Publishers, Inc., Wheaton, Illinois 60189. All rights reserved.

The New King James Version®. © 1982 by Thomas Nelson, Inc. Used by permission. All rights reserved.

"I Go to the Rock," words and music by Dottie Rambo. © 1977 New Spring, Inc. (ASCAP). Administered by Brentwood-Benson Music Publishing, Inc. Used by permission.

Liz Curtis Higgs, *Bad Girls of the Bible* (Colorado Springs: Waterbrook, 1999). Title and author referred to within the text of this novel.

Publisher's Note: This novel is a work of fiction. Any references to real events, businesses, organizations, and locales are intended only to give the fiction a sense of reality and authenticity. Any resemblance to actual persons, living or dead, is entirely coincidental.

Library of Congress Cataloging-in-Publication Data

Jackson, Neta.
 Who do I lean on? / Neta Jackson.
 p. cm. — (Yada Yada house of hope ; bk 3)
 ISBN 978-1-59554-525-1 (pbk.)
 1. Christian women—Fiction. 2. Shelters for the homeless—Fiction.
3. Chicago (Ill.)—Fiction. I. Title.
PS3560.A2415W476 2010
 813'.54—dc22 2010007704

Printed in the United States of America

10 11 12 13 14 15 RRD 6 5 4 3 2 1

To Pam
My ministry partner
My "Avis," my sistah, my friend
For putting up with me on all our travels
Speaking words of encouragement when I falter
Praying God's Word to keep our focus
Laughing about all our bloopers
Correcting me when I need it
And doing it all
In love

prologue

JULY 2006

Philip Fairbanks watched stoically as the young man in the gold brocade vest and gold bow tie snapped cards out of the automatic shuffler and dealt two cards facedown in front of each player. But feeling his left eye beginning to twitch, he glanced around the poker room, already busy this early on a Friday afternoon. Wouldn't do to give the other players a clue that he was nervous. He took it all in—the hum of activity at the other tables, the chandeliers glittering overhead, the clink of glasses as pretty young things in revealing black teddies brought drinks from the bar—trying to recapture the thrill he'd felt when he first came to the casino "just for fun" with his business partner. But today, the atmosphere seemed to be closing in on him. Like a cloying silk blanket generating static electricity, waiting to spark.

He turned back. The opening bid was already on the table. Two hundred each. Leaning forward, Philip casually picked up

the two cards he'd been dealt. *Two tens.* A pair of dimes . . . He had to do better than that.

"There you are!" Two young women moving through the poker room of the Horseshoe Casino made a beeline toward them, stopping by two frat-types who helped make up Philip's table. "Crystal and I've been looking all over for you! What are you playing?"

"Texas Hold 'Em," said one frat boy with a blond buzz cut. "The game I was telling you about. Can you wait? We've already started, but it goes fast."

Philip put his cards facedown. He didn't like spectators. The girls were too close. Distracting. He could smell a faint whiff of gardenia perfume. Too heavy. He felt like telling the girls to beat it. No, he just had to focus. He raised an eyebrow at the middle-aged guy to the left of the dealer. Was the man going to fold, or . . . ?

The bald man frowned at his hand. "I'll raise it three hundred." He pushed his chips forward. Philip shrugged as if bored, stacked the same number of chips, and pushed them into the pile. The two college kids each matched the first bid.

All right. It was starting to look interesting. Two thousand on the table. He needed twice that to cover the business account before Henry Fenchel got the company's bank statement next week. Shouldn't be a problem. After all, the Fairbanks and Fenchel Commercial Development Firm was his brainchild. His money as much as Henry's. He'd just been off his game last weekend— having his sons show up in Chicago for their grandmother's funeral had distracted him. And his new credit cards had only arrived two days ago, after he'd frozen his personal cards to keep his wife from using them. Why it had taken so long was beyond irritating.

Still, he wasn't too worried. If he had a few good games this

weekend, he would make up the money he'd borrowed from the business account . . . plus gravy.

Philip watched, impassive, as the dealer burned the top card and then flipped the next three cards faceup on the table. The community cards, called the "flop." *A jack . . . another ten . . . a six.* All different suits. But that ten would give him three of a kind. Philip studied the faces of the other three players. Nothing. Well, the bet would tell.

The big guy shook his head and passed. *Ah, good.* Now it was up to Philip to bet. He could simply check, see what the other two would do . . . no. He'd push it. Maybe they'd fold. Could he win with three of a kind? Not a great hand, but he'd won with less. Still, he shouldn't appear overconfident.

"I'll raise two hundred."

The twentysomething to his left pursed his lips. Philip wanted to smile but didn't. The kid had to match, raise, or fold. The girls standing behind them whispered something, gave Philip a flirty glance, and giggled. Philip wished they'd go away. Bad for concentration. Half a minute ticked by. The young man shrugged and matched the bid. So did his friend.

Back to the bald-headed guy. Sweat glistened on his forehead. Philip didn't think he'd raise it after passing the bet when he had a chance. But now it was either match or fold. *Don't sweat it, buddy. You've only got five hundred in the pot. Go ahead. Fold—*

The man pushed chips worth a matching two hundred into the pot.

Well, okay. The pot was now twenty-eight hundred. Maybe he'd make up the four thousand he owed Fairbanks and Fenchel on the first game. Sweet.

The dealer burned the top card, then flipped a single card faceup next to the original flop of three. *An eight of hearts.* That made two hearts on the table—the eight and the six. It didn't help Philip. His best hand was still only three of a kind. Maybe he should get out, take his losses, and try again. He'd only be out seven hundred. He'd still have the rest of the four thousand to play, and the night was young.

The older guy checked again. Philip tried to read him. The guy couldn't have a good hand, or he would've bet right out of the gate. He was leaving it to Philip to make the call—reacting rather than taking the initiative. *Chump.* Philip waited a good thirty seconds and then raised the pot another two hundred.

The whispering continued. Philip glared at the young women. They backed off, still whispering and laughing.

One of the college kids folded; the other matched Philip's bet. That made a pot of thirty-two hundred. Back to the bald guy. What would he do?

The man chewed his lip. Took out a handkerchief and mopped the back of his neck. Shaking his head, he matched the bid, moving his chips to the center of the table.

Was the fool bluffing? If so, he was taking it too far.

Last play. Philip watched as the dealer burned the top card of the deck and flipped the next card faceup next to the other four. The final card. Sometimes called "Fifth Street," sometimes "the river." Philip's heart pumped. *Another ten!* With two on the table and two in his hand, he could make *four* of a kind. Not bad . . . not bad at all!

The bald guy looked at his cards. Looked at the five community cards on the table. Each player could use any three from

the table to make his five-card final hand. The only unknowns were the two cards each player was holding. Philip tried to picture what the guy could possibly use. The new ten made three hearts—ten, eight, six. Maybe the guy had a pair, or even two . . . or an ace, hoping to take the pot with a single high card.

None of which would win over his four of a kind.

The guy suddenly moved all his chips into the center of the table. *What—?* Those chips were worth another thousand! Philip recalculated. The guy probably had two hearts in his hand—a flush, five cards in the same suit.

A decent hand. But his four of a kind would beat it.

What the heck. This is what made it fun. Philip matched the man's thousand and sat back.

Fifty-four hundred in the pot.

The second kid threw up his hands. "I fold. You guys are nuts."

"That's it?" the dealer said. "Lay down your hands."

Breaking into a wide smile, the bald guy laid down two hearts—a nine and a seven. *Humph, a flush. Just what I thought.* Philip gave the guy five seconds to enjoy his "victory," then laid down his tens. "Four of a kind beats your flush," he said, finally allowing a small smile. *Ohh, that was easy.* He mentally added the pot to the twenty-one hundred in chips he still had. *Seventy-five hundred.* Not bad for a twenty-minute game. Even after he repaid the four thousand he'd borrowed from the business account— Henry none the wiser—he'd still have thirty-five hundred in cool profit . . .

"Not a flush. A *straight* flush, buddy! Lookit that. Six, seven, eight, nine, ten—all hearts! Beats *your* four of a kind. Ha ha!"

The bald guy started raking in the pile of chips from the middle of the table.

Philip stared. Why hadn't he seen it? He felt his face redden. Now he felt like a fool. Worse than seeing his winnings evaporate.

Well, he wasn't going to let this chump get the best of him. He still had twenty-one hundred to work some magic. He looked up at the dealer. "I'm in again. What's the minimum bid?"

Philip pulled the Lexus into his space in the parking garage at Richmond Towers on Monday morning and turned off the motor. He sat for several long minutes before opening the car door, a sense of dread pooling in his gut. The weekend at the casino had gone badly. He should've pulled out while his losses were minimal. But it would have been so easy to make it all right! Just one good win and he could've covered the withdrawal from the business account *and* made a profit. But it didn't go down that way. He'd taken out a couple thousand from his personal account, sure his luck would turn . . . and then had to do it a few more times. Now he'd lost ten thousand of his own money, and he still had four thousand to pay back to Fairbanks and Fenchel.

He got out of the car and retrieved his overnight bag from the trunk. Well, he'd take care of the business account and worry about the rest later. He'd make the transfer with his personal debit card and hope Henry wouldn't notice the withdrawal and deposit if the balance was good. Even if he did, he'd smooth

Henry's feathers, just tell him it was an emergency. What was the problem if he put it back?

But now he was out nearly fifteen grand. He never meant to let his losses get that high.

Philip slid his security card through the keypad that let him into the residential elevators. He should have come home Sunday—maybe even Saturday—before he'd lost so much money. But the penthouse was so empty these days without Gabby and the boys . . . no, he couldn't go there. *Don't look back, Philip. What's done is done. It wasn't working.*

Stepping into an empty elevator, he punched the button for the thirty-second floor. Still, he spent as little time as possible in the penthouse. Everywhere he turned, it was like he expected to see them—the boys tussling over the remote . . . Gabby's mop of auburn curls on the pillow next to him . . .

It wasn't supposed to turn out this way! Gabby had gone off her rocker—dragging that smelly old bag lady home the first time Fenchel and his wife had come to dinner. Then she took that charity job at the homeless shelter without even discussing it with him! It was like she'd forgotten why they came to Chicago in the first place. Just decided to dance to her own music, never mind that it clashed with his.

But bringing her elderly mother and the mutt to stay at the penthouse had been the last straw . . . No, costing him the deal with a potential client—*that* was the last straw. He blamed Fenchel for that. Henry should have known better than to trust Gabby to deliver a phone message with sensitive information related to the business. She was so clueless about business protocol, she was like a loose cannon on a pitching ship.

The elevator dinged at the top floor of Richmond Towers, and the door slid open. Kicking her out had been drastic, but the situation had gotten intolerable. Maybe a few months on her own would knock some sense into her. She'd gotten a lawyer—some do-gooder from Legal Aid—but he knew Gabby. She wouldn't want a divorce. If he didn't rush things, if he worked stuff out with the boys, she'd come around. Let it pinch for a while.

Philip glanced at his Rolex as he crossed the marble foyer and pulled out his keys. He still had time to get a quick shower, change his clothes, and do the money transfer online before he headed to the office. Monday morning traffic into the city from Indiana hadn't been too bad. If he hustled, he could still get to the office by ten.

Intent on a quick in-and-out, Philip headed down the hallway to the master bedroom—but stopped as he entered. Something was wrong here. He scanned the room.

Gabby's dresser was missing.

He tossed his overnight bag on the bed and scanned the room once more. What else was missing? Had she said something about this? He flipped open his cell phone and scrolled down through recent calls. There . . . Gabby's new cell phone ID, dated last Friday. He hadn't bothered to listen to the message or return the call. Figured whatever it was could wait. But had she just—?

He turned on his heel and strode back down the hallway, jerking doors open as he went. Half the linens and towels from the linen closet—gone. Both the boys' bedrooms—cleaned out. In the kitchen, the breakfast nook table and chairs had disappeared. He opened the cupboards. Most of the dishes, pots and pans, and

utensils still seemed to be there. Hard to tell. At least she'd left enough for him to function.

Philip crossed to the dining room . . . it looked untouched. Even their wedding china was still in the china cabinet. *Huh.* Why didn't she just clean him out while she was at it? Go figure.

Wait. His study. *She better not have touched my study!* Practically breaking into a run, Philip threw open the door to his inner sanctum. But everything looked just as he'd left it . . . no, wait. The bookshelves had been disturbed. The family photo albums were gone. And a bunch of books. And a file drawer was open. The one that usually held their medical records, the boys' school records—personal stuff.

He stood in the middle of the room. His computer, his papers, untouched. But something else seemed missing . . . what was it? His eyes roved the room, then settled on an empty spot on one of his bookshelves and realized what it was.

The framed photo of the two of them on their fifth wedding anniversary, cake smudges on their noses, Gabby's hair a halo of red-gold curls, laughing up at him mischievously.

That photo. Happier times . . . Why had she taken it? Or had she thrown it away? A quick check of the wastebasket in the study and the kitchen trash can yielded nothing. But somehow the photo's absence yawned larger than the rest of the missing items put together.

Philip walked slowly into the living room. As far as he could tell, only one easy chair was missing, plus some framed photographs from the walls. That was it.

Running a hand through his dark hair, he stood by the floor-to-ceiling windows looking out over Lake Shore Drive and Lake

Michigan beyond, battling his emotions. Gabby had more *chutz-pah* than he'd given her credit for. She'd been in the penthouse once before when he wasn't there—had left a glass with her lipstick on it as a calling card. *Huh.* He should've been warned. In spite of himself, a tiny smile curled one edge of his mouth. This raid was like the old Gabby—impetuous, daring—like the girl in the photo.

The tiny smile died. Now she was gone, along with her stuff. It wasn't the things she'd taken that bothered him so much, but what it meant. He hadn't thought it would go this far! Was it too late to turn things around? She'd not only taken her stuff but everything that belonged to P.J. and Paul too!

An unexpected wave of loss swept over him . . . but it was drowned a moment later by a larger surge of anger. *No!* No way was she going to just take the boys away from him. He swore under his breath. Where were the boys supposed to sleep when they came to visit? And now he was fifteen grand in the hole! He couldn't just go out and buy new furniture for their bedrooms, not to mention CD players, clothes, sports equipment—all the stuff it took to keep two preteens housed and entertained. He didn't have time for this crap—

A vaguely familiar figure caught his eye thirty-two stories below in the narrow park that created a verdant buffer between the luxury high-rise and Lake Shore Drive. Looked kind of like the old bag lady Gabby had run into, the one who'd started this whole mess. She had a yellow dog with her this time . . . *Wait.* Philip leaned closer to the wraparound window and squinted. Not just any yellow dog. That was Dandy! His mother-in-law's dog—or Gabby's dog now that her mother had passed. What was that old woman doing with Gabby's dog? Stupid question. She

probably stole him while Gabby was out in North Dakota burying her mother. Give those thieving street people a dime, and they'd rob you blind.

Well, the old bag wasn't going to get away with it!

With a reckless energy that surprised even Philip after his short night at the casino hotel, he strode out of the penthouse and back into the elevator . . . and a few minutes later he was half-running across the frontage road between Richmond Towers and the park. "Hey, you!" he yelled. What was her name? Couldn't remember it. "You with the dog!"

The old lady had sat down on a bench, but she looked up as he ran toward her. The dog made a low guttural noise. Philip stopped. "Is that Dandy? Martha Shepherd's dog?"

She looked him up and down, narrow eyes glittering between sagging folds of skin. "Was."

So she was going to play games. He wanted to shake her. "Okay, so you know Mrs. Shepherd died a week ago. But that dog belongs to my wife now. Our son Paul is crazy about that dog. You—whatever your name is—you stole him. Give him back—*now*." He thrust a hand out, ready to jerk the leash out of her hand if she didn't give it up.

The old woman stood up. "Well! Don't that just rot my socks. You sayin' you want the dog?" She took a menacing step in his direction. Dandy growled again, his top lip curling over his canines. Philip pulled his hand back. "*You?*" she hissed. "Mister high-an'-mighty Philip Fairbanks? Who don't even have the decency to give food an' shelter to that *wife* you mentioned two breaths ago. You kicked her out on the street, left her no place to go. Now you want a *dog?*"

She stabbed a finger in his chest so hard it hurt. Startled, Philip took a step backward. "And if'n I got my facts straight, you don't even have time ta take care o' them two boys o' yours. Just packed 'em off to they grandfolks. Guess you thinkin' this dog can take their place."

Philip felt his face flush. She had no right—

"Oh yeah. Almost fergot. You kicked poor Miss Martha outta your fancy digs too. But, hey." The old lady shrugged. "Guess you figgered if ol' Lucy here could live out in the street, must be good enough for your wife and her ol' lady too. Why, I'm kinda flattered—for about half a second."

She punched that stubby finger in his chest again. "But I *feel* for ya, Mister Fairbanks. Now that you don' got no wife, no kids, no mother-in-law ta take care of, must get kinda lonely up there in the sky. Guess you be needin' a *dog* to take care of. Ain't so hard. Just gotta take him for a walk mornin' an' evenin', and pick up his poops—they got a law, see, says ya hafta clean up after ya dog. Sign's right over there." She jerked a thumb somewhere behind her. "So . . . here." She held out the leash in her clawlike hand. "Guess he's yours. Go on. Take him."

Philip stared at the old woman . . . *Lucy*, that was her name. The old bag was nuts! He suddenly felt foolish. What had he intended to do? Return the dog to Gabby, like a peace offering? Maybe . . . but mostly, he'd just been angry. Angry at everything. Nothing was going right.

He threw up his hands. "Look. I can't take the dog now. I have to go to work. But you . . ." He shook a finger at her, trying to regain the upper hand. "You have no business with that dog. An old lady like you can't take care of a dog living out on the streets.

Just take the dog back to Gabrielle, wherever she is. If I see you around here again with Dandy, I'll . . . I'll call the police."

Philip wheeled and walked stiffly back toward Richmond Towers. He gave a fierce shake of his head, but Lucy's words still burned in his ears.

chapter 1

For the umpteenth time, my twelve-year-old jumped up from the living room floor where he and his older brother had been squabbling over last Sunday's newspaper comics and peered out the front bay window. "Mom! When's Dad coming? He said six and it's already six thirty!"

"Yeah, and wherever we're going for supper, it better be air-conditioned." His older brother's voice rode the edge between whining and wilting. "All that fan's doing is moving hot air around, Mom."

I'd been hanging around the living room for the past half hour, rearranging books in the built-in bookcase on either side of the painted brick gas fireplace and watering the new houseplants my coworkers at the Manna House Women's Shelter had given me as housewarming gifts, not wanting to miss even one minute of precious time with Paul and P.J. before their dad came to pick

1

them up. I bit back the first words that rushed to my mouth—
"Ask *him* why he's late!"—and instead chirped, "He'll be here any
minute, I'm sure. Friday night traffic can be a beast, you know."

Like a prophecy fulfilled, we heard two short honks outside.
"See? There he is."

Both Paul and P.J. grabbed their duffel bags and scurried for
the front door. I followed them outside, trying to imprint the
backs of their heads in my mind to last me for the next twenty-
four hours until Philip returned them. Free from boarding school
regulations, Paul's hair had grown back into the tousled chestnut-
red curls that reminded me of my own at that age. P.J.'s hair was
dark and straight like his dad's, but the two inches he'd added
over the summer were still a startling revelation, as if his new
height had been attached to his fourteenth birthday—the birth-
day I'd missed.

I'd missed Paul's birthday too, for that matter. But that was
going to change this weekend.

"Hey!" I called after them. "I need a good-bye hug."

"Oh yeah! Sorry, Mom." Paul did an about-face, ran back
to give me a smack, then disappeared into the backseat of the
Lexus. P.J. waited until I caught up to him on the sidewalk and let
me give him a hug, then he opened the front passenger door and
lowered his lanky body inside.

I gave a little wave as the car pulled away, a lump crowding
into my throat.

So this is my new reality.

I should be in that car too, all of us going out together for
pizza, or whatever they were going to do tonight.

Instead, I turned and looked at the three-story six-flat that

was now my home. A classic Chicago brick with bay windows at the front of each apartment. Late afternoon sun—still muggy and warm—trickled through the leaves of the trees lining the mostly residential street, casting speckled light and shadows dancing on the brick facade. My new apartment was on the first floor—a gift I gratefully embraced every time I looked out the front windows and saw the ground only seven feet down. No more dizzying heights.

I brushed a damp curl off my forehead. No use moping. I had more phone calls to make if I was going to pull off this welcome-home-birthday-party surprise that Jodi Baxter and I'd been cooking up. The boys had arrived last weekend from Virginia, where they'd been staying with Philip's parents the last six weeks, but I'd wanted to give them a week to get adjusted to the new apartment and the new situation between Philip and me before I invited people over to celebrate. Frankly, as hard as it was to let the boys out of my sight, Philip's taking the boys for tonight and tomorrow gave me time to make party food and do some shopping. I'd better get to it.

I ran up the six wide steps leading into the building and into the small foyer with its six gleaming mailboxes, three on each side—and stopped. I'd come out without my keys! The inside foyer door was locked—and there was no one in my apartment to buzz me in.

Stupid, stupid, stupid!

I peered through the glass panels of the foyer door. My apartment door to the right stood open. Well, that was half the battle. If I could get through the foyer door, I was in. The only thing standing between me and getting inside were the glass windowpanes

in the door. *Huh.* All I had to do was break one, reach inside, and open the handle—

Nope. A broken windowpane in the door would be an open invitation for any stray Tom, Dick, or Harry to walk into the building too.

I walked back outside and looked at my bay windows. The fan sat in the open window closest to the steps—but would still be a long reach, even if I got up on the wide cement "arms" of the low wall on either side of the outside landing where I stood. Even if I could reach it, I'd have to find a way to take the screen out first. If only I had something sturdy to stand on so I could reach it from below.

Rats! I sat down on the top step and buried my face in my hands. This was so . . . so *stupid!* How in the world was I going to get in? Even my cell phone was inside the apartment—but a lot of good it'd do me, even if I had it. Anybody I called wouldn't have a key to my place anyway. Guess I'd have to sit here until one of the other residents in the building came home, and—

Wait a minute! I stood up, went back inside the foyer, and pushed the buzzer of the apartment above me. I waited thirty seconds—no response. I pushed the third-floor buzzer. Still no response. *Oh, please, please, somebody be home.* I crossed to the other side of the foyer and pushed the buzzer for the other third-floor apartment and waited. Suddenly the intercom crackled.

"Yeah?"

"It's Gabby Fairbanks in the first-floor apartment! I—"

"Who?"

"Gabby Fairbanks! First-floor apartment! I—"

"You got the wrong apartment. No Fairbanks up here."

"No, wait—" The intercom went dead.

I pushed the buzzer again and leaned on it this time.

The intercom came alive. *"What?"*

"I'm locked out! Can you let me in?"

"Oh. Wait a minnit . . ." The intercom went dead.

I waited a good five minutes, but finally a black dude in a big T-shirt, baggy jeans, and bare feet came down the stairs and pulled open the foyer door. "Thank you so much," I gushed, slipping inside before he changed his mind. "Gotta remember to take my keys. So sorry to bother you."

The young man, maybe late twenties, jerked his head at my open door. "That your apartment?"

"Yes. I just moved in a few weeks ago. My name's Gabby. You are . . . ?"

"Cinco. My brother lives up on third. He's letting me crash there."

"Oh. Nice to meet you. Thanks for helping me out." I held out my hand and he shook it awkwardly, then I slipped into my apartment and let out a long breath. I really should get to know my neighbors in the building.

Although I'd have to hurry up, because if my dream came true, I might have new neighbors before long.

chapter 2

Jodi Baxter showed up at my apartment at noon the next day, juggling a cake carrier and two shopping bags. "The keyboard's in the van," she huffed, dumping her armload on the living room floor. Then she clamped her hand over her mouth. "Paul's not here, is he?" she whispered.

I shook my head with a laugh. "Told you, the boys are with their dad today. The stuff for P.J. came too, right?"

My friend nodded. "Yeah, but it's going to take two of us to get those boxes in. Whew! It's hot in here. You got enough fans?"

"Not really. I've got three. We just move them around." *Oh, for central air.* I propped open the foyer door with a wastebasket and followed her into the sultry steam bath outside—my house keys safely hooked to a belt loop on my jeans as added insurance—and the two of us carried in the long, heavy box from the back of the Baxter minivan. On the second trip we brought in the other box, not as heavy but big and square. We set them on the wooden window seat in front of the open bay windows in the sunroom

just off the living room. One fan on the highest setting moved the muggy air around.

"Wow." I ran my hand along the length of the long box. "I hope Paul likes it. Thanks for letting me have it sent to your house. I didn't want to risk the UPS guy showing up here when I was at work—or worse, when the boys were here."

"No problem. Oh, by the way . . ." Jodi dug into one of her shopping bags. "I snatched a couple of sandwich plates from Manna House instead of staying for lunch after the typing class. Tuna on white bread, chips, and potato salad. Figured you'd be busy cooking for tonight, but we need lunch, right?"

I grinned as I took the paper plates she handed to me, neatly wrapped in aluminum foil, and headed down the long hallway that led to the kitchen in the back. "You'd make a good Jewish mother, Jodi Baxter," I tossed over my shoulder. "How'd the typing class at the shelter go today?"

Jodi lugged her bags down the hallway right after me. "It was okay. Althea wasn't there. Somebody said she's no longer on the bed list. But Kim and Wanda are still coming—Kim's been practicing on the computer, I can tell—and a new girl I hadn't met before . . . Tawny or something like that. Real young. What's *her* story?"

I peeled the foil from the paper plates, poured two glasses of apple juice from the fridge, and set them on the breakfast nook table—the one I'd hauled away from the penthouse at Richmond Towers. "Don't know." I shrugged, plopping into a chair. "She's only been at the shelter two or three days." I started to bite into the tuna sandwich and then looked guiltily at Jodi. "You, um, wanna pray for the food?"

Jodi laughed. "Sure." She closed her eyes and was quiet a moment. I watched her through half-closed lids, her brown shoulder-length hair swinging forward as she bowed her head. Maybe she was just going to give thanks silently—but then she started to pray aloud, so I closed my eyes.

"Thanks, Jesus, for being present with us today. Thanks for this food You provided for the ladies at Manna House—and for us." She giggled a little. "And thank You for the special occasions we're celebrating today—Paul and P.J. being back home with their mom, and for their birthdays Gabby didn't get to celebrate a few weeks ago. *And* that we can celebrate a birthday for little Gracie, who was born sometime in this month a year ago. Oh, God! You have done so much in such a short time for that precious little girl . . ."

Jodi stopped. I opened my eyes. She was fishing for a tissue but coming up short. I handed her a paper napkin.

"Sorry." She blew her nose. "Had a flash about the first time I saw Gracie and her birth mom, huddled in a doorway last November. Hoo boy." Jodi shook her head. "Had no idea when Denny and I took them to the shelter that Carmelita was a drug addict—or that my *son* and his fiancée would end up adopting her baby when she died. But now look at us—celebrating Gracie's first birthday." Jodi eyed me sideways. "Even though I'm waaay too young to be a grandmother."

I laughed. "Not to mention your Josh is waaay too young to be a daddy. What is he, twenty?"

"Almost twenty-two. But it feels like he just graduated from high school. Uh . . . did I ever say amen? Amen, Lord." "Grandma Jodi" took a bite of her sandwich and wrinkled her nose at it. "Ugh, kind of soggy. Sorry."

Soggy or not, we were both hungry. As we scarfed down our lunch from the shelter, I thought about what Jodi had said about Gracie. From what little I knew, Gracie's short life had been nothing short of a miracle. After Carmelita was discovered in a drug house dead of an overdose, the staff at Manna House had found a note among her things saying if anything ever happened to her, she wanted Edesa Reyes, one of the shelter volunteers, to keep her baby. Edesa, a young black woman in the U.S. on a student visa from Honduras, spoke fluent Spanish and had bonded quickly with Carmelita. But when Carmelita died, Edesa's fiancé, Josh Baxter, pushed up their wedding date so Carmelita's orphaned baby could have a mom *and* a dad.

And now it was August. Nine months since Gracie's mother had died. Eight months after Josh and Edesa Baxter's Christmas wedding. Four months since Philip and I moved to Chicago chasing Philip's ambitions. Three and a half months since I tripped over a homeless woman and ended up with a job at the Manna House Women's Shelter. Two months since my husband said I wasn't the "corporate wife" he needed . . . since he'd kicked me out and sent our sons away, and I'd ended up on the shelter's bed list myself.

Three short weeks since I'd moved into this apartment and could finally bring my sons home . . .

"Guess we better get busy." Jodi jumped up and tossed her paper plate in the kitchen wastebasket, interrupting my thoughts. "You're making a separate cake for your boys, right? I don't think they'd appreciate this teddy bear cake I'm trying to decorate for Gracie. Ha. It's been so long since I've put together one of these things, it might look like a mud-covered snowman by the time I'm

done." She mopped perspiration off her face with a paper napkin. "Say, any chance you could move all three of those fans in here?"

By the time five o'clock rolled around, we had two cakes on the counter and two kinds of pasta salad in the fridge. The other guests were supposed to bring food too.

Jodi's teddy bear cake had turned out perfect: chocolate icing "fur," Oreo cookie ears, chocolate mint eyes and nose, licorice rope mouth, a white icing tummy with a heart-shaped "red hot" for a belly button. "Too cute," I murmured. "Hope P.J. and Paul don't mind a plain old layer cake."

"Mind?! It's three layers of chocolate fudge! Besides, you've got those trick candles—" The front door buzzer sounded. "Whoops. Somebody's here. Want me to get that?"

But I was already halfway down the hall. "Yikes! Hope it's not the boys already. I told Philip six!" Instead of buzzing the intercom, I opened the front door a crack and peeked out. "Oh good! It's Estelle and Harry. And DaShawn!" I flung the door wide.

That was the nice thing about a first-floor apartment—I could actually see who was standing in the outer foyer beyond the glass-paneled door. I crossed the hall and pulled it open. Estelle Williams—one of my coworkers at Manna House and my personal "mother hen"—swept right past me in a loose yellow caftan. "Too hot for a hug, honey. I'll make it up to you this winter. C'mon, Harry. You too, DaShawn. Bring in those wings and stick 'em in the oven."

Harry Bentley, his brown dome shining with perspiration, gave

me a wink and obediently followed his ladylove into the apartment with the aluminum pan he was carrying. His grandson trailed behind with an identical pan. "Hi, Miz Fairbanks. Your kids here?"

I shook my head. "Not yet. We want all the guests to get here first." As the trio disappeared toward the kitchen, I wondered how Mr. Bentley was adjusting to suddenly having custody of the nine-year-old grandson he hadn't even known existed until a few months ago. So far so good, as far as I could tell.

The Baxter crew was next to arrive. Denny Baxter, Jodi's husband, lugged two shopping bags into the apartment and mopped his face with a handkerchief. "Uh, tell me again how Jodi got to drive the minivan by *herself*, while the four of us"—he tipped his head at Josh and Edesa coming in behind him, wrestling Gracie's stroller into the apartment—"had to take the El and walk . . . how many blocks?"

Jodi swooped Gracie out of the stroller and gave the tiny girl a big cuddle. "Tell your grandpa he helped me load those boxes for Gabby's boys himself, so he *knows* I had to get them here early." She handed Gracie to me and motioned to Edesa to follow her back to the kitchen.

The buzzer rang again. "C'mon, Gracie," I murmured to the sweet-smelling toddler in my arms. "Let's go see who's coming to your party." With my free hand I opened the foyer door for Mabel Turner, the director of the Manna House Women's Shelter—a woman with steel nerves covered in brown velvet. "Oh, hey, C.J." I beamed at her fourteen-year-old nephew, whose tight cornrows all over his head didn't do much to toughen his "pretty boy" features.

The boy hunched his shoulders, not meeting my eyes. "I go by Jermaine now," he mumbled. "My real name."

"Oh! So the *J* in C.J. stands for Jermaine. What does—?" But C.J. had already disappeared inside before I found out what *C* stood for.

"Don't close that door!" someone hollered. I peeked out to see Precious and her daughter Sabrina—sixteen and pregnant—climbing out of Mabel's car, along with Tanya and her eight-year-old Sammy. Both moms and their offspring were long-term "guests" at the Manna House shelter.

"Get in here quick! Paul and P.J. might get back any minute—ouch! Let go of my hair, sweetie." The toddler in my arms had grabbed a fistful of my corkscrew curls and squealed.

"*Oomph.* Sabrina don't do quick anymore." Precious practically pushed her gorgeous teenager—too cute for her own good, according to Precious—up the short flight of steps. "An' she only five and a half months gone. Girl, I'm gonna need a wheelbarrow for you by the time that baby gonna pop."

Sabrina arched her eyebrows in that exaggerated patience teens reserve for their parents, but she coyly held her arms out to Gracie as the knot of new arrivals came into the apartment building. The baby let go of my hair and willingly threw herself into the girl's arms. I shooed Tanya and Sammy inside, but hung back with Precious. Waving my hand at the building, I dropped my voice. "What do you think?"

"What do *I* think?" Precious practically snorted. "Sista girl, if these apartments have a hot shower an' a front door and a back door I can lock, they beautiful. What I want to know is what *you* thinkin'. You gonna buy this building or not? When can we move in?"

"That's what I want to do, Precious. But the boys just came back this week. I've been busy getting them registered for school

and haven't had a chance to talk to my lawyer. Or the Manna House board. Hopefully next week, though. Just . . . pray, okay?"

"Pray? Gabby girl, my knees got dents in 'em from all the hours I been spendin' praying 'bout this crazy idea of yours."

"You haven't said anything to Tanya yet, have you?" Tanya had been a teen mother herself, and she and Sammy had never had a home of their own.

Precious tossed her head full of tiny twists. "Whatchu think I am? You ask me not to say nothin', so nothin' is what I'm sayin'. 'Cept to God, of course. *He* gettin' an earful."

A familiar car turned the corner. "Quick, get inside. There's Philip with the boys." We hustled inside. "They're here, they're here, everybody! Come out of the sunporch, away from those windows, okay? . . . Where's Jodi? Oh, there you are. Jodi, you take care of the apartment door, okay? When they buzz the intercom, I'll go out and let them in from the foyer, but when the boys get to the apartment door, you pull it open and everybody yell 'Surprise!' Okay?"

Laughing and jostling, my guests obediently crowded into the not-too-big living room while we waited for the front door buzzer. A hot minute went by. Then two. What in the world was taking the boys so—

Blaaaaaat.

"Quiet! Quiet. I'm going out." I slipped out the front door. *Rats!* What was Philip doing in the foyer? He was supposed to just let the boys out and drive off, wasn't he?

I hesitated, but the mirage didn't disappear, so I pulled the foyer door open partway. "Uh, hi, guys!"

"What's the matter, Mom? Doesn't the buzzer work? You could've just buzzed us in." P.J. shouldered his way past me.

"Uh, yeah, it's fine. It's just . . . well, since the apartment is right here on the first floor, it's almost as easy to—"

Paul squeezed past me next, so I had to step back and open the door wider. I shot a glance over their heads at their father with a *what-are-you-doing-here* frown.

Philip Fairbanks, cool and debonair as always in his aviator sunglasses, held up two mammoth plastic shopping bags. "Got some gear for the boys—belated birthday gifts, you know."

My eyes widened in panic. The Sports Authority logo splashed across the bags in big bold script. *Double rats!* If Philip had pre-empted my birthday gifts, I'd . . . but I couldn't go there right now. I had to get rid of Philip.

"Uh, I can take those." I reached for the bags. "Thanks for bringing the boys back on time. We—"

"No problem. They're heavy. I'll take them in." Philip pushed past me with the bags. "The boys want me to see their 'new digs' anyway, as they say."

At that exact moment, the front door swung wide open and a chorus of voices from inside yelled, "Surprise!" . . . "Happy birthday!" . . . "Welcome home!"

The boys looked startled but slowly advanced into the front room, where they were mobbed with handshakes and hugs. Philip stopped just short of the open doorway and looked at me. "What's this?"

I stepped in front of him, barring his way. "A surprise birthday party for Paul and P.J. obviously. Now, please—"

The corners of Philip's handsome mouth tipped up. "So . . . am I invited?"

I glared at my estranged husband. What in the world was he

thinking?! But before I could tell him to disappear and take his Lexus with him, his quip must have carried into the living room, because Paul suddenly darted between us. "Oh, could Dad stay too? Please, Mom? That'd be great! Please?"

My mouth hung open as my brain synapses ricocheted inside my skull, searching for the right words that would make Philip leave—*now*—but not hurt Paul, who was already confused by our separation. But my silence, which couldn't have lasted more than two seconds, must have been interpreted as permission, because Paul grabbed his father by the arm and dragged him past me into the party.

My party. My party for *my* sons.

chapter 3

As the tall figure of my husband and Paul stepped inside, the jolly living room buzz hiccoughed and disappeared, as if sucked up by an invisible vacuum cleaner. Suppressing the urge to pull out fistfuls of my Orphan Annie hair and scream like a two-year-old, I hustled after them—but did not close the door. "Uh, everyone, this is Philip, the boys' dad. Paul, uh, wanted him to stay for a few minutes."

Get that, Philip? A few minutes!

Flustered, I tried to make introductions. "P.J. and Paul, you remember my boss, Ms. Turner, the director of Manna House. And this is her nephew, uh . . . Jermaine. He's starting ninth grade at Lane Tech too, same as you, P.J. Thought you might like to meet a few kids before you start school."

The slender black boy gave a hopeful nod, but P.J. didn't react.

Estelle's lips were pressed together as though barely restraining brickbats she'd like to rain down on Philip's head, so I skipped her for the moment and rushed on. "And you boys remember Mr.

Bentley, the doorman at Richmond Towers . . ." I almost added, ". . . where your dad lives," but wisdom said don't make a point of it. "And this handsome young man is his grandson, DaShawn."

DaShawn was all sunshine. "You dudes got a cool crib here. Thanks for inviting us to your party!" The boy looked up at his grandfather and stage whispered, "We gonna eat soon, Grandpa? I'm hungry!"

That broke the ice and people laughed. *Bless DaShawn.* "You're right, DaShawn. The rest of you can introduce yourselves. Food will be in the dining room in five minutes." I beckoned to Jodi, eager to flee.

"I'll do it." Estelle brushed past me. "You stay here and play hostess. C'mon, Jodi."

Oh, thanks a lot, Estelle. But I couldn't blame my friend for weaseling out of the situation. What in the world was I going to do with an uninvited guest who just happened to be the man who'd kicked me out of house and home barely two months ago?

Correction. The penthouse at Richmond Towers had been a house, but certainly not a home.

I turned back to my hostess duties in time to hear Philip say, "Bentley. Haven't seen you around the past couple of weeks. You working the night shift now?"

"No, Fairbanks," Mr. Bentley said evenly. "I quit the job. Now that I've got custody of my grandson here, I want to spend more time with him before school starts."

I covered my mouth to keep from laughing. On the job at Richmond Towers, Harry Bentley had *always* called Philip "Mr. Fairbanks." *Oh, Mr. B, you got him good.* Still, I was surprised by the news.

"Mr. Bentley! You quit your job? How—" I stopped. Maybe it was rude to ask how he was going to support both himself *and* a kid.

But the middle-aged black man winked at me as if he knew what was on my mind. "It was just a job to supplement my retirement anyway."

Retired? Mr. Bentley was pushing sixty, but he didn't look old enough to be retired yet. But before I could satisfy my curiosity, he said, "By the way, DaShawn and I are going to go to the zoo and some of the museums before school starts. Was going to ask if P.J. and Paul might want to come along too."

I almost forgot Philip was standing right there. "Oh, Mr. B! That would be great! I'm only working half time at Manna House until school starts—maybe we could go together."

Estelle appeared in the doorway. "Food's ready. Somebody want to say a blessing over the food and over our birthday boys?"

"It's Gracie's birthday too, don't forget!" Precious piped up.

"That's right, and you just volunteered to say the blessing. C'mon now, everybody join hands."

Join hands? Did the woman know what she was doing? I ducked into a space between Mr. Bentley and DaShawn, so I wouldn't be forced to hold hands with Philip. But who would? Everybody here knew our story, and Philip's name might as well be Mud. But Paul and P.J. crowded on either side of their dad—oh my, God's angels must be working overtime in the neighborhood—not exactly holding hands, but at least filling a chink in the ragged circle.

I lowered my eyelids but peeked through my lashes as Precious grabbed Gracie's small hand—still in Sabrina's arms—and raised her other hand like a Pentecostal preacher. "Precious

Jesus! Thanks be to God! This is a mighty good day, and we give You *all* the glory. Bless this bunch, every one of 'em, an' espe-cially bless Paul and P.J. on they birthdays, even though the days is past, an' bless lil' Gracie, this precious baby girl You've given to all of us, who's got a birthday sometime here in August even if we don't know the exact—"

"Precious," growled Estelle. "Bless the *food.*"

"—day," Precious rolled right on, "'cause You got our days numbered, Jesus, an' that's all that matters. Now we thank You for the food we're about to eat, an' remove all impurities so nobody gets sick. *Aaaa . . .*"—Precious opened her eyes and simpered at Estelle—"*. . . men!*"

With grins and chuckles, the party threaded through the long hallway to the dining area in the back, where the pasta salads, a pot of smoky greens, hot wings, enchiladas, crusty bread, bowls of chips, and lemonade were set out on one of my mother's flowered tablecloths. I knew no one in this crew would mind the makeshift table beneath the cloth, made from a plywood board sitting on two sawhorses I'd found in the basement—but that was before Philip invited himself. *Rats.* I steeled myself for a joke about decorating the place in "Early Alley" or something. But Philip just filled his plate and took a tour of the boys' bedrooms along the hallway. At least those rooms were filled with the good maple beds and dressers I'd hauled out of the penthouse.

I avoided Philip as much as I could, but I was distracted out of my mind by his presence. *Why is he still here?!* I noticed Denny Baxter talking to him in the living room—bless that man. Had Jodi snapped up the only decent husband in the universe? The two men could have been cut from *Sports Afield* and *GQ*. Denny,

midforties, rugged-looking, salt-and-pepper brown hair, school T-shirt, shorts, gym shoes, very much the high school coach or athletic director—whichever—but with two amazing dimples that creased his cheeks whenever he smiled, making me want to go "kitchy koo" under his chin. Philip stood half a head taller, tan and slender beneath his polo shirt, slacks creased, dark brown hair combed back, though it sometimes fell over his forehead in a boyish moment, brown eyes and dark lashes that could melt my insides like butter in the sun.

Denny—casual. Philip—cultured.

Why is my heart pounding?

Why is Philip here?

Why is he being so . . . decent?

"Time for birthday cake!" Estelle hollered into the living room. "Gabby, get in here and light those candles before this heat melts the frosting. Everybody else, give us one minute!"

The woman had taken over my house. She probably noticed that I was a complete zombie, needing my buttons pushed like an obedient robot.

Jodi Baxter was sticking a big candle "1" in the teddy bear cake's stomach.

"I'm sorry, Estelle. You and Jodi are doing all the work."

"Humph." Estelle handed me the kitchen matches. "You better be glad we are. Otherwise I might just punch that man's lights out. Lord, help me!"

I grinned, struck a kitchen match, and lit the fourteen skinny sparkler candles on the triple-layer chocolate fudge cake I'd made for my boys, which was starting to lean in the heat. I knew Estelle was just sputtering, but I kinda wished she'd go ahead.

"Y'all get in here!" Estelle called again, and the noisy guests once more crowded into the small dining room.

"Look at the teddy bear cake, Gracie!" cooed Grandpa Denny.

Sammy bounced excitedly. "Two cakes, Mama! Can I have a piece of each?"

"Who's got a camera?"

Somebody started a ragtag version of "Happy Birthday," and we managed to get *P.J.-Paul-and-Gracieeeee* in there in one breath before Precious screeched, "C'mon, blow out those candles 'fore that chocolate tower topples over!"

Paul huffed and puffed, but the sparkler candles wouldn't blow out, of course.

"Ha, I got it." Smirking, P.J. snatched them out of the cake and doused them in a glass of lemonade.

Estelle handed P.J. a knife. "At least there's a *real* cake under all that frosting, young man—unlike a certain birthday cake that shall go unmentioned." She leveled a tattletale eye at Harry Bentley to the knowing chuckles of guests from Manna House.

DaShawn hooted. "Yeah! My grandpa fooled Miss Estelle with a foam pillow cake on her birthday. He better watch out. She aimin' to get him back."

"Really, Mr. Bentley?" Young Paul was obviously impressed, seeing a new side of the unflappable doorman. "Cool. You want some real cake, Miss Estelle?"

"No, no." Mr. Bentley threw up his hands. "She's not safe around cake. I got the last one dumped on my head. Here, let me cut that cake. How big a piece you want?"

By now, everyone was laughing. As Harry Bentley handed out wide pieces of triple layer cake, I grinned happily. My sons

were enjoying themselves. My sons were home. This party was a great idea, surrounded by our new friends. If only—

I glanced at Philip, cake in hand, head tilted as he listened to Paul, who was talking to his dad with his mouth full. Like a blip on a radar screen, my heart caught. This was how it should be—the four of us celebrating the boys' birthdays, together with friends. I had wanted so much for Philip to get to know my new friends and coworkers at the Manna House shelter. But our worlds here in Chicago had spun into different orbits, until they'd collided like meteors in space, reducing my sphere into jagged hunks of debris.

At least it felt that way, until God started to put my world back together again. There was still a big hole where that meteor hit, but at least I was functional again. Moving forward.

So why now? Maybe I should be glad Philip stayed for the party. Maybe he was realizing the penthouse wasn't a pie in the sky after all, up there by himself. Glad he could see so much life and love closer to the ground.

The blip got stronger. *Was he having second thoughts about us?* Not that I would ask him straight out! The party was drifting back down the hallway to the living room again, but on impulse I planted myself in front of Philip before he followed. "Hey. Thought you were only going to stay a few minutes."

He looked at me. Those eyes. "I didn't say that. You said that."

"But this is *my* party for the boys, Philip. You had them since yesterday; now this is my time. What's going on?"

He took a last bite of chocolate fudge cake, chewed, swallowed, and then set his paper plate on the makeshift table. The look on his face . . . he almost seemed wistful. "Nothing's 'going on,' Gabby. This birthday party for the boys—our boys—is nice.

Real nice. Just wish you'd let me know about it. Paul obviously wanted both his parents to be here. P.J. too. Even if things aren't working for us right now, we can—"

"Mom? Dad?" Paul, his curls damp on his forehead with the humidity, appeared in the doorway. "They're letting the baby open her presents. Can we open ours? Those boxes on the window seat are for us, aren't they, Mom?"

But Philip's words were still echoing in my ears. He'd called me Gabby. And did he really say *"right now"*? Meaning what?

"Mom?"

"Yes. Yes, of course, honey. Coming."

Paul disappeared again. I sighed. "Might as well stay while they open gifts," I said over my shoulder as I followed our youngest down the hall. This was so . . . awkward. Frankly, I wished the floor would open up and swallow Philip. Or me.

But it was hard to stay morose while Gracie was gleefully tearing paper off her packages. First a sorting toy, then a cute squeezable doll, a stuffed penguin, cute pink overalls, and pink tights with ruffles on the rump. Josh and Edesa opened the last few, because by this time Gracie was happily playing with the wrapping paper and the boxes.

Denny Baxter rubbed his hands together. "Okay! So who gets those big boxes on the window seat in the sunroom? Do we draw straws?"

"Back off, bud." Jodi backhanded her husband on the arm. "This is Gabby's show."

Jodi and I had managed to "wrap" the boxes in brown paper from grocery bags to hide the contents, and I'd stuck a big red bow on the top of each. Trying to ignore the big plastic bags

sitting nearby with the Sports Authority logo, I said, "P.J., your birthday was first. The square one is yours."

For a moment, I saw P.J.'s fourteen-year-old cool veneer slip, and he also ripped off the brown paper and packing tape with gusto. Digging through inflated plastic padding, he lifted out a gleaming blue-and-gold lacrosse helmet, and matching gloves and shoulder pads. Lane Tech colors. "Uh . . ." He looked at his father. "Dad just got us some lacrosse equipment—and some shoes too."

Huh. Figured. I'd steeled myself for this.

"Well, guess we both know what you like," I said brightly. "Don't worry. We'll exchange it for some other gear."

"Can I keep the stuff Dad got? He let me pick out what I wanted. He got Paul some too, so we can practice together."

It was getting harder to maintain brightness. "We'll work it out, honey . . . Paul? You want to open the long box? No duplicates this time." My laugh fell flat.

Paul didn't seem to notice. "Yeah! You wanna help me, DaShawn?" Paul and Harry Bentley's grandson tore off the brown paper, then Paul stepped back, reading the box, his eyes big. "Mom! A Casio keyboard?! Awriiiight! Anyone got a knife? I wanna open it!"

Josh Baxter produced a pocketknife, and a few moments later Paul slid out the gleaming keyboard. "Wow, Mom! Just what I wanted! Can we set it up?"

I didn't know anything about keyboards, but Josh seemed to know a great deal, and before long had it set up on the window seat, plugged in, and Paul was running his hands over the keys.

"Josh used to run the soundboard at SouledOut Community

Church," Jodi murmured to me. "He had to set up a lot of keyboards!"

I was glad but already distracted by what was happening at the window seat. "Look at Jermaine."

Mabel's nephew had drawn alongside Paul, reverently touching the panel of buttons. "You play?" he asked Paul.

"Yeah. Some. Mostly my own stuff. Do you?"

The older boy's face was alight. "Yeah. Wanna do some stuff?"

"Sure!" Paul, on his knees in front of the keyboard, scooted over, and within moments Jermaine was pounding out something on the bass keys while Paul trilled a tune on the treble keys. Soon people were crowding around, listening and clapping as jazzy music filled the apartment.

Satisfaction seeped deep into my spirit. Well, one bull's-eye out of two tries wasn't bad. But just then I smelled Philip's familiar Armani aftershave and heard a whisper in my ear. "Good heavens, Gabrielle. Don't you realize that skinny black kid is a fairy? I don't want Paul hanging out with a sissy!"

"*Philip!*" I snapped, anxiously looking around to see who might have heard.

"Okay, okay." Philip put up his hands as if backing off. "I'm just saying . . ."

chapter 4

* * *

A fly droned in my ear. I brushed it away, unwilling to own that it was Monday already. Moving air from the window fan felt cool after the oppressive humidity that had hung over the city all weekend. Morning light filtered through the miniblinds, but the sun rose how early? Surely it couldn't be time to get up yet.

I cracked an eyelid. The digital alarm said 5:56. *Ahh*. A good half hour before the alarm. I curled my arms around my pillow, willing myself to fall asleep again. After all, once Monday started—

The fly came back, louder than the fan . . . then stopped.

Argh! I sat up straight and frantically ran fingers through my tangled cap of natural curls. All my life I'd lived with the morbid fear that one day a fly or mosquito or bee would crawl into the reddish-brown corkscrews that haloed my head and hide there. Make a nest. Raise a family.

People with sleek, straight hair didn't have to worry about that.

The fly had to go.

Turning on the bedroom light, I slid out of bed, grabbed a slipper, and stood stock-still. Zzzzzzz. There. I waited until the little bugger landed on the wall . . .

Swat!

Success.

But now I was wide-awake. Wrapping a thin kimono around my silky black boy-shorts-and-tank-top sleepwear, I padded out of my tiny bedroom at the rear of the apartment into the kitchen and started the coffee. After an inch had dripped into the pot, I poured a first cup, added milk from the fridge, and sat down at the little kitchen table while the rest of the pot was filling.

Monday already. It should have been a good weekend, except Philip's stupid comment about Mabel's nephew had upset me to no end. What if Mabel had overheard? Or Jermaine? Sure, the boy was a bit effeminate, but that didn't mean anything. Not at fourteen—did it? So what if he had a passion for music instead of football! I thought it was neat that Paul had found a kid who shared his creative genius, even if Jermaine was a couple of years older. Couldn't Philip see that?

I should talk with my boys about this, before Philip's mindset poisoned their attitudes too.

Still, the welcome-home-birthday-party combo on Saturday had been fun . . . well, if I hadn't been so distracted by Philip inviting himself in when he brought the boys back. And ruining my birthday surprise for P.J. by buying similar stuff at the Sports Authority. At least Paul had been ecstatic about the Casio keyboard. A splurge on my part. Had nearly wiped out my last

check from Manna House. But the life insurance money from my mother should arrive any day now. She would've approved of the keyboard for Paul.

Sunday was good too. I thought the boys had enjoyed their first visit to SouledOut Community Church. *"Start now, baby,"* Estelle had told me. *"Take 'em to church every Sunday. Tell 'em it's part of the package. They'll get used to it."* I hoped so. We'd been sporadic attenders at best back in Virginia, mostly for Christmas, Easter, weddings, and funerals. It helped that the boys already knew some of the folks at SouledOut, since half the people who had come to their party were members there. Well, maybe Mr. Bentley wasn't a member, but he'd been pretty regular since he'd started romancing Estelle Williams. Such beautiful people at SouledOut, a lovely mix of brown and black and white and tan. And even one redhead lately. Me.

Now it was Monday. P.J. started cross-country practice at Lane Tech today. Had to get him there by nine and pick him up at ten thirty—which meant I had to leave staff meeting a little early. I had a rental car for now until I could buy a car, but he'd have to learn how to take the bus sooner or later. The kids still had three weeks until school started, but fall sports practices started early. Lacrosse was a spring sport, so P.J. had signed up for cross-country to help him stay in condition. But, oh, Lord, I was so lucky to get the boys registered for school last week! Lane Tech College Prep for P.J.—just a day school, praise God—and Sunnyside Magnet School for Paul, a K-through-eight school right in our neighborhood. No, not luck. An answer to a lot of prayer. *Thank You, thank You, Lord . . .*

Getting the boys in school had been first on my agenda when

their grandfather arrived in Chicago a week ago with the boys. After P.J.'s summer lacrosse camp was over at the end of July, Mike Fairbanks had decided to drive their big Suburban from Petersburg, Virginia, in order to bring the boys' bikes too. Over Nana Marlene's protests, no doubt. Philip's mother still clung to the belief that P.J. and Paul were returning—*must* return—to George Washington College Prep boarding school in the fall because, well, that's what the Virginia Fairbanks males *did*. In fact, Philip had left the boys' bikes with his parents when we'd moved to Chicago last spring, assuming the same thing. *"They'll need them when they go back to school, Gabrielle."*

But now the bikes were here, courtesy of Philip's father. Locked in the basement of this six-flat. A symbolic reality that Chicago was now home for P.J. and Paul too. *Bless Mike Fairbanks, God.* Why was it only now, when my marriage with Philip was falling apart, that his father had become my advocate?

I refilled my coffee cup and let the hot liquid do its magic on my recalcitrant brain cells. *Staff meeting* . . . Should I bring up the idea about buying this six-flat and turning it into second-stage housing for homeless moms like Precious and Tanya? So far I'd only mentioned my crazy idea to Mabel. And my lawyer. Barely. But I needed some idea of what I was going to do when that check from my mother's insurance arrived—

"Mom?" Paul's sleepy voice made me jump. My twelve-year-old stood in the kitchen doorway in his pajama bottoms and skinny, bare torso.

"Hey, kiddo. What are you doing up? I was going to let you sleep in a bit longer."

"I'm thirsty."

"Okay. You want water or some O.J.?"

"Just water." Paul plopped into a kitchen chair, elbows on the table, chin in his hands. "Mom, how come you gave Grandma's dog to that old bag lady—Lucy what's-her-face? It's not fair. Dandy's like family!" He stuck out his lip, ignoring the glass of water I put in front of him.

Ah. Dandy. Knew I'd have to answer for that sooner or later. "You really want a dog, don't you, bud." A stall, I knew.

"Yeah. But we already had a dog . . . well, kinda. When Grandma—" The corner of his mouth curled into a small smile. "Did the homeless people at the shelter really call her 'Gramma Shep'?"

I smiled. "Sure did."

He sighed. "Cool. Anyway, when Grandma died, I thought Dandy would come live with us! I would've taken care of him."

I laid a hand on his arm. "I know you would, bud. But your dad, well, he didn't want a dog in the penthouse, you know that."

"Yeah, but . . . since you guys . . . I mean, since you . . ." Suddenly Paul's face took on the stricken look of a child who had just backed into the elephant in the middle of the room. His lip trembled. Before I could say anything, he tore out of the kitchen, tipping the chair over in the process, and slammed the door of his bedroom. I grabbed the glass of water before it tipped over too, waited thirty long seconds, and then padded quietly to his bedroom and opened the door.

Paul was sprawled on his bottom bunk, face in the pillow, shoulders shaking. "Aw, honey . . ." I sat on the edge of the bed and gathered him into my arms. "I know, kiddo, I know. It hurts."

We sat that way for several minutes, while he cried in my lap. Then he sniffed and sat up, glaring at me reproachfully. "Why do you guys want to get divorced anyway? What about P.J. and me?"

Divorce. Had Philip used that word around the boys? I swallowed. "I . . . we haven't said anything about divorce, honey. Just . . . we need some time apart right now. To work things out." *Oh, God. Am I getting his hopes up? After what Philip did, do I even want to work things out? Help me, Lord. I don't know what to say!*

There I was again, jumping right into the "help me!" prayers. But sometimes that's all I knew what to pray.

I drove the gray Nissan I'd rented into the parking lot of Lane Tech. The high school campus sprawled on the southwest corner of Addison and Western Avenue. Wide front lawn, classic brick building with several wings, athletic field, outdoor stadium, surrounded by city on all sides. Definitely a change from George Washington Prep, with its white-pillared campus tucked into the rolling countryside around Petersburg.

No uniforms or blazers here. Instead, the kids spilling out of other cars with their gym bags looked like a regular United Nations. Unlike other neighborhood high schools, Lane Tech College Prep took applications from all over the city and had a long waiting list. Fortunately, P.J.'s lacrosse camp this summer had helped shoehorn him into the list this fall. Lane Tech had an up-and-coming lacrosse team.

"Do you know where to go, kiddo? Want me to go with you?"

"No, Mom! I'll find it." P.J. piled out of the Nissan with his gym bag, wearing running shoes, shorts, and a T-shirt. Where did he get that confidence? New city. New school. Didn't know a soul. First year of high school, no less. When I'd started high school in Minot, North Dakota, I knew half the kids already from middle school.

Must be his dad's genes. Well.

I rolled down the passenger side window. "P.J., wait! Remember, I've got a ten o'clock staff meeting. I'll leave early, but it might be eleven by the time I get here. Meet me right here in the lot, okay?"

"I'll be fine, Mom. See ya." P.J. trotted off, gym bag over his shoulder.

A voice piped up from the backseat. "Can I ride up front with you, Mom? I'm twelve now."

I glanced at Paul in the rearview. "Sorry, bud. I checked it out. Backseat for *twelve and under,* not *under twelve.*"

Scowling, Paul flipped his seat belt buckle and slid over behind me, where I couldn't see him. "Seat belt," I reminded, waiting until I heard it click before jockeying the car out of the lot. I'd given my just-twelve-year-old the choice of staying at the apartment and playing with his keyboard until I got home at two, or coming with me to the shelter. To my relief, he chose to come. And the shelter had a rec room with a Ping-Pong table, a TV, and games.

We rode in silence for a mile or so as traffic moved in starts and stops along Addison. Suddenly Paul said, "Hey! Is that Wrigley Field? Where we went that time to see the Cubs?"

The huge ballpark loomed in the distance like a poignant

memory. *Memorial Day weekend. Our first weekend together as a family after picking the boys up from school in Virginia. Still full of hopes and dreams for our new life in Chicago.* "That's it. That was a fun day, wasn't it?"

No answer. But I turned my head just enough to catch his face pressed against the window behind me, watching the curved walls of Wrigley Field slide past as I turned the corner by the Addison El station and headed north. I knew what was going on in his mind. *Would we ever have a fun day like that again, all of us together?*

A few blocks north of the ballpark, the Manna House shelter was tucked into a neighborhood known as Wrigleyville North. I parked on a side street, leaving plenty of exit room between me and the next parked car. I'd gotten blocked in once when I drove Philip's Lexus to work and had to leave it on the street overnight.

Another one of my so-called sins that contributed to the downfall of my marriage. Well, maybe not, but it didn't help.

"How come the shelter looks so much like a church?" Paul gazed up at the building as we waited at the top of the wide steps to be buzzed in. The brick building was less than a year old, and at its peak the wooden beams of a cross stretched top to bottom and side to side inside a circular stained-glass window.

"Because the old church that used to house the shelter burned down, so they rebuilt it along the lines of the original building— oh! Here we go." As the buzzer sounded, I pulled open the big oak door. "Hi, Angela!" I waved at the young receptionist in the glassed-in cubicle as we crossed the foyer. "Will you sign me in? And you remember my son Paul, don't you? He's here with me today."

"Sure! Hi, Paul. Nice to have a man about the place." The pretty olive-skinned girl winked at Paul beneath her sleek black bangs, then grabbed the phone as it rang.

Huh. I pulled open the double doors into the multipurpose room. *She doesn't have to worry about some ol' fly making a nest in that straight silky hair.* A distinct advantage of Asian parentage.

The multipurpose room was abuzz, not untypical for Monday morning. "Sarge," the shelter's no-nonsense night manager, was still on site, arguing with Wanda, a rather verbose Jamaican woman—one of the few who managed to stand up to Sarge's Italian toughness. Someone was sleeping on one of the couches with a jacket over her head, couldn't tell who. A couple of unfamiliar faces glanced our way as we came in and looked away, just sitting, not doing anything. Must have come in over the weekend. Sheila, a heavy-chested black woman who usually kept to herself, was vacuuming the various rugs that carpeted the room in a patchwork, one of the many chores residents did daily. I still didn't know her very well, even though I'd been a resident here myself for several weeks this summer. I really should—

"Paul!" A childish voice greeted us from across the large open room. Sammy came running. "I didn't know you was gonna come with your mom today. You wanna play with me an' Keisha? We just started Monopoly, but it's funner with more."

Paul shrugged. "I guess. Okay, Mom?"

"Sure. I'll be downstairs in my office if you need me." *Perfect.* Keisha was ten, the oldest of the few children currently at the shelter—well, not counting sixteen-year-old Sabrina, who qualified as a "child" because she was here with her mother. Keisha's grandmother, Celia, a vacant-eyed woman in her fifties, seemed

to be her guardian, though I didn't know their story. Thank goodness Paul didn't mind playing with younger kids. Monopoly would keep him busy until staff meeting was over at least, if the kids didn't end up fighting.

Manna House was designed for homeless women, not families, and didn't have enough kids to develop a full-blown youth program, but the shelter occasionally took in moms with young children if there was bed space. And residents like Precious McGill and Tanya—I didn't even know her last name—felt it keenly, not being able to make a home for their kids.

Which was exactly why my "House of Hope" idea stuck like peanut butter to the roof of my spirit.

I scurried downstairs to the lower level, which housed the shelter's dining room, kitchen, laundry facilities, rec room—and my office. A former broom closet. Still, I got a rush every time I unlocked the door with the nameplate: Gabby Fairbanks, Program Director.

Except—the door was already unlocked. And a ribbon of light shone from beneath the door of the windowless room. *What?* Had I left it unlocked all weekend, and the light on too? Or . . .

I tentatively pushed the door open, unsure what I'd find.

A yellow furball explosion nearly knocked me over. As I protected myself from the excited wriggling dog, I saw a familiar craggy face under a cap of thinning gray hair grinning at me from my desk chair.

Lucy!

chapter 5

"Lucy Tucker, you goose! You scared the bejeebers out of me." I bent down and gave the wriggling yellow dog with her a good scratch on the rump. "Okay, okay, glad to see you too, Dandy. Where have you two been the last couple of weeks?"

"Around." Lucy's standard answer. Don't know why I bothered to ask.

I hadn't seen Lucy but once since we'd come back from North Dakota in July, when she'd ridden along with my mom's casket in the Manna House van to bury my mother. What a strange friendship they'd formed! Lucy, the streetwise "bag lady," and Martha Shepherd, my slightly demented mother, who had spent most of her life in a small town on the Western prairie. Both of them in their seventies—actually, that was a guess in Lucy's case—but there the similarity ended.

I brought my mother to Chicago when it was obvious she could no longer live alone. Brought her to work with me at the shelter so she didn't have to stay alone at the penthouse. Until my

husband gave his ultimatum: find another place for Grandma or send her home. According to Philip, the penthouse just wasn't big enough for a family of four *and* a mother-in-law *and* her rambunctious mutt.

For Lucy it was simple. Martha should stay at Manna House. "She homeless, ain't she?"

My mother became "Gramma Shep" to the other residents—happy to just sit in the multipurpose room while drama bustled around her, patiently listening to anyone who wanted to talk or vent, tickled to read a story to a whiny kid. Streetwise Lucy, who normally only came to the shelter when she had to ("Too many rules!"), took over care for Dandy, walking him every day, something my mother could no longer do—especially not in Chicago. A responsibility that bonded Lucy to my mother and Dandy in a special way I didn't have the heart to break.

Which is why I gave Dandy to Lucy when my mother died.

Something I still needed to explain to my youngest son.

I dumped my purse and tote bag on the desk. "You two doing all right?"

"We doin' okay. Dandy makin' friends with half the city. But I stopped by ta pick up some more dog food from that stash ya got here—ya know, when he was Hero Dog."

Oh yes, Hero Dog. The night Dandy had scared off a midnight intruder. When the media got hold of the story, Chicagoans smothered "Hero Dog" with bags of food, chew toys, and stuffed animals. And checks for the shelter. Which was how we got that big whale of a white passenger van the residents dubbed "Moby Van." Most of the other stuff got donated to an organization that helped fixed-income seniors care for their

pets, except for six months' worth of dog food we kept stashed here for Dandy.

"No problem. You got room in your cart for a whole bag?" Lucy's cart stood in a corner of my office, relatively empty, considering. "Uh, where's all your stuff?"

"In the wash. Didn't have no quarters for the Laundromat. Angela said I could use the machines if nobody else had 'em signed up. That's why I came early. Me an' Dandy been here since breakfast."

"Well, I'm glad to see you both." Definitely glad to see Dandy looking fit and healthy. I couldn't help worrying how he'd fare as a "street dog." Cold weather, though . . . that would be a different story, something we needed to talk about.

But not now. "Hey, I know somebody upstairs who'd love to see Dandy. My boys are back, Lucy. I got them registered for school and everything. Paul's here today. You mind taking Dandy upstairs to see him? I've got work to do before staff meeting anyway."

"Okay by me." The old lady hefted herself out of my desk chair, dressed as usual in several layers of mismatched clothes. "If you think your kid's nose ain't gonna get outta joint 'cause Dandy's with me."

Ah. Very astute. Maybe I should leave well enough alone. Paul was probably immersed in the Monopoly game by now, but if he saw Dandy . . .

No. What if he found out Dandy had been here and he didn't get to see him? He'd *really* feel like he'd been cut out of Dandy's life.

"Mm. He might. But I still think he'd love to see Dandy. Go on . . . and thanks. You can leave your cart here if you want."

Lucy pondered. She rarely went anywhere without that cart. "Well, okay. If you gonna be here the whole time. C'mon, Dandy." She lumbered through the door, Dandy at her heels, but before they disappeared I heard her holler, "Hiya, Estelle! Whatchu makin' for lunch today?"

I shut the door, isolating my cocoon. If I got started talking to Estelle, staff meeting would be here and I wouldn't have gotten a thing done!

I was startled by a knock at my door. Estelle Williams poked her head in. "You comin' to staff meeting, girl?"

"What—? Oh, thanks, Estelle." Where had the time gone? I'd been trying to take five or ten minutes to pray before starting my workday—how hard should that be?—but it was still a struggle not to check my e-mail first to see if there was anything urgent and plunge right back into work I'd left undone on Friday. Especially since I'd cut back to half time for the next few weeks until the boys started school. Fewer hours. Same amount of work.

But I grabbed a pad of paper and a couple of folders and scurried up the stairs behind the shelter's lunch cook, who was still wearing her white net cap and big white apron over wide navy blue slacks and a rumpled white blouse. "You go on, Estelle," I huffed at the top of the stairs. "I need to check on Paul and try to catch Mabel before the meeting."

"Then, girl, you shoulda come up ten minutes ago. I'll save you a seat." Estelle had a mild way of scolding me, like she'd dripped honey all over a prickly pear.

Mabel was striding across the multipurpose room, professional as always, notebook in hand, makeup perfectly blended with her creamy walnut skin, talking to Stephanie Cooper, a thirtysomething social worker with straight, straw-colored hair and wearing jeans, who worked two days a week at the shelter as a case manager. "Mabel!" I called. "Can I see you a sec? Oh wait . . ." I glanced around the multipurpose room. No kids. "Oh no! Anybody seen Paul and Sammy and Keisha?"

"They wanted to take the dog for a walk," one of the couch-sitters offered.

"Not by themselves!" I shrieked. All I got was a shrug. "Sorry, Mabel," I called over my shoulder. "Gotta find Paul." I dashed into the foyer, where Angela was turning over phone duty to one of the residents for the next hour. "Angela, did you see the kids go out with Dandy? Was Lucy with them?"

"Yeah, I saw them. Not Lucy though. But I think Hannah went with them—no, wait. It was Tanya."

At Hannah's name, I was about to bolt out the door, staff meeting or no staff meeting. The wannabe cosmetician was barely twenty, and not the brightest crayon in the box. But if Tanya had gone with them, it was probably okay. Sammy's mom was a real sweetie, one of the young women I was hoping to recruit for the House of Hope, if it ever materialized.

But now . . . Oh no! I'd wanted to check with Mabel about bringing up the House of Hope idea at staff meeting! Could I catch her before—?

I ran back through the multipurpose room, past the TV room and toddler playroom to the "schoolroom," which boasted four computers, several school desks, and assorted chairs. Mabel

was already praying over a circle of bowed heads crowned with Stephanie's straw-colored hair, all varieties of black hair—straight, straightened, kinky, and salt-and-pepper—and now my mop of auburn curls as I slipped into the chair next to Estelle.

Rats! I didn't get a chance to ask Mabel first.

". . . praise You, Lord, for Your hand of protection over each resident in this house. You are the Creator and Sustainer of every woman who comes through our doors, each one precious in Your sight. You are a gracious and merciful God, patient with all our shortcomings . . ."

Mabel's prayers still took some getting used to. I expected staff prayers to dive into the long list of needs we had at the shelter—more volunteer church groups to cook the evening meal . . . someone to cover night duty for Sarge, who wanted to take a week of vacation . . . how to help the residents over fifty, whose possibilities for job training and finding a job were almost nil . . . the used-up girl who came in off the street last week, desperately wanting help to kick her habit and to get away from her pimp, but who only managed to stay half a day before the drug-induced hunger in her body drove her back out to her old life. The needs at the shelter were all more or less desperate. But Mabel always started meetings with "just lovin' on God," as Estelle called it.

As Mabel breathed out her last murmur of worship and opened her notebook to read that day's agenda, I quickly scribbled a note and passed it to her. *I'd like to bring up the House of Hope idea, get some feedback from the staff. What do you think?—G*

She glanced at the note, tucked it in her notebook, and continued reading her agenda. A report from Sarge about the fight in the second-floor shower over the weekend. Reviewing the new

residents who had come in the past week, their case management assignments, any special needs. Gabby's new schedule for the next few weeks. Need for more case managers by the time cold weather filled up the shelter. Suggestion from residents for renaming the multipurpose room . . .

I tried to catch Mabel's eye, pointing to my note. Calling on Sarge to make her weekly report, Mabel pulled out my note, wrote something on the bottom, folded it, and passed it back to me. I opened the note. *Not today. Let's go to the board with it first. Is Saturday good?*

The board? I knew I'd need to talk to the board at some point. But . . . Saturday? I wasn't ready for something that official! I'd been hoping to brainstorm the idea with some of the staff and my friends here at the shelter to get their ideas. Besides, it was going to be hard keeping it under my hat another whole week. I really wanted—needed—to talk about it. Was it a good idea? Or just out-and-out crazy?

Well, at least I had an appointment with Lee Boyer, my Legal Aid lawyer, on Wednesday. I definitely needed to talk to him about my options. He'd been the one who went out of his way to get me out of the shelter and into an apartment so I could prove to a judge I was capable of providing for my boys in the custody suit he planned to file on my behalf. Once I had my own apartment it'd be a "slam dunk," according to Lee.

Funny thing, Philip hadn't even protested once I got the ball rolling. I'd expected all kinds of delays and roadblocks to bringing the boys back. Maybe he'd been counting on his parents joining his fight to keep the boys in Virginia—"for school," of course. Frankly, I'd expected an uphill battle with all the Fairbanks. But

to my surprise, Mike Fairbanks had sided with me when Philip dumped me. Said he'd bring the boys back as soon as I had a place to live. And he was as good as his word.

". . . and Tawny," Mabel was saying. "Bright young thing. Got dumped out of the foster-care system when she turned eighteen last month, has been staying with different friends until she came here a few days ago. She seems very motivated to finish her GED, get a job, and go on to college."

I'd only been paying half attention until I heard the name. "Tawny? Yeah, Jodi Baxter said she showed up for the typing class Saturday morning." I'd no sooner joined the conversation than the hands of the schoolroom clock caught my eye. Almost 10:45! I jumped up. "Oops. I have to pick up P.J. at Lane Tech. Sorry. It's only for a few weeks until school starts." I inched apologetically toward the door. "I'll check in when I get back to see what I missed."

Mabel nodded. "Okay. We only have a few more items. We'll table the discussion about a new name for the multipurpose room. I think you'll want to be here for that, Gabby. Some of the residents think we ought to rename it in memory of Gramma Shep—but we can talk about it next week."

I almost sat down again. Name the multipurpose room after my mom? Of course I wanted to be here for that discussion! Maybe—

But I made myself slip out and run for the car.

Still no Paul that I could see—inside or outside the shelter.

Oh, that boy! He was going to be grounded big time for not telling me he was going out!

But even as I jumped into the rental car and peeled rubber

going around the first corner, I knew I only had myself to blame. Why did I think I could handle this superwoman single mom stuff—program director for a shelter full of aimless homeless women, sole wage earner, solo parent most of the week, chauffeur, shopper, entertainer, housekeeper, cook, prospective real estate investor—when for the past fifteen years I'd basically traded my aspirations and a stiff backbone for the comfort of Southern charm and old money . . . like Esau in the Sunday school stories I'd grown up with, trading his birthright for a pot of savory stew.

chapter 6

The parking lot at Lane Tech was virtually empty by the time I pulled in at 10:59. P.J. was waiting at the same spot where I'd let him out, except his T-shirt was wet around the neck and armpits, and his dark hair lay damp on his forehead. "Sorry, kiddo," I said as he jumped into the front seat. "Did you have to wait long?"

He shrugged.

"Put on your seat belt . . . How did it go? Looks like the coach worked you hard."

"Yeah." He turned his head toward the window, but not before I caught the hint of a grin playing the corner of his mouth.

I hooted. "You rascal. Did you run? I bet you came in first the very first day."

He shook his head. "Not really." But the grin widened. "But I kept up with the front group. Coach called me out, said, 'Good job, Fairbanks.'"

I reached over and rumpled his damp hair. "Well, I second that, *Fairbanks*. Good job! Why don't you call your dad?" I handed

P.J. my cell phone. "He'd like to hear how your first day of practice went, I'm sure." A self-righteous amicability smothered the angst I'd been feeling just fifteen minutes ago. Yeah, I could be the mature single-again mom, generously keeping the jerk father in the picture, refusing to make my sons choose between their parents.

But he shrugged and handed the phone back. "Maybe later."

I dropped P.J. off at the apartment, telling him I'd be off work at two and to stay put. The rest of the afternoon, we'd do whatever he wanted. When I got back to the shelter, the dog walkers had returned and Paul was triumphantly purchasing another tiny plastic house with Monopoly money to put on Park Place. Still feeling magnanimous, I decided to wait until we were alone to talk with him about leaving the premises. I knocked on Mabel's office door instead.

"Sorry I had to leave staff meeting early. What'd I miss?"

Mabel turned from her computer. "I was just typing up the minutes. But sit down, Gabby. Let's talk about this transitional housing idea of yours. If you want to bring it to the board on Saturday, we need a proposal—description of the property, how it's going to be financed, how to partner with city resources . . ."

I sat, nodding my head as the director listed things the board would want to know. When she finished, I drew in a big breath and then blew it out again. "Um, write up a proposal. You're right. Definitely right. Except . . . I don't *know* how it could work! That's why I need help, brainstorming with people who do know this kind of stuff. I mean, what if I gave Manna House two hundred thousand for a down payment? A donation, you know, earmarked for purchase of the building. Could Manna House pay the monthly mortgage?"

Mabel just looked at me for a long moment or two, tapping the eraser end of a pencil on her desk. Then her eyebrows—those perfectly plucked arches—went up, and her dark eyes widened just a fraction. "A donation. That's a pretty hefty donation for someone who was penniless a few weeks ago. Is that wise? Would you have anything left to live on? Besides your *huge* salary for part-time work here at Manna House, of course." Her full lips parted in a teasing smile.

"I don't know. I mean, yeah, I'd have something left. Not a whole lot, but something." Something like fifty grand. Which I was counting on to help meet expenses for the boys, and I'd need a hunk of it pretty soon to get a car.

Mabel tapped the pencil eraser a few more times and then put it down. "Have you talked to your lawyer? You're still working with Lee Boyer at Legal Aid, aren't you?"

I nodded. "Yes. I mean, he's the one filing the custody petition for me. But no, I haven't had time to really discuss this idea with him." Not for lack of Lee's persistence. He'd called me several times the past few weeks, but I was feeling confused about Lee Boyer. Was he my lawyer? My friend? Both? Or . . . more? I'd cancelled my last two appointments to give myself some space. "Just until I get the boys settled," I'd told him.

"Well, talk to your lawyer, Gabby. You need to get your own finances squared away and make some decisions about your situation. You and Philip have only been separated . . . what? Less than two months? And you just lost your mother. That's a lot of change and a lot of stress. Might not be the best time to make a major decision like this."

I blinked back sudden tears. "But I really think this is God's

idea, Mabel." My voice croaked. "Jodi Baxter thinks so too. I don't know how it all fits together, but—"

How could I explain what the shelter meant to me? It was here I'd met God again, discovered He'd been whispering my name and calling me to "come" all those years I'd left Him behind. But I couldn't hear Him until I'd lost everything. Now I wanted to give something back. I didn't want to forget what it felt like to be in Precious's and Tanya's shoes, with no home for my children.

I felt Mabel's hand on mine. "Gabby." Her voice was gentle. "If this is God's idea, then it's going to happen. God's timing is perfect. You don't have to rush it."

"I know." I fished for a tissue and blotted my eyes. Probably raccoon eyes by now.

Mabel's hand left mine and she sat back. "But tell you what. Talk to Boyer, get his legal advice, and maybe he can recommend a financial adviser. And write down your vision for this House of Hope idea, wild as it may sound. Plus as many facts as you can—cost of the building, purchase requirements, repairs needed, whatever you can pull together. Put it down on paper. Meanwhile, I'll do some fact-finding on current city and federal resources for rent subsidies—something I've been wanting to do anyway. We'll put it on the agenda for Saturday . . . but we can always take it off, Gabby, if you decide not to pursue it right now, or just need more time."

"Thanks, Mabel. I really appreciate this."

"And one more thing."

A grin tickled my mouth. With Mabel, there was always "one more thing."

"Pray about it. The psalmist said, 'Unless the Lord builds the house, its builders labor in vain.' That would definitely apply to *this* house. Do you have a prayer partner?"

"Uh . . . not exactly."

"Find one. Estelle, Edesa, Jodi Baxter . . . someone. Pray about it together. I'll be praying about it too."

"I'd like that." I stood up to go. "Thanks again, Mabel."

"Oh—and one more thing."

Now I laughed aloud.

"Okay, okay, never mind." She waved me off and turned to her computer, pretending to work.

"Mabel! What?"

She whirled her desk chair to face me. "Your Paul seems to get along well with the kids here. The last few weeks before school starts are likely to be nuts around here, since city summer camps are over and we don't really have any activities for the kids going on. Do you think he'd want to volunteer a few days a week? During the time you're here? Just play with the kids, be a big brother. We could give him a volunteer T-shirt."

My feet wanted to dance. "*Yes!* I mean, I'll have to ask him. No, better yet, *you* ask him. Make it official. Give me ten minutes to disappear, though. Don't want him to think it was my idea." I darted out the door—and two seconds later poked my head back in. "Oh, one more thing," I snickered. "He already has a T-shirt. You gave one to both boys the first time they visited."

Still grinning, I slipped through the multipurpose room and down the stairs without Paul noticing me. I'd been worried about finding something for the boys to do until school started,

even with my shortened hours. But look at God! He'd answered my prayer before I'd even prayed about it.

"Yeah," I overhead Paul telling P.J. in the backseat as we headed for Foster Avenue Beach later that afternoon. "Ms. Turner asked if I'd be a volunteer at the shelter, helping out with the little kids. She gave me another T-shirt since I've worn that other one a lot. I'm supposed to wear it so the kids know I'm the boss."

"Ha!" P.J. snorted. "Did you tell her you used the first one to clean your bicycle after you greased the wheels?"

I stifled a laugh and stayed out of it. Younger brothers always lived in their older siblings' shadows. But Mabel's volunteer job offer had definitely raised Paul's status. His big brother couldn't tease him for "playing with the little kids" if it was a *job*.

Foster Avenue Beach was within sight of Richmond Towers, but the boys had already been there a few times earlier in the summer, and this is where they'd swim when they were with their dad, so familiarity and consistency had points in their favor. I spread my beach towel so my back was to the row of luxury high-rises in the distance. P.J. and Paul were both good swimmers and the beach had several lifeguards on duty, so I let my mind and body relax, watching the boys dash for the shoreline.

It didn't get much better than this . . . except for the hole in my heart. But I stuffed Philip's rejection underneath the pleasure of the moment, smothering the nagging pain with the warmth of the sun on my skin, the breeze running gentle fingers through

my tangled curls, and the sheer joy of watching P.J. and Paul cavort in the water.

And the long envelope from Putnam, Fields, and Pederson that was in the mailbox when Paul and I got home from the shelter the next day definitely buoyed my spirits. A check for two hundred thousand dollars, my share of my mother's term life insurance policy.

I turned right around and drove to the little branch bank near Manna House where I'd opened a new account and put it all in my checking account. For now. And then I walked a few yards to the Emerald City Coffee Shop underneath the Sheridan El Station, ordered the Kona Mocha—maxi-size—and two of their to-die-for buttery pumpkin cookies, settled back on one of their cushiony couches near the front window . . . and started to cry with sheer thankfulness.

"Mom!" Paul accosted me just as I was heading out the door of the shelter at ten thirty on Wednesday to pick up P.J. from his third day of cross-country practice. After taking him home, I needed to go straight to Legal Aid for my eleven o'clock appointment with Lee Boyer. "Mom! Why don't we take Sammy and Keisha swimming with us at Foster Beach this afternoon? They never get to go swimming!"

Keisha and Sammy? No way would that be relaxing! I doubted if either of them knew how to swim, and I'd have to keep an eagle eye on them. I opened my mouth to say no, and then hesitated. Here I was taking time off for a personal appointment from my

already shortened day, and even though Mabel was generous with flexible hours for doctor's appointments and the like, I still felt I should make up the time somehow. Taking Keisha and Sammy swimming with my boys this afternoon would certainly fall under my job description of program director for the shelter.

"Good idea, buddy. But it has to be after my appointment at Legal Aid, and they need to ask their moms. You work it out, okay? I'll be back to pick you up after lunch—and if they don't have swimsuits, tell them to bring an extra pair of shorts and a T-shirt!"

I smiled as Paul ran off in his orange-and-black T-shirt that said "Manna House Volunteer" across the front, with "I'm part of God's miracle" in small letters beneath. The week was settling into a workable routine. P.J. seemed just as glad to chill out at the apartment after his sweaty workout with the Lane Tech cross-country team, and by two o'clock when I got off work, we were all ready to do something together. The beach. Grocery shopping. Maybe the bike trail along the lake one day—though I had to get a bicycle first. And Mr. Bentley was picking us up to go to the zoo on Thursday.

After all the pain and uncertainty of the first part of the summer, these few weeks felt like being rocked in God's lap. *Thank You, Jesus. Thank You . . .*

I was still basking in the blessings of God when I walked into Lee Boyer's office at eleven. "Hey, Gabby!" he said, jumping up from his desk and giving me a quick hug and big smile. A professional hug, I told myself. "Glad you didn't cancel another appointment. I've got good news! We've got a court date to hear your petitions on"—he glanced at some papers—"September

eighth. That's three weeks from Friday. I figured you'd want time to get P.J. and Paul settled in school." He looked up and grinned again. "I'm eager to hear how it's going since your boys got back."

Lee Boyer. Dressed in his usual jeans, Birkenstock sandals, open-necked short-sleeved dress shirt, brown hair with gold flecks brushed neatly to one side, and friendly light brown eyes behind retro wire-rims. He was such a down-home guy. I'd liked him from the first time I'd made an appointment at Legal Aid, and he'd certainly gone out of his way to help me find a place to live so I could get custody of my sons. He seemed to like me too . . . which got a little confusing at times.

Like now. I hadn't come for a personal chat. "I . . . the boys are fine . . . but I really need some legal advice about money."

"Ah. The inheritance your folks left you. That's good, that's good, Gabby. Now that you've got an apartment and a nest egg in the bank, that can only strengthen our case for getting custody of the boys. Not that I have any doubt that a judge will rule in your favor." He smiled and leaned back in his desk chair. "I suppose you want to set up some kind of trust fund for the boys?"

I licked my lips. "Well, not exactly. I have an idea, something I want to talk to you about. The building where I live . . . it's still for sale, right?"

Lee peered at me over the top of his wire rims. "As far as I know. But if you're thinking of buying property, don't you want to look at some single family homes? Or a condo here in the city? You don't have to jump into anything right away. The apartment you're renting is sufficient as far as your legal case is—"

"It's not about my custody case." I squirmed a bit in my

chair. "It's that building. I want to buy a six-flat. And live in the building. It's all part of this idea . . ." Taking a deep breath, I told Lee about my idea of purchasing a building that would provide second-stage housing for some of the homeless moms at Manna House, real apartments where they could be a family with their kids, not sharing bunk rooms in an emergency shelter. "I even have a name for it. The House of Hope." I grinned. Just saying the name triggered goose bumps up my arms.

Lee blew out a breath. "Whew. When you get an idea, you don't waste any time jumping out of the starting gate, do you!" He leaned forward, his eyes searching mine. "Gabby, it's okay to take some time to get yourself squared away before jumping into such a big financial commitment." He cocked his head. "How much are we talking about here anyway? Your inheritance, I mean."

"Uh, well, my share of my parents' life insurance is two hundred thousand, plus another fifty when the sale on their house closes—and that's after Mom's attorney pays the inheritance taxes. My aunt is buying the house, so it's a sure thing."

His eyebrows went up. "Two hundred fifty thousand? That's it?"

"Well, yes. Of course I wouldn't put all of it toward the building. But that's why I need some financial advice. How much would I need for a down payment? And what would be the best way to do something like that? I mean, should I just make a major donation to Manna House, earmarked for purchase of this building? Seems like that would save me a lot on taxes. Or should I use my money as a down payment on the building and buy it myself? I mean, two hundred thousand would be a substantial down payment, wouldn't it?"

Lee threw up his hands. "Whoa, whoa, whoa. Gabby, slow down. Look, I'm not a financial adviser, but as your lawyer, I would *not* advise you to give away the major portion of your inheritance like that. Really, you need some sound financial advice, someone who can help you invest your money, make it work for you. That's not a large inheritance—it's nice, but it doesn't put you on easy street."

I stared at him. Words rushed to the tip of my tongue, like foot soldiers defending my idea, but I pushed them back, afraid my voice would quiver.

Lee's voice softened. "Gabby, I'm not just speaking as your lawyer, but as your friend. I really care about what happens to you and your boys. And this . . . this idea just doesn't seem wise. Noble, yes. But let's get things settled with the custody case, follow through on your divorce, give yourself some time. And as I said before, the divorce settlement could give you a nice financial footing as well."

Divorce. Why did he keep bringing that up? As for time . . . "No, there's not plenty of time," I said, tipping my chin up. "Not if someone else buys the six-flat in the meantime. I don't think you understand. This House of Hope is very important to me. It has to be that building. I'm already living there. It's close to Manna House. It's for sale. I'm going to be talking to the Manna House board on Saturday, and I wanted your advice how best to go about it. But if you're just going to shoot it down . . ." I stood up. "Maybe I'd better go."

"Gabby, wait." Lee got up and came around his desk. "Please sit."

I slowly sat back down as he perched on the edge of his desk.

"Okay. I hear you. This idea is important to you. If you are determined to go ahead, then my advice is, buy the building yourself. Property is a good investment. Pay the mortgage payments with rent from the other apartments. I don't know how that would work with subsidized housing—but the board of Manna House should be able to figure that out. I'm pretty sure there's a Low-Income Housing Trust Fund that works with a number of landlords to provide subsidized rents."

I nodded. "All right. That makes sense. I don't want to do something foolish. But . . ." How could I explain to Lee that this wasn't just my idea, but an idea that God had dropped into my spirit?

Lee reached out and took one of my hands in his. "There is one more thing we need to talk about. With this inheritance you've just received, you don't exactly qualify for Legal Aid any more." He grinned mischievously. "I think I can make a case for following through on the petitions we've already started on your custody case. But you're going to need to hire another lawyer to handle things beyond that."

I stared at my hand in his, his touch sending tiny waves of heat all the way up my arm and making my heart jackhammer. "But I don't want another lawyer. You've been a great help to me, Lee. I mean, you understand my situation. I don't want to start all over again with someone else."

He smiled gently. "Well, look at it this way. If I'm not your lawyer, that doesn't mean I can't keep on being your friend. In fact, if we end our professional relationship, it opens the door to other possibilities . . . and I'd like that, Gabby. Very much."

chapter 7

Open the door to what other possibilities?

All the way back to the shelter, Lee's quip replayed itself in my brain like an LED advertising billboard. A dozen reactions sprang to the tip of my tongue—*Of course we can be friends . . . Don't cut me loose now; I need you! . . . I'm still married, so back off, buddy!*—but for the life of me, I couldn't remember what I said in return. I'd stammered something, said I really had to go, could he recommend a financial adviser, told him I'd call. I think. Or had I bumbled out of there like a tongue-tied idiot?

I wasn't ready for that kind of friend.

And yet . . . the memory of Lee's touch sent heat into my cheeks again. I liked that he found me attractive at the ripe old age of thirty-nine. And I couldn't deny I found *him* attractive. Even more, he made me feel safe. At ease in a way I never had been with Philip. I liked that he had stood up for me in front of Philip the day of my mom's funeral. He seemed to like me for who I

was—even though he'd met me at my messy worst. Most of all, he believed in me. Made me feel like a real person.

But divorce Philip? I still kept thinking I was going to wake up from a bad dream. That Philip would show up, realize what he'd done, beg me to forgive him, and say he wanted us to be a family again. After all, we had two sons—growing boys who needed both their parents. Philip and I had been in love once. Surely there was a spark somewhere under all the debris from our wrecked marriage that could be fanned once more into a flame.

And if there was, I didn't want to do anything to snuff it out forever.

Parking the rental, I managed to dash into Manna House while lunch was still being served, eat Estelle's midweek offering of sloppy joes and mustard potato salad, assure Sammy's mom and Keisha's grandmother that the beach was safe and I'd have the kids back to the shelter by five, and herd Paul and his charges out of there by two o'clock—all without raising Estelle's suspicions that I was feeling like a teenager who'd just been asked out on her first date. I had to totally avoid her to do that, though. Didn't know how she did it, but Estelle seemed to read me like Gandalf the Wizard reading his crystal ball.

Both Sammy and Keisha were afraid to wade into the lake farther than their knees, but they found plenty to do digging in the wet sand with a plastic Big Gulp cup someone had left behind. Soon Paul was showing them how to pack the wet sand into walls and forts, decorated with rocks and sticks. Even P.J. got involved, scooping out an inlet that captured Lake Michigan's small tide creeping up the sand—who knew the Great Lakes had tides?— into their man-made moat.

"Can we go to the beach tomorrow, Miss Gabby?" Keisha begged, hanging on to me for dear life when I brought them back to Manna House.

I shook my head. Mr. Bentley had invited the boys and me to go to the zoo with him and DaShawn. "Maybe next week, okay?" I should have known that was as good as a promise as far as Sammy and Keisha were concerned.

Mr. Bentley picked us up at two thirty sharp the next day in his RAV4.

P.J. had balked that morning when I reminded the boys we had a date for the zoo that afternoon. "Aw, Mom, do I hafta go? I mean, a zoo's a zoo, I've seen a gazillion of them." Hardly true, though Philip and I had taken the boys to the Metro Richmond Zoo numerous times when they were small. "And it's not like we're going with someone my age," he fussed. "DaShawn's just a little kid." Which *was* true, though DaShawn would surely protest the label. And then the zinger. "Don't you know any white kids my age? We didn't have to hang out with black kids back in Petersburg."

Half a dozen snapbacks fought for airtime as I whisked breakfast dishes through the sudsy dishwater, my back to P.J. so he couldn't read my face. What was going on here? Was I raising a teenage bigot? But hanging around people like my boss, who calmly dealt with several crises every week at the shelter, must've been having a good effect on me because I maintained my composure and decided not to make it a big deal.

"I'd really like it if you came with us, P.J. It's supposed to rain tomorrow—this'll give us something to do together while the weather's nice. We won't have time to explore the city once you've got homework every day and cross-country meets on the weekends. I'm sure you'll make friends your age once school starts. But until you make your own friends, guess you're stuck hanging out with mine." Mustering a grin, I grabbed a dish towel, whirled it into a rope, and snapped him with it.

"Okay, okay," he said, backing off. "Just don't expect me to entertain the twerps."

As we piled into Mr. Bentley's compact SUV later that day, I almost offered to sit in the back with the "twerps," but Mr. B gallantly held the front passenger door open for me, so I let the boys sort out the seating arrangement for themselves. Once we hit Lake Shore Drive, it didn't take long to find ourselves at Lincoln Park Zoo, situated at the south end of Lincoln Park, which ran alongside the Drive going toward the Loop. As Mr. B pulled up to the entry booth and fished for his wallet, I dove for my purse. "I thought you said the zoo was free!"

"It is." Mr. Bentley winked at me. "They just gouge you for the parking . . . Now you put that away. This is my treat. It'd be the same for the car whether it was just DaShawn an' me, or a carful."

"Hm. Maybe we ought to ride bikes next time—right, boys?"

Only groans from the backseat. But I was half-serious. A bike trail ran the full length of Chicago's lakeshore. It'd be fun to bike it one of these days.

We got zoo maps and let the boys pick what areas they

wanted to see. "Gorillas!" DaShawn shouted. Paul voted for "big animals like giraffes and stuff." P.J. shrugged and managed to look bored. But I noticed that Mr. Bentley shut one eye and squinted with the other, holding the map at different distances, as if he was having difficulty reading it.

He caught me watching him and quickly stuffed the map in his pants pocket. "Okay! Big animals first. They're at the north end, and if we're lucky, the polar bears might be swimming. Then we can work our way down to the Gorilla House." Before DaShawn could complain, he herded the boys over to one of the food vendors and bought hot dogs and lemonade for everybody.

As we trailed the boys past the rhinos, ostriches, and camels, I decided to just out with it. "Are you having trouble with your eyes, Mr. B?"

"Nah. It's nothing. Just got this weird blind spot in my left eye."

"A blind spot! You should get it checked out. An ophthalmologist might be able to do something before it gets worse."

He shrugged. "Yeah, already did. Doctor's hoping it'll just go away. Me too!"

"Grandpa! Grandpa!" DaShawn was yelling at us from the bottom of a ramp that led to an underwater window in the polar bear exhibit. "Come see!"

Sure enough, one of the polar bears was in the water, his massive body passing by the underwater window like a silent surge of raw power. A crowd quickly gathered, but we held our front row places, mouths open, as the big brute turned and swam past again and again, paws as big as dinner plates, long gray-white fur rippling.

"Beautiful," I breathed.

Nothing else in the zoo quite matched the polar bear water dance, since most of the other animals lay comatose in the muggy August heat or hid away in their dens, but we dutifully wandered toward the south end of the park, taking in the Gorilla House and some of the other indoor exhibits. P.J. actually forgot to be bored when we ducked into a building that featured snakes, bats, and other creepy, crawly things.

My feet were tired, and I was glad when the boys caught sight of paddleboats for rent on the lagoon at the far end of the zoo. "My treat," I insisted. "You guys go." Anything for a chance to sit down for a while.

Even though the paddleboats were four-seaters, Mr. Bentley waved the boys off and stayed with me. "Whoo-ee," he huffed, sinking down onto a bench. "I must be crazy thinking I can raise a nine-year-old." He tipped his chin toward the paddleboat, where P.J. and Paul were pedaling furiously in the front two seats and DaShawn was squealing with delight behind them. "How you doin' with the single-parent thing, Firecracker?"

I sighed. "I don't know. I'm afraid I let Philip take care of a lot of things, never thinking I'd have to know stuff—like how to buy a car. And I need one, like, yesterday! But a savvy car salesman could sniff out in two seconds that I'm a sucker." I looked at him hopefully. "You got any advice?"

Mr. Bentley chuckled.

"You really askin'? Buy used. Just a year or two old can save you some big bucks, and it'll still have a lot of miles left on it. Less of an invitation to car thieves too. But you gotta know what to check out so you don't get a lemon."

I deliberately raised my eyes upward at the treetops waving in the slight breeze coming off the lake across Lake Shore Drive, tempering the muggy heat . . . and cleared my throat. "You know what I'm going to ask you, right?"

I drove the rental to work the next morning under cloudy skies with Mr. Bentley's promise to help me look for a good used car this weekend. But before then, I had to write up a proposal to present at the Manna House board meeting on Saturday morning—and it was already Friday! Decided I'd have to miss Edesa's weekly Bible study today, even though she was starting something new—something about *Bad Girls of the Bible*. Ought to tickle the curiosity of our cast of shady characters coming off the streets anyway.

Armed with a cup of coffee from the coffee cart in the multipurpose room, I unlocked my office door, dumped my bag on the desk, and pulled the desk phone toward me. Lee Boyer had left phone numbers on my voice mail for the real estate agent handling the sale of the six-flat I lived in, as well as a number for the current owner. I needed some hard facts for my proposal, and time was running out.

But before I could make my first call, the door opened and Sammy peeked in. "Didn't Paul come today, Miss Gabby?" The door swung wider, revealing three more anxious faces—siblings Trina and Rufino, ages seven and six respectively, and ten-year-old Keisha.

"Sorry, kids." Paul had elected to stay home that morning to

play around on his new keyboard. "Paul is practicing his music today. But he'll be back next week." I hoped. It *was* a volunteer job, after all. I hoped Paul's enthusiasm for entertaining the younger kids at the shelter hadn't run out yet. "Keisha, you know how to work the DVD player in the rec room, don't you? Why don't you put on some of those VeggieTales movies we got last week?" Someone had donated a whole shopping bag full of DVDs, some of which were so violent and R-rated, I had to trash them. But I pulled out the good ones, including some VeggieTales that should keep the kids entertained for a while.

An hour later I heard the familiar banging of pots that announced Estelle Williams had arrived and lunch-making was in the works. Grinning, I came out of my office and leaned across the counter dividing dining room and kitchen. "Guess what we did yesterday?"

Estelle, dressed in her usual hairnet and roomy apron covering a loose white blouse and black baggy Capri pants, dumped large cans of tomato soup into a big pot on the stove. "Don't have to guess. You went to the zoo. And didn't invite me."

I blinked. That hadn't even occurred to me. "Oh, Estelle. I'm sorry. Mr. Bentley invited the boys and me . . . I mean, we were his guests, so it didn't occur to me to invite someone else."

"Humph. Not blaming you. But *Mister* Harry Bentley could've invited me."

"Wait a minute. Yesterday was Thursday. Didn't you start a cooking class on Thursday afternoons?" I scooted over to the activity sheet posted on the wall beside the counter and hooted. "Yes, there it is! You couldn't have come anyway, so what are you fussing about?"

"Humph. Doesn't matter. He could've *asked*. Then I could've said no."

I laughed out loud. "Estelle Williams! You usually bend over backward to deny any romantic interest going on between you two—which doesn't fool anyone, by the way. But here you are, pouting like a jilted lover that Mr. B took us to the zoo without you."

"Am not." *Bang.* Another pot went on the stove.

"Besides, his car only seats five."

"Well." But she looked sideways at me and her tone changed. "Did he say anything about me yesterday?"

"Uh . . . nope. Nothing."

"Humph."

"But I asked him about his eyes."

Now she stopped completely. "You didn't tell him *I* told you anything, did you?"

"Didn't have to. He was squinting and holding the zoo's visitor guide at all angles. I just asked. And he said the doctor hopes it'll go away."

"*Go away?*" A cloud passed over her face. "It's been weeks, and Harry's not tellin' me much of anything anymore. Stubborn old goat. I'm worried about him. Gotta help me pray, Gabby."

"I will. And I've got something for you to help *me* pray about." I handed her the proposal I'd just printed out.

Wiping her hands on a dish towel, Estelle leaned on her elbows on the counter and read through my proposal. Her eyes widened. "Girl! You full of surprises. What's this House of Hope idea? You want to *buy* the building you livin' in and turn it into apartments for some of our single moms here?"

I looked around to make sure we were alone and lowered my voice, hardly able to contain my excitement. "And look what I found out. Somebody in 3A is moving out the end of August, which means Tanya and Sammy—or Precious and Sabrina, whoever needs it most—could move in September first! Well"—I backed off—"maybe not September first. I think all the apartments need some repairs and refurbishing. And the board has to agree to help get rent subsidies from the city."

Estelle started to laugh, her shoulders shaking as she handed back my proposal. "Gabby Fairbanks. This idea is so crazy, it's gotta have God's hand all over it."

I grinned. "That's exactly what Jodi Baxter said."

But the moment I said her name, I clapped my hand over my mouth. *Jodi Baxter!* Mabel told me I needed a prayer partner, and Jodi had been part of this House of Hope idea from day one. Here I was telling Estelle, and I hadn't even told Jodi about the board meeting tomorrow morning!

I made a beeline for my office. What made me think this crazy idea was going to fly without prayer?

chapter 8

Jodi Baxter picked up on the first ring. "Gabby! I was just think-ing about calling you. Haven't talked to you since the birthday party last weekend. Oh, guess I saw you at church on Sunday. What's going on? Everything okay?"

"Yeah, it's been a good week." I gave her a quick rundown of how I'd been keeping the boys busy. "But I called to ask you something."

"Sure. Fire away."

"Well." I took a big breath. "I talked to Mabel about our House of Hope idea, *and* she's actually letting me present a pro-posal to the board tomorrow morning."

"Oh, Gabby! That's wonderful. I'll definitely be praying. What time is the board meeting?"

"Ten. But, uh, that's what I'm calling about. Mabel encour-aged me to find a prayer partner to pray with me about this, and I'm wondering if you—"

"Of course! Oh, Gabby, I'd love to be your prayer partner! On

one condition. That we make it a two-way street. I mean, if you'll pray for me too."

I wasn't sure what to say. I mean, that made sense. "I'm not sure exactly how prayer partners work, but—"

"Well, one thing I've learned by praying with the Yada Yada Prayer Group. Praying *for* someone or for their requests is all well and good, but there's nothing like praying *with* each other. So . . . hm. Tell you what. Denny and I are driving Amanda down to Champaign on Saturday afternoon, but I've already told them I can't leave until after I teach my typing class there at the shelter. Why don't I just come early, say . . . nine thirty? That'll give us half an hour to pray before the board meeting at ten. Sound okay?"

"Oh, Jodi. Could you? I wasn't going to ask you to make a special trip. Just thought we'd pray, you know, over the phone or something. But I'd really love to see you before the board meeting. I could show you my proposal too. Except your class doesn't start until eleven. You'll be there a whole hour and a half before your typing class."

She snickered. "Don't worry about that. That'll get me out of Amanda's hair tomorrow morning. Otherwise I'll be nagging her about what she's packing or fussing because of all the last-minute stuff she'll just then be 'remembering' she has to have in her dorm room. Know what I mean? So, see you tomorrow . . . Oh, wait a sec."

Jodi must have muffled the speaker, though I still heard two voices in the background. Then she was back. "Amanda wants to know how Dandy is."

"Dandy? I presume he's okay. Lucy stopped by with him on

Monday, and he was fine. Almost his old self. But I haven't seen either of them since."

Jodi turned away from the phone, but I heard, "Gabby says he's fine. He's still with Lucy . . . I know, honey, but I'm sure Gabby knows what she's doing." Her voice came back to my ear with a slight chuckle. "Amanda disapproves of you giving Gramma Shep's dog to Lucy, in case you haven't figured that out. But I think it was a very kind thing."

"Well, tell her she's not alone. My Paul is upset about it too. Can't blame him. I have my own doubts about the wisdom of it, especially when it's raining. And I presume it's going to get cold in a few months."

Jodi laughed. "That's right. You haven't been here for a Chicago winter yet. But I'm sure Lucy will figure it out. She's been on the streets a long time."

I glanced at my watch. "Yikes! I've got to go pick up P.J. See you tomorrow at nine thirty . . . and thanks, Jodi."

I'd meant to tell Jodi about my conversation with Lee Boyer but decided it could wait until tomorrow. That'd be a good thing to pray about anyway. Who was I going to get for a lawyer now? Even more, I wanted to tell her about him wanting to take our friendship to another level. At least, that's what I thought he meant . . .

I'd managed to set aside my conversation with Lee for the past two days. But all day Friday it distracted me so much that when the apartment door buzzer rang later that day and I pulled

the door open to see Philip standing in the outer foyer to pick up the boys for their overnight, I felt guilty. Caught red-handed. A married woman thinking about another man.

I left him standing in the foyer, called for the boys, and headed back to the kitchen. But a moment later I heard Paul saying, "Dad! Dad! Come in and listen to the song I wrote!"

Oh great. Why can't they just leave? I didn't want to talk to Philip just then. But a few moments later I heard Paul on the electronic keyboard, playing a jazzy little number he'd created that morning. I couldn't help but smile. He'd played it for me as soon as I got home after work. It was good.

Five minutes later P.J. poked his head into the kitchen. "Bye, Mom. We're leaving now. No surprise parties when we get back tomorrow, okay?"

I grinned at him. "Promise." I headed for the front room to say good-bye to Paul too. But as I came into the room, I saw Philip standing by the window seat in front of the bay windows in the sunroom reading a sheet of paper he held in his hand. My heart somersaulted into my throat. *The proposal!* When I got home from work, Paul had been so eager for me to hear the song he'd made up, I'd dumped my stuff on the window seat and sat down to listen . . . and never put it away.

In four giant strides, I snatched the paper out of Philip's hand. "Nosy, aren't you?"

"It was lying right here. Couldn't help seeing it." His eyebrows lifted curiously. "I see you're planning to buy this building. Where'd you get that kind of money?"

I gritted my teeth and barely hissed the words, not wanting the boys to hear. "None of your business."

"Grandma left Mom and her sisters a bunch of money when she died," Paul piped up helpfully from the living room, where he was struggling to put on his backpack stuffed with clothes for his overnight.

"Ah."

That's all Philip said. And when they were gone, I leaned against the front door and banged my head against it. The last person in this world I wanted to know about my proposal to buy this building and create a House of Hope was Philip Fairbanks.

When I met Jodi Baxter at Manna House the next morning, I vented. "He saw the proposal, Jodi! He knows I want to buy the building! What am I going to do?"

"Is that bad?"

I stared at her. "Yes! I mean . . . sure, he'd find out eventually, but I'd rather he found out when it was a done deal instead of just an idea. He . . . I don't know, what if he tries to buy it himself just to throw a monkey wrench in my plans?"

Now it was her turn to stare at me. "He'd do that? Just to be mean?"

"I don't know! I wouldn't have thought so a couple of months ago. But the way he's been acting . . . it's all crazy. I just . . . I just wish he didn't know about it yet." I covered my face with my hands and moaned.

"Gabby." Jodi took my hands away from my face and held them. "Gabby, we're here to pray about this proposal, and that's still what we're going to do. Remember, if this is God's plan, if

God is in it, then nothing Philip does will be able to thwart it. You need to trust God with this. Here, let me read you something." She grabbed my Bible sitting on the desk and flipped pages. "Here it is, Proverbs three, five and six. 'Trust in the Lord with all your heart and lean not on your own understanding; in all your ways'—including this House of Hope proposal—'acknowledge Him, and He will make your paths straight.'" She closed the Bible. "See? It's a promise!"

I wagged my head. "I wish I had your faith, Jodi."

She gave a short laugh. "Well, I give you permission to quote me the next time I'm fussing and worrying about something. It's usually easier for me to trust God for other people's problems than it is for my own. But that's why it's good to have a prayer partner or a group of praying sisters, Gabby. To hold up our shaky faith, to remind us of God's promises, to stand with us when we don't feel so strong by ourselves."

I nodded and sniffed, grabbing for a tissue from my desk. "Well, that's what I need right now. For you to pray with me about this proposal, because I'm definitely quaking in my shoes right now."

Twenty minutes later, fortified by the prayer time with Jodi, I took my stack of proposals—a copy for each board member—and made my way to the schoolroom on the main floor, where Mabel was arranging chairs in a circle. Within minutes, the board members trickled in, a diverse assortment of professional men and women. Besides Mabel, two others were women—Rev. Liz Handley, the former director of Manna House, now retired, and Stephanie Cooper, a social worker for the city's Department of Child and Family Services, both of whom doubled as case

managers here at the shelter. Two were local pastors, Pastor Stevens and Rev. Álvarez, whose churches—New Hope Missionary Baptist and Iglesia Cristiana Evangélica—led Sunday Evening Praise on various weeks here at the shelter. The board member I knew best was Peter Douglass, an African-American businessman who sold computer software, better known among my Yada Yada Prayer Group friends as "Avis's new husband."

Mabel asked Rev. Handley to open with prayer, which she did, short and to the point. I hid a grin. The shelter's former director and its current one couldn't be more different—even besides the fact that Liz was white and Mabel was black. Mabel's prayers, even in a staff meeting, were straight from the heart and often long. Rev. Handley's prayer sounded formal, as if she'd memorized it. Mabel's face had a classic mature beauty, her warm brown skin always perfectly made up, and she wore her clothes well. Liz Handley was more of a "character"—squat and dumpy, salt-and-pepper hair cut as short as a man's, a round face with twinkling eyes and a hearty laugh.

But my thoughts were interrupted when Peter Douglass, the board chair, spoke my name. "—Fairbanks has joined us with a housing proposal she'd like us to consider. We have a number of items on our agenda today, but since Gabby is here, let's move this item to number one. Gabby?"

I glanced at Mabel, hoping she'd go first and introduce the board to my idea for second-stage housing, and I'd follow with my specific proposal about a building. But she just gave me an encouraging smile to go ahead. So I took a deep breath and launched into my story.

"I think all of you know that, um, my mother and I found

ourselves suddenly homeless this summer, and we spent several weeks here at Manna House as residents." I allowed a self-conscious grin. "Actually, I might recommend the experience for all staff personnel and board members—it gives one a whole new perspective."

A few chuckles around the room helped put me at ease, so I continued. "Since I was separated from my children and couldn't get them back until I found suitable housing, I became painfully aware how desperately some of our single moms need to find a place to live where they can be a real family. But the process is often tediously slow, given the long waiting lists for some of the subsidized housing in the city. I know I'm fairly new to the staff here, but I . . . um, I think I have an idea for how Manna House could provide that kind of environment . . ." I stopped, feeling flustered. "Actually, my proposal only concerns one aspect of this idea, and that's how to obtain a building. After that, well, I need your expertise and ideas how to make this a vital part of Manna House's ministry to some of our residents."

I handed out the proposal I'd written and gave time for the board members to read it, sweating profusely in the lightweight pantsuit I'd worn to be suitably dressed to speak to the board. I saw a few heads nodding and heard murmurs around the circle.

"Mm, 'House of Hope' . . . nice concept."

"Not a bad price for a six-flat."

"On-site staff living in one of the apartments . . . that's good."

"I suppose rent from the apartments would cover the monthly mortgage? But—"

To my relief, Mabel jumped in. She'd been doing research

on Chicago's Low-Income Housing Trust Fund, which provided rent subsidies to the poor. I didn't understand all the agencies and examples she mentioned, but the gist was clear: renters who qualify pay 30 percent of whatever income they have—zero if they have no income—and the trust fund pays the rest. "The program actually requires a three-party arrangement," she said, a smile playing on the corners of her mouth. "The city, via the Trust Fund. A housing provider or private landlord—which is what Gabby's proposal is about. And a service provider. In our case, that would be Manna House."

For a brief moment silence fell on the group circled in the schoolroom of the Manna House Women's Shelter. And then a gasp—mine—as the weight of what she'd just said sank into my heart. "Oh. Oh! Then . . . it's really possible?"

chapter 9

A lively discussion about "possible" followed that took my breath away. The board was really trying to figure out how to make this House of Hope work! But the discussion was pulled up abruptly by a knock at the door of the schoolroom, followed by Jodi Baxter poking her head in. "Sorry to interrupt, but it's almost eleven and I'm supposed to teach typing in the schoolroom here. You know, using the computers. Should we, uh, cancel class today?"

"Oh, no, no, Jodi, we thought we'd be done by eleven." Mabel looked around at the group. "Should we table the rest of the agenda until next month? Or—"

Rev. Handley heaved herself up out of her chair. "No, I'd rather keep going as long as we're here. How about the chapel? It's usually empty this time of day." The former director marched out the door, but not before giving me an encouraging squeeze on the shoulder. "Hang in there, Gabby. You've got some spitfire under that mop of yours."

The board members trailed out of the schoolroom—so named in hopes of having a full-blown afterschool program one of these days—some of them still talking among themselves about how to apply to the city's trust fund and what the criteria should be for House of Hope applicants.

Jodi stared after their retreating backs and then turned to me, her mouth hanging open. "Did they . . . did I just hear . . . ?"

I nodded, feeling as if my grin was going to reach both ears.

"Whoa!" Jodi sat down with a plop in one of the chairs. "Why am I always so surprised when God answers our prayers?"

I laughed nervously. "Yeah, me too. But you said if it was God's idea, it could happen even if it looked impossible."

She eyed me sideways. "Yeah, I know what I *said*. But believe me, this faith business takes a *lot* of faith sometimes! Oh—I gotta go tell Kim and the others they can come in now before they get sucked into some blithering talk show in the TV room. But call me later! I want to hear all about the meeting."

I left Jodi to her typing class and ran downstairs to my office to get my things, mentally running through the list of tasks I wanted to get done the rest of the day before Philip brought the boys back that evening. Did I have time to call my sisters before Mr. Bentley came to pick me up to go car hunting at one o'clock? Celeste and Honor and I were still trying to find a time all three of us could talk on a conference call in three different time zones.

Still planning my to-do list, I headed out the front door—and ran right into Lucy Tucker bumping her wire cart up the front steps of Manna House.

"Hey, hey, hey! Watch where ya goin', Fuzz Top." Lucy glared at me as she pointed at Dandy's food bowl that had bounced out

of the cart and was clattering down the steps. Her head was wrapped in a scarf that looked like one of my mother's, one of several we'd given her from my mother's things.

"Sorry, Lucy!" I scurried down the steps to pick up the bowl, stopping to shower some love on my mom's dog, who was running circles around my ankles until I sat down on the steps and gave him a good scratch on the rump. "What are you guys doing here?"

"Humph," Lucy snorted. "Gotta fill my bucket with some more dog food." She pointed at a bright yellow plastic cat litter bucket tucked down in her cart among her usual assortment of plastic bags. "Dog eats more'n I do, an' he only half my size."

I stifled a grin. A third her size or less was more like it. "You filled it up just last Monday. Why don't you take a whole bag of dog food, Lucy? There's a twenty-five-pound bag stored in my office." *And I'd love to get it out of there.*

She looked at me as if I were crazy. "Don't you know *nuthin'* 'bout livin' on the street, Miss Gabby? Gotta keep *ever'thing* in plastic. Otherwise, one good rain soak it all. An' how you think I'm gonna fit that big bag in here? Humph." The old lady bumped her cart up the last step and rang the doorbell. "Some people don't use the brains they was born with."

I waved good-bye as the door opened and Lucy and Dandy disappeared inside the shelter. "Must be a bad hair day," I chuckled to myself, though as long as I'd known Lucy, I couldn't actually remember a good hair day. Even when it got washed—which was seldom enough—Lucy's hair still looked like a gray squirrel's nest.

I was still smiling when I pulled up in front of the six-flat in

my rental car, thinking about Lucy's head wrapped in one of my mother's head scarves—a replacement for the purple knit hat she used to wear, which had disappeared the day of my mom's Manna House funeral. Just before the burial back home in North Dakota, I'd found the hat hidden inside my mom's casket. I never told Lucy I'd found her sacrificial gift. *So. Mom has Lucy's purple hat, and Lucy has my mom's scarves.* As far as Lucy was concerned, wearing those scarves probably had nothing to do with a bad hair day.

As I got out of the car, I stood on the sidewalk looking at the wide stone lintel above the outer doorway of the six-flat. New excitement flickered in my chest as I tried to imagine how we could put House of Hope on that lintel in big letters. Chisel it in? Paint it on? Wooden letters?

"Huh! First things first, Gabby!" I told myself, using my keys to let myself into the building and then into apartment 1B. *Like buying the building.* I dumped my bag and tossed my keys into the basket on the hallway table. *And, yikes, coordinating that with Manna House and the city so I'm not stuck with empty apartments and paying a hefty mortgage . . .*

That last prospect unnerved me, so I reheated a cup of cold breakfast coffee in the microwave and sank into a chair at the kitchen table. Suddenly "possible" looked a lot more complicated than it had an hour ago. Not to mention that the coffee tasted terrible. I made a new pot, and while it dripped, leaned my elbows on the table and pressed my fingers to my eyes. *God, I know I can't do this on my own! Please, if it's Your idea, if this is something You want to use to bless single moms like Precious and Tanya and even me when they find themselves homeless, help me to trust You to work out the details and the timing and . . . and everything!*

The coffee timer dinged. Smelled wonderful. And I was proud of myself for obeying Rule One about prayer, according to Jodi Baxter: *Pray first.*

My conference call to my sisters only half worked. I tried at noon Chicago time and got Celeste on her landline at the ranger station in Denali National Park. It was only nine o'clock there, but her husband, Tom, was already out chasing down a report of campers trying to feed bears. "And then they wonder why somebody gets mauled!" Celeste fumed.

At least I didn't have to deal with *bears* here in Chicago. I put Celeste on hold and dialed Honor's cell in Los Angeles, but only got her voice mail. "Huh. You think she's out already or still in bed?" I asked Celeste when I got her back on the line. Our middle sister was a tad unpredictable.

"Who knows? She's doing that jewelry thing, you know. Maybe she's got an art fair or something. We can try again tomorrow. How are you doing, Gabby? Did P.J. and Paul get the package I sent them for their birthdays? What's up with Philip these days?"

We commiserated for nearly an hour until Mr. Bentley rang my door buzzer, and a few minutes later I hopped into the front seat of his RAV4. I still wasn't used to seeing Mr. B in his "civvies," but that tweedy slouch cap really did suit his shaved head. "What are you grinning about, Firecracker?" he asked, glancing at me sideways as he pulled out.

"Just feeling glad. I talked to my sister in Alaska. We're trying

to keep in touch better since Mom died. It feels good to have family right now." A sudden lump caught in my throat. Oh dear, Mr. B was going to think I was an emotional yo-yo, up one minute, down the next. But talking to my sisters again after years of emotional distance was like a miracle. I blinked back some happy tears. "And," I rushed on, "I met with the Manna House board this morning, and guess what?" I spilled it all—the crazy idea Jodi and I had come up with for me to buy the six-flat and turn it into a House of Hope for homeless single moms. "In partnership with Manna House, of course."

Mr. Bentley stared at me so long, I was afraid he was going to run a stop sign or something. Finally he wagged his head. "Young lady, do you know what you're doing?"

I snorted. "No. Not really." But I was still grinning.

Mr. B threw back his head and laughed. "Good! You might just have a chance with this crazy scheme if you realize that." And he chuckled all the way to the Toyota dealership, where he said we wanted to look at the pre-owned Subaru wagon they'd advertised online. "But let me do the talking," he murmured as the salesman led us past the new Toyotas—my eyes lingered on a silver Prius like the one Lee Boyer had—to the cars they took as trade-ins.

The Subaru Forester wasn't bad. Only three years old with twenty-seven thousand miles on it. Sticker price said $16,999. A nice burgundy red, clean inside, automatic transmission, fairly roomy space behind the second seat, even a rollback luggage cover to keep the area nice and neat. Mr. Bentley spent a long time looking under the hood, inspecting the tires, even getting down and looking under the chassis while I wandered a bit, looking at some

of the other, sportier cars on the lot. I was tempted by the new Toyotas . . . I mean, why not? Wouldn't have to be a Prius. Some of those Camrys were really nice—sunroof, leather seats . . .

"Come on, Gabby!" Mr. Bentley called. "Let's take it for a drive."

I drove. It handled pretty nice. When I tried to say something, Mr. B held up his hand for silence, as if he was listening to the motor or something.

I felt a little annoyed. Sure, I'd asked him to help me look for a car. But what if I didn't want to buy a pre-owned? Someone got rid of it for a reason, right? Maybe I'd just be buying someone else's problems.

We drove it back onto the lot. Mr. Bentley steered me away from the salesman and pretended to look at some of the other cars. "It's a steal, Gabby. Good, solid car. I know a mechanic who can check it out for you, to be sure. But as far as I can tell, somebody probably just wanted to upgrade. A lot of people do that, even though the car they got is still perfectly good."

I got stubborn. "But shouldn't we look at some of the new Toyotas? You drive a RAV4 and like it. Wouldn't a new car be smart in the long run?"

He scratched the horseshoe-shaped beard along his jawline. "Well, sure, if that's really what you want to do. But a new car in the Wrigleyville neighborhood . . . well, just more of a temptation for car thieves. You'll spend a whole lot less on a pre-owned and still get a good car for you and your boys. No shame in that. All my cars are at least a year old when I buy—even the RAV4. And pardon me saying so, but you're on your own now, Gabby girl. Doesn't hurt to cut your expenses where you can."

My face heated. Mr. B was right. Sure, I had Mom's insurance money right now, but it was going to have to go a mighty long way—especially if I was going to take a leap of faith and buy an honest-to-goodness Chicago six-flat! I sighed. "You're right. Guess I got a little greedy. Should I—?" I dug my checkbook out of my purse.

"Put that away! No way are you going to pay that sticker price. C'mon, let's go talk to that baby-faced salesman, who's probably only been on the job a month." Harry Bentley chuckled. "He ain't had to deal with Harry Bentley before!"

Don't know how Harry finagled it, but we drove the Subaru to a mechanic friend of his, who gave the Forester a once-over and a clean bill of health. "'Cept the coolant in the air conditioner is low. We can recharge it, but there might be a leak that could be expensive. Can't tell without running a pressure test. You'd want to get that fixed, 'specially in this hot weather."

Mr. B told him to hold off on recharging, and once back at the dealer, used what the mechanic found to knock down the price a cool thousand. I paid cash, drove the wagon home, and parked it in front of the six-flat with Mr. B tailing me. I walked back to his RAV4, and he rolled down the passenger side window. "Take that in next week, have my guy recharge it, see what happens. He'll do right by you."

"Thanks, Mr. B. Don't know what I'd do without you." He shrugged it off, as I knew he would. "The boys will be home soon. You want to stay for supper or something?"

"Can't. Gotta pick up DaShawn. My former partner—a great gal named Cindy—took him to a Cubs game today." He grinned as he started the car. "Radio just said they beat the Cardinals, 5 to 4. Go Cubbies!"

I was stuck back on this great gal named Cindy. "Your former partner? What do you mean, partner?" I tried to imagine Mr. Bentley, former doorman at Richmond Towers, with a side business that needed a partner . . . named *Cindy*?

"You know . . . partner. Two to a car, got my back, all that stuff. She was the best on the force. Still is. I'm a retired Chicago cop, Firecracker. Didn't you know that?"

chapter 10

Know that? I stared at the spare tire mounted on the back of the black-and-silver RAV4 as it disappeared around the corner. How could I not know something as important as that? To be honest, I'd just assumed Mr. Bentley had been a doorman all his life.

Mercy! A retired Chicago cop.

I felt embarrassed. Stupid me. What else didn't I know about Harry Bentley? Or about his ladylove, Estelle Williams, for that matter? Still didn't know why she'd once been a resident at Manna House. She never said. On the other hand, I had never asked her either.

That was going to change.

I was locking my "new" burgundy red Subaru and wondering if the rental car place could come pick up their car today so I wouldn't have to wait until Monday and pay for another two days, when Philip's big black SUV came down the street and pulled up to the curb. P.J. and Paul piled out. "What's that, Mom? A new car?" Paul ran a circle around it. "Kinda small for an SUV, isn't it?"

"Big enough." I kept my voice light. "Yep, just drove it home." I snatched him as he whirled past. "C'mere, kiddo. I need a hug." He let me hug him long enough for him to snatch the car keys out of my hand, unlock the car, and crawl in, inspecting the travel cup holders, the pockets on the back of the front seats, and figuring out how to work the rollback cover over the luggage space in back. Even P.J. got into the driver's seat, checking out the dash and console. I had to smile when he adjusted the rearview mirror to check out his hair and wraparound sunglasses.

I was so distracted watching the boys that I didn't realize Philip had gotten out of the Lexus until I heard his voice right beside me. "So. You got a used car."

I looked up. *Gosh.* With the wraparound sunglasses P.J. was wearing, the two looked like spitting images of each other. The fact kind of unnerved me—or maybe because I didn't know what Philip really meant. Did he approve? Disapprove? Did he think a secondhand car wasn't good enough for his boys?

"Yes," I said—and bit my tongue, realizing how easy it would be for me to blather on making excuses for why I got a pre-owned car, trying to convince Philip it was a good deal.

He was dressed in neatly pressed tan slacks, dress shoes, and an open-necked short-sleeved black silk shirt that looked good against his tan skin and dark hair. Dressy casual, like he was going somewhere. Not exactly knockabout clothes like he'd been hanging out with the boys at some city fest or down at the lakefront.

"You're a half hour early," I said. "You got somewhere to go?" *Ouch.* I knew Philip didn't like me asking personal questions about his comings and goings. It just popped out. But why not, if

he was going to bring the boys back early? What if I hadn't been here?

Wasn't surprised that he didn't answer. He just walked over to the Subaru and inspected a tiny dent in the rear fender, then walked around the car giving it the eye, and came back to me. "Looks okay for a 2003. Hope you had a mechanic check it out. They give you decent financing?"

He was fishing. No way was I going to tell him I paid cash. "Mm." I took a few steps to the Subaru and knocked on the windows. "Come on, guys! I've got to call the rental car place to pick up the car before they close!"

Philip was still standing on the curb. "Is it far? If you want to drop it off, I could follow you over and give you a lift back."

I stared at him. Had Philip Fairbanks just offered to do me a favor? I opened my mouth but stumbled over the words. "Uh . . . no, thanks anyway. This place picks up and delivers. You, uh, look like you're headed someplace. Don't want to make you late." I raised my voice. "Boys! Come on! Lock up the car!"

Philip shrugged and headed for the Lexus. Then he turned. "Maybe you and I could get together next week sometime, talk over some stuff."

What—? "About the boys, you mean?"

"Well, yes, that too. But maybe we should talk about us. Think we could do that?"

The boys dashed past, grabbing their duffel bags off the sidewalk and bounding up the low steps to the front door, Paul jangling my keys. "We got a new movie, Mom!" P.J. hollered over his shoulder. "Can we watch it tonight?"

I was glad for the momentary distraction. Philip wanted to

talk? In person? The two of us? Sudden anger . . . confusion . . . longing . . . all pounded on the doors in my heart where I'd locked them all away, begging to come spewing out.

Don't, Gabby, don't. You don't have to respond right now. Breathe, Gabby . . .

"Um, let me call you about that, okay? I gotta run." And I did, escaping into the foyer of the six-flat as the big black Lexus pulled away with a squeal of its tires.

"Mo-om!" P.J. yelled from the living room while I was putting together a quick taco salad to eat while we watched their new DVD. "I thought you were going to get an air conditioner this weekend!"

"I tried!" I yelled back. Well, I had called one store. "They're out. Everything's for fall now—leaf blowers and stuff like that." Which was a bummer. I'd hoped to get two or three end-of-the-season air conditioners at a rock-bottom price. At least I'd be prepared for next summer. Hadn't figured they'd all be gone.

Well, the three fans would have to do for a few more weeks. While waiting for the hamburger to fry, I called Jodi Baxter. No answer. She'd said to call her, hadn't she? Then I remembered. She and Denny were going to drive Amanda down to Champaign-Urbana that afternoon to get her settled for her second year at the University of Illinois. How long a drive was it? Three hours? Three down . . . three back . . . it would probably be late by the time they got in.

Shoot! I had to talk to Jodi! Somebody! What was I going to do about Philip's request?

The boys had bought one of their favorite movies, *Secondhand Lions* with Robert Duvall and Michael Caine, even though we'd seen it at least two times already, and it kept us laughing the third time around despite the lingering August heat and the noise from the fans trying to keep the air moving. Curled up in my mom's wingback rocker, I relished just hanging out with my boys having simple fun—but felt guilty about it too. Was I too easily slipping into "just me and the boys" mode, too easily giving up on my marriage, giving up hope that it could be the four of us again?

Philip said he wanted to talk about "us." What did he mean by that? I hadn't filed for divorce yet—even though Lee said it would be a slam dunk—but I *had* filed for unlawful eviction and custody of the boys. Wouldn't he have said something if he'd gotten those papers in the mail? Lee said we had a court date now.

So what did Philip want to talk about? Getting a divorce? Or . . .

My heart constricted. Was he having second thoughts about our separation?

Taking a deep breath to loosen my chest, I gathered up the empty taco salad bowl, bag of corn chips, and dirty dishes, and stole out of the room while the boys were cheering for the two old brothers running off the conniving scoundrels who only wanted their money. Dumping the dirty dishes into the dishwasher, I tried Jodi's number again. Still no answer. *Rats.* I'd have to wait until tomorrow at church.

Which I did. I pulled the Subaru into the big parking lot of

the shopping center on Howard Street the next morning, which marked the city limit between Chicago and Evanston, its first suburban neighbor to the north. The large storefront hosting SouledOut Community Church would be hard to miss, the name painted in bold red script across the wide windows. The large open room, painted in bright blue and coral colors that reminded me of a Mexican restaurant, was rapidly filling up as P.J., Paul, and I came through the double-glass doors.

The boys had grumbled as usual about going to church on Sunday morning, but I held fast to Estelle's no-nonsense approach. *"Just tell 'em that's the way it is."* And I suspected they found the lively service a lot more interesting than they let on.

I looked around for familiar faces, but didn't see Estelle or Mr. B that morning. However, the Baxter's Dodge Caravan pulled up outside, and Jodi came in, followed by Edesa and Josh carrying little Gracie while Denny drove off to park the car. Jodi immediately came over to me. "Oh, Gabby. I saw that you called a couple of times last night. I'm so sorry, but we didn't get home until close to midnight. We decided to go out for dinner after getting Amanda settled in the dorm, and . . ." Jodi got all puppy-dog faced. "For some reason, it feels harder letting her go this year than the first time."

"Uh-oh. You mean it doesn't get any easier? Don't worry about not calling. I just wanted to—"

"Oh, look! Pastor Clark is back!" Jodi interrupted. "Let's talk later, okay, Gabby? I promise!" And she scurried off to join others welcoming the tall, thin white man who was one of SouledOut's pastors. I vaguely remembered the church praying for Pastor Clark about two months ago when he'd gone to the hospital with

chest pains, but that was the Sunday before *my* life ended up in the "critically ill" ward, and I had to admit I hadn't given poor Pastor Clark a single thought since then.

I was glad to see Avis Douglass leading worship this morning—she was my favorite worship leader on the team—and she called the church to worship this morning with a call-and-response based on Psalm 103, basically giving thanks to God for restoring Pastor Clark to the congregation after his heart attack. The poor man still looked frail to me, but I noticed happy tears trickling down his face, seeming glad just to be there as the congregation worshipped with song after song.

When the kids and teens had been dismissed to their Sunday school classes, Pastor Cobbs, the other pastor—a short, African-American man with energy to spare—was all over the low platform that morning, preaching on a verse from 2 Corinthians, chapter 12, saying that "God's grace is sufficient, brothers and sisters, *sufficient* all by itself—"

"Say it, pastor!" a woman called. Sounded like Florida, one of the Yada Yada Prayer Group sisters.

"—because His 'power is made *perfect*' . . . Do you hear that, brothers and sisters? Made *perfect* in our weakness."

"Well," someone else said.

"And I want you all to know that this brother here"—Pastor Cobbs stepped off the platform, walked over to Pastor Clark, and laid his hand on the tall man's bony shoulder—"This brother here has been *weak*, laid up in a hospital room, poked full of tubes, hooked up to all kinds of fancy machines. And yet the power of God was so evident on this man, all kinds of hospital staff kept coming into his room just to be in the Presence. And you may be

thinkin' that Pastor Clark was takin' a sabbatical from ministry these past many weeks, but I don't think there was a doctor, a nurse, a PT or PA or food service person who came into that hospital room that this man didn't pray for. Not quietly either. He asked, 'How can I pray for you, son? How can I pray for you, daughter?' And they'd tell him. And he'd hold their hands and pray. Pastor Clark here had his own congregation goin' on up there on that hospital floor!"

By this time, everyone was clapping and shouting and saying, "Hallelujah!" Which of course led into some more praise singing and prayer that each of us, when we're feeling weak, would remember this man's example and realize that God's power working in us isn't dependent on us feeling strong and confident and all that. "In fact," Pastor Cobbs ended, "sometimes God needs to take us down so He can remind us of the Power Source who changes lives. Amen?"

"Amen!" people shouted back, and the word seemed to still resound in the air even when the service ended and everyone gathered around the coffee table, consuming sweet rolls and coffee and lemonade.

"I don't see Estelle or Mr. Bentley or DaShawn today," I mused aloud to Jodi as I slipped cream into my coffee. "Mr. B helped me buy a car yesterday, but he didn't say anything about not coming to church. Do you know where they are?"

Jodi shook her head, picking out a sweet roll. "Not for sure. Estelle and Stu were leaving just as we were coming out to get in the car, and Stu said she was taking Estelle to check on her son— something like that."

"Her son?"

"That's what she said." Jodi grimaced. "To tell the truth, I didn't know she had a son."

"Huh. That makes two of us." At least I wasn't the only one in the dark. "And Mr. B?"

"I don't know. Maybe he went with them." Jodi balanced her sweet roll on top of her cup of coffee. "But, hey, what's this about a new car? And I still want to hear more about what the board said about your proposal! Do you have time now?"

P.J. and Paul were hanging out with some of the other SouledOut teens, so I followed her to a couple of chairs in a corner. "But that's not all I need to talk to you about. It's . . . Philip."

chapter 11

Jodi's eyebrows shot up when I told her about Philip wanting to talk. "You're kidding."

I snorted. "Would I kid about something like that?"

"What did you say?"

"Nothing! Just . . . I'd call him later. Actually can't remember exactly what I said. It was like he'd thrown marbles under my feet and I couldn't get my balance! I mean, he barely returns my calls when we have to make a decision about the boys—and now he wants to talk? Doesn't that just rot your socks?"

Jodi giggled. "Now you sound like Lucy." Then she sobered up. "He actually said he wanted to talk about you two? Not the boys?"

I made a face. "Huh. Even talking about the boys would have been a big deal. We haven't had an actual conversation since—" I felt color rise into my face. Not since the disastrous day I'd ignored everybody's advice and confronted Philip in his office about kicking me out of the penthouse. But he'd whittled me

down good, made me feel like he'd done me a favor kicking me out and putting me on the street where I belonged. "Anyway," I finished lamely, "he said not just the boys, but about us."

"Whew." Jodi blew out a long breath, staring into her Styrofoam cup of coffee. "Wonder what he'll say when you talk to him."

"*If* I talk to him."

Her head jerked up. "Gabby! What do you mean, *if*? What if your husband wants to—"

"*Ex*-husband." My voice was as cold as the coffee. I tossed the remains of my cup into the closest potted plant.

A long silence sat between us. I studied my nails. Badly in need of a manicure. I should go back to Adele's Hair and Nails and give Hannah the nail girl some business. Especially if I was going to talk to Philip for longer than two minutes. He'd notice if I had ragged nails.

Finally Jodi spoke, her voice soft. "Gabby. I know you've been through a lot . . . no, I take that back. I *don't* know what you've been through, but it sounds awful from what you've told me. But what if Philip wants to talk about getting back together? Maybe he's willing to work on the relationship. Isn't that what you want?"

"I don't know," I mumbled. "Don't know what I want. I guess, in one way, yeah. I'd like us to be a family again, especially for the boys' sake. But . . ." I didn't want to say it, but Jodi—whose own husband adored her—couldn't possibly understand the stress I felt just being around Philip, who knew all the right buttons to push to reduce me to pulp. Talk? Did we even know how? I shrugged. "He probably just wants to talk about getting a divorce. Probably

wants to talk me into a 'no-fault' or something, no alimony or child support. Might as well just let our lawyers talk."

"Oh, Gabby." Jodi laid a hand gently on mine. "There's only one way to find out. And that's to talk to him. That's all I'm saying. Just talk. But I'm not in your shoes. You're the one who has to decide, and it's got to be hard. Do you want to pray about it?"

I jerked my hand away and stood up. "No. Not now. I—I'm sorry, Jodi. I need to get the boys home." Which was a pathetic lie, but I was close to tears and wanted to get out of there. I didn't want to pray about it! Didn't want Jodi or God or anyone else to tell me I "should" talk to Philip.

I was miserable as I drove home from SouledOut. How could I treat my friend like that? Jodi Baxter, of all people! Hadn't she listened patiently to me spilling my guts the past month and a half about the breakup of my marriage? Hadn't I asked her to be my prayer partner? So why had I gotten all riled up when she wanted to pray with me about this latest wrinkle?

The boys—bored as usual on a Sunday afternoon—wanted to do something. Me, I just wanted to pull the blinds, turn on the fan, and take a long nap. "Look, Mom." P.J. shoved *The Chicago Guide to Summer Festivals* in my face. It listed a Greek festival going on that weekend in the Lincoln Square neighborhood. "They've got *souvlaki* or whatever you call it and a bunch of other neat Greek foods. And live music and dancing and lots of stuff. It's not that far. See?" P.J. spread a Chicago city map out on our makeshift dining room table and found the Lincoln Square neighborhood

north of us where the Greek Orthodox Church hosting the festival was located.

I gave the map a cursory glance. "I don't know, guys. Parking could be a nightmare." Lame excuse. But I let it hang there, hoping it might carry the day and I could crawl into my cocoon.

P.J. snatched up the brochure and the map and stomped out of the room. "Fine," he tossed over his shoulder. "Paul and I can go by ourselves if you don't want to. I can figure out how to get there by bus."

That did it. They probably could get there by themselves—I saw lots of teenagers using the El and buses to get around town. But I knew if P.J. and Paul were out and about, navigating a still-strange city by themselves, I could forget a nap even if I stayed home in the bed with the covers over my head. I sighed and picked up my purse. "Okay, okay! You guys win. Let's go."

As it turned out, I said to Estelle the next day, leaning over the kitchen counter at Manna House, the Greek Festival was noisy and fun and took my mind off stewing about Philip. "I even got talked into trying one of the traditional line dances by a fifty-something Greek gentleman with dark twinkly eyes." I giggled. "Much to the embarrassment of my sons." I held out my arms to the side shoulder-high and did a few steps with a line of imaginary partners. *"Dum de dum de dum . . . Opa!"*

"Uh-huh." Estelle poured two cups of fresh coffee, added cream to one, and passed it over the kitchen counter. "You gotta watch out for those fifty-something Romeos who can dance your

feet off. Next thing you know they gonna be down on their knee promising undying love."

I stopped dancing. "Estelle! Did Harry Bentley ask you—?"

She cut me off with a look. "Now, don't you go readin' more into that than just good advice, girl! I'm just sayin'." She snatched up the required hairnet to cover her topknot and took a tray of hamburger patties out of the freezer to thaw.

I hid a grin. It was definitely true that Estelle had been swept off her feet by Mr. Harry Bentley dancing the Mashed Potato at Manna House's first-ever Fun Night. But something else niggled at my brain . . .

"Um, speaking of Harry, I missed you guys at church yesterday. Jodi said something about you needing to check up on your son." I stirred some more powdered creamer into my coffee, trying to be casual. "I didn't realize you had a son. Is everything okay?"

For a few moments, Estelle busied herself banging trays around and pulling condiments out of the refrigerator. Then she sighed and came back to her coffee. "Oh, he's grown. Usually takes care of himself. But he's . . . where's that sugar?" She dumped twice as much sugar into her coffee as she normally used.

"What's his name?" I prompted.

"Leroy. After his daddy. But his daddy left when the doctors diagnosed the boy as schizophrenic *and* bipolar." She reached for the sugar again, but I grabbed her hand. "Oh, right," she said. "Already did that." Estelle's chest rose and fell as she heaved a big sigh.

"So . . . is he okay?"

She shrugged. "As long as he takes his meds. But he's on disability and can't work. So he has too much time on his hands.

Sometimes he gets rebellious, doesn't take his meds, and then . . . well." She wagged her head. "Just help me pray for Leroy, Gabby."

I wasn't going to let her off that easily. "And yesterday?"

She gave me a look. "You sure are nosy this morning."

"Ha. Got a right to be. You know all *my* business, but turns out there's a whole lot about Estelle Williams I don't know. Like why you ended up here at Manna House in the first place."

"Sometimes," she murmured, "you just gotta keep goin' forward, not lookin' back . . ."

My own eyes caught the wall clock behind her head. "Rats! It's ten already. Staff meeting!" I grabbed my coffee and headed for the stairs. "You coming?"

Unlike the Manna House board meeting, where the pastors and businesspeople sat in a neat circle of chairs, the staff—both paid and volunteer—were sitting helter-skelter on any available surface in the schoolroom. I squeezed into a school desk. Josh Baxter jumped up and offered his chair to Estelle and leaned against the computer table. I saw him wink at Edesa across the room.

Huh. Newlyweds.

Attendance at the Monday staff meeting usually fluctuated, depending on who was around that day. Today the room was surprisingly full—even Sarge, the blustery night manager who usually left when Mabel arrived, had stayed. When I raised my eyebrows at her, she threw up her hands. "Got to put in my two bits about the name for the multipurpose room, no?"

Naming the multipurpose room! I'd forgotten that was coming up today.

"Which is first on the agenda today," Mabel said. "Everybody here?" She offered an opening prayer, surprisingly short for Mabel, and got down to business. "As you all know from last week, several people have suggested we name the multipurpose room in memory of Martha Shepherd, known to most of our residents as 'Gramma Shep.'"

Chuckles and nods skipped around the room.

"Do I take that as agreement for naming the room in memory of Gabby's mother?" Mabel asked.

This time there was a chorus of "Aye!" and "Yes!" Precious, there as a volunteer, piped up, "Better be, or we gonna have a mutiny on our hands among the residents." Everyone laughed.

"All right. Suggestions for the actual name?"

Ideas flew. Everyone liked the idea of including my mom's last name—*Shepherd*—in the name, because of its double meaning of Jesus being the Good Shepherd. But then the discussion got sticky. *The Martha Shepherd Room*? Too formal. "What about Shepherd's Crook?" Precious said. "Ain't that the stick thing the Good Shepherd carries, ya know, with that hook thing on the end?"

Estelle wagged her head. "Uh-uh. You know whatever name we come up with, it's gonna get shortened to something. You want us to be calling that room 'The Crook'?"

That got a laugh.

"Could call it The Crook an' Cranny," Sarged quipped. "That's how we shoehorn people in here, into every crook and cranny!"

"That's 'Nook and Cranny,' Sarge," someone snickered, amid general laughter.

Shepherd's Nook? Some people liked that one. "It sounds cozy," Angela Kwon said, twirling a lock of straight black hair around a finger. Others protested that "Nook" didn't have any connection to "Shepherd."

"What about Shepherd's Fold, then?" Edesa Baxter suggested. "*Mi tío*—my uncle—in Honduras raises sheep. That is what he calls the sheds where he pens the sheep safely for the night. Kind of like a shelter."

I liked that. A shelter for the sheep. So did several others—though "The Fold" for short didn't have the snappy ring to it that "The Nook" did.

A few other suggestions were made, but we kept coming back to Shepherd's Fold. Josh raised his hand. "We could have a little plaque on the wall that says, 'Shepherd's Fold . . . In Memory of Martha Shepherd' or something."

Heads nodded. Mabel said, "Everyone agreed?"

"*Bueno! Bueno!*" Sarge gloated. "Though could somebody get me one of those shepherd's crooks to use on the pesky stragglers that keep comin' in at ten past eight every night. *Capiche?*"

The room broke into laughter. But my eyes misted as Mabel prayed a prayer of blessing on the new name for the multipurpose room. I couldn't wait to tell Aunt Mercy and my sisters. I hoped my sisters would be pleased. I knew my mother would be.

Mabel stood after her "Amen." "I hope you all don't mind cutting staff meeting short today. I have a dentist appointment." She made a face and pointed to her cheek. "Cracked my tooth yesterday eating caramel corn with Jermaine."

"Works for me." I wiggled my way out of the tight school desk. "I have to go pick up P.J. at Lane Tech. But this is the next-to-last time, I promise! School starts in two weeks!"

I managed to get out the door right on the heels of Mabel and Estelle just before traffic snarled behind me as everyone tried to scoot out the schoolroom door at the same time. But that's how I overheard Mabel murmur to Estelle, "Is Leroy all right? Did the fire damage your house too much?"

chapter 12

＊ ＊ ＊

Fire? At Estelle's house? Estelle had a house?

I had to run out to pick up P.J., or I would have followed Estelle then and there. What was Mabel talking about? None of this computed. If Estelle had a house, why had she ended up a resident at Manna House? And now she was sharing an apartment with Leslie Stuart on the second floor of the Baxters' two-flat.

I hurried back to the shelter after picking up P.J. from cross-country practice, hoping to talk to Estelle before the lunch crunch hit. But by the time I checked on Paul, who was doing his volunteer thing playing Ping-Pong with a handful of kids in the rec room, Estelle was hollering orders at her two assistants who had pulled lunch prep on the residents' chore chart. "Tawny! Turn those burgers over! No, no, not with a fork . . . Wanda, show that girl where the spatula is!"

"Mi? Mi? How do mi know where dat ting is? . . . Ohh. *Dat* ting."

Decided this wasn't a good time to have a heart-to-heart with

Estelle. I'd catch her later. But I felt a tad sorry for the new girl, Tawny, who scurried like a mouse trying to stay out of the way of the big cats. Both Wanda and Estelle were large women, and Wanda's Jamaican *patois* wasn't so easy to understand.

Unlocking my office door, I glanced back at the girl in the kitchen, now flipping burgers on the hot stove-top grill. *Tawny . . .* she'd been aptly named. The teenager's skin was fawn-colored, her long bushy hair—barely covered by the ugly hairnet—a fusion of brown, tan, and gold rivulets. Hard to tell what her ethnicity was. Mabel said she'd been dumped out of the foster-care system when she turned eighteen, even though she didn't have her high school diploma yet. But the girl had *chutzpah*, turning up at Jodi's typing class twice now, saying she wanted to get her GED, maybe even go to college.

I slipped into my office and turned on the computer. *Still, she's just a kid . . . a kid with no home, no parents apparently . . .* As I waited for the computer to boot up, I looked around at the excess of stuffed toy dogs still piled on every available surface in my office, left at the shelter after Dandy had made himself a "hero dog" by attacking a burglar and getting himself knife-wounded in the process. Chicago loved heroes, even dog heroes. We'd given away most of the stuff left by well-wishers, but kept the stuffed animals to give to children who ended up in the shelter.

I picked up a soft black dog with floppy ears and a pink ribbon around its neck. *Would Tawny . . . ?*

I never did get a chance to talk to Estelle that Monday. Forgot she taught a sewing class on Mondays, even though I'd donated

my one and only sewing machine to the effort. She was busy at the far end of the dining room helping the three ladies who showed up how to lay out a pattern for a simple apron when I left with Paul at two o'clock. And I took the boys shopping that afternoon for school clothes at Woodfield Mall, "Chicago's Largest Shopping Center." I figured a big mall with lots of stores would be a safe bet to find what the boys needed for school, and we'd be back in time for supper and a quiet evening when I could call Estelle.

What I didn't figure on was just how long it took to get to "Chicago's Largest Shopping Center" from the north side. Schaumberg, it turned out, was way out past O'Hare Airport, past a half-dozen suburbs, past a huge forest preserve, and traffic on I-90 was already starting to creep with homebound traffic. It was almost four o'clock by the time we parked and found our way around the mall.

As far as I was concerned, one big department store should've been able to cough up the necessary gym shoes, socks, jeans, shirts, and underwear for two boys. But no, they wanted to check out all the specialty teen shops too. P.J. had shot up at least three inches in the past year, faster than he could wear out his clothes. They'd probably be just right for Paul, I mused, as the boys tried on the latest Gap jeans . . . but it didn't seem fair for P.J. to get all the new clothes while Paul wore hand-me-downs. And both boys were going to need winter jackets and boots, though I held off on those. Good grief, it was still eighty degrees outside! Chicago's deep freeze would definitely be different from Virginia's mild winters, but maybe Philip could help buy some of the big-ticket items for the boys. Something to talk about when we talked . . .

If we talked.

Which reminded me, maybe I should talk to Estelle about Philip, get a second opinion about whether I should talk to him. Then maybe I wouldn't seem so nosy if I said, oh by the way, I heard Mabel say something about your son and a fire at your house?

I parked myself on a bench when the boys got diverted by a video game arcade and called Estelle's cell, but only got voice mail and had to leave a brief message.

The boys wanted to eat at the Rainforest Cafe at the mall, billed as "A Wild Place to Shop & Eat." It was wild all right, and I don't mean just the simulated rainstorms with thunder, lightning, rainbows, and animated wildlife in the "trees" hanging over the tables that punctuated our supper of Lava Nachos, Rainforest Burgers (the boys), Rasta Pasta (me), and lemonade. A gazillion other families must have had the same idea to "shop Woodfield" that day, and the place was full of kids on too much sugar.

By the time we got back to the car with our bulging packages, I had a splitting headache and a bulging balance on my new Visa card. The light was blinking on the answering machine when we walked in the door of the apartment, but I didn't bother to listen to the messages before falling into bed. Probably Estelle calling back. Right now I didn't want to talk about Philip or anything. Whatever it was could wait.

I should have listened to the messages.

Prying my eyes open with my first cup of coffee the next

morning, I pushed the Play button and got the first beep. "Hey, Gabby. Jodi here. Just checking in to see if you're okay. I want you to know I'm praying for wisdom about you-know-what. And a sense of peace too. Love you!" *Sweet.* At least she wasn't mad at me for walking out on her at church on Sunday. And smart enough not to mention what she was praying about in case the boys checked the messages before I did. I should've called her first . . . well, I'd do it today.

Philip's voice caught me up short as the next message beeped. "Gabrielle, please pick up if you're there. Can we get together like I mentioned last Saturday? What about four o'clock this Friday? Before I pick up the boys. Can we meet somewhere? Let me know."

Now my eyes were wide open. I quickly glanced at the boys' bedroom doors that opened on the hallway, hoping they hadn't heard. Both still closed. I hit Delete before the next message played. Didn't want the boys to know Philip had asked me to talk in case I decided not to. What did he *want?* He was polite enough on the phone message. Actually, he'd been pretty decent when he dropped the boys off on Saturday. Even offered to follow me so I could take the rental car back and have a ride home. Or was that a first attempt to have "the talk"? Just him and me in the Lexus on the way back from the rental car place—

Third beep. "Gabby? It's Mabel. Call me tonight if you get this. Estelle won't be in tomorrow. She had a family emergency. I need you to put together a lunch team for tomorrow, maybe the next day too. Let me know what you can do."

Oh no! Another emergency? Mabel said "family emergency," so it had to be about Estelle's son . . . Leroy, she said his name

was. Poor Estelle. Was this related to the fire at Estelle's house over the weekend? Hopefully this wasn't something worse. But whatever it was, I needed to hustle if I was going to put together a lunch team for *today*, or I'd be cooking lunch by myself.

I managed to get the boys up and moving and P.J. dropped off at cross-country practice in time to get to work ten minutes early that morning. I headed straight for Mabel's office, leaving Paul to sign us in and figure out his volunteer activities by himself. "Mabel!" I burst in without knocking. "What—?"

Mabel was on the phone. She held up a manicured finger. "Yes, yes . . . Thanks, Harry. Tell her not to worry. We'll cover things here . . . Okay. Keep us posted." She hung up and turned to me, rubbing worry lines out of her usually smooth forehead.

"Was that Mr. Bentley?" I asked. "Sorry I didn't call back last night . . . didn't get the message until this morning. What's wrong? Is Estelle okay?"

Mabel nodded. "Yes, that was Mr. Bentley and yes, Estelle is okay." She sighed and absently tucked her straightened bob behind one ear. "It's her son, Leroy. He's in the burn unit at the county hospital with third-degree burns over a third of his body."

I gasped and sank into a chair. "But what happened? You said something yesterday about a fire, but Estelle didn't seem all that upset. So how—?"

Mabel held up a hand. "Two different episodes. Estelle came in yesterday, said there'd been a minor kitchen fire at the house. Leroy was okay, but she was worried that he'd caused the fire—on purpose or accidentally, she didn't know. She hadn't heard from him for several days . . . happens when he doesn't take his meds. He has a long history of mental problems, you know."

I was about to say, "I didn't even know Estelle *had* a son until yesterday!" but Mabel didn't stop for my little snit.

"She told me yesterday maybe she should put Leroy in a mental health facility before he hurt himself. She'd been resisting that idea for years. Then . . . well, I don't know all the details. Harry was listening to his police scanner, heard the address of a major house fire yesterday afternoon and recognized it as Estelle's house—the family home, I mean, where Leroy lives. Harry called Estelle right away, but by the time they got there, the house was basically a total loss, and an ambulance had already taken Leroy to Stroger Hospital. Estelle's with him now, of course. And she's all over herself for letting Leroy stay in the house on his own too long."

I could hardly speak. "Is he . . . is her son badly burned?" Just burning my hand on the stove was painful. I could hardly imagine how Estelle must feel, knowing her son was in terrible pain.

Mabel shook her head. "Don't know." She straightened and pushed back from her desk, all business again. "Well. Main thing we need to do is put together some lunch teams to cover for Estelle. Can you work on that this morning? Start with Precious—she's done it before. But someone will need to check on the menus and food supplies on hand. Estelle usually takes care of all that."

And now it was in my lap. Which was okay . . . though I wanted to ask Mabel why Leroy was living alone. Why didn't Estelle live with him—it was her house, wasn't it? And how come she ended up here at Manna House a couple of years ago? But Mabel was already back on the phone.

I found Precious in the schoolroom, trying to update her résumé. But before I could say what I'd come for, she pounced.

"Girl, you just the sistah I need to see. Can you proofread this for me? I gotta find a job an' soon. Money I had is all run out, and Sabrina gettin' bigger all the time. That baby gonna be here 'fore we know it." The thin, strappy woman eyed me sideways from beneath the fall of short kinky twists that fell across her forehead. "An' I don't mean ta ride on ya, but anything happenin' 'bout this grand idea of yours ta turn that building into a place for us single moms? Me an' Sabrina, we gonna need someplace ta live, an' quick, 'fore that baby gets here."

I ran my fingers through my own mop of red curls, my head spinning. Yes, I needed to get moving on the next steps for the House of Hope, but I wasn't even sure what came first—buying the building or approaching the city? And in the meantime, Philip had thrown me off center asking to talk . . . and now Estelle was out of commission and I was supposed to make sure Manna House served lunch to the fifteen or twenty residents who weren't out for the day, plus staff . . .

I blew out my pent-up frustration. "Uh, Precious, we've got a situation." I quickly filled her in on Estelle's absence and the need to put together a lunch team. "You know your way around that kitchen better than I do. Can you help me put together a lunch team today? If you'll find a couple extra hands—"

Precious was already halfway out the door. "No, *you* go find the warm bodies. You think they gonna listen to me if I tell them they gotta cook today? You're on staff. They'll listen to you. *I'll* go hunt up Estelle's menu and see if we got the goods."

chapter 13

Estelle didn't come back until Thursday, and in that time Pluto had been demoted as a planet and Precious and I managed to pull off two halfway decent lunches for twenty-five folks. The former was big news on CNN and for the astronomy junkies at Chicago's Adler Planetarium, but for me, filling Estelle's shoes in the Manna House kitchen and getting only two complaints—and that was because we ran out of watermelon the second day—should have been right up there with CNN's top stories.

When I'd gone looking for helpers, I'd spied the stuffed animal dogs I'd secretly placed on Tawny's and Sabrina's bunks sitting on their pillows like spoiled show dogs, and Sarge told me on the sly that both teenagers had gone to sleep hugging their new comfort friends. Which gave me the courage to ask Tawny if she'd mind doing lunch prep again—"Since you know your way around the kitchen better than I do"—after her stint on Monday. Okay, maybe I stretched the truth a little, but she deserved some

encouragement after surviving kitchen duty bouncing back and forth between Estelle and Wanda. Besides, it gave me a chance to get to know the girl a little.

But I sure was glad to see Estelle come sweeping through the double doors into the multipurpose room—correction, Shepherd's Fold—on Thursday morning, shaking water off her umbrella as an early thunderstorm shook the building. Her hair had been pulled into a no-nonsense topknot and she looked like she hadn't slept much the past few days. Against my selfish instincts—I didn't really want to "do lunch" again—I trailed her downstairs to the kitchen. "Are you sure you should be back at work? You look like you could use some R & R."

She stowed her carryall bag under the counter and tied on a big apron. "Don't need sleep. Need to get back to work. Only so much bedside-sittin' a body can do." She cast a critical eye over the counters, stove, and appliances. "Hm. Not bad. Everything looks clean. And praise Jesus, somebody made coffee." She raised an eyebrow at me. "You?"

"Heard you were coming back today. Thought you might need it." I grabbed the pot, poured two cups, and headed for the nearest table in the dining room. "Estelle, please, take a minute to sit down. I want to hear how your son is doing. Mabel said he has third-degree burns. That sounds terribly painful. Is he going to be all right?"

Estelle hesitated and then gave in, easing herself into a folding chair while I brought sugar for her, creamer for me, and a couple of spoons. She stirred absently and heaved a big sigh. "Hard for me to tell. They've got him in a sterile environment, pouring all kinds of intravenous fluids into him, antibiotics and all that. And

he's pretty knocked out on morphine to cut the pain." Her dark eyes teared a little. "He's got burns on a third of his body, mostly along his left side—his left arm, part of his torso and back, and his left leg. They started skin treatment yesterday, putting moist dressings on the burns, then taking them off . . . Lord, Lord, couldn't stand to watch it." She shuddered.

"But, what happened? Mabel said your house is a total loss from the fire. He was living in your house?"

"Mm." Estelle seemed lost in thought.

I waited, but when nothing more was forthcoming, I said bluntly, "Estelle, I don't understand. If you have a house, why were you a resident here at Manna House a couple of years ago? I mean, why is your son living in your house and not you?"

She allowed a sad smile. "Kind of a long story. Told you the other day Leroy has mental problems. One day he's gentle as a lamb, other days . . . well. He lived with me a long time, held odd jobs in construction. But sometimes he'd get upset, wouldn't take his meds. Then . . . well. All hell would break loose. Got so we couldn't live together."

I stared at her. "What are you saying? He got violent? I mean, did he hurt you?"

She didn't answer.

"So *you* moved out and let Leroy stay there? That doesn't make any sense!"

"Not to you, maybe. Did to me." Her eyes got soft. "If I'd kicked him out, where could he go? He would've just ended up in some institution."

"But *you* ended up in a homeless shelter! Seems upside down to me."

"Maybe, maybe not. But what mother can kick out her own child from the only home he knows? He's family!"

Family. The irony was not lost on me. That hadn't stopped Philip from kicking *me* out. But I kept my mouth shut. Estelle's son was in the hospital with serious burns and her house was a total loss. Kind of put my woes in perspective.

"Oh, Estelle, I'm so terribly sorry. Is there anything I can do?"

Estelle shook her head. "Can't talk about it anymore. I'm too tired." Then she frowned at me. "I think you called me a couple of days ago and left a message, something about Philip. Didn't get it until yesterday. What's going on?"

"Oh, just . . . Philip said he wants to talk. About us. But I—"

"What's he want to talk about?" Estelle's frown deepened.

I felt guilty diverting attention from Estelle's big crisis to my petty marital problems. "I don't know! But as you well know, talking 'about us' isn't our strong point. Usually turns out to be Philip talking at me, and me mentally bouncing around trying to figure out how to keep the Fairbanks boat from rocking."

"Humph. Told you before, don't talk to that man alone. Look what happened when you ignored Mama Estelle's advice and sailed into his office, like a curly-headed pigeon flying into a skeet shoot."

I groaned. "Don't remind me. I haven't said I'd meet him. Don't really want to talk to him at all."

"Oh, you have to talk to him, Gabby girl."

"What?" *Not* what I expected from Estelle.

"He wants to talk. That's new. Could be anything. Might be good, might be bad. Only way to find out is to talk to him. Or ask

him straight up what it's about. All I'm sayin' is, ain't real smart to go it alone. That's all I'm sayin'." Estelle pushed herself up from the table. "Gotta get to work. Hang in there, Gabby."

I kicked myself later for bringing up the stuff with Philip. Hadn't asked Estelle how the fire started, or what was going to happen now that her house was gone. On the other hand, those topics might be a little touchy. Maybe it was just as well.

By the time Paul and I left Manna House that afternoon, the morning rain had moved out over the lake, replaced by a hazy sky and muggy air. Dropping Paul off at the apartment, I decided it was as good a time as any to take the car to Mr. B's mechanic and get the air conditioner fixed. He even said he'd fix it while I waited. "Harry told me to take good care of you," the mechanic said. "He's always brought me his business. Glad I can return the favor."

By the time the car was fixed, I was wilting from the heat. "Dad called a few minutes ago," P.J. said, not looking up from the video game he was playing as I came in the door. "I told him you'd call him back . . . aha! *Zam zam!* Gotcha!"

Oh, thanks a lot, buddy. I rolled my eyes at P.J. behind his back and headed for the kitchen, where I stuck my head into the fridge . . . *Darn it!* Who drank all the cold pop? Stupid question. All I could find in the pantry were a couple of cans of warm, generic lemon-lime soda. Did I buy that? Oh well. I poured the contents of a can over ice, crushed the can, and went out onto the back porch to toss it into the plastic wastebasket I used for

recyclables . . . which was overflowing. I'd forgotten to empty it into the big recycle bin out by the Dumpster. Which got me thinking . . . Did the city pay for that Dumpster and recycle bin? Or the landlord? If I bought the building, would I have to pay for services like that? I had an hour to kill before the boys and I took in the 5:30 movie at the Broadway Theater—our plan for this Thursday. Maybe I should do some more research on the responsibilities of owning a six-flat in Chicago . . .

I let the screen door slam behind me. I was stalling and I knew it. This was the third time this week Philip had left a message, and I still hadn't returned his calls. Had to admit, that in itself was enough to annoy any normal person, me included.

Okay, I'd call him back—but first I dialed Jodi Baxter's number. She sounded a bit breathless when she answered.

"Hey, Jodi. It's Gabby. Philip's been calling. He wants to meet tomorrow before he picks up the boys. I still haven't called him back. Thought I could use that prayer we talked about . . . and, uh, I have a favor to ask."

"A favor? Sure, if I—hey, hey, hey! Isaac! Don't bang that on Havah's head! That is not a toy! Gabby? Hang on a minute . . ." Jodi put the phone down, and I could hear the screeching of some little kids and Jodi's teacher voice sounding as if she was distracting them with something. Then she was back. "Sorry. I'm babysitting Ruth Garfield's twins while she gets her hair done at Adele's. Cute little buggers, but hoo boy. Mischief is their middle name. Now, what were you saying about needing a favor?"

I told her I'd decided to talk to Philip, probably tomorrow, but Estelle didn't think I should talk to him alone. Would she consider going with me?

Jodi didn't answer right away.

"I mean, if you can't, I understand," I blathered. "Estelle just said—"

"No, no, it's not that. I was just trying to think. If Denny and I were having a problem and he wanted to talk, he'd shut up like a clam if I showed up with someone else. Would Philip be willing to talk to you if I came along?"

Denny and Philip. *Huh.* That was like trying to compare Chicago hot dogs and *fois de gras.* Still, maybe they had a few guy things in common. I sighed. "Probably not. In fact, highly unlikely. But . . ." I was grasping. "What if you 'just happened' to drop by wherever we decide to go, act all surprised, say hi and go sit somewhere else?"

"Mm. I don't know, Gabby. He'd see through that in a minute. Look, why don't you just call him and ask what this is about. If he wants to talk divorce or legal stuff about the kids, tell him you want your lawyer present. Otherwise . . ." Her voice trailed off.

"Otherwise what?"

Jodi gave a short laugh. "Otherwise, we better pray! Because I've run out of my half-baked wisdom and I think we need to ask God for some of His!"

Jodi's prayer calmed my spirit. Didn't God have my back? She prayed those words from Psalm 56: "When I am afraid, I will trust in You . . . in God I trust; I will not be afraid." And it was true. In the past few months, when I'd trusted God for the things

I didn't understand or when I didn't know what to do, God always came through. Somehow.

I made sure the boys were busy, went outside to sit on the flat cement "arms" that hugged the outside landing and front steps, and called Philip on his cell. Couldn't believe it when he answered. "Gabrielle! I've left several messages. Why—"

"I know, Philip. I should have called before now. But I don't know if I want to talk about us. Can you tell me what this is about?"

A brief silence. "It's . . . personal. I'd rather talk face-to-face."

Take the initiative, Gabby. "Look, if it's about our legal situation"—ouch, why didn't I just say "divorce"?—"I think I'd like to have my lawyer present."

"Don't need our lawyers. Like I said, it's personal. Can we just talk? You name the place. I'll meet you there. Like five o'clock tomorrow? I'm supposed to pick the boys up at six. Just one hour, Gabby."

He called me Gabby. I let a moment of silence go by. Then . . . "All right. I'll meet you at the Emerald City Coffee Shop. It's right under the Sheridan El Station, a few blocks north of Wrigley Field."

The wall clocks at Manna House seemed to crawl on Friday. Nine hours until my meeting with Philip . . . eight and a half . . . eight . . .

This was stupid! You'd think I was in a hurry to talk to him . . . No, that wasn't it. I was in a hurry to get it over with.

I'd wanted to sit in on Edesa Baxter's Bible study she'd started on *Bad Girls of the Bible*, using a book by Liz Curtis Higgs. The ladies who attended last week, I'd been told, had eaten it up like chocolate. But I only caught the tail end of her study about Lot's wife and the consequences of momentary disobedience after doing my midmorning run to get P.J. from Lane Tech. Maybe Edesa would loan me the book and I could catch up.

I concentrated on work to make the time go faster. Getting the afterschool program up and running by the time school started was the main priority right now. Kids whose lives had been uprooted needed a lot of extra help to not fall through the cracks at school. Avis Douglass, Jodi's principal at Bethune Elementary, had sent us some helpful math and reading materials for grades one through five. But I needed at least two volunteers to be here daily . . . and so far I only had Precious, who'd be great with the younger kids. She only had a high school education herself, but she was the queen of trivia—what's new in NASA's space program . . . who just got traded in the NBA . . . the latest squabble at Chicago's city council . . . the sorry state of bridges in the U.S.— you name it, Precious had the latest facts. Or opinions, anyway.

But her daughter Sabrina had two more years of high school, and the girl would need a *lot* of help with schoolwork once that baby got here. Had to be someone besides her mother—*wait*. What about Carolyn? She'd been at the shelter when I first came and only recently got her own apartment. But Carolyn had been a lit major and former librarian, for goodness' sake! She said she wanted to come back to Manna House to volunteer and we'd been talking about starting a book club . . . why not ask her to put together an honest-to-goodness afterschool program *and*

tutor Sabrina? For that matter, why didn't we run our own GED program for our residents? Seemed like half of the adult women hadn't finished high school.

Two o'clock—my quitting time until the boys went back to school—galloped across the finish line before I knew it. I'd managed to get hold of Carolyn and she agreed to come in Monday to talk about it. I gathered up my things, collared Paul—whose enthusiasm for entertaining half a dozen bored kids seemed to be fading—and took P.J. and Paul out for ice cream and a swim at Foster Avenue Beach. When we got home, they flopped in front of the TV and the fans and didn't seem the least bit curious when I said I had to go "out" at quarter to five.

"Don't forget to pack your duffel bags with a change of clothes and underwear," I reminded them, freshening my lipstick and giving my auburn curls a comb-through in front of the hallway mirror. "Your dad will be here to pick you up at six."

On the dot. Philip had one hour to underwhelm me.

chapter 14

❋ ❋ ❋

I arrived at the coffee shop ten minutes early. No way did I want to arrive late and apologetic. I ordered an iced latte and looked around for a seat. The couch by the window? No, too cozy. But most of the small tables were occupied. *Rats*. Maybe I should have suggested something like that funky retro place Lee Boyer had taken me to after he showed me the six-flat . . . *no, no, no*. Meet Philip at the same place I'd been with Lee? Too weird. This would have to do.

A middle-aged guy with a shock of uncombed hair packed up his computer, stuffed it in a messenger bag, and vacated a tiny table by the opposite window. I zipped over and claimed the space, swiping crumbs off the table with a napkin he'd left.

I sipped my latte, letting the creamy cold coffee soothe my nerves. Philip's black Lexus slowed outside just as an El train rattled into the station overhead, unloaded and loaded, and pulled out again. New customers fresh off the train trailed in. The Lexus

disappeared from sight . . . but a few minutes later Philip pushed open the door and walked in.

Several heads turned as he entered. The glances of the females lingered. Couldn't blame them. Even at forty-one, Philip Fairbanks had movie-star good looks. Tall and slender, his dark hair and tan skin complemented the pale green dress shirt he wore with an open collar, topping a neat pair of black slacks and black loafers.

Two twentysomethings at a nearby table wearing Gap-inspired wrinkle-look tops, short skirts, and flip-flops gave each other *gosh-darn-it* looks when Philip headed for my table and sat down across from me. For a nanosecond, a smug smile tugged at the corner of my mouth—that age-old rivalry when The Man chooses The Alpha Woman over the other females in the herd. I'd dressed carefully—white slacks, russet cotton top that complemented my reddish-gold auburn hair, russet-colored beaded earrings that dangled, and gold strap sandals. But reality snuffed out the smug smile. *If they only knew.* I had to stifle the urge to toss out, *"You want him? You can have him!"*

"Thanks for meeting me, Gabrielle." Philip took off his wrap-around sunglasses and slipped them into his shirt pocket.

How did we start this talk anyway? "Do you want to get a coffee? Something to drink?"

He shook his head. "I'm fine. Everything okay with the boys this week? Do they have everything they need to start school?"

Okay, safe start. Talk about the boys. "Pretty much. They still need backpacks. Might need some sports equipment, depending on what they sign up for. And winter coats and boots when the time comes."

"Okay."

"Okay what? Are you offering to get that stuff for the boys?"

"Yeah, yeah, sure."

I wanted to say, *"See? We should have met with our lawyers to iron out all the child support stuff, get it down on paper."* But I sipped my iced latte to keep from filling up space with empty chatter.

"I—" Philip glanced out the window a moment, then back at me. "I know this might sound phony after everything that's happened, but I really am sorry about your mother, Gabrielle. Sorry she died staying in a shelter. I, uh . . ." He cleared his throat. "At the time, I thought it'd be better for everyone if she had her own place, a retirement home or something. Didn't think you'd put her in the shelter. It's just . . . everything felt out of control— summer plans for the boys falling through, losing an important client at work, the house suddenly crowded . . ."

I didn't trust myself to speak. What was he saying? Was he apologizing for kicking my mother out? Not really. Sorry things worked out the way they did? I was supposed to feel sorry for him because things felt out of control?

My hand holding the tall latte started to shake. I set it down and put my hands in my lap.

Philip actually kept eye contact. "It's been a rough time for all of us. But in the long run, you seem to be doing good, Gabby. The money from your folks . . . that was a surprise. Who would have thought? I'm glad things are working out for you."

I hardly knew how to respond. He actually sounded glad— relieved?—I'd gotten myself together. But I still didn't trust myself to speak. Or maybe I didn't trust what he was saying.

He glanced at the tables near us and lowered his voice. "But to

be honest, things haven't been going too well on my end. The business . . . well, a start-up company has its highs and lows. Just can't sustain too many lows. And personally . . . I'll be frank. I've gotten myself in kind of a jam. Which is why I wanted to talk to you."

I all but snorted. Philip—confident, bold, over-the-top, I-can-do-anything Philip Fairbanks—was actually admitting things weren't going well? If the business was floundering, what did that have to do with me?

But my thoughts must have been plastered all over my face because he held up both hands, palms out, as if begging for patience. "Just hear me out, Gabby. I need a loan—a personal loan. I've got a debt I need to pay off, and—"

"A *loan*?" I found my voice. So *that's* what this was about! "You want *me* to give you a loan? Good grief, Philip, you've got all kinds of credit! Just ask the bank for a loan."

He shook his head. "It's not that easy. Uh, things have gotten complicated. I've let business and personal stuff overlap . . . when you own the company, it's easy to do, you know. Anyway, while that's getting sorted out, a loan the size I need would take a whole lot of paperwork and collateral I can't afford right now. And time. Time is an issue. I need this loan right away."

My eyes narrowed. "It's a gambling debt, isn't it?"

He threw open his hands. "I've made some mistakes. Right now I just want to take care of my debts and get back on track."

"Mistakes. Uh-huh. Exactly what size loan are you talking about?"

He tried to be casual. "Twenty-five thousand. Fifty would be better. Would get me back on track faster. Just need to get over this hump."

I wanted to laugh. Hysterically. "Philip Fairbanks! This is ridiculous. I work for a homeless shelter, for heaven's sake. Part time, I might add, until the boys go back to school. You've got a commercial real estate company that's capable of pulling in big bucks. Why ask me?"

"I told you, the company's had some rough times lately. And, well, this is personal. I'd rather not involve Henry. I know you got some money from your folks. I don't know how much, but an inheritance usually comes in a lump sum. I'm talking about a short-term loan. Short-term, Gabrielle. I'll pay it back. I just need to put things straight, get back on track. You know I'm good for it."

I started shaking my head the moment he said *"money from your folks."* "I need that money, Philip. And you know it. I'm starting from scratch, thanks to you." A well of emotion threatened to push through the plug I'd stuck in it. I stood up, bumping the table and almost sending my half-empty latte onto the floor. But I grabbed it in time and stalked to the counter to get a glass of water. This was why we met in a public place or I might have gone off on Philip right about then.

I was tempted to head out the door without even finishing the conversation. But I took my ice water back to the table and sat down. "Besides," I said, as if I hadn't left, "I have plans for that money."

A small smile tugged at his mouth. "I know. You'd like to buy that building. Which seems like a big risk, Gabby. I'd hate to see you get in over your head—"

"I don't believe this! You've got a *gambling* debt, and you're talking to me about risk?"

He put up his hands again. "Okay, point taken. But even if you go ahead with that plan, unless you're signing papers today, you won't need a down payment for another couple of weeks, right? And by then I'll have the money back to you. With interest. I promise. And . . ." His voice trailed off, and he started to draw circles on the table with his finger.

I waited. *I really should just get up and walk out the door.* But he seemed to be struggling to say something. Morbid curiosity got the better of me. "And?"

The circles stopped and he looked up, his brown eyes searching mine. "Once I'm out from under this cloud, Gabby, maybe we could sit down and talk about where we go from here. You and me, I mean. And the boys. Maybe . . . maybe it's not too late to repair the damage."

It was like he knocked the breath out of me. What did he just say? *Repair the damage?* Did he really say that?

I stood up, not looking at him, reaching for my purse. "It's almost six. The boys are waiting for you."

He followed me out to the sidewalk. "Will you consider the loan, Gabby?"

Another El train lurched and groaned into the station overhead.

"When?" I shouted over the din.

"When?" Philip grimaced. "Well, yesterday would be good."

I headed for my car without replying but heard him call after me, "Just think about it, Gabrielle. Please?"

chapter 15

The black SUV with Philip and the boys was barely out of sight before I ran back into the apartment, grabbed the phone, and called Jodi Baxter. "The nerve of that man!" I exploded in her ear, not even taking time to identify myself. "He wants a *loan*, Jodi! Can you believe it? He's asking me for a loan!"

"You're kidding! . . . You're not kidding."

"I am not kidding. He's got a gambling debt—don't know how much or who he owes money to. The casino? Do they give credit? But he said something about his business being in trouble too. Anyway, he asked for twenty-five thousand—" I heard a gasp at the other end. "Ha. You think that's bad? He said fifty would be even better, would help him get 'back on track' faster. And *then*—"

"Whoa. Slow down, Gabby. I better sit." I heard their screen door slam in the background and the creaking of the back porch swing. "Now, start at the beginning. Because I don't believe Philip walked in and said right off, 'Hi, Gabby, will you loan me twenty-five thousand bucks?'"

"Okay, okay," I muttered. "Give me a sec . . ." I plumped up a couple of fat throw pillows on the window seat in the sunporch, set a fan in one of the open windows, and made myself comfy. Then I told Jodi as best I could the gist of my conversation with Philip barely an hour ago, starting with his pseudo sympathy for the loss of my mom . . .

"But that's not all," I said when I'd covered most of it. "He got all weird at the end, kind of emotional. Said once he was out from under this 'cloud'—paying off his debt, I guess—he wanted to talk about how we could 'repair the damage' to our marriage."

"No! He actually said he wanted to repair the damage to your marriage?"

"Well, what he said was, he wanted us to talk about 'where we go from here.' And 'Maybe it's not too late to repair the damage.'"

"Oh. My. Goodness. Gabby, that's huge! What did you say?"

"Uh . . . nothing. I was so taken aback, I just got up and left. It was time to leave anyway."

"You just left."

Why was Jodi repeating everything I said? "Yes! I just left . . . no, take that back. When we got outside I asked, 'When'—like, how soon did he need the loan. He tried to joke, said he needed it yesterday. But he meant as soon as possible." Even as the words came out of my mouth, I wished I *had* just left without saying anything else. "Oh, Jodi, do you think by asking when he needed the money, it sounded like I was going to give it to him?"

The squeaking from the swing on the Baxters' back porch stopped, as if Jodi was pondering my question. "I don't know.

Maybe. But don't worry, Gabby. You haven't committed yourself to anything. I'm just . . . I dunno. Kind of flabbergasted he even suggested that maybe it wasn't too late to repair the damage to the marriage."

"Except . . ." How could I put into words what I was feeling right now? Or not feeling might be more like it.

"Except what?" Jodi finally asked.

"Maybe it is too late."

Sitting on the beach near Montrose Harbor an hour later, I dug my toes into the warm sand and hugged my knees. After the phone call with Jodi, I'd grabbed my car keys and got out of the house. Didn't even change clothes. So what if I still had my white slacks on. Lucy wasn't around to give me what for. I chuckled, remembering the time the frumpy bag lady had lectured me on not wearing my good clothes to the beach. Frankly, I wished Lucy and Dandy would turn up about now. I could use a little down-to-earth distraction after my weird talk with Philip and trying to field Jodi Baxter's fixation on my estranged husband's "repair the damage" comment.

Jodi meant well. After all, *she* had a marriage worth saving. And of course there was a lot of stuff in the Bible about honoring marriage vows. But Estelle! I laughed to myself again. Estelle made no bones about saying she'd like to "put down her religion" long enough to give Philip a good whack upside his head!

A puff of warm wind off the lake stirred up my mop of curls as erratic thoughts tumbled inside my head. But now . . . Would

everyone get all excited if I said Philip wanted to work on our marriage? Was he serious? Or just buttering me up to make me consider giving him that loan?

Wouldn't put it past him.

But even if he was serious . . . why didn't I feel anything? Didn't I want us to be a family again? Even though the boys seemed to be adjusting to our separation, I knew they were still hurting. They'd probably like nothing better than to see Mom and Dad get together again.

I dug my toes deeper into the sand. And what about me? Didn't I get lonely? Stupid question. Crawling into a single bed every night made me feel like the last kitty in the litter, no one to snuggle with. Didn't I struggle with feeling rejected, like an old shoe tossed into the garbage? Like every day. Wouldn't I rather be married than a single mom, eking out a living on my own? Yes . . . maybe.

And that was the rub. I *had* been rejected, tossed out, left to claw my way out of a pit. But now I was standing on my own two feet. And I had plans. Good plans. Okay, maybe impossible plans, but plans that made me feel like the real Gabby.

And Philip wasn't part of them.

My answering machine light winked at me when hunger drove me in from the beach. I punched the Play button as I pulled out some leftover chicken salad and ate it cold, straight from the plastic container. "Gabby? It's Jodi. I realize we didn't really talk about that loan Philip wants, much less pray about it. Some prayer

partner I am! Sorry I got off track. I'll be praying you get some good advice about that. Maybe you should talk to your lawyer—or a financial wizard, if you've got one. Though I realize it's not just a money thing. More like a wisdom thing. Okay. I'm blathering. Just wanted to apologize. Don't sit up all night worrying. Or if you do, call me and we'll pray on the phone. Bye!"

Couldn't help smiling. I loved that Jodi, I really did. When I first met her, she'd seemed so together—perfect family, perfect husband, perfect church attendance, perfect Christian . . . but on our road trip to North Dakota with my mom's casket in the back of the shelter van, she admitted she'd done the "good Christian girl" thing so long, she didn't even realize how judgmental and self-righteous she'd become until she got involved with the Yada Yada bunch.

"Remember Yo-Yo, the girl in our prayer group who wears overalls all the time? She wasn't brought up in church," Jodi had told me somewhere on that long drag through the Midwestern plains, *"so she makes me explain myself whenever I use churchy clichés. 'Why didn't ya just say so!' she huffs. And Florida? She's got antennas fine-tuned to pick up on any self-righteous, better-than-thou Pharisee stuff. Whew, she can take me down quicker than I can say hallelujah."*

That had cracked me up, made me wish I could be part of a group of praying sisters like that, women who were *real*. The one time Jodi had taken me to the Yada Yada Prayer Group, they'd prayed for me so powerfully that I would "live into the meaning of my name"—which Edesa Baxter said meant *"Strong woman of God"*—that I went back to the shelter with renewed hope that God had not forgotten me and my mom, that He would give me the strength to get through the mess my life had become.

And He had. So far anyway. It had to be God's doing, because

I never would have dreamed I'd be able to stand on my own two feet without Philip. Or in spite of Philip. And *never* in a million years did I imagine Philip would come crawling to me, asking for a *loan*.

It was almost pathetic.

I dumped the empty leftover container into the sink and started to reach for the phone. I should call Jodi back, pray with her about what I should do . . . but I hesitated. What if God wanted me to give him that loan? Give him the benefit of the doubt? Help him "get over this hump" so we could move on and talk about where we go from here?

Instead I called Lee Boyer's cell. After all, Jodi said I should get some wise advice. What was a lawyer for if not to get advice about something as big as a twenty-five-thousand-dollar loan?

We met for breakfast the next morning at Kitsch'ns in the Roscoe neighborhood south of Wrigleyville, the same funky place Lee had taken me to before. "Gabby!" he said, sliding into the chair opposite me at the wobbly sidewalk table outside the tiny restaurant. "I'm so glad you called me. What the heck is this about? Philip is asking you for a *loan*?—Wait. Let's order, then I want to hear all about it."

Lee was wearing Birkenstocks, rusty-tan cargo shorts, and a short-sleeve T-shirt that showed off the freckles on his tan arms. Quite a contrast to my "dress for success" husband—which was one of the things that endeared Lee to me. While waiting for our omelets, I told him the whole story. All except the part about

Philip saying once he got over this hump, he wanted to talk about "where do we go from here."

The look on Lee's face behind his wire rims was priceless. He laughed aloud. "Unbelievable! Look, I'm sorry. Don't mean to laugh at a guy who's down on his luck, but this is beautiful. You're on your way up; he's unraveling. Definitely works in your favor when we see the judge about your custody petition."

A waiter in jeans made the rounds of the sidewalk tables and refilled our coffee. I waited until he was gone. "I don't think Philip is going to give me a problem about custody. The boys are with me now, and he agreed to have them just Friday night and Saturday. Works with his schedule, I think."

Lee wagged his head. "Don't take anything for granted, Gabby girl. I won't feel easy until you have it court-approved and in writing. As for the loan?" Lee leaned toward me, tapping a finger on the table for emphasis. "Don't . . . do . . . it. That would be a huge mistake. *You* need that money, every penny. It'll look good—real good—on your bank statement when you go before the judge to prove you have the means to support the boys. And if you're serious about buying the six-flat you're living in . . . say, by the way, I called the realtor handling the building. He seemed very interested when I told him I had a reliable client who already lived in the building. I'll make an appointment for you next week if you want to move on it."

"My lawyer says don't do it," I told my sisters on the phone. Celeste, Honor, and I had actually managed to pull off our

Saturday three-way call this time—noon my time, ten in California, nine in Alaska.

"I guess not!" Celeste barked. "That's Mom's money. And after the way he treated her? She'd turn over in her grave if you loaned that money to him."

I let that go. Our mom never had been one to hold grudges. If Martha Shepherd thought her son-in-law was trying to quit gambling and do right by his family, she'd probably forgive him and *give* him the money. Though come to think of it, he never did admit he needed help as a problem gambler. Just that he'd "made some mistakes."

"But Gabby said she didn't tell her lawyer what Philip said about wanting to work on their marriage," Honor said, talking to Celeste as if I wasn't on the line. "Doesn't that make a difference? Maybe loaning him the money would show good faith on Gabby's part that—"

"Honor Shepherd!" Celeste practically yelled in our ears. "Are you high on something? He just said that to make her think he's turned around. But did he say he was sorry? Unless I missed something, I didn't hear 'sorry' in there. I'm with the lawyer, Gabby. Don't do it."

"Well, I think she could loan him *something*. He said he'd pay it back."

"And you believe him? That's the trouble with you, Honor. That's why you're raising River and Ryan in a trailer park, because you believed all the nonsense their loser father kept promising."

"And what's wrong with a trailer park? We got a nice double-wide now with our share of the inheritance money—nicer than

that log cabin you and Tom live in, up there in that godforsaken wilderness they call a national forest."

"How would you know, Honor? You've never been here. We happen to *like*—"

"Celeste! Honor!" I butted in. "I'm losing you! I'm just getting static . . . sorry . . . we'll talk next week, okay? Love you! Bye!" I put the phone down like a hot potato. *Good grief.* What was up with those two?

I glanced at the kitchen clock. Yikes, Philip would be bringing the boys back in a few hours and I still needed to do the grocery shopping. And, drat, I'd wanted to go looking for a decent dining room table to replace the ridiculous plywood-on-sawhorses sitting under that linen tablecloth. Well, forget the table. No time for that now. The boys still had one week to go until school started, which meant they'd be in the house eating all day.

But even as I grabbed the scrawled grocery list off the refrigerator door, I realized a lot more than restocking my pantry had to be in place by six o'clock.

Philip, no doubt, would be expecting my answer by then.

chapter 16

Well, so what? I told myself, lugging the last of the grocery bags into the house a couple of hours later. I had my answer, didn't I? At least my lawyer and my big sister agreed with my first, second, and third inclinations—don't give Philip a loan. *In fact*, I thought, stuffing the freezer with frozen waffles and Tombstone pizzas, *he has a lot of nerve, asking me for money after he cut me off without a dime!* I got hot just thinking about it. As far as I was concerned, it served him right to be suffering financial loss just like he'd made me suffer—

The loud door buzzer down the hall rattled my interior monologue. *What?* I glanced at the clock. Only five o'clock! Was Philip back early? *Oh no. Oh, God, I don't feel ready.* Ignoring the intercom as I ran down the hall, I opened the front door a crack and peeked into the outer foyer . . . and breathed a sigh of relief. Estelle Williams, dressed in a bright yellow-and-black caftan, was fanning herself with a piece of junk mail on the other side of the glass-paneled door while Harry's grandson gleefully pressed my doorbell as if it were dispensing free gum balls.

I stepped into the outer hall and pulled open the locked door. "Estelle! You must really be desperate to show up on my doorstep, because you *know* I don't have central air. Where's . . . Oh, hi, Mr. B." Harry Bentley backed into the foyer still trying to lock his car with the remote key. I waved the trio inside. "Come in, come in. Did you go to the hospital today? Is Leroy doing okay?"

Estelle heaved a sigh. "So-so. Gonna be a long haul. We stopped by the house too—what's left of it—to see what we could salvage. Not much. Lord, have mercy. What a mess."

Harry pulled a large handkerchief from his back pocket and mopped sweat from his shaved head, glistening like a brown bowling ball. "I decided to get her out of that burned-up mess and do something fun to take her mind off it—"

"We gonna see fireworks tonight—from a boat!" DaShawn blurted, bouncing up and down. "Grandpa got free tickets! Can P.J. and Paul come too?"

Harry grinned sheepishly. "Like the boy said. You know, one of those Chicago lakefront cruises. The department gets these complimentary tickets to give out all the time. My partner—ex-partner, sorry—thought we could use a bunch." He pulled out a handful of tickets. "We've got enough for the Fairbanks Musketeers—you too, Firecracker."

"Oh, Harry, that sounds like fun. I'm sure the boys would love it. But they're still out with their dad, won't be home for another hour . . . You want to play with that, DaShawn?" The boy had pounced on P.J.'s Nintendo, which was still hooked up to the TV. "Sure, go ahead. You all want some ice water or something?" I started for the kitchen.

Estelle stopped fanning and perked up. "The boys aren't here? Good. Was hopin' we could talk private-like." She was right on my heels and plopped herself at my kitchen table, waving Harry into a chair. "Don't worry about no ice water, girl. I wanna know did you talk to Philip? Did you take somebody with you? What did he want?"

I got the water anyway and joined Estelle and Harry at the tiny table. "Yes, I did. I mean, yes, I talked to him. No, I didn't take anybody with me, because . . ." I filled her in on Jodi's point of view when a guy says he wants to talk. Alone.

"Smart girl, that Jodi," Harry smirked. "Listen and learn, Estelle."

"Humph. Don't remember askin' you. Go on, Gabby."

"Okay. Maybe you guys can give me some advice about what I should do . . ."

Even as I retold what had transpired between Philip and me at the Emerald City Coffee Shop, I thought, *What am I doing? Haven't I already made up my mind how to answer Philip?* But something still nettled me. I wanted to feel more confident that I was doing the right thing. I was pretty sure Estelle would agree with me. But I'd like to know what Mr. Bentley thought about the whole thing. He'd been around the block a few times and he'd always given me good advice.

"Lord, have mercy!" Estelle said, rolling her eyes when I'd told my story. "That man must be in a heap o' trouble for him to come askin' *you* for a loan. You told him to go soak his head, right?"

I laughed. "Not yet. I told myself I didn't have to respond to anything right then, so I just listened and left. Frankly, why

should I rescue him after what he did? That's what everybody is telling me. Don't do it."

Mr. B's cell phone rang. He glanced at the caller ID and got up. "Sorry. Gotta take this. Be back in a minute." He disappeared into the dining room.

Estelle was right back on our conversation. "Everybody who?"

"Well . . ." I told her about my conversations with Lee Boyer and my sisters.

"You said you talked to Jodi? What did she say?"

"She didn't really give me her opinion about the loan. Just offered to pray with me about it."

"Did you?"

I squirmed. "Uh, not really. Haven't really had ti—"

"Uh-huh. I figured."

I frowned. "What do you mean? Estelle! *You* don't think I should give him the money, do you?"

"You kidding? I happen to agree with you and Mister Lawyer and your big sis. But can't say my reasons are all that holy. Yours either, for that matter. Oh, Harry's back . . . Everything okay?"

Mr. Bentley sank back into his chair, a smug grin on his face. "Yep. That was Cindy. They've picked up our man. Indictment came out this morning."

"Oh, praise Jesus!" Estelle said. "I'm glad that dirty cop is off the street."

Mr. Bentley grunted. "For about a minute. He'll pay his bond and be out tomorrow. But at least they'll put him on leave from the force till the trial."

"Hello-o." I waved my hand in their faces. "What are you guys talking about?"

"Sorry. Just some old police business. What'd I miss while I was out?"

"Gabby says everybody tellin' her don't go givin' Philip a loan. But she wants to know what *you're* thinkin'."

Mr. B pursed his lips and scratched his beard. "Sounds to me like Fairbanks is a classic 'problem gambler.' I've seen it take down guys on the force again and again. He's addicted, just like a drug addict. Doesn't know when to stop. Even if you did loan him money out of the kindness of your heart, you wouldn't be doing him a favor. He'd just gamble it away. And you'd just be enabling a bad habit."

Don't know why I stuck up for Philip. "He promised to pay it back. I think he honestly realizes—"

Harry shook his head. "Maybe your husband thinks he sees the light, even promises himself he won't do it anymore. I don't much care for the man, but I'd be the first one to cheer if he actually got some help, turned things around, decided to treat you right. But throwing money at a gambling problem is the worst thing you can do. If you care for your husband at all, don't loan him that money. Any money."

Estelle rolled her eyes heavenward and wagged her head. "Mm-mm-mm. Outta the mouth o' babes an' old men. Now *that* sounds like a God-reason to say no. Now that we got our petty little selves outta the way, maybe we're ready to pray 'bout this? What do you say, honey?"

For some reason, tears rolled down my face as Estelle prayed. A sense of peace replaced my anxiety as I held hands with Estelle and Harry. Saying no felt right now. Not out of vengeance. Not because it was Mom's money. Not even because

it was mine and I needed it. But because it was the right thing for Philip's sake.

The door buzzer rang while we were still praying. "I'll get it!" DaShawn yelled.

Estelle, Harry, and I looked at each other. "It's okay," I said, starting toward the front of the apartment. "I'm glad you guys came. Go ahead and ask the boys if they'd like to go on the fireworks cruise—" Which was a moot point, because by the time we got to the living room, DaShawn was already begging P.J. and Paul to go with them.

"Can we, Mom? Huh? Can we?" Paul bounced on his feet. Even P.J. looked interested as DaShawn showed them the brochure of Windy City Cruises.

Philip had come in with the boys, not just let them out as he usually did. I noticed he was dressed basically in the same clothes he'd worn yesterday, and he didn't look happy to see me with company. "Bentley," he acknowledged with a stiff nod. "And Miss . . . I'm sorry. I've forgotten your name."

"Haven't forgotten yours," Estelle quipped. "Estelle Williams, chief cook and bottle washer at Manna House Women's Shelter, friend of sinners and friend of your wife."

Philip seemed taken aback. He frowned. "Uh . . . I was hoping you and I could talk, Gabrielle."

"Estelle and Harry were just leaving," I said, more breezily than I felt. "Boys! Would you like to go on this boat cruise with DaShawn's grandpa and Miss Estelle? You'd have to go now."

"What about supper?" P.J. wanted to know.

"Don't worry, we'll feed you." Harry grinned.

Within a few minutes, P.J. and Paul had scrambled into the backseat of Harry's RAV4 with DaShawn and were fighting over whose seat belt was whose.

"Are you sure you want to talk to Philip by yourself, baby?" Estelle murmured to me as she got in the front seat. "You could just tell him the answer is no and come with us. You don't have to explain yourself."

"I know, Estelle. But I'll be okay. Thanks for taking the boys. This works out for the best. I was wondering how we were going to talk with them around."

I watched until Harry's car turned the corner, and then went back into the house. Philip was sitting forward on the upholstered chair I'd taken from the penthouse, elbows on the padded arms, hands together in front of his face. He looked up as I came in. "Did you think about my request, Gabrielle?"

"I did." I sat down in the rocking chair I'd brought from my mom's house, crossing my legs at the ankle, hoping my mascara hadn't run when I got teary during our prayer time. "The answer is no, Philip. I'm not going to give you a loan."

His jaw clenched. "Why? I need this, Gabrielle! I said I'd pay you back. You've got the money—more than enough, right? How would it hurt you to help me out for a couple of weeks?"

"It would hurt you, Philip. You need more than money. You need to get some help. Your gambling has obviously become a big problem."

"Yeah, yeah." He snorted and leaned back in the chair. "Fine. I'll get some help. But first I need to get out from under this debt. *That's* the problem."

"No, your problem is you've become somebody I don't even recognize anymore. What you did to my mother and me? That's not the Philip Fairbanks I married."

Philip looked at me sharply. "So that's what this is about. I figured as much. This is payback, isn't it?" He suddenly stood up and stabbed a finger at me. "Well, let me tell you something, Gabrielle Fairbanks. You *owe* me! You owe me a whole lot more than twenty-five or even fifty grand."

I nearly fell out of the rocker. "I *owe* you? What are you talking about?"

"How long have we been married? Fifteen, sixteen years? How much income did you contribute to our family during that time? *Nada.* Oh, oh, I take that back. You had that sweet little job playing games with the old folks at the nursing home, which gave you a little spending money for . . . what? One year? Two? Meanwhile, who was paying the real bills? I was. Gave you a beautiful home. Gave you two closets full of clothes. Put food on the table—a Belfort Signature table, I might add. Paid for the boys' school, their sports, vacations to the ocean . . . Add *that* up, Gabrielle. Add up sixteen years of marriage in dollars and cents, and you'll see what I'm asking you for is peanuts! Peanuts!"

By this time, Philip was pacing back and forth, running a hand down the back of his head. I was so furious I couldn't say anything for a few moments. But then I found my feet and my voice. I stood up. "How *dare* you reduce our marriage to dollars and cents, to who owes who what?" My voice was shaking. "I won't play that game, Philip. My answer is still no. You'll have to find the money somewhere else."

I crossed the room and opened the front door. "I want you to go. Go!"

Philip glared at me for several moments, and then strode to the door. But at the door he turned, only inches from my face. I could smell his Armani aftershave. "You think you are so holy, so self-righteous, Gabrielle. Going to church now, helping out the homeless. You've told everybody you know—and probably the media too—your pathetic sob story, how I'm the villain who tore our marriage apart. But get one thing straight, Gabby! You walked out of our marriage the day we moved to Chicago. You think I'm not the person you married? I could say the same thing about you!"

chapter 17

❋ ❋ ❋

The outer door had barely closed behind Philip when I grabbed the closest thing at hand and threw it across the room. "I *owe* him?!" I screeched at the empty house. "I *owe* him?"

Unfortunately, I'd grabbed a glass candle jar off an end table and it smashed against the painted brick gas fireplace on the other side of the room, scattering glass and broken candle wax in a dozen directions.

I stalked down the hallway, then back again with a broom from the pantry. "He thinks I owe *him?*" I muttered to myself as I swept shards of glass into a pile. Hadn't I read somewhere that if everything an at-home mom did had to be hired out—*ha! Including sex?*—it would exceed most paychecks their husbands brought home.

In the middle of my rant, Estelle called to say they had the time wrong and the fireworks cruise didn't start until nine thirty, so they'd be late getting home. "Fine," I said and hung up before she could ask how my talk with Philip went. I was so

upset by Philip's accusations—he thought *I* had walked out on the marriage? What kind of baloney was that?!—I didn't want to talk to anybody. I watched a dumb movie on TV, and then used the fact that the boys didn't get home until almost midnight as an excuse to let them sleep in Sunday morning and not go to church.

The boys nixed my suggestion about going for a bike ride along the lakefront that afternoon and instead wandered over to the playground to shoot baskets at the school where Paul would be starting in another week. I stayed home and did laundry, ignoring the phone. Lee Boyer left a message that he'd made an appointment with the realtor for eleven on Tuesday and he'd see me then. And Jodi Baxter left a message saying she didn't see me at church and was I okay?

No, I was not okay, but I didn't feel like talking about it either.

Monday's gray gloom and dripping skies matched my mood as I squished into the shelter. I'd dropped off P.J. at Lane Tech for his last week of preseason practice—rain or shine, the coach said—and talked Paul into coming to the shelter at least a couple of days this final week, but frankly, I didn't want to be there either. *What's wrong with me?* I wondered as I signed in. I'd felt such peace about saying no to Philip after the prayer time with Estelle and Harry. Now I just hoped I wouldn't snarl at the first person who talked to me . . .

"Mom!" I heard Paul squeal from beyond the double doors. "It's Dandy and Lucy!"

Sure enough, Lucy Tucker was sprawled on one of the couches in the newly named Shepherd's Fold, her damp hair

plastered against her head, grinning as the yellow dog practically break-danced around Paul, who was down on his knees trying to keep from being bowled over. "Look, Mom, you can hardly see where the stitches are anymore."

It was true. Dandy's hair had grown out over the long knife cut over his shoulder, but overall his hair looked rather matted and dirty, which made me wince. "Hi, Lucy." I plopped down on the couch beside the old lady. "You dropping in for your weekly spa treatment?" *Ha ha.* My hint that a shower and hair wash would be in order. Which gave me an idea. "Hey, Paul, why don't you give Dandy a bath and a blow-dry this morning? Is that okay with you, Lucy?"

The older woman shrugged. "Guess so. Though he jus' gonna get dirty again on a day like this, mud everywhere."

"Why don't you stay a few days until the weather dries out? Weather guy said rain today and tomorrow. Want me to see if there's a bed available?"

Lucy shrugged again, which struck me as odd. She usually had a definite opinion one way or the other. I told Paul to round up Sammy and Keisha—he was going to need the two older kids to help—and I'd set things up for them in the laundry room downstairs. Mabel's office was empty, but a quick look at the bed list at the reception desk showed me there were two beds left. They'd be gone by evening if this rain kept up. I signed Lucy's name for two days and told Angela I'd work it out with Mabel later if there was a problem.

"What's that?" Lucy pointed to the handmade poster on the double doors with scrawled bubble letters: *Shepherd's Fold.*

"That's the new name for the multipurpose room. You know,

Shepherd was my mom's last name, and a Shepherd's Fold is where the shepherd keeps his sheep safe and secure."

"Whatchu think I am, stupid? I *know* what it means an' I know it's named after Miss Martha. What I wanna know is, where's the bronze plaque? That stupid poster gotta go. It's an insult to her memory. We gotta put that name up on a nice, big bronze plaque that says, 'In memory of Miss Martha Shepherd' or somethin' decent. Maybe frame her picture too."

I barely had time to assure Lucy that I'd take her suggestion to the staff meeting that morning when Carolyn showed up to talk about the afterschool program. The shelter's former book maven still looked the same as the day she'd moved out—brownish-gray hair slicked back into a long ponytail, no makeup, and forty extra pounds. But frankly, I thought my idea to ask Carolyn to oversee the afterschool program was brilliant—a lot better use of her talents than just leading a book club once a week. It had taken me a few weeks after I started working at Manna House to realize that the dumpy middle-aged woman had a master's degree in literature. Still on disability after an emotional breakdown and time spent first in a psychiatric facility and then here at the shelter, she'd finally gotten a tiny two-room apartment at Deborah's Place.

But I'd missed her everyday presence, missed seeing that straggly ponytail hunched over a Scrabble board or game of chess. As far as I was concerned, Carolyn and I had a lot in common—two educated women who never thought they'd end up in a homeless shelter. But we had.

The two of us hunkered down in my office to put together a rough plan we could take to the staff meeting at ten. Squeals and

doggy whines from the laundry room punctuated our work for about twenty minutes, but shouts of, "Come back, Dandy!" drew both of us out of my office in time to see a sudsy Dandy escape up the stairs to the main floor. By the time we caught the dog, wrestled him back into the laundry room tub, and got him rinsed and dried off, it was already time for staff meeting.

Our damp, rumpled clothes raised a few eyebrows and grins when Carolyn and I joined the others in the schoolroom. I was glad to see Edesa and Josh Baxter there. Regular volunteers were always welcome to attend staff meetings whenever they could. Estelle caught my eye, and I knew she wanted to know what went down when I talked to Philip the other night, but I just mouthed, "*Later.*"

As we plunged into that week's agenda—a new social work intern to assist Sarge at night starting in September, a slug fight over the weekend involving two of the residents, and my proposal that Carolyn take on the afterschool program—I realized my spirit had lifted from the cloud of gloom I'd been under all weekend. That's what I needed, to just keep busy, immerse myself in the work here, forget about Philip. After all, I'd given him my answer and I had a good reason for saying no. What had I expected, that he'd say, "*Sure, I understand. Thanks anyway*"?

". . . classes start this week at UIC," Josh was saying, "so we don't have as much time to look for an apartment. So far we haven't found anything we can afford, and we're starting to feel desperate. If anyone hears of anything for rent in this area, let us know."

Mabel, of course, suggested we stop and pray about that right then, but I had to leave in the middle of her prayer to pick

up P.J. and drop him off at home, and by the time I got back, the staff meeting was over. I poked my head into Mabel's office, where she was talking to Josh and Edesa. "Oops, sorry," I said. "Just wondered if you've got any time today. Couple of things I need to talk about . . ."

Mabel peered at me over the top of her reading glasses, then at her appointment book. "I'm free at two. See you then."

I gulped but nodded. Paul and I were supposed to leave at two. But if I was going to talk with the realtor tomorrow, I'd really like to know if things were moving ahead with the city on this second-stage housing idea before I signed on the dotted line. Owning a building just to rent out apartments to any Tom, Dick, or Henrietta wasn't exactly what I had in mind.

Carolyn had stayed after the staff meeting to do more work on the afterschool plans, and bless her, she agreed to challenge Paul to a game of chess to keep him occupied during my meeting. Estelle, of course, tried to corner me after lunch and pry out of me what happened when I talked to Philip, but all I said was that I'd told him no, like she and Harry advised, and of course he wasn't happy about it, but what did we expect?

She gave me a real funny look and muttered, "You and me gonna have a talk, girlfriend. Somethin' don't smell right."

I escaped saying I had a meeting with Mabel, promised Paul I'd try to make it short, and knocked on the director's door right at two o'clock.

"So," she said, as I sank into the sturdy armchair beside her desk. "What's up?"

I let slip a wry smile. Mabel was one of the most attractive, mature African-American women I'd ever met. She definitely had

pleasant features, but it was more than that. Her unlined face, framed by her straightened bob, radiated calm. "What's up is I want to be like you when I grow up, Mabel. I come in here, and all my ragtag ends flying every which way just seem to sew themselves up like a quilted baby blanket."

Mabel almost laughed. Almost. "If there's peace in this office, Gabby girl, all the credit goes to God, because I've got a few ragtag ends myself. Jermaine, for one. He starts high school next week—well, you know that, since P.J. is starting Lane Tech too—and I'm on my knees a couple of hours every night praying he won't get picked on like he did last year."

I'd almost forgotten that Mabel's nephew, who suffered a lot of teasing by the more macho types, had tried to commit suicide just months ago. "Oh, Mabel, I'm sorry. I didn't mean to imply you don't have any troubles. It's just . . . how do you keep so peaceful in the midst of all the craziness around here? Like that new woman messing with Tina. Whew! Glad I wasn't here." Sarge's description of the fistfight that started over "get your stuff off my bunk" had all the earmarks of a street feud.

Mabel tapped the Bible she kept on her desk. "Just have to stay in the Word. Stay in the Word . . . because it's not enough to believe *in* God, Gabby. You have to *believe God.* He's a mighty big God, if we let Him *be* God in all our messy situations."

I squirmed. Couldn't say I'd managed to "stay in the Word" the past few weeks since the boys had returned. But if that's what it took to be like Mabel, I needed to make the time. I actually made a note in my notebook—*Pick up where I left off in Matthew's gospel*—then looked up. "Speaking of P.J. and Jermaine, do you want to work out some kind of ride sharing? I'd like to increase

my hours again once school starts, but if I could work eight to four, I'd be glad to pick them up after school if you want to do the morning run."

Now Mabel did smile. "Great idea. I'd like to be sure Jermaine gets to school and home again in one piece, at least for the first few weeks. Tell you what, I'll pick up P.J. at your apartment at 7:45 on . . . hm, Monday is Labor Day . . . so next Tuesday." She looked up from her calendar. "Speaking of Labor Day weekend, how about a picnic for the residents at one of the forest preserves or something? This is the first Labor Day since Manna House was rebuilt. Might be a nice tradition to start."

I made another note: *Plan Labor Day picnic ASAP*. Then I brought up the House of Hope proposal and felt encouraged. Mabel had already made contact with the city's Department of Housing and Urban Development, which funded the Low-Income Housing Trust Fund and had started the application process for Manna House to be the service provider. "There will be papers you'll need to sign, Gabby, as the housing provider once you actually own the building. So I'd encourage you to go ahead as quickly as possible—*if* you're still clear this is what you want to do."

I nodded, both excited and anxious. "How long is this going to take? Sabrina's baby is due in November, I think, and I know that girl doesn't want her baby born in a shelter."

Mabel shrugged. "I don't know . . . thirty days minimum if we're lucky. Could be sixty or even ninety days. Depends on several things—how quickly you can get a mortgage, how fast HUD processes the paperwork . . . you know what I'm talking about."

I sagged a bit into my chair. "Yeah, I know. I just wish it

was done already so we could move Precious and Tanya in next weekend."

Mabel just nodded and looked at me thoughtfully. "One other thing . . . you've got your boys back living with you and seeing their father on the weekend. But what's happening with you and your husband? You told me you've filed for custody and redress for unlawful eviction . . . but you haven't mentioned divorce. Are you hoping that you and Philip can reconcile? How does buying this six-flat fit into that?"

I looked down at my lap and then reached for a tissue on her desk. The next thing I knew I was telling her all about Philip "wanting to talk," and how he ended up asking me for a loan to bail him out of his gambling debt, even saying that once he was out from under this cloud, he wanted to talk about "what's next" and that maybe it wasn't too late to "repair the damage."

Mabel listened without speaking up to that point, but then she actually whistled. "Praise God, Gabby. That's amazing! What a breakthrough. But . . . I don't know if loaning him the money would be wise. He—"

"Huh!" I interrupted. "Don't praise God yet. Wait until you hear what happened when I told him I *wasn't* going to loan him the money." The anger I'd been dealing with all weekend crept into my voice as I told her what he'd said, that I "owed" him that money. "And then . . . Mabel, he actually had the audacity to tell me that the failure of our marriage was my fault! That I'd 'left the marriage' when we moved here to Chicago. Can you believe it? I gave up my job, gave up living near my children, gave up my beautiful Southern home with a porch and a yard to follow him here to Chicago! And now he's trying to blame *me*!"

Mabel sat for a long minute with her eyes closed, as if deep in thought. Finally she opened her eyes and gazed at me with a tender, pained expression that almost hurt to see. "There's something to that, you know," she said quietly.

chapter 18

❋ ❋ ❋

That couldn't be what she said.

For a moment I just sat there, my face stinging as if she'd slapped me. *"What? Are you saying he's right?"*

Mabel picked up a pen, rolled it in her fingers, and then put it down again. "No. Believe me, from the little I know, Philip seems like a first-class jerk. I just mean that the breakdown of your marriage isn't all Philip's fault. You bear some responsibility too."

I felt my back stiffen, as if a line had just been drawn in the sand and Mabel had stepped over to the other side. "What exactly are you saying, Mabel?" My voice was tight, holding back the things I wanted to yell, like, *"What do you know, Mabel Turner? Are you forgetting he threw me out and stole my kids?!"*

"All I'm saying, Gabby, is that if you and Philip do talk about repairing the damage to your relationship, it will be important for you to take responsibility for some stuff. I'm not blaming you, or saying it's your fault or that he had any right to kick you out. It's

just that . . . I've been troubled by some things that have happened since I've known you."

Hot tears sprang to the back of my eyes, but I was determined not to cry. I gritted my teeth. "Like what?"

Mabel grew thoughtful. "When I offered you the job as program director, you didn't go home and talk it over with your husband. You interviewed, accepted the job, and then told him it was a done deal."

"I was afraid he'd squash the idea!" I cried. "You know that!"

"I realize you had your reasons. But I was concerned that no marriage can tolerate that kind of behind-the-back decision making for long, especially for something that affects a family as much as a job."

Angry tears finally spilled over. I grabbed at the tissue box on her desk again. "This isn't fair, Mabel! You . . . you said yourself that you believed God brought me to Manna House for a special purpose! But *now* . . . oh, now you're saying I should've got down on my knees like a wimp and *asked* my Almighty Husband for permission to take this job—and you *know* if I'd done that, that would've been the end. No job. The last you'd have seen of me."

She waited while I blew my nose. Then she said, "Maybe. Maybe not."

I narrowed my eyes. "What do you mean by that?"

"You're absolutely right. I did say I believed God brought you to Manna House for a special purpose, and I still believe that—"

"Then why are you blaming me for taking the job? I don't understand you, Mabel!"

"Let me finish, Gabby. If we believe God has a purpose for bringing you here, then we can also trust Him to make it happen.

But you were afraid—afraid if you talked it over with your husband, he'd say no. So you took it into your own hands to make it happen, rather than trust God to work it out. But what if you had included Philip in this decision? What if—"

But I had started shaking my head. "You don't understand," I said fiercely. "Philip never would have agreed to me taking this job. He was down on me even coming here to visit! It didn't enhance my image as a 'good corporate wife' and all that."

"That may be so. I don't know. But our timing isn't always God's timing. Maybe you wouldn't have been able to start right away. Maybe there were steps in between that would have helped change Philip's perspective. But my guess is that your choice to move ahead without Philip's agreement put a major stress on your relationship." She tipped her head to the side. "True?"

A tension headache had started to screw its way into the back of my head. I stood up abruptly. "I . . . I can't do this right now. I'm sorry, Mabel. I need to go . . . take Paul home. Maybe we can, you know, talk later . . ." I stalked out of her office, poked my head into the multipurpose room—yeah, yeah, the Fold—and yelled in the direction of the chess game, "Paul! We gotta go!"

"Wait a sec, Mom! I'm winning!"

"*Now*, Paul!"

I was pretty much a basket case the rest of the day. The boys decided I was in a "mood" and stayed out of my way. So what if they watched TV all afternoon—it was a rainy day and school would start next week anyway. Wouldn't rot their brains for just one day.

But I felt . . . betrayed. By Mabel, of all people! And I'd thought I could count on her to be in my corner through all this mess. She'd always bent over backward to give me time off to see the lawyer, let me use the phone to work on getting the boys back, gave me flex time in my schedule when I needed it—like the past few weeks, when I had to pick up P.J. midmorning . . . which, I had to admit, still counted for something.

So why was she turning things around now? Dumping the blame for my failed marriage into *my* lap?

Stewing over our conversation made my head hurt the rest of the day, and I went to bed early. Briefly thought about calling Jodi Baxter, just to have *someone* to lean on, then remembered she'd gone all wide-eyed about that maybe-it's-not-too-late-to-repair-the-damage nonsense Philip had fed me. *Huh.* I doubted very much he intended to talk about "what's next for us" after I'd said I wasn't going to give him any money.

But lying on my bed in the back bedroom wide-awake, staring into the dim light of Chicago's long evening, I felt as if I was going nuts. I wanted to talk to somebody . . . but who? My sisters? Not Honor. Maybe Celeste. She'd stick up for me. Or maybe Lee Boyer . . . *he* had absolutely no sympathy for Philip. And not just that, he had a lot of feelings for me. A man who really cared—and would care more if I gave him any encouragement.

I suddenly wanted to talk to Lee very much. See him. Closing my eyes, I could almost feel his touch as he laid his hand over mine in his office. I tried to imagine how it would feel to lean into his embrace, feel his arms around me . . .

Fishing for my cell, I rang his number, but all I got was his voice mail. That threw me. "Uh . . . Hi, Lee. It's Gabby. Call me

if you get this . . . on second thought, don't call. I'm going to bed. Guess I'll see you tomorrow at the realtor's office."

So much for Lee always being there to lean on.

I cried myself to sleep.

Paul showed up for breakfast in his pajamas saying he didn't want to volunteer at the shelter today, maybe tomorrow if it stopped raining and we could take the kids to the beach in the afternoon. I didn't push him. Frankly, I didn't feel much like going to work either, but I sucked it up like a big girl and sailed into the Manna House foyer only five minutes late after dropping off P.J. at the high school.

Mabel came to her office door as I was signing in. "You all right, Gabby?"

I put on a bright smile. "Sure, Mabel. Sorry I got a little emotional yesterday. I'll be fine. Oh . . . I've got an eleven o'clock appointment with the realtor. I'll let you know how it goes."

That's right, Gabby, just move on. Don't let Philip's rants goad you—or even Mabel's opinion of what went wrong in your marriage. After all, that was in the past. What's done was done. Good things were happening now—the House of Hope idea was still afloat, I was moving ahead on buying the building, I'd be seeing Lee in a matter of hours . . .

Lee was waiting for me at the realtor's office, wearing a white short-sleeved shirt with open collar, khaki jeans, and boots. His

version of business casual. He gave me a quick hug—the professional kind, sorta sideways, since we were standing in the waiting room of Coldwell Banker realty. "Gabby! Sorry I didn't get your message last night. My cell phone battery died and I didn't realize it until later. Are you all right?"

I nodded, realizing his warm concern could easily pull the plug I'd stuck in my emotional dike. "Just cold feet, I guess. I realize I don't have a clue how to navigate this thing. Glad you're here." All of which was true . . . just not why I'd called last night.

His light brown eyes crinkled behind his wire rims. "Don't worry. I'm not a real estate lawyer, but I think I can get us through this. And I happen to know the owner would much rather get a deal now than have that building sit on the market for six months waiting for his asking price."

I let Lee do most of the talking. Twice the agent representing the building stepped into another office and made a call to the owner . . . but when it was over, the owner had accepted our offer, which was less than the asking price, because I was willing to put 30 percent down instead of the usual 5 or 10 percent.

There was one glitch. Two of the tenants—not one—were moving out on Labor Day weekend, just days away. The apartments needed to be rented—but I didn't want new tenants in there, since I had plans for the building. Normally, the apartments would stand empty for a few weeks while they were refurbished for new tenants, but the current owner didn't want to put out the expense now that I'd signed the first papers. And I didn't legally own the building until the closing date, which had to wait for a title search, application for mortgage, all the red tape.

We finally agreed on a rider that I could do basic cleanup and

painting—at my expense—but no structural changes or major repairs before the closing date in case the sale fell through for some reason.

The rain had stopped. Outside the realtor's office, Lee grabbed me and swung me around. "Wahoo! This calls for a celebration, don't you think? Let's do lunch. On me."

I laughed, grabbing for his arm to keep the world from spinning. "It's always on you, Lee. Maybe this one should be on me—as thanks for being a great tugboat."

"Hey! Who are you calling a tugboat? Okay, you can pay, but let's take my car. I'll bring you back to get yours."

Lunch at Hing Wang Restaurant for Chinese was giddy, and we laughed a lot. Which was good, since I avoided dragging up my last fiasco with Philip and yesterday's shocker with Mabel. Until we were back in Lee's Prius, that is.

"Say, what happened when you turned down Philip's request for a loan? You *did* tell him no, right, Gabby? . . . Hey, watch it, buddy." He blew his horn at a pizza delivery van that cut in front of us.

I nodded, hoping that would suffice, but Lee had his eyes on errant traffic. So I said, "Yep. Told him no. Thanks for the good advice."

"And . . . ?" Lee glanced over at me.

I turned my face toward the window, but a tear escaped and slid down my cheek.

"Hey, hey . . . what's wrong, baby?" Lee pulled out of traffic and into a No Parking space along Broadway. He reached for me and pulled me into his arms. "What did that bully do that's making you cry?"

So there it was. Lee's safe arms around me. The plug came out, and I ended up blubbering all over his white shirt. Bit by bit he drew out of me what Philip had said when I gave him my answer to his request for a loan.

"Don't cry, Gabby," he murmured into my hair, pulling me closer. "Don't let him mess with you. You don't owe him anything! And as for that other crap—that's just what it is. Don't let it get to you."

Tell that to Mabel, I thought. Should I tell Lee what she said?

I opened my mouth, but Lee murmured, "Shh . . . shh . . ." and laid a finger on my lips. Then he turned my face up, touching my lips softly with his.

And I let him.

chapter 19

I was still slightly giddy when I finally got back to the shelter. Precious was manning the reception desk and Mabel's office was empty, which meant people were still at lunch.

"You missed lunch," Precious said, handing me the logbook. "Taco salad."

"Oh, I ate out . . . You got a pen?" I hummed a little non-tune.

Precious eyed me suspiciously from beneath the row of kinky twists that fell over her forehead. "What you all hum-happy 'bout?"

"Oh, nothing much . . ." The memory of Lee's kiss still tingled on my lips. Still humming, I made a pretense of paging through the logbook. "Except, oh yes, we did make an offer on the six-flat, and—"

Precious snatched the logbook away. "And *what?*"

I grinned at her. "*And* the owner accepted our offer!"

"Praise *Jesus!*" Precious threw her hands in the air. "Hallelujah!

Look at God, movin' that mighty mountain. So when can me an' Sabrina move in?"

Voices were rising on the other side of the double doors. I lowered mine. "Not until we close. We have to apply for a mortgage, and they've got to do a credit check and a title search, all that stuff. Not sure how long it'll take. And meantime, Mabel's got to work it out with the city how you apply for the rent subsidy. She's going to handle that end of it."

Precious stuck a lip out. "I knew it. That baby gonna come out and we *still* gonna be here at the shelter. Can't we hurry this along a little?"

"Don't think so. Oh! There is one thing we can do." I beamed at her. "A couple of tenants are moving out Labor Day weekend, and Lee worked it out so we can fix up those apartments before closing. How about a painting party? Want to help choose the colors?"

"Wait a minute. Lee who? And what's all this 'we' and 'our' business? I thought *you* was the one buyin' this building."

I felt my face color. "Uh, I am. Lee is just my lawyer. Lee Boyer. You know."

"Don't know nothin' 'bout no Lee Lawyer." She eyed me closely. "That why you missed lunch?"

"I told you. We ate out. A little celebration." I could feel the tips of my ears getting hot—and was relieved when Mabel came through the double doors talking to two women I didn't recognize, but who had the depleted look of "just off the street." Must've come in this morning. I used the interruption to escape through Shepherd's Fold and down to my office . . . only to run into Estelle bossing the cleanup crew.

"There you are! Saved you some taco salad. In the fridge. An' you got—"

"Oh. Thanks anyway, Estelle. I ate out." And I zipped toward my broom-closet office.

But before I could unlock the door, Estelle hollered after me. "—a visitor in there. And ain't you s'posed to tell me when you not gonna be here for lunch? I gotta plan these things, ya know."

My "visitor" turned out to be Dandy, wiggling his rump and bestowing wet kisses on whatever bare skin he could find. Fending him off, I poked my head back out. "I'm sorry, Estelle. I didn't know ahead of time. I'll be sure to let you know next time. And what's Dandy doing in here?"

"Don't ask me! Lucy just said to tell you she had to go someplace and could you take care of Dandy for a couple of days."

A couple of *days*? That's when I noticed she'd left his dog dishes and the bucket of food. Huh! She could've at least *asked*.

I blew out a long breath. Well, Paul would be happy about it anyway.

I was tempted to tell Estelle about my meeting with the realtor—she was one of the few who knew about my House of Hope idea outside of the board—but getting into *any* conversation with Estelle was likely to lead to questions about my talk with Philip, and I just didn't want to talk about it with her. Or Jodi. Or anyone at Manna House, for that matter. Not after Mabel jumped all over me about "taking responsibility" for my part in the marriage bust-up. Once was enough.

My eye caught my Bible sitting on the desk. But I left it there. Didn't really feel like talking to God about it either.

But Dandy? Now there was a good listener with no opinions. "Hey there, Dandy. Good dog," I murmured as I scratched his rump. "Remember that guy who kicked you out of the penthouse? Well, he's still being his same jerk self . . ."

To my relief, Mabel didn't try to follow up on our conversation from Monday. In fact, my mood brightened with the sun peeking through the clouds on Wednesday. Paul had been ecstatic when I brought Dandy home for a visit and willingly came to the shelter with me and Dandy when I promised one last "beach day" with the shelter kids.

It felt good to stay busy. I went to the bank and applied for a mortgage. Carolyn showed up twice more that week to work with me on the afterschool program. And I started calling forest preserves to see if I could get a picnic permit for a group of thirty or forty folks for Labor Day.

Not a chance. Seemed like every group-size picnic site in the Chicago area had been booked for months. *Huh. Maybe I should book one now for next year.* But Friday morning I finally found one—though only available Sunday, not Monday—at a forest preserve called Sunset Bridge Meadow along the Des Plaines River, which wound its way through a whole string of forest preserves just west of the city. Some family reunion had cancelled at the last minute—their loss, our gain. Sunset Bridge had a large picnic shelter, restrooms, an open meadow surrounded by woods, and the river running through it. Perfect.

But a picnic meant food, which meant I had to talk to Estelle.

She didn't usually work weekends—and this was a holiday weekend at that. We hadn't spoken much that week, but I could always plead "busy."

Estelle came in about ten. I waited until she had tied on her apron and stuffed her loose topknot under the required poufy cap, then popped out of my tiny office and leaned casually over the counter between kitchen and dining room. "Hi, Estelle! I've got a big favor to ask you."

The older woman eyed me, and then dumped a large sack of corn on the cob on the counter in front of me. "If you gonna lean on me for a favor, you can start shuckin'."

I obediently picked up an ear of corn and started pulling off the husk. "I'm trying to put together a Labor Day picnic for the ladies, but the only day I could find a picnic site is Sunday. And obviously we need food. I'm wondering—"

"Nope." She shucked two ears of corn to my one. "Not Sunday. I don't work on Sunday. That's the Lord's Day."

I was taken aback. And got huffy. "Well, *somebody* has to work on Sunday, don't they? Because these ladies have to eat on the *Lord's Day* too. But don't get your tail in a knot. I was just asking. I'll find somebody else." I tossed my stripped-down ear of corn on the pile, turned on my heel, and stalked back to my office.

Dandy got up and wiggled a welcome like I'd been gone five hours instead of five minutes. "Move, dog," I snarled. Where was Lucy anyway? She'd been gone three days already. I plonked myself down in the desk chair and pressed my fingers to my eyes. I wanted to be mad . . . but instead I started to cry. How did Estelle and I get to be at odds?

I heard my door open and knew it was Estelle. Reaching for a tissue, I blotted my eyes and blew my nose before looking up. "What do you want?"

She sank into the folding chair beside my desk. "To say I'm sorry. Look, Gabby. I know when somebody's been avoiding me. Just got my goat that you came askin' for a favor after blowin' me off all week. But eye for an eye wasn't called for. What you doin' for the ladies is real nice. They'll enjoy getting out . . . Tell you what. I'll put together some picnic food on Saturday—shouldn't be too hard. Mostly shopping for a couple of melons, brats and buns, some deli potato salad, lemonade—stuff like that. I'll leave it in the fridge and you can take it in the coolers we got back there. Sound okay?"

I nodded, but now the tears started up again. Gag, I hated being such a crybaby! I grabbed for another wad of tissues . . . but found myself wrapped in Estelle's arms and my head on her ample bosom. "Come on, now, Gabby girl," she murmured, "what's goin' on? Somethin' happened when you talked to Philip, didn't it? Come on, now, you can tell Mama Estelle. I ain't gonna bite you."

For a few minutes, all I could do was cry. Wasn't even sure why. I'd gotten beyond Philip's mean words, hadn't I? The New Gabby wasn't going to be blown away every time the man who'd kicked me out tried to kick me again. He'd done his worst and I'd survived, hadn't I? I had my boys back, we had a nice apartment, they were starting school here in Chicago soon, the House of Hope idea was moving ahead . . . So what was the big deal?

But Estelle had put her finger on it. I'd been avoiding her . . .

and Jodi . . . and everyone who'd become my friend. And I felt so alone. Why? Why was I afraid to tell them what Philip had said to me? Afraid to tell anybody about my conversation with Mabel? Why? Why?

Because I was afraid it might be true.

chapter 20

I finally got hold of myself long enough to give Estelle a brief rundown of what Philip had dumped on me when I gave him my "no" answer. "I'm s-sorry I've been avoiding you, Estelle. Just didn't want to talk about it." I blew my nose and reluctantly reached for my car keys. "There's more, but I've gotta run—P.J.'s last day of preseason practice."

"Hm." Estelle hefted herself out of the folding chair. "Just remember one thing, honey. *The truth will always set you free.* But there are a lot of things masquerading as truth these days, an' Satan, he's whisperin' a lotta nonsense in our ears he'd like us to believe 'bout ourselves an' other people. But there's only one place to get your truth. Here, look this up an' read it when you got some time." She scrawled something on a scrap of paper and stuck it in my Bible. "Now, shoo, get on outta here so I can get cookin'."

I was halfway up the stairs to the main floor when she hollered after me. "An' since you gonna pick up P.J., bring him on

back to the shelter for lunch. I'm fixin' a surprise back-to-school lunch for all the kids of residents an' staff."

My spirit felt lighter after crying on Estelle's shoulder, even though I didn't quite tell her everything, like what Mabel had said. *It wasn't intentional*, I told myself as I pulled into the Lane Tech parking lot. *I just ran out of time.*

"How'd it go, kiddo?" I asked as P.J. jumped into the front seat of the Subaru.

"Good." My oldest fiddled with the radio until he found a pop station and hiked up the volume. "We find out next week who Coach is putting on the varsity team, but there's a good chance I'll make it. The first meet on home turf is coming up in a few weeks, September something." He glanced at me sideways. "Will you and Dad come?"

"Absolutely—but only if you turn that thing *down* twenty decibels! . . . Ahh, thanks, that's better. As for your dad, you'll have to ask him. Might depend on when it is. But you'll see him tonight, right?"

P.J. shrugged. "Guess so. He hasn't called all week."

Which was true. I'd been just as glad, figured Philip was mad at me for turning him down—and I had *nothing* to say to him since he made that stupid "you owe me" remark. But it hurt knowing stuff between us was hurting the boys too.

"Be patient, kiddo. Your dad's going through a hard time right now . . . Hey, is it okay if we go back to the shelter? Estelle's making a special back-to-school lunch for everybody—staff kids too."

P.J. didn't answer, just pumped up the music again and turned his head away.

True to her word, Estelle had made a special kid-friendly lunch—hamburgers, chips, corn on the cob, and ice-cream bars. Harry showed up with his grandson and Mabel's nephew. I noticed Jermaine put his food tray down across from P.J., but there was no interaction between the two until Paul plopped his tray down beside Jermaine and started jabbering away. Probably talking music.

Mabel surprised Paul by naming him "Volunteer of the Month" and presenting him with a poster that had a photo of Paul in his volunteer T-shirt with all the shelter kids. Sammy, Keisha, Trina, and Rufino wanted to sign the poster, and even Dessa and Bam-Bam, the toddlers, added their scribbles. Paul covered his embarrassment by acting the clown, but I knew he was pleased.

The second surprise was a backpack filled with school supplies for each kid, donated by one of the big insurance agencies in the city—the company logo boldly emblazoned on the bag, of course. Sammy and the other schoolkids excitedly dug through the contents. P.J. and Paul, however, looked at the bags and then at each other. I could read the look between them: *"No way."* Sabrina didn't take one either.

I made an announcement about the Labor Day picnic—"On Sunday, not Monday!"—and said whoever wanted to go should sign up today and I'd be back tomorrow to pick up the list so I could work out transportation. I started the list with my name and my boys, and then handed the clipboard to Harry Bentley. "You and DaShawn are invited too, Mr. B." I lowered my voice and teased, "You used to be a cop, right? We could use some security."

"Might just do that." Harry signed, and I chuckled. He obviously hadn't checked with Estelle, who didn't *do* Sundays.

Lucy still hadn't come back to pick up Dandy. "I think Lucy should just give him back to us," Paul pouted as he packed his duffel bag for the overnight with their dad. "Maybe she's never coming back. He's practically my dog anyway . . . hey! Can he come with us to Dad's?"

I lifted a knowing eyebrow at Paul.

"Oh, right. Well, will you promise to feed him? And walk him?"

Assuring Paul I would, I hustled the boys so they'd be ready by six o'clock when Philip usually picked them up. But six came and went, then six thirty . . .

I didn't particularly want to talk to Philip, but I dialed his cell phone and got his voice mail. But when he hadn't shown up by seven, I tried again. Again I got voice mail—but this time he called back just as I was telling him what I thought of a father who stood up his own kids.

"Gabby, I can't talk right now . . . Look, can I call you back?"

"Philip! It's seven o'clock! The boys have been waiting for you for an hour." The background on his end was noisy. Other voices. Some music.

"I know. I thought I'd be done here. Something got delayed."

"Something-*what* got delayed? Something more important than your kids?"

"Just some . . . business I had to attend to. And no, it couldn't wait." Philip's tone got tight. "I wouldn't have to do this if you

had—" In the background I heard someone yell his name. He tried to muffle the phone, but I heard him say, "I *said*, just give me a minute, Fagan." Then he came back on. "Look, Gabby, I have to go. I *will* pick up the boys. Just ask them to sit tight." The phone went dead.

Irked, I went ahead and fed the boys some boxed macaroni and cheese and hot dogs, but I had a hard time trying to cover for their dad. I was mad, and the boys knew it. Finally the front door buzzer sounded at eight o'clock. Philip was already back in the car when the boys clomped out the front door and down the steps. "See you tomorrow night, guys," I called after them, watching P.J.'s dark hair and Paul's red-gold curls disappear into the backseat of the Lexus.

Only after I went back inside did I realize the significance of *both* boys climbing into the backseat.

Well, good. Philip needed to know the boys had feelings too. What kind of business was he doing, anyway, on a Friday night? *Huh.* Probably out drinking with Henry Fenchel and some business client, Fagan-somebody. Except, what did he mean he wouldn't have to do this if I had . . . if I had what? Given him the loan? Was he getting a loan from somebody else? Well, let him. It wasn't my responsibility.

"Come on, Dandy; guess it's just you and me." The yellow dog flopped by my feet as I tried to watch TV, but another Friday night by myself made me feel depressed. Turning it off, I curled up on the window seat in the sunroom at the front of the apartment and stared at the streetlights shining through the trees. Holding two fingers together, I touched my mouth, trying to remember Lee's soft kiss . . .

Good grief! If Lee felt that way about me, why didn't he ask me out on a date? I'd love to see a movie or go out to dinner or . . . or even bowling! What did Lee like to do on weekends? I had no idea. Why had I let him kiss me when I still hardly knew the guy!

Well, I wasn't going to call him and whine. It was almost ten. I should just walk Dandy and go to bed. Would it be safe? I got the dog's leash and stepped outside, glad to see at least two other dog walkers. The night air was mild. Warm, not hot. Nice for September first. But it'd soon be fall, with winter not far behind. "What are you and Lucy going to do then, huh, boy?" I murmured to Dandy, as he lifted his leg for the tenth time, marking every tree along the sidewalk.

As we returned to the six-flat, I saw bright lights in the first- and third-floor apartments on the left side of the building. Windows open. I could hear loud voices from the third floor. An argument. Those were the people moving out tomorrow.

My spirit revived a notch or two. It'd be fun to fix up those apartments for Precious and Tanya and their kids. Maybe I could get a work party together on Monday. "Labor Day," I snickered at Dandy as he curled up on the scatter rug beside my bed. "Get it? Labor . . . work . . ."

I was just about to turn off the light when I spied my Bible I'd brought home from my office and realized I hadn't read the note Estelle had stuck in it. I pulled it out. All she'd scrawled was a Bible verse: *John 8:31–32.* Plumping up my pillows, I found the Bible passage and read it aloud to Dandy. "Then Jesus said to those Jews who believed Him, 'If you abide in My word, you are My disciples indeed. And you shall know the truth, and the truth shall make you free.'"

Huh. That's what Estelle had said to me . . . *"The truth will set you free."* What was she trying to tell me? Something about Satan telling us lies about who we are and who other people are. And the only place to get the truth was God's Word—just like these verses said. I read them again. *"If you abide in My word"*—hmm, definitely hadn't been doing much "abiding" in God's Word lately—*"you shall know the truth, and the truth shall make you free."*

I shut the Bible, turned out the bedside light, and slid down beneath the sheet. "God," I whispered into the inky darkness, "I've been kind of afraid to know what You think about all this mess with Philip. Afraid maybe You'll end up on Philip's side and I'll be the person in the wrong again. But if the truth sets us free, guess I shouldn't be afraid, right? I'm sorry I've been avoiding You. Not wanting to pray, not reading my Bible. You've done a lot already to free up my spirit, now that I found You again at Manna House. I want to be Your disciple, Lord, like it says in those verses. So I'm going to try to be a little more faithful about 'abiding' in Your Word . . ."

As sleep overtook me, I found myself wondering what "abide" meant. *Funny word . . . kinda archaic . . . My kids would say, "Huh?" . . . Maybe it just means "hanging out" with God . . . no, more than that. Soaking in His words? Soaking, that was it . . .*

I woke up to thumps out in the stairwell and voices cursing. Moving day. Standing by the open back door with my coffee, I winced as I saw broken furniture, an old box spring, and bags of trash get dumped out in back by the alley. Who was going to pick

that up? Shuddering at the prospect of being the future owner and having to deal with all that, I decided to get out of there until the move was over.

Top on my list of things to do was picking up the picnic list and making sure we had enough transportation. I drove to the shelter—and ran into Jodi Baxter on the front steps, just about to ring the doorbell. Right on time for her typing class. She was wearing a denim skirt and had pulled her brown shoulder-length hair into a short ponytail. "Hey," I said and fumbled for my Manna House key. "I can let you in."

"Hey, yourself." Jodi didn't move, even when I got the door open. "I was hoping I'd see you. I left a couple of messages this week but you haven't returned my phone calls. Did I . . . I mean, are you upset with me for some reason?"

I let the door wheeze shut again and sighed. "No . . . well, yeah, kind of." I sank down onto the top step. She sat down beside me. "But not just you. Just ask Estelle. I've been avoiding her too. Avoiding everybody, I guess. Even the Big Man Upstairs." I rolled my eyes heavenward and made Jodi smile. "I'm sorry, Jodi. You're a good friend. And a good prayer partner. It's just . . . you got so excited about Philip and me 'fixing' our marriage, I didn't feel like you were really listening to me."

She winced. "Ouch. Okay. I'm listening now."

We sat outside for several minutes while I tried to tell Jodi everything that had happened since I told Philip I wouldn't give him the loan. It came out all in a jumble, but she put her arm around me and pulled me close. "Oh, Gabby, I'm so sorry. You're right. I was too quick to jump ahead, hoping things could get resolved between you and Philip, and didn't take time to put

myself in your shoes." She glanced at her watch. "Ack, I'm late. The ladies are probably waiting on me for class, if they haven't given up already. But I really do want to hear more. I promise to shut up and listen this time." She gave me another hug and stood up. "I'm glad we bumped into each other. I've really missed you, my friend."

I stood up too. "Yeah, missed you too . . . Uh, by the way, what are you and Denny doing tomorrow?"

"Tomorrow? Besides church you mean?" She squinted as if reading her schedule on the bright sky. "Nothing much, far as I know."

"You guys want to go on a picnic? Can we borrow your grill . . . and your Caravan?"

chapter 21

Not counting people who had their own cars—Harry Bentley and the Baxters and Mabel—twenty-five ladies had signed up for the Labor Day picnic. "Your minivan won't be enough," I moaned to Jodi before she left. "And Moby Van only holds fifteen."

"Talk to Josh," she suggested. "Maybe he can borrow the SouledOut van."

I didn't tell Josh his mother had suggested it—but he seemed excited about bringing Edesa and Gracie to the picnic when I got him on the phone. "Sounds like fun. Don't know of any reason we couldn't use the church van. I'll let you know."

"You're a prince, Josh," I gushed. Frankly, having another man on hand made me feel more secure herding a large group of streetwise females, many of whom, I was told, had never been to a forest preserve. I didn't want to lose anybody in the river.

I did my grocery shopping, stopped by the dry cleaners, and got my nails done. By the time I got back to the six-flat in late afternoon, both moving trucks were gone. Curious, I tried the

door to the first-floor apartment across the hall from me. Locked. *Drat.* I'd have to get the key to do any painting. But the third-floor apartment door was open.

I peeked into the empty apartment . . . "empty" being a relative term. Trash still littered the front room—a stained carpet, a broken lamp, old newspapers, even some clothes. I heard my front door buzzer while I was still in the apartment. Almost six . . . had to be the boys. I located the intercom and buzzed them in, then yelled down the stairwell, "I'm up here!"

The boys thundered up the stairs. P.J. stopped at the front door. "Whoa. What a mess." But Paul came on in and ran down the hall, opening doors and looking in every room. "Hey, can we play up here?"

"Sure," I said, grabbing him and knuckling the top of his head. "We can play drag-the-carpet-out-to-the-garbage, and then—"

"Aw, that's not what I meant."

"Well, let's not waste a trip down. Here, help me roll up this rug . . ."

It took all three of us to heave the old carpet into the Dumpster in the alley. If the first-floor apartment was in similar shape, I'd need a cleaning crew before we could do any painting.

Back in our own apartment, I stuck a frozen pizza into the oven. "Wash your hands, guys. This won't take long. You have fun with Dad?"

P.J. ran his hands under the kitchen faucet and wiped them on his shorts. "I dunno. Kinda boring. Dad took us out for breakfast this morning, but then he spent most of the day in his office."

"Yeah," Paul piped up. "We played video games all morning, then he let us go swimming at Foster Beach."

"He didn't go with you?"

Paul shook his head. "Nah. But it was okay. They've got a lifeguard there."

I zipped my lip. No, it was not okay. Wasn't the whole point for Philip to spend time with his sons?

I did get the boys up in time to go to church at SouledOut, even though they griped about not getting to sleep in. Frankly, I was sorely tempted to let them sleep so I could get to work on the empty apartments, but I couldn't very well ask to use the church van today and miss another Sunday.

And I was so glad we went. I'd pretty much taken going to church for granted growing up. But today, singing "We come rejoicing into His presence" and seeing arms lifted all over the room was almost a tribal experience for me. The congregation was such a mishmash of colors and cultures—where else would people who might not have much in common come together and sing with such abandon? For that moment I felt part of a family— a sense of belonging that made me feel connected to people all over the world who were together worshiping God today.

If only it would last.

I'm so sorry, God, I prayed as the youth were finally dismissed for Sunday school. *How easily I gave this up in Virginia, traded it in for a few extra hours to eat a lazy breakfast and read the Sunday paper...*

Out of the corner of my eye I saw P.J. and Paul leave the building with the other teens and climb into the church van. "Where are they going?" I whispered to Jodi.

"The lake," she whispered back. "Pastor Cobbs asked Josh to teach the teens a series on Sea of Galilee stories from the Gospels, and Josh being Josh, he thought taking the teens to the lake might make it seem more real and relevant—though I'd like to know what he's going to do about Jesus telling Peter to get out of the boat and walk on the water. Half the teens might just try it!" Jodi started to giggle and we both had to stifle it when Pastor Cobbs—the younger pastor of the two-man pastoral team at SouledOut—got up to preach.

The van came back while the rest of us were enjoying coffee and sweet rolls after the worship service. P.J. and Paul both hung around Josh with some of the other teens, talking and horsing around. "Aw, Mom!" P.J. whined when I told them I needed to leave to get ready for the Manna House picnic. "Do I hafta go?"

"What?" Josh overheard us and feigned horror. "Your mom's making me drive! You're not going to leave me alone with all those women, are you? Hey—make you a deal. Why don't you guys stay here and ride with me in the church van? What time do you want us there to load up, Mrs. Fairbanks—two thirty?"

The boys were already in cargo shorts, T-shirts, and gym shoes—typical teen garb even for church these days—so I said fine, a bit amused at this sudden bonding between my sons and Josh Baxter.

"Bring Dandy!" Paul yelled after me as I headed for the Subaru in the parking lot.

True to his word, Josh pulled up with my two boys and his wife and baby in the SouledOut van right at two thirty, followed a few moments later by the senior Baxters and their Dodge Caravan. Most of the women and shelter kids were already

waiting outside on the front steps, and I noticed we'd picked up a few more strays. No problem. With the shelter van, too, we'd get everybody in.

Edesa helped me pack two large food coolers with the picnic stuff Estelle had left in the refrigerator, and Josh and Denny Baxter loaded them in the Caravan with their grill. Paul wanted Dandy to ride in the SouledOut van with him and P.J., but I didn't want Josh and Edesa to have to be responsible for ten women, my two sons, *and* the dog, so I said Dandy had to ride with me in Moby Van. To my surprise, Paul hopped out of the church van and climbed in behind me with Dandy.

"Where's Mabel?" Precious yelled from the back. "She was on the list!"

"Going to meet us there! Everybody buckled up? All right, let's go."

I waved at Josh behind me and had just started to pull out into the street, when I heard someone yelling, "Hey! Hey, wait for me, dagnabit!" Stomping on the brake, I glanced in my rearview mirror, trying to see who we'd left. Someone was knocking on the windows of the passenger side. Then the side door slid back.

"Where y'all goin'?" said a gravelly voice. "Hey, there he is! Hiya, Dandy boy! Didya miss me? I'm back!"

"Aw, Mom!" Paul hissed in my ear. "It's Lucy!"

Ignoring groans and complaints from the already crowded van, Lucy dragged her cart into the van and parked her ample behind on the seat next to Paul while Dandy joyfully gave the old lady a hero's welcome. Twisting in my seat, I could see Paul smoldering next to the window. But Lucy rummaged in her cart and handed him something wrapped in a plastic bread bag. "Got

somethin' for ya, Paul," she said. "Little thank-ya present for takin' such good care of Dandy. Share 'em with your maw."

Paul handed me the bag and I peeked inside.

Big, fat blueberries.

Paul was sullen the whole trip. I told myself I'd find a time at the picnic when we could talk through his feelings about having to share Dandy. But when we pulled into the parking lot at Sunset Bridge Meadow, I saw we had a bigger problem than Lucy showing up. Another group was using the picnic shelter.

Bikers.

At least fifteen Harleys filled the lot, all leather and chrome. My heart sank . . . and then I saw Harry Bentley's car at the end of the row of bikes—*Oh, hallelujah*—and Harry himself over at the rustic shelter talking to one of the bikers. "Hang on, ladies," I said, climbing out. "Don't get out yet."

Yeah, right. I was only halfway across the meadow when I realized all the ladies in Moby Van were right behind me, including Paul holding on to Dandy's leash. And then the SouledOut van pulled into the lot, followed by the Baxters' minivan.

Mr. Bentley was mopping his brown dome with a big handkerchief, surrounded by a dozen or more muscular white dudes in red kerchiefs, sporting a variety of beards, earrings, and leather vests. "I told these fellows you have a permit for this picnic grove, Gabby." Underneath Mr. B's tone I heard, *"I sure hope you have one!"*

By now we were surrounded by a swarm of Manna House

residents and a handful of staff, volunteers, and kids. "Uh, sure, right here." I pulled out the permit that had been faxed to me on Friday—a concession because we were a social service agency— and handed it to the guy Harry had been talking to.

Mr. Leather Pants took the permit and grunted as he looked it over. "Manna House . . . is that like 'manna from heaven' from the Bible?"

"Uh, I think so." Mabel would know but she wasn't here. "It's a Christian homeless shelter for women."

"A *Christian* shelter." Precious sniffed.

"Hey, wait a minnit!" Lucy elbowed her way to the front of the Manna House crowd and looked Mr. Leather Pants up and down. "Ain't you the guy gave me a ride on that big bike t'other day in Michigan?"

I stared at Lucy. She'd been in *Michigan*? And this biker dude had given her a *ride*?

The bearded man broke into a wide grin and waggled a finger at her. "Lucy Tucker, right? Yeah! You was hoofin' it along that two-lane road, tryin' ta find the bus station. I see ya made it back to Chi-Town okay."

Lucy turned to Mr. Bentley and me, cackling like an old hen. "Heh, heh, heh. You guys don't hafta worry. These dudes are all right. They just a bunch of Jesus freaks on wheels."

The big guy grinned, revealing a gold tooth. "Show 'em, fellas!" He turned around, along with the rest of his motley crew—and there, emblazoned in big red stitching on the back of their black leather vests, were the words GOD SQUAD and beneath them, CHRISTIAN MOTORCYCLE CLUB.

"Hey! That's fantastic!" Josh said, stepping forward and

extending his hand. Within moments, the group of leather-clad bikers were shaking hands and greeting the women from Manna House, some of whom still looked frightened at all these tough-looking men.

"Well, now, isn't this a pretty how-d'ya-do," murmured a familiar voice in my ear. "Wonder which group is gonna turn the other cheek?"

I turned. "Estelle! What are you doing here? I thought you didn't do picnics on Sundays!"

"I said I don't *cook* on Sundays. Didn't say I don't *come* to picnics. Besides, you got Harry to sign up. What was I s'posed to do? Sit home an' twiddle my thumbs?"

"Ma'am?" Big Dude interrupted. "Sorry me an' the boys took your spot. We're travelin' from Michigan to a Christian Biker Rally and needed a place to eat our lunch. We'll be movin' on since you got a permit an' all that."

"Well, now, what's the big problem?" Precious butted in. "Lookit this shelter. 'Nuff picnic tables for a hunnerd folks or more, an' what we got? Forty . . . maybe fifty all together? We all God's children, ain't we? Well . . ." She glanced around at the Manna House residents. "Well, maybe not all of us, but enough to count. Jesus said if two or three folks get together in His name, He shows up too. So to my way of figurin', we all just one big family. I'm gettin' hungry, so I say let's eat!"

Big Guy looked at me. I shrugged. Not exactly what I'd planned, but . . .

chapter 22

Turned out the picnic was a blast. The bikers were downright gentlemanly, helping us set up the Baxters' grill, adding their sandwiches and bags of chips and coolers of colas to the feast. One of the bikers—a smaller guy who actually wore a safety helmet— even hopped on his bike and roared down the highway, and by the time the coals were ready he was back with more hot dogs and buns to throw on the grill.

I cornered Lucy. "What were you doing in Michigan? I mean, you just up and disappeared! What did that biker mean, you got tired of picking? Blueberries?"

"Humph. Grew up pickin'. Gotta make some money somehow to see me through the winter, don'tcha know. Now, how 'bout another slice of that melon. I gotta go sit with Dandy so Paul can play some ball."

Josh had produced a couple of bats, a softball, and mitts— he'd been thinking of the kids—and we ended up with two rowdy teams made up of both bikers and "maidens," as our residents

had been dubbed by the God Squad. Since the picnic and ballgame were no longer mostly female, the boys—even Paul—looked like they were having a great time.

"Look at God," Estelle murmured to Jodi and me as we cleaned up paper plates, leftover buns, and searched for missing caps to the plastic containers of catsup and mustard. "We make our plans, but God comes up with an even better idea."

I decided not to comment on Estelle *cleaning up* on a Sunday. "Yeah, and I was worried about security, you know, all these women out here in the middle of nowhere, with only a few guys to stick up for us if anything happened."

Jodi swooped up Gracie, who had discovered a bag of marshmallows. "Oh no, sweetie. Let Grammy get those out of your mouth—"

"Look, look, Gracie!" I screeched. "Your mama just knocked a home run! Way to go, Edesa!"

We clapped and hooted from the picnic shelter as Jodi's daughter-in-law rounded third base, which consisted of somebody's T-shirt. As the pretty Honduran girl slid into home plate—another T-shirt—Jodi sighed. "Please keep praying for Edesa and Josh. Things are really stressful for them with you-know-who in that tiny apartment. Can't even call it an apartment, it's so small!" She nuzzled Gracie's loose curls, then looked at Estelle, who'd resumed cleanup. "Speaking of our grown kids, Harry said you guys weren't at church this morning because you went to visit Leroy. How's he doing?"

Estelle shook her head. "Humph. They say he's doing good, but it ain't a pretty sight for a mother to see her boy suffer like that." The older woman heaved a sigh and sat down on one of the picnic table benches. "Gotta pray for me, sisters. I don't know

what I'm gonna do with him when he does get better, now that he done burned the house down. Jus' never wanted to put him in an institution. But . . ."

"Oh, Estelle," Jodi said. "Of course we'll pray. All the Yada Yada sisters are praying already. In fact, let's pray right now." Jodi looked at me. "How about you, Gabby? How can we pray for you? Yesterday you said Philip was late picking up the boys. Do you think he did that on purpose since you told him you wouldn't loan him any money?"

Another cheer went up from the makeshift ball field. Mabel's nephew had hit the ball and was heading for first base. The outfield fumbled it, and I heard P.J. yell, "Run to second, you wuss!" But others yelled, "Stay there! Stay there!" Jermaine looked confused, ran, and got tagged out.

I winced, trying to remember Jodi's question. "No-o, I don't think Philip would deliberately take it out on the boys like that. But it was kind of weird. When I got him on his cell phone, he said he got stuck with a business client, somebody named Fagan, I think, who—"

Estelle's head snapped up. "Stop. Gabby, did you say *Fagan?*"

"Well, yeah, I think that's what he said. Don't know if it was a first name or last name. But somebody told him to hurry up on the phone and Philip said something like, 'Just a minute, Fagan!'"

Estelle got to her feet faster than I'd ever seen her move. "Girl, if that's the Fagan I think it is, that man of yours is in real trouble now. I gotta tell Harry."

I didn't know what had gotten Estelle's tail in a knot, but whoever Philip's client was, he wasn't my problem. I had all I could handle

getting everyone to clean up the picnic grounds and get the vans loaded for our trip back home. The "God Squad" escorted our vans halfway back to the city, much to the delight of the shelter residents and kids, then peeled off when the highway signs pointed north to Wisconsin.

Once we got back to Manna House, Lucy marched off with Dandy and her wire cart, and I noticed Paul sulking on the front steps. I sat down beside him. "I know you feel sad, kiddo. But maybe it's just as well. You're starting school in two days and Dandy would be alone all day. At least with Lucy, he's got a companion twenty-four/seven." Paul got up and stomped off, hands jammed in the pockets of his cargo shorts. Didn't blame him. My words sounded hollow even to my own ears.

What Paul needed was his own dog.

As for P.J. . . . that boy was going to hear from me about calling Jermaine a "wuss" in front of everyone.

However, it turned out to be serendipity that we had our picnic on Sunday, because the Monday holiday woke up cloudy and wet. I made coffee and took it back to bed, curling up with my Bible. A good time to make good on my promise to God to "abide" in His Word, since I didn't have to go in to work that day. I actually read several more chapters in Matthew's gospel before my phone rang at eight o'clock.

Jodi was on the line. "Didn't you say you could use a work crew over there in those two empty apartments? We were going to barbecue today with Josh and Edesa, but with weather like this—ha. I don't think so! Can you use some help?" She laughed. "After all, it's *Labor* Day!"

No way was I going to turn down a volunteer work crew. I

called over to Manna House and talked to Precious, told her we weren't ready to paint yet but could use a cleaning crew.

"You talk to Tanya yet?" she asked.

"Uh, no. Kinda wanted this House of Hope idea to be a sure thing before I got her hopes up. Mabel's not there today, is she?"

"Nope. But Tanya's a big girl, Gabby. She could use a little hope right now. Want me to talk to her? I'm sure she an' Sammy would love to come help out."

We finally decided Precious would recruit Tanya, I'd pick them up in an hour, and once we got back here to the six-flat, then I'd tell her my dream for the House of Hope. We didn't even ask Sabrina, since we were starting on the third-floor apartment, and Precious said no way was she going to push that girl and her big tummy up all those stairs.

When I pulled up in front of the six-flat, Precious wisely disappeared inside with Sammy, but I held Tanya back to tell her about my dream of developing this building as second-stage housing for homeless single moms. "You and Precious are first on our list if it all comes through," I said. "But we're still working on it, so don't tell Sammy yet."

The next thing I knew, Tanya had thrown her arms around my neck and started to cry. "Oh, Miss Gabby," she sniffled, her braided head tucked tight next to my auburn mop. "That would be the answer to my prayers."

I held her for a few moments, and then untangled myself from her hug. "Don't stop praying yet, Tanya. We've still got a few hurdles. Come on, I've got to wake up my boys if Sammy hasn't done it already."

P.J. and Paul complained at first about having to work on

a holiday, but when the Baxter clan showed up at ten o'clock, it started to feel like a party. Jodi had brought a whole slew of cleaning supplies—buckets, a mop, rags, and several different kinds of cleaners—so with what I also rustled up, we assigned tasks and set to work. Edesa, Precious, and Tanya tackled the filthy kitchen on the third floor, Jodi volunteered to do the bathroom, and I put all three boys to work with garbage bags just collecting all the trash left in the various rooms and on the back porch. Denny Baxter had brought his toolbox, and he and Josh went room to room repairing windows that wouldn't stay open, the dripping kitchen faucet, sagging rods in the closets, and who knew what else.

Repairs I'd never thought of that would need to be done in every apartment as they became available.

"Oh, brother," I sighed, sinking down on the closed toilet seat in the bathroom where Jodi was scrubbing the gritty ring around the bathtub. "I think I'm in over my head. Painting the apartments is one thing. But seeing Denny and Josh doing all that fix-it stuff, I realize the owner of a building is responsible for all kinds of repairs! Electrical wiring gone bad . . . rusted pipes . . . broken fixtures . . . rotting porch railings . . . *aagh!* I can't do that stuff!"

"Well"—*scrub, scrub, scrub*—"just ask Denny or Josh to help you out when you need it. Or hire somebody."

"Oh yeah, right. What were we thinking, Jodi—six apartments full of women and kids? We need a man!"

Jodi blew a stray lock of hair out of her face and grinned up at me. "We? You're the one who . . ." Jodi's voice trailed off and she got a funny look on her face. "Wait a minute. You need a

man, and I know a certain man who needs an apartment." She rolled her eyes and tipped her head "out there" toward the rest of the apartment.

My mouth dropped open. "You mean . . . Josh and Edesa? But . . ." My mind did cartwheels. "But the whole idea is to turn the building into second-stage housing for homeless single moms."

Jodi popped up and sat on the edge of the tub. "Sure. But you're the owner and you live in the building, kind of like a housemother. And you just said yourself you need a property manager—someone to do all that stuff you can't do and would have to hire out. Why not Josh? He's pretty good at that stuff."

Good grief. Why hadn't I thought of this before? Having Josh and Edesa Baxter living in the building would be a godsend! Still, hurdles kept rising up in my mind like an animated obstacle course. "But, Jodi! There are only two available apartments right now, and I promised Precious and Tanya they were tops on the list. *Especially* Precious, because Sabrina's baby is due in a couple of months."

"Gabby Fairbanks." Jodi closed the bathroom door and lowered her voice. "Have you really thought this through? I mean, does Tanya need a three-bedroom apartment? It's just her and Sammy! Now Precious and Sabrina could probably use one after the baby comes—but even that is more than most families are able to afford. Maybe Precious and Tanya could share an apartment for the time being until another one opens up. It's still a whole lot better than a bunk room at the shelter."

I ran a hand through my hair, absently untangling a few snarls as I tried to "think this through," as Jodi said. "What about

the rent? Could Josh and Edesa afford it? It's ridiculous—thirteen hundred a month! But I'll need the rent from all the apartments—one way or the other—to cover my mortgage. Though I should probably reduce it in exchange for the work he'd do."

Jodi got back down on her knees by the tub and turned the water on to rinse the scrubbing she'd been doing. "Yeah, well, the rent's a good question. You'd have to talk to Josh and Edesa about that. In fact"—she grimaced at me guiltily—"I think I need to drop out of this conversation. I'm a little biased about wanting them to find a bigger place to live. Sorry. I probably misspoke."

"No, no, it's a good idea, Jodi. Makes a lot of sense all the way around. I really do need a property manager, and the fact that Josh and Edesa are also volunteers at the shelter makes them perfect candidates! But I don't quite know what to do next."

Jodi turned off the water. "Well, we could pray about it. Want to? Right now?"

So there we sat, on the toilet and the tub, praying about whether to ask Josh and Edesa to be property managers for the new House of Hope, when someone pounded at the door. "Mom? You in there?" P.J. hollered from the other side of the door. "It's past lunchtime! You want me to order some pizza?"

chapter 23

Tanked up on Gino's pizza and root beer, my volunteer cleaning crew had made Apartment 3A look fairly presentable when Lee Boyer showed up with the keys to the two empty apartments. It was the first time I'd seen him since he'd kissed me, and I felt a flutter of panic. At least my heart was tripping double time. He gave me a wink when no one was looking, but otherwise he was a model of decorum. "Hm. Nice," he said, glancing around 3A. But as he was leaving, he pulled me aside. "Gabby. I'm not sure you should put in all this work until you actually own the building. What if—"

"Have some faith, Lee!" I gave him my brightest smile and a wave, then turned to the tired crew and held up the keys to 1A. "Ta-da! Who wants to take a look?"

Nobody moved. I heard a few groans. "Huh! If that apartment downstairs be a big mess like this one? . . . uh-uh." Precious shook the tiny twists covering her head. "My joints already hurtin' after all this scrubbin'."

"Okay, okay. We don't have to clean it today. Just look." Though I knew I wouldn't have the nerve to ask this volunteer crew to come back a second time.

But I was pleasantly surprised. Apartment 1A had been completely cleared out, floors had been swept, and both the bathroom and kitchen were basically clean. "Ready to paint, I'd say," Jodi said happily, rubbing hand cream into her water-wrinkled fingers.

Her husband gave her a look. "Right. *After* preparing the walls, filling in the nail holes, taping the wood trim, and"—he jiggled the light switch in the living room, which did nothing—"repairing this light."

"Oh, stop it, Denny." Jodi backhanded his arm. "Don't discourage Gabby. It's probably just a burned-out bulb."

"Maybe." Denny wandered off to check out the other room lights.

Jodi winked at me and murmured, "Or maybe just confirmation that you need a maintenance person *on site*."

"Shh!" I hissed back at her. "Don't say anything to Josh and Edesa until I have a chance to talk to Mabel in private. It, um, might be a little sticky." I tipped my head toward Precious and Tanya, who were already arguing about who got the first-floor apartment.

I was just as glad we didn't have a big cleaning job in that apartment, because as soon as everyone left, I had to focus on the other "big job" at hand—getting the boys ready for their first day of school the next day. Book bags, jeans, new underwear and T-shirts laid out, and bag lunches made and in the fridge . . . though the next morning I wondered why I bothered. P.J. showed up for breakfast in an old T-shirt ("You want me to look like a

twinky new kid?" he growled), and after Mabel picked him up, I discovered his lunch still sitting in the fridge.

Well, let him go hungry. He wouldn't forget tomorrow.

Scattered clouds dotted the sky over Chicago, but the temperature was a pleasant seventy degrees as Paul and I walked toward Sunnyside Magnet School. Suddenly my heart felt so full, I felt like doing a little jig right there on the sidewalk . . . but I settled for giving Paul a sudden sideways hug.

"Mo-om!" My twelve-year-old pulled away, looking around in a panic. "What if somebody sees you?"

"Sorry, kiddo." I meekly resumed walking straight ahead, but couldn't help the big grin on my face. "I'm just so . . . so grateful that you're here, that I get a chance to walk you to school today, that I might just burst—and then you'll have a big mess to clean up right here on the sidewalk." I laughed and he rolled his eyes, but I was rewarded with a grin as he shook his head at his hopeless mother.

"Hey, Paul!" a youthful voice yelled. "Wait up!"

We turned to see Sammy and Tanya hurrying to catch up with us a block from the school. Sammy was so excited he ran at the mouth. "I didn't know you was goin' to Sunnyside too! What grade you in? Man, I hope I don't get ol' Bean Face for anything this year—she the strictest P.E. teacher ever. You probably on the third floor with the older kids. You gonna do band? I wanna do band, but they don't let you start till sixth grade . . ."

The two boys walked ahead of us, then Paul turned and waved us off. Tanya and I stopped and let them go into the school yard alone. "Oh, Miss Gabby," Tanya breathed. "If we get to move into your building like you say, maybe Paul can walk

Sammy to school every day. That would make me so happy . . . mm-mm. Jesus, Jesus! Thank You, Jesus!" Tanya gave me a spontaneous hug. "Things be lookin' up for us now, Miss Gabby. I just know it."

Yes, thank You, Jesus. Even as I waved good-bye to my young friend from the shelter and walked home to get my car—I'd need it later that day to pick up P.J. and Jermaine at Lane Tech as Mabel and I had agreed—I was convicted by Tanya's spontaneous thanksgiving to God. I felt so grateful to have a home for my sons, so glad they were with me and enrolled in school here in Chicago instead of a thousand miles away in Virginia, so excited about the future of the House of Hope . . . but was I giving thanks to God for how far He'd brought us in the past two months? For how far we'd come from those first few terrible weeks after Philip had abandoned me?

Philip . . . A messy stew of anger, confusion, and sadness threatened to boil up and consume my glad heart. He'd gotten so *weird* lately, almost as if he'd forgotten that he'd kicked me out of house and home, and was wrestling with some monkey on his back. And what in the world did Estelle mean by saying, "That man of yours is in real trouble now!" when I mentioned Philip's meeting with Fagan-somebody. She'd taken off like a shot to tell Harry, of all people. Why would they care who his clients were?

I put a lid on the stew. I didn't want to think about Philip. Today was a happy day and I wanted to sing some praises to God, like Jodi Baxter and Edesa and their Yada Yada sisters did. I stuck a CD in the player of the Subaru as I drove the few blocks between my six-flat and Manna House, and there it was. My song. The

song that had been a spiritual lifeboat to me in those first dark days at the shelter. I belted it out along with the CD . . .

Where do I go . . . when the storms of life are raging?
Who do I talk to . . . when nobody wants to listen?
Who do I lean on . . . when there's no foundation stable?
I go to the Rock I know that's able, I go to the Rock! . . .

I was still humming and doing a white-girl jive to the gospel song as I came into the shelter. Angela Kwon eyed me suspiciously as I signed in at the receptionist's cubby. "What are you all happy about, Mrs. Curly Top?"

"First day of school." I grinned.

"Oh yeah. No kids. Maybe it'll be quieter around here during the day now."

"Nope, that's not the reason. I'm just thankful that God"—*there, I said it!*—"gave my kids back to me and I got them into decent schools!" I swiveled my head. "Is Mabel in yet?"

At Angela's nod, I crossed the foyer and knocked at the office door, still humming. But when I heard the director's familiar, "Come!" the song in my heart suddenly twitched and died, replaced by an uneasy misgiving. Mabel and I hadn't actually talked since a week ago, when she'd suddenly turned tables on me and said I bore some responsibility for the demise of my marriage. We'd both backed off the touchy subject, but I'd basically avoided getting into another actual conversation.

Still, I opened the door and peeked in. "Got a minute? I have something I want to run by you regarding the House of Hope plans."

Mabel looked up. "Yes. I need to talk to you too."

Uh-oh. Feeling even more uneasy, I closed the door behind

me and sat down in the chair beside her desk. "Oh. Okay. What's up?"

"About our conversation last week . . ."

I squirmed. I really did *not* want to talk about Philip and me right now, especially if she was going to dump more guilt into my lap.

"I think I owe you an apology."

I blinked. "What do you mean?"

"I . . . well, for one thing, I let my concern about you not telling your husband about this job simmer way too long without saying anything. So when I did say something—after he'd kicked you out and disappeared with your boys—it sounded like I was blaming you for *that*, as if it was your fault. I'm sorry for that." She sighed.

I didn't trust myself to speak right then. She'd sounded so . . . so "righteous" the last time we talked. What brought about this revelation?

Almost as if she read my mind, a corner of Mabel's mouth tipped in a wry grimace. "I was listening to 1390 on the radio a few days ago—you know, the gospel music station—and a Christian counselor was saying we in the church too often blame the victim in our rush to find a 'quick fix' for hurting marriages. True, I was concerned about the communication breakdown between you two. But no one *deserves* the kind of emotional abuse you've experienced, Gabby. Especially the constant belittling that made you afraid to talk to your own husband about this job."

I swallowed past the lump in my throat. "Thank you." The words came out husky and I fished for a tissue. Why did I always end up crying in Mabel's office? I quickly pushed away the

niggling notion that there might be some truth in what she'd said last week. She'd apologized, hadn't she?

Mabel picked up a pencil and rolled it between the fingers of both hands. "Uh . . . but there is something else I need to talk about."

I dabbed at my eyes. *Now* what?

"About P.J. and Jermaine."

"Oh." I tensed up again. I was pretty sure what was coming. The picnic—

"I don't think it's going to work out for P.J. and Jermaine to ride together to school."

"Why? P.J. was ready on time this morning when you came by. And I plan to pick them up—"

"It's not that. P.J. didn't talk to Jermaine the whole way to school—which I can deal with. We can't force the boys to be friends. But two blocks away from the school, P.J. suddenly ordered me to stop. He wanted out, said he'd walk the rest of the way. I refused. It wasn't safe. There was no good place to pull over, not with rush-hour traffic at that time of the morning. Besides, you and I had agreed on a drop-off and pick-up spot, and I wasn't about to change that without discussion. So I pulled into the parking lot . . . but then P.J. wouldn't get out of the car until Jermaine got out and walked away. Then he got out and ran past him, but I could tell he said something snotty in passing. And after hearing what he called Jermaine at the picnic, I have a pretty good idea."

My heart sank like a lead weight into my belly. "Oh, Mabel. I'm so sorry. I'll talk to P.J. I don't know why he's—"

She held up her hand like a stop sign. "Fine. But I don't want

Jermaine getting hurt while P.J. is learning how to behave like a decent human being. That boy is already fragile. He's been called names all his life by other kids because he's more effeminate—might as well say it—than the average boy. But I'm not going to put him into a situation where he's going to be belittled before he even starts his school day." Mabel leaned forward and said softly, "You of all people ought to understand what I'm saying, Gabby."

chapter 24

Mabel was ready to scrap our plan to share rides then and there, but I begged her to let me pick up both boys today as we'd planned, and I would make sure P.J. acted decently toward Jermaine. "We don't want to let P.J. think his rude behavior got him what he wanted, do we? Not riding with Jermaine, I mean."

She pursed her lips for a moment or two, and then reluctantly agreed. Maybe because she'd backed off from last week's conversation, I suddenly got up and gave my boss a hug. "I'm with you one hundred percent on this, Mabel," I whispered in her ear, "even though it hurts that it's *my* son who's acting like a jerk." This time Mabel was the one who reached for the tissue box.

I headed for the door, but almost belched a hysterical laugh when I heard Mabel say, "Oh, one more thing, Gabby . . . didn't you say you had something you wanted to talk about when you first came in?"

I started to wave her off, thinking I'd had enough of talking with Mabel for one session. Then decided I should act like an

adult. I turned and sat down again. "Well, this might sound crazy, but . . ."

She listened while I ran through Jodi's and my new idea for the House of Hope. Two of our best volunteers—Josh and Edesa Baxter—desperately needed a larger apartment. The House of Hope could use a property manager on site, and we already knew Josh was pretty handy around the shelter. "I could reduce their rent or something in exchange for helping me keep up the property."

A slow grin lit up Mabel's face. "What a wonderful idea, Gabby! Why not? It's up to the property owner, not the city, to say how many apartments are available for second-stage housing. I put down five on the application to the Housing Trust Fund, but changing it to four is no problem. And"—her smile got bigger— "isn't that just like God to make a way out of no way for His children? How long have Josh and Edesa been looking for a bigger apartment? Could be they haven't found anything because God had something better in mind than just finding an apartment! And to tell you the truth, it makes your crazy House of Hope idea a lot more viable to have more staff on site."

I was so excited by her response I wanted to call Josh and Edesa on the spot with the proposal. And then I remembered. "There's, uh, just one hitch. Precious and Tanya. I've told both of them they're at the top of the list to get an apartment when we sign the final papers with the city. But there are only two apartments available."

Mabel leaned forward, all professional again. "Gabby. There's no way Tanya and Sammy need a *three*-bedroom apartment. Or even Precious and Sabrina! It's perfectly legit to offer them a

shared apartment. A lot of second-stage housing units are shared. There's one in the city for single women, and each apartment is shared by three women. It's still an apartment with all the amenities of home—living room, dining room, kitchen . . . and closets!" She smiled. "Believe me, sometimes I think that's what shelter women miss most. Having their own closet."

I wanted to believe her. "But if Precious and Tanya are expecting their own place . . ."

"Make it temporary if you want to. When another apartment comes available, you can shuffle things around if that seems right." She leaned forward again. "Gabby, the important thing is to make sure you're listening to God and asking the Holy Spirit to guide you in these decisions. Are you prayed up about this? Even the best idea can fall flat if God's not in it. The Bible says, 'Unless the Lord builds the house—'"

"'—its builders labor in vain,'" I finished. "I know, I know. Haven't really prayed about this—it just came up yesterday when the Baxters were helping me clean up one of the empty apartments."

"Well then. Now's as good a time as any." Mabel reached across her desk and took both my hands in hers. "Lord," she said, squeezing her eyes shut, "I've got Gabby Fairbanks by the hand and we're coming to You with another one of her crazy, wonderful ideas . . ."

I spent most of the morning working with Carolyn getting the schoolroom ready to start the afterschool program that afternoon. She'd been haunting garage sales all weekend and showed up with

two boxes of kid books to use as readers. I sorted through them, taping the ones with loose covers or torn pages. "Oh, wow, these take me back." I laughed, holding up a handful of thin paperbacks about the Berenstain Bears. "And all these Scholastic Junior Classics! *Robin Hood . . . Wind in the Willows . . . Alice in Wonderland . . .*" I set aside a couple that needed mending. "This is great, Carolyn."

"Yeah, couldn't believe I found them at a garage sale. Too bad we only have four kids in the afterschool program. I'd love to give a whole passel of kids the love of reading." She sighed and opened the next box. "Should've been a teacher instead of a librarian."

I stared at her. "Carolyn! You just gave me an idea. Maybe we should open up our afterschool program to neighborhood kids too! I bet there are a lot of kids around here whose parents don't have time to help them with homework."

Carolyn's pale eyes glittered. "You mean it?"

"Sure! But we'd need more volunteers." The idea bounced around in my head like a pinball—we'd need more computers, I'd have to write up a proposal for the board, find more volunteers, budget for more supplies—and got hung up on a reality check. "Okay, okay, maybe we're getting ahead of ourselves here. We're just getting this program started . . . We should probably wade in the water for a month or so, get our feet wet with the few kids we've already got before we expand the program."

"Yeah, guess you're right." Carolyn shrugged and started sorting another stack of books.

I reached over and grabbed her hand. "I still think it's a great idea, though. Why don't we pray about it—you and me?"

"Guess so." She shrugged again. "That your cell phone ringing?"

Sure enough. I dug it out of my bag and flipped it open long enough to see who was calling—Lee Boyer—and closed it again. "I mean pray right now." *After all, like Mabel said, unless the Lord builds the house . . .*

Carolyn let me do most of the praying, though she offered a hearty, "Amen!" Then I excused myself and took my cell phone outside where I could get a stronger signal, though I had to walk down the sidewalk to get away from the residents having a smoke on the front steps. "Lee? It's me, Gabby. You called?"

"Yeah. Just wanted to remind you that we've got a date in court this Friday for a judge to rule on your petitions. Philip and his lawyer got notices too."

My petitions. One for unlawful eviction and the other for custody of my sons.

"Lee . . ." I said slowly. "What happens if I win the one about unlawful eviction? I don't want to go back to the penthouse."

"Don't worry about it. We'll request compensation, damages—some kind of financial settlement to help with your current housing."

"But—" Given Philip's current gambling debts, I doubted I'd ever see a penny in damages.

"The important thing, Gabby, is to not let him get away with what he did. It's unconscionable! Personally, I can't wait to hear the judge ream him out."

Somehow my own fantasies about "payback" had lost their glitter—especially since Estelle and Harry had prayed with me about doing what was right for me, the boys, *and* for Philip. "Lee, all I really want is legal custody of my sons."

"I know. It's going to be all right. I'll see you Friday at the

Richard J. Daley Center in the Loop. Got something to take down the address and courtroom number?"

I didn't but ran back inside and grabbed some notepaper from the reception cubby. I was scribbling the address for the Daley Plaza when the front door buzzer went off and Angela buzzed the person in.

Josh Baxter, all lanky and sweaty, a book bag slung over his shoulder, backed through the door saying to someone outside, "Sorry . . . sorry, don't have a light. Nope, don't smoke." He swung around. "Oh, hi, Mrs. Fairbanks. Thought I'd stop in and make sure all the computer programs for the afterschool program are loaded and working before I head to class. Today's the first day, right?"

I grinned. Just the man I wanted to see. "Carolyn will be delighted. But, um, before you do that, could I talk to you a minute in my office?"

His perpetual grin faded. "Uh-oh. What'd I do?"

I laughed. He was still such a kid. "Nothing! Just an idea I want to throw your way."

As we came out of my office ten minutes later, Estelle Williams leaned over the kitchen counter and watched Josh take the stairs back up to the main floor two at a time. "Now, what's that boy so happy about?"

I peered around the kitchen looking for other ears. "Where's your help?"

"You tell me. Mabel didn't post a new chore chart, so of

course nobody showed up." She gave me a wicked grin. "Except you. Grab a hairnet and a peeler, Firecracker." She shoved a two-pound bag of carrots at me.

"I . . . oh, all right." Josh Baxter was now helping Carolyn in the schoolroom. I guessed I could spare half an hour to help Estelle get lunch out. I picked up the vegetable peeler and double-checked for stray ears. "Can you keep a secret?"

"Ha," she snorted. "Question is, can *you* keep a secret? You're just dying to tell me." Estelle snapped a hairnet over my curls and snickered. "Now you look like a white turnip instead of a head of escarole."

Ignoring her teasing, I eagerly rehearsed the possibility of Josh and Edesa renting one of the apartments in my six-flat in exchange for becoming part-time property managers for the House of Hope. "He's going to talk to Edesa, and we'll have to figure out a fair exchange of hours-for-rent, but . . . oh, Estelle. Wouldn't that be wonderful? Not to mention"—another perk fell into my spirit like a shooting star—"having Josh around as a 'big brother' would be wonderful for my boys. You know, since their dad isn't around that much."

"Mm. Yes." But Estelle gave me a funny look.

"What?"

She frowned. "What you said about the boys' dad. If that man ain't careful, he won't be around at all."

"Estelle! What are you talking about? What does Philip have to do with this?—Wait a minute. Does this have anything to do with you going bonkers when I mentioned that client Philip was talking to? That Fagan person? Why? Do you know him? Does Harry?"

Footsteps clattered down the stairs. Tawny, the "new kid" who'd landed at Manna House after DCFS washed its hands of her, and a thirtysomething black woman with a hard face I'd noticed smoking outside with some of the others this morning, sidled up to the counter. "Mabel said we're on lunch today," Tawny said. "This is—what's your name, lady? . . . Oh yeah, Bertie. Whatchu want us to do, Estelle?"

"Humph. Wash your hands at that sink back there and get you both a clean apron and hairnet. I'll be back in five." Estelle took me by the elbow and propelled me toward my office, shutting the door behind us. "Sit," she ordered, plopping into my desk chair.

I sat in the extra folding chair. "What's this about?"

Estelle shook her head. "Don't know yet. But Harry's trying to find out. Because if this Fagan person is who we think he is, Philip has got himself in a heap o' trouble."

"But who is he?"

"Rogue cop, got himself indicted by Internal Affairs of the police department." Estelle shook her head and clucked her tongue. "From what Harry's told me, you don't want to mess with Matty Fagan."

chapter 25

What Estelle said didn't make sense to me. Why would Philip do business with some cop who was being indicted by the Chicago Police Department?

Had to be some other guy named Fagan.

But I felt uneasy the rest of the day. In spite of everything, Philip was my sons' dad and I didn't want them to suffer any more drama than they had already. I pulled out one of my "desperate Gabby" prayers and kept it going all afternoon: "Please, God, don't let Philip get mixed up in any mess with this Fagan character—for P.J. and Paul's sake at least."

At three o'clock, I walked to Sunnyside with Tanya and the other shelter moms to pick up our kids since it was the first day, but realized the kids could soon walk back to Manna House as a group in a few days—including Paul. Seemed like a win-win situation to me. Paul could hang out where I worked after school, could even get help with his homework from Carolyn in the afterschool program if he wanted to—and there was always Ping-Pong,

board games, and the DVD player when he got done. I made a mental note to mention this when I went for my custody hearing on Friday.

I poked my head into the rec room when it was time to pick up P.J. and Jermaine at five, but Paul and ten-year-old Keisha were doing battle with the foosball paddles and he waved me off. "Pick me up on your way home! . . . Ha! You just knocked the ball into my goal, Keisha!"

Fine with me. I'd rather not have Paul along if I had to deal with any mess involving P.J. and Jermaine. I pulled into the parking lot at 4:55 and waited at the designated spot for the boys. P.J. had cross-country practice after school, and Mabel said Jermaine would either be using the library to study or signing up for one of the afterschool clubs.

Jermaine was the first one to show up, wearing skinny jeans and a Lane Tech T-shirt, his head neatly braided in tiny cornrows with short braids-and-beads hanging down the back of his neck. I waved at him and leaned over to open the front passenger door. "Hi! Get in!"

Jermaine hesitated and leaned down, peering at me through the open door. "That's okay, Mrs. Fairbanks. P.J.'s gonna want to sit in front."

"It's fine, Jermaine. You got here first." I gave the boy a warm smile.

Somewhat reluctantly, Mabel's nephew lowered himself into the front seat. He had such big eyes, as pretty as a girl's. I started to ask if he'd signed up for any clubs when I spotted P.J. coming across the wide front lawn toward the parking lot, walking with a handful of other lanky boys, all wearing baggy shorts with gym

bags slung over their shoulders. *Good.* He was beginning to make some friends. I resisted tapping on the horn, sure that he'd seen the red Subaru. *Don't embarrass him, Gabby,* I told myself.

P.J. stopped a good twenty feet away from the car and stood talking to the other kids. Once his eyes darted our way, but he quickly looked away.

That rascal. He's pretending he doesn't see us. What's he waiting for?

I got out of the car and stood with the door open. I was just about to shout, "P.J.! Over here!" when he glanced over his shoulder once more, caught my eye . . . then deliberately turned his back to us, moving slowly in the opposite direction, almost as if he was herding the knot of kids away.

A shot of anger surged through my body like a lit fuse. I opened my mouth to screech, "P.J. Fairbanks, get over here right now!"—but I shut it again, got back in the car, and turned on the ignition. Enough of this nonsense! Whatever Philip Fairbanks, Jr., thought was going to happen—maybe wait until his buddies got picked up and he could hop in the car unnoticed by anybody that mattered—he had another thing coming.

Wheeling out of the parking lot, I turned onto Addison and headed east toward the lake. Jermaine stared at me, wide-eyed and open-mouthed. "You just gonna leave P.J. back there?"

"Mm-hm," I murmured through gritted teeth. And no, I was *not* going to go back and get him on a second run.

"But . . . it's okay, Mrs. Fairbanks. I don't mind waitin'."

"*I* mind. He's being rude." I took a slug from the water bottle in the cup holder to douse the fuse still sparking in my spirit. "So." I glanced at Jermaine as I slowed for a red light and put on a smile. "Did you find any clubs you're interested in?"

I listened with half a mind as Jermaine told me about signing up for the drama club, though he'd really like to join the jazz ensemble and play keyboard, but designing sets for the school plays sounded like fun. The other half of my mind spun like a top. How *was* P.J. going to get home? Take the bus? He had money. I'd given both boys five bucks "just in case." Or walk. Couldn't be more than a mile and a half, maybe two to our apartment. Would he be safe? It was still light for several more hours, and Addison was a main street . . .

I dropped Jermaine off at the shelter—Mabel's car was still parked across the street—and asked him to send Paul out. I left the car running, my resolve starting to waver. *Maybe I should go back. Maybe leaving him standing there was enough to teach him not to mess with me . . .* when my cell phone rang. I didn't recognize the caller ID.

"Mom!" P.J. shouted in my ear. "You just drove off and left me! How am I s'posed to get home?" He must have borrowed another kid's cell.

My resolve resumed its backbone. "You figure it out, kiddo." I flipped the phone closed just as Paul ran down the Manna House steps and hopped into the backseat.

"Where's P.J.?" Paul leaned forward to peer into the front seat. "Thought you went to pick him up."

I second-guessed myself the whole time I put together the hamburger roll-ups—a kid-friendly recipe Jodi had given me—for supper. Was I doing the right thing? What if P.J. didn't get home soon? I wouldn't even know where to start looking for him!

I had just sent Paul outside with the garbage and taken the hamburger-filled pastries out of the oven when I heard banging out in the front hallway and a muffled voice yelling, "Let me in!" What in the world—was there something wrong with the buzzer?

I ran down the hall and opened the door a crack. P.J.! "Thank You, Jesus!" I breathed and flung the door wider.

That's when I saw two figures out in the foyer. P.J. *and* Philip.

Oh no, P.J.! You didn't . . .

I crossed the hall and pulled open the glass-paneled door. "Hey! What's with the banging? Did you try the buzzer?"

"Been punchin' it for five minutes. Why didn't you answer it?"

"But it didn't—" Before I had a chance to finish, P.J. brushed past me and stomped into the apartment, followed by the slamming of his bedroom door.

Philip—suit coat off, tie loosened—frowned at me. "What's the meaning of this, Gabrielle? P.J. called me at the office, said you left him standing in the parking lot and he didn't have a ride home from school. Called *me* wanting me to pick him up!"

I stepped into the foyer, letting the door close behind me. I folded my arms and lifted my chin. "Guess he forgot to tell you I was there waiting for him, and he refused to get in the car."

"He said he was just talking to his friends and you drove off!"

"No, he was talking to his friends so he wouldn't have to get in the car. Because he didn't want to be seen with another kid I was taking home."

Philip snorted. "Who? That wuss you invited to the boys' birthday party?"

It was all I could do not to haul off and slap him. "*Wuss?*

Where do you get off insulting Jermaine that way! He's Mabel's nephew, and we agreed to share rides taking the boys to and from school. P.J. was very rude to Mabel and Jermaine when she drove them this morning. I wasn't going to let him get away with it again!" ·

"Good grief. Give the kid a break, Gabby. It was the first day of school. He's the new kid, trying to make a good impression."

"All the freshmen are new. Besides, that doesn't excuse being rude."

It was like Philip hadn't heard me. "He said he didn't have any lunch either."

I snorted. "He forgot it."

"And why did he have to pound on the door? Can't get into his own house?"

"He *has* a key. Must've forgotten that too." I rolled my eyes. "Just . . . leave, Philip."

Philip ran his hand through his hair in that boyish way I used to find endearing. But I was angry—angry that P.J. had called his dad and dragged him into this. So much for the "tough love" lesson I was trying to teach the kid.

"Fine." Philip pointed a finger at me. "But a judge may have second thoughts about giving you *custody* when he hears you left your own kid high and dry on the first day of school."

A long finger of ice down my spine froze me to the spot as Philip pulled open the outer door and hustled down the steps to his car. He was threatening me?

Shaken, I turned the door handle and pushed on the inside foyer door. It had clicked shut. I fished in the pocket of my jeans for the key . . . no key. *Dang!* I kicked the door—and winced,

I had just sent Paul outside with the garbage and taken the hamburger-filled pastries out of the oven when I heard banging out in the front hallway and a muffled voice yelling, "Let me in!" What in the world—was there something wrong with the buzzer?

I ran down the hall and opened the door a crack. P.J.! "Thank You, Jesus!" I breathed and flung the door wider.

That's when I saw two figures out in the foyer. P.J. *and* Philip.

Oh no, P.J.! You didn't . . .

I crossed the hall and pulled open the glass-paneled door. "Hey! What's with the banging? Did you try the buzzer?"

"Been punchin' it for five minutes. Why didn't you answer it?"

"But it didn't—" Before I had a chance to finish, P.J. brushed past me and stomped into the apartment, followed by the slamming of his bedroom door.

Philip—suit coat off, tie loosened—frowned at me. "What's the meaning of this, Gabrielle? P.J. called me at the office, said you left him standing in the parking lot and he didn't have a ride home from school. Called *me* wanting me to pick him up!"

I stepped into the foyer, letting the door close behind me. I folded my arms and lifted my chin. "Guess he forgot to tell you I was there waiting for him, and he refused to get in the car."

"He said he was just talking to his friends and you drove off!"

"No, he was talking to his friends so he wouldn't have to get in the car. Because he didn't want to be seen with another kid I was taking home."

Philip snorted. "Who? That wuss you invited to the boys' birthday party?"

It was all I could do not to haul off and slap him. "*Wuss?*

215

Where do you get off insulting Jermaine that way! He's Mabel's nephew, and we agreed to share rides taking the boys to and from school. P.J. was very rude to Mabel and Jermaine when she drove them this morning. I wasn't going to let him get away with it again!"

"Good grief. Give the kid a break, Gabby. It was the first day of school. He's the new kid, trying to make a good impression."

"All the freshmen are new. Besides, that doesn't excuse being rude."

It was like Philip hadn't heard me. "He said he didn't have any lunch either."

I snorted. "He forgot it."

"And why did he have to pound on the door? Can't get into his own house?"

"He *has* a key. Must've forgotten that too." I rolled my eyes. "Just . . . leave, Philip."

Philip ran his hand through his hair in that boyish way I used to find endearing. But I was angry—angry that P.J. had called his dad and dragged him into this. So much for the "tough love" lesson I was trying to teach the kid.

"Fine." Philip pointed a finger at me. "But a judge may have second thoughts about giving you *custody* when he hears you left your own kid high and dry on the first day of school."

A long finger of ice down my spine froze me to the spot as Philip pulled open the outer door and hustled down the steps to his car. He was threatening me?

Shaken, I turned the door handle and pushed on the inside foyer door. It had clicked shut. I fished in the pocket of my jeans for the key . . . no key. *Dang!* I kicked the door—and winced,

realizing I only had sandals on. I eyed the buzzer—was it working or not? I pressed the button under the mailbox that said "Fairbanks" and heard . . . nothing.

Paul finally heard me banging on the foyer door and let me in. "Why didn't you ring the buzzer?" he griped, following me back to the kitchen. "I'm hungry. Is supper ready?"

I didn't trust myself to speak, just flopped hamburger roll-ups on three plates and sent him to get P.J. for supper. I decided to say nothing to P.J. about his behavior until we'd both cooled off a little and got some food under our belts.

But my "talk" with P.J. later that evening didn't go too well. I made it clear that his rude behavior about riding with Jermaine was unacceptable, though I got a halfhearted shrug when I asked if he understood. Finally I told him that if he conducted himself decently with our current plan for the rest of the week, *then* we'd talk about him taking the city bus.

It wasn't just P.J.'s sullen demeanor during our talk; the kid was fourteen, after all. Not even the fact that he'd referred to Jermaine as a "wuss" at the picnic—though I told him he'd be grounded for a week if I ever heard him use insulting labels like that to refer to *anybody*, and I didn't *care* if his father had said it first.

What really rattled me were his parting words as I left his bedroom. "Why can't I live with Dad? *He* wouldn't make me ride with some loser like Jermaine. Don't know why you brought us to Chicago anyway. If you and Dad aren't gonna get it together, Paul and I oughta at least get some say about where we're going to live!"

chapter 26

I woke early the next morning . . . with P.J.'s last words ringing loudly in my ears. I burrowed my face into the pillow, fighting back tears. *Oh, God, I really don't know what to do. I'm trying to trust You with my kids, but I'm so scared I'll lose them again . . .*

I was still feeling rattled when I got to work. It was Wednesday—Nurse Day—and I had to thread my way through a dozen or more residents in the dining room waiting to see Delores Enriquez, the county hospital nurse who donated her time one morning a week to take care of basic medical problems. Locking myself into my broom-closet office, I tried to shut out the noisy chatter outside and get to work. But my talk with P.J. ate away at me, like a big slug of Drano corroding my insides.

I stared at the cursor blinking from the computer screen as P.J.'s words mocked me. *Why can't I live with Dad? If you and Dad aren't gonna get it together . . .*

"Oh, God," I moaned, leaning my elbows on the desk and pressing my fingers against my skull. "I can't do this. I don't want

to lose my kids!" Had P.J. told his dad he wanted to live with him? Philip hadn't said anything last night . . . except that threat about telling the judge I'd "abandoned" my kid in the parking lot on his first day of high school.

Stupid, stupid, stupid . . .

Lee Boyer had assured me my custody petition was a slam dunk. But what if it wasn't? What if Philip challenged it? What if the judge gave the boys a choice where they wanted to live? What if . . . what if P.J. said he wanted to go back to Virginia and live with Nana and Grandad, so he could continue going to George Washington Prep with all his old friends? Would the judge let him?

Nausea swept over me and I pulled the wastebasket within upchuck distance. The feeling passed, but now all my nerves felt as if they were going to jump out of my skin. I paced back and forth in the tiny office—five steps this way, five steps back—running a hand through my snarly curls. *I should've just ignored P.J.'s snit and made the best of it, waited it out. Standing up for Jermaine isn't worth starting a landslide that might take my kids away from me.*

I immediately winced at my selfish thought and sank back into my desk chair. "Oh, God," I moaned again. "I need some help here. I feel like I'm going crazy!"

Come to Me . . .

I made myself sit still. Those were the words that kept coming to me when I'd started reading the gospel of Matthew, even before Philip kicked me out. That's what Jesus said. *"Come to Me . . . and I will give you rest."*

I sat quietly for a few minutes. What did it mean to "come to God and find rest" when I was on the verge of being a nervous

wreck? I needed someone to pray with me. That's what a prayer partner was for, wasn't it? I picked up the phone and dialed Jodi Baxter's number—and got her voice mail. Of course. School had started and she was teaching a room full of squirrelly third graders at Bethune Elementary.

Well, I could pray with Estelle. I opened my office door and peeked outside. Estelle usually came in early on Wednesday to help Delores with sign-ups and teach her knitting group. But . . . no Estelle. Only Precious and Diane-of-the-Big-Afro behind the kitchen counter, banging a few pots and pans. I slipped up to the counter. "Where's Estelle?"

Precious pulled a plastic container from the refrigerator and plopped it on the counter. "What do I know? Mabel just said Estelle had an emergency doctor's appointment—eye doc or something—and could I throw some food together for the lunch crew. Huh. How come I always end up coverin' lunch when Estelle don't show up? Don't nobody blame me if it's Leftover Surprise today."

Emergency doctor's appointment? Eye doctor? For herself or Harry?

Well, okay. Guess I needed to "get my own prayers on," as Precious would say—when she was in a better mood anyway. But I had to get out of my office. Felt as if the walls were closing in on me. And I had an idea how to stop my mind from spinning like a Tilt-A-Whirl and get focused.

Five minutes later I was sitting in my red Subaru, parked— hallelujah—under a leafy locust tree along the side street around the corner from Manna House, windows open to a slight breeze, listening to the gospel CD Josh Baxter had given me:

. . . The earth all around me is sinking sand
On Christ the Solid Rock I stand
When I need a shelter, when I need a friend
I go to the Rock . . .

Listening to the CD and spending some time praying helped calm my spirit enough that I was able to get through the day. I even worked up the courage to step into Mabel's office at one point and ask, "How'd it go this morning?"

The director gave me a little smile. "Okay. Good, actually. P.J. got in the car and said, 'Hi, Miss Turner. Hi, Jermaine.' Didn't say anything the rest of the way, but we'll take what we can get, right? Oh—he also said, 'Thanks' when he got out."

My spirit hiked up a notch. That was more than I expected out of P.J., given our bum talk the night before. And he did get into the car when I drove into the school parking lot at five that afternoon, sliding into the front seat and turning on the radio full blast. We waited five minutes for Jermaine, who climbed wordlessly into the back. The radio filled the car, negating the need for any conversation and I let it alone.

But I did call Jodi that evening and asked her to pray with me about the whole Jermaine-P.J.-ride-to-school-live-with-me-or-Philip-custody-hearing-coming-up stew mushing around in my spirit. "Sheesh," she said. "I'm the same way, Gabby. I let the what-ifs get me all in a panic, when nothing has happened yet. Remember that verse we talked about? 'Trust in the Lord with all your heart—'"

"Yeah, I've got it taped on the kitchen cupboard. It's that part about 'lean not on your own understanding' I need to work on."

She sighed. "Me too." But she prayed over the phone, thanking God "that Gabby can trust You to make her paths straight like the verses in Proverbs promise."

"Thanks, Jodi," I said when she'd finished. "By the way, Estelle didn't come to work today. Do you know anything about an emergency eye doctor's appointment?" I figured Jodi might know since Estelle and her housemate, Stu, lived on the second floor of the Baxter's two-flat.

"Really? No, but come to think of it, I haven't seen her this evening. I'll run upstairs and ask Stu what's up and call you back."

Jodi called back in ten minutes. "Stu doesn't know much either—but it's not Estelle. It's Harry. Stu says he called Estelle this morning before she was even out of bed, like six or something, and the next thing she knew, Estelle was throwing her clothes on and muttering, 'I told that man to get himself to the eye specialist, but did he go? No, the stubborn old goat'—or something like that."

I couldn't help but laugh. I could just see Estelle stomping around, telling Harry a thing or two even if he wasn't there. But my laugh quickly died. "Sounds like it might be serious. She still isn't back? I wonder if we should call her, find out what's wrong."

"Good idea. But let's pray for her and Harry first, okay?"

I called Estelle's cell phone two times that night and left a message both times, but didn't get a call back. Both boys already had homework—and I hadn't been able to convince Paul to use

the afterschool time to get his done and earn a free evening—so I spent most of the evening making sure they were doing their work and not getting distracted by their iPods or the TV. Couldn't believe it, though, when the house phone rang and it was for P.J.—from a girl. Good grief, school had just started two days ago and girls were calling him already?

"Can you believe it?" I told Angela when I signed in at the reception desk the next morning. "P.J. got a call from a *girl* last night. He's only been at school two days. And since when do the girls call the boys?"

Angela laughed and handed me a couple of messages. "Oh, Gabby. You're showing your age. Girls call guys all the time these days, even make the first move. Equal opportunity, you know! And besides, that P.J. is pretty cute. Give him a few years and he'll be breaking hearts right and left." She winked and answered the incessant phone. "Manna House. Can I help you?"

I pushed that image—a trail of broken hearts in P.J.'s wake—out of my head before it sent me into a deep depression and glanced at the messages as I headed downstairs to my office. A phone call from Peter Douglass, asking if the shelter could use a couple more computers. And a handwritten note from Sarge, saying a newbie had come in last night and asked for me by name. I squinted at the name: Naomi Jackson.

Naomi . . . Naomi Jackson. I vaguely remembered a girl by that name. By the time I got to my office, I remembered. White girl, tangled brown hair with blonde streaks under a brown felt cap. Pierced nose—maybe her lip too, couldn't remember—and high as a kite on something! I'd only been working at the shelter a few days and did her intake, shaking in my shoes because I had no

idea what I was doing. Mabel had been out, but took over when she came back, and I'd been impressed how straightforward she'd treated Naomi—no-nonsense, firm, kind.

But the kid had only stayed one day. The craving for a fix had been too strong.

That was almost three months ago. The staff had wondered if she'd come back. I was glad she had—but why in the world was she asking for me?

I went looking for her and found her curled up in an over-stuffed chair in Shepherd's Fold, sound asleep. I gently shook her arm. "Naomi?"

The girl opened her eyes, seemingly confused about where she was. She still had the same stud in her nose—none in her lip, though—and streaked brown-and-blonde hair pushed up haphazardly under the same brown felt cap. But this time a black eye and facial bruise ran halfway down her cheek.

But she wasn't high. Recognition lighted her eyes and she half-smiled—only half because the swollen cheek hindered a full one. "Hey, Mrs. Fairbanks. You 'member me?"

I sat down in the chair next to her. "I do. I'm glad to see you came back, Naomi."

"Yeah." She wagged her head. "Shoulda come back sooner, but . . ."

"What happened to your face? Who beat you, Naomi?"

"Aw, it ain't nothin'. My pimp, he got a little excited when I told him I was leavin'—but I mean it this time, Mrs. Fairbanks. I gotta get off the streets." She grabbed a throw pillow and hugged it to her chest, rocking it like a rag doll. "Them streets gonna kill me if I don' get off that smack."

I watched her for a few moments, feeling helpless. How did one help a girl as far gone as Naomi? But I wanted to—wanted to gather her in my arms and hold her, rock her, kiss her hair, tell her it was going to be all right. But what did I know? I was the program director. Not a case manager or social worker. Not her mother either.

"I got a note from Sarge saying you wanted to see me. I'm surprised you remembered my name."

The girl blushed. "Aw, that's 'cause you was the first person I met when I came here the last time. I remembered that. You talked to me like I was a real person."

I had? All I could remember was being scared to death because she was high on drugs and might do something. "I'm glad . . ." I said, distracted momentarily by the double doors swinging open and Estelle coming in. I stood up, hoping to catch her. "Be strong, Naomi. It might be tough for a while to stick it out—but you'll be glad you did. I've seen some mighty big miracles happen here. Including me."

The girl squinted up at me. "You? Naw. You look like a good person—not like me."

"You don't have to be good to have God do a miracle in your life," I murmured—and suddenly bent and kissed her on the forehead. Probably not kosher. But I didn't care. How long had it been since she'd had a kiss from someone who wasn't trying to get something from her?

chapter 27

Estelle had stopped to pour herself a cup of coffee from the coffee cart and thumped the carafe down when a mere few drops leaked into her cup. "Humph, can't even get a decent cup of coffee," she snapped, gathering up her bags again as I arrived.

"I'll make you some fresh," I said, quickly snatching up the empty carafes and following in her wake down the stairs to the kitchen. Within minutes I had a pot dripping and the rich, nutty aroma wafted through the kitchen like a lazy genie. I poured two steaming cups and doctored them with milk (for me) and sugar (for Estelle).

"Gimme that," she said and added another heaping tablespoon of sugar. "Why you always so stingy with the sweet stuff?"

I steered her to a nearby table and waited until she'd taken a few long sips. "So tell me what's going on with Harry. What's this emergency with his eyes? I'm worried."

Estelle sighed. "You should be. Don't know if I understand it myself—but he started seeing flashes of light in his eye during the

night, scared him silly. I got myself over to his apartment and tried to calm him down until we could call the Medical Center at U of I and get him in to see an eye specialist." She wagged her head, both hands gripping her coffee cup. "He went last week and they did some laser treatment to pin down a retinal tear. Harry said it hurt like heck, but now they saying he's got a retinal detachment. They patched up both eyes and told him to stay still till they can get him in for surgery later tomorrow."

"What? They patched up *both* eyes? How's he supposed to see? And what about DaShawn?"

Estelle snorted. "That's just it. He can't see nothin', not supposed to do nothin' either. We took DaShawn to school before heading to the Medical Center and Jodi brought him home with her till we got back. You know he's goin' to Bethune Elementary where Jodi teaches, right? Anyway, after I got Harry back home and settled, I picked up DaShawn and kept him with me for the night. Jodi took the boy to school this morning. I told Harry he can stay with me till he gets this eye thing taken care of. Between Stu an' me an' the Baxters, I think we can work things out for DaShawn."

"But what about Mr. B?" This was worse than I'd imagined. "How's *he* supposed to manage?"

Estelle's eyes suddenly filled up and she fished for a tissue somewhere in the folds of her roomy tunic. "I don't know, Gabby. He needs somebody with him, that's what. Otherwise he gonna be liftin' off those bandages an' peekin', just to get around. But the doc said he has to totally rest his eyes so those retinal tears don't get worse." She blew her nose and stood up. "That's why I'm gonna put lunch together an' get myself outta here. Who's

on lunch duty today? I could use some extra help . . . What day's today anyway?"

"Thursday." I headed for the chore chart Mabel posted on the dining room bulletin board each morning. "Uh, it's Kim and Wanda."

"Mm, Kim and Wanda. Okay . . . wait. Thursday?" Estelle slapped her forehead. "I'm s'posed to teach cooking class this afternoon too! Well, I can't do it. *Somebody's* got to go sit with Harry. Denny Baxter's comin' this evening to hang out with Harry so I can go see Leroy. I been readin' to my boy from the Bible—seems to calm him some."

No wonder Estelle was edgy, with the two men in her life *both* laid up. I assured her I'd take care of cancelling her class and hurried off to find Kim and Wanda and ask if they could come early to help Estelle with lunch. As I came into Shepherd's Fold, I spotted Wanda standing with Precious and several other residents in the center of the room, clapping and laughing. A gospel CD had been turned up loud on the CD player and the object of their amusement was soon apparent—little Gracie Baxter was gyrating and bouncing to the music like a toddler version of *American Idol*, egged on by the attention of her circle of "aunties."

Her mom must be around somewhere . . . which suddenly gave me an idea. I touched Wanda's shoulder. "Is Edesa here?"

"Mi t'ink she talkin' to Mabel . . . Now look at dat lil gal. She de cutest ting."

Gracie was cute, but I had other things on my mind. "Estelle is in a bind and needs some extra help. Can you find Kim and go a little early to help with lunch?"

The big Jamaican woman shrugged. "No problem." She

sidled off, but first she gave Gracie a tickle under her chin, which set off a ripple of giggles.

I was just about to go off in search of Edesa, when Gracie's adoptive mother came through the swinging double doors, sized up the situation, and swept the one-year-old into her arms. "*Niña, niña*, are you showing off again?" She clucked reprovingly at the grinning women. "*Por favor*, don't encourage her. She gets too much attention as it is."

"Pooh," said Precious. "If we can't spoil Gracie, who will? Besides, if a girl gotta dance, she gotta dance!" Precious shimmied her shoulders and hips from side to side with a "Mmm-mm-mm" as the knot of women drifted.

I grinned at her antics but beckoned to Edesa. "Can I talk to you a minute? I need a favor." I'd been meaning to ask her about teaching a class on nutrition for our residents from her Public Health studies. If she had time, maybe she could cover Estelle's cooking class today!

"*Sí.*" Edesa jiggled Gracie on her hip. "But, oh, Gabby! *Muchas gracias* for offering one of your apartments to our little *familia*! I could hardly believe it when Josh told me! What a blessing that will be. When do you think we can move?"

Even as the words spilled from Edesa's mouth, I saw Precious freeze in midshimmy and stare at us. Stare at me, rather—a startled look that took only a nanosecond to turn from question to accusation.

As the moment froze, I felt caught in a time warp, kicking myself that I hadn't talked to Precious and Tanya yet about the new plan. I gave Precious a pleading look, but she turned and marched out of the room.

Edesa hesitated. "Did I say something wrong, *mi amiga?*"

I shook my head. "No, no . . . It's my fault. I'll explain . . . but give me a minute, will you?" I ran after Precious, but no one was in the hall and the stairs were empty. Where had she gone? I ran up the stairs and peeked in each of the bunkrooms, but still no Precious. Then I heard a flush, and a moment later Precious came out of the bathrooms into the small lounge. She stopped when she saw me.

"Precious—" I said.

She folded her thin arms across her chest. "So. When was you gonna tell us you promised one of them apartments to somebody else?"

"I'm sorry, Precious. I meant to talk with you and Tanya this week. It's just that I realized how much work it's going to take to maintain the building, and Josh is pretty handy, and they've been looking for a bigger place, so I thought—"

"Yeah, yeah, I feel ya. Your heart all bleedin' for that poor little family, all crunched up in that tiny little apartment which, by the way, *they live in by they own selves.* But"—Precious shook a finger in my face—"you promised me an' Sabrina were top of your list for this so-called House of Hope. Tanya an' her Sammy too. But, hm, lemme see . . ." The arms crossed again and her chin went up. ". . . that's *two* apartments an' *three* families you done promised can move in. So. Which one of us was you gonna bump to make room for them Baxters?"

I sank down on one of the threadbare couches in the upper lounge. This had all made sense when Mabel and I talked about it in her office, but now I felt like a certifiable jerk. "You and Tanya are still at the top of my list, Precious. I was . . . I was going to ask

you and Tanya if you'd be willing to share an apartment to start with—at least until another apartment opens up. And ask Josh and Edesa to move into the House of Hope as property manager. But"—my voice cracked—"I can see I went about this all wrong. I should have talked to you and Tanya before I said anything to Josh and Edesa. I'm so sorry." I wagged my head miserably.

Precious just stood in front of me, arms still crossed. Finally she spoke. "But you didn't. So . . . what we s'posed to do now?"

I didn't know what to say. I'd done it again—running ahead of God with my "good idea." When was I going to learn to "lean not on my own understanding" like those verses in Proverbs said? Mabel always said if my "good idea" was part of God's plan, it was going to work out in His time and in His way. I didn't have to rush it.

I looked up at Precious and heaved a sigh. "I think I need to go back to Josh and Edesa and tell them I spoke out of turn. That I'd already promised that apartment to someone else."

Precious sat down on the couch beside me. "You'd do that?"

Suddenly it seemed simple. Just own up to my mistake. Start over. I nodded. "I could tell them they're first in line for the next apartment that opens up."

"An' when would that be?"

I shook my head. "I don't know. I'll try to find out."

We just sat on the couch not saying anything for several minutes, but I could feel the tension dissolving between us. Then she said, "You serious about makin' this right?"

I nodded.

"Okay. Then this is the way it's gonna go down. Step one. You got this big idea how to stretch two apartments an' fix everybody's

problems. Step two. You talk to me an' Tanya about it—though right now you talkin' to me an' *I'm* gonna go talk to Tanya. She don't have to know you already jumped the gun and talked to the Baxters. Step three. Tanya an' me gonna talk about it and decide if we *like* the idea of sharin' an apartment—which gonna be five people in three bedrooms once Sabrina's baby get here."

"I know. I—"

"Zip it, Miss Gabby. I'm talkin' here. Step four. Tanya an' me will tell you what we think of your big idea. Then you'll know what ya gotta say to Josh and Edesa. Maybe nothin' if we take you up on it."

I felt confused. "What do you mean? I was going to go downstairs right now and tell Edesa I can't offer the apartment after all."

"An' I'm tellin' you I just want a chance to be part of the decision—since you first off made me an' Tanya think we each gettin' our own place."

Now it was my turn to stare at Precious. Who *was* this woman who had accumulated more spiritual wisdom in her streetwise noggin than I had in all my "churchy" years growing up? Was she really willing to consider this idea after I'd changed the plan without telling her? Finally I spoke. "I . . . I hardly know what to say. Just promise you'll be honest with me, even if the answer is no. And if it is no, the sooner I can say something to Josh and Edesa, the better."

Precious snorted and stood up. "Since when has Precious McGill ever shied away from speakin' my mind? Now let me go find Tanya and tell her about this big idea. Gonna be easier for her to be honest 'bout how she feel if you're not there."

chapter 28

It was hard for me to talk to Edesa about filling in for Estelle's cooking class today and not say anything about the problem with the apartment. But she seemed excited about teaching some nutrition basics even on short notice and the apartment didn't come up again. "This is what I want to do when I graduate, Gabby," she said, her dark eyes dancing. "I can wing it today—but next time, give me more notice so I can prepare properly!" She laughed, her face breaking into that wide Edesa-smile that seemed to turn on highlights from within her warm mahogany skin.

Lunchtime came and went, but Precious and Tanya didn't show. I set aside two plates for them with the baked chicken, green beans, and macaroni on the lunch menu. Estelle had disappeared as soon as food was on the counter, leaving Wanda in charge of supervising serving and cleanup.

After lunch, Edesa put Gracie down for a nap in one of the beanbag chairs in the empty rec room and used the time before the two o'clock class to prepare some notes. When I peeked out

my office door at two thirty, she was using that day's menu to illustrate the five basic food groups. ". . . and the cheese sauce in the mac 'n cheese counts as protein from the dairy group. But if you look at the basic food groups on the paper I passed out, what was missing? . . . Tawny?" I closed my door with a smile. Edesa seemed as happy as if she had a class of thirty instead of just the five who showed up.

But still no sign of Precious and Tanya. I started to feel anxious. Should I go look for them? I didn't want to make them feel pressured. But if I had to tell Edesa that the apartment offer was off, I wanted to do it before she left. Otherwise I'd feel like a wimp doing it over the phone.

I picked up one of the stuffed dogs still stacked around my office and glared at its mopey face, beginning to regret I'd let hurt feelings get tangled up in the decision. If I backed out on Josh and Edesa now, I could hardly blame them if they got tired of waiting and rented something else—and that would be the end of my good idea. A property manager and his family right on the premises, a couple I knew and trusted and who were already volunteers at Manna House . . . it would've been so perfect!

Rats! I threw the stuffed dog into a corner with more force than necessary. *I* was the one buying the building, the one offering most of the apartments for second-stage housing. Didn't I have the right to do what I thought best? And like Mabel said, most women who qualified for second-stage housing didn't end up with their own three-bedroom apartments! But no, I was trying to please everybody.

Double rats! Why did I—

A light tap at my office door was followed immediately by

Precious and Tanya slipping into my office, momentarily allowing chatter from the class outside to slip in with them. Precious jerked a thumb in that direction. "Since when did Edesa start teaching healthy eatin'? I shoulda put Sabrina in that class! That girl carryin' a baby and eatin' like a teenager with pizza on the brain."

I tried to read their faces but got nowhere. "Edesa's just filling in for Estelle. Long story. Besides, Sabrina's at school. Don't they talk about the importance of nutrition in her birthing classes at the hospital?"

"Huh. Don't get me started. She's missed so many of those classes—"

"Precious!" Tanya hissed. "That ain't what we came to talk about."

"Oh. Right." Precious gazed somewhere over my head. "We gonna do it."

I looked cautiously from one to the other. "Do what?"

Tanya giggled. "Share the apartment—if we can have the first floor, you know, 'cause Sabrina ain't gonna be walkin' up no three flights of stairs."

I hardly dared breathe. "You . . . really? You're okay with sharing an apartment?"

Tanya nodded. "To tell you the truth, Miss Gabby, I was kinda scared thinkin' about Sammy and me alone in one of those big ol' apartments. How would I ever get enough furniture to fill it up? And Sammy an' me don't need three bedrooms—in fact, he sleeps better if he's in the same room as me. 'Course it's different for Precious an' Sabrina . . ."

Precious made a face. "Got that right. I been relishin' the

thought of havin' a whole bedroom to myself, an' one for Sabrina—that girl drives me nuts, the way she throws her clothes around—and a baby room we could fix up with teddy bears or Winnie-the-Pooh or somethin'."

"But I told Precious if we're housemates, we can help each other with the cookin' and cleanin' an' babysittin' too!"

I still was having a hard time believing what I was hearing. "And the bedroom situation?"

Precious shrugged. "Like she said, Tanya an' Sammy would just as soon share a bedroom—for now anyway—so she's cool if Sabrina an' me have the other two. An' I'm thinkin' it might be better for the baby to sleep in Sabrina's room anyway, help her remember she's a mama now. If that baby had a room all its own, Sabrina is likely to sleep right through its nighttime feedings, an' I'd be the one gettin' up at 2 a.m. Uh-uh. Been there, done *that*." She shook her head, sending her twists swinging.

"Besides." Tanya smiled shyly. "I like the idea of Mr. Josh an' Miss Edesa livin' there too. My Sammy don't know his daddy, an', well, it'll just be nice to have a young man like Mr. Josh around the place. He's good with all the kids. An' we all love Miss Edesa and little Gracie. It'll kinda be like . . ." She seemed embarrassed. "Kinda like the family we never had."

Long after Precious and Tanya had slipped out of the room, I sat at my desk talking to God. *Oh, God, forgive me. I nearly made a mess of things—but just look at You, God. You took it away from me and then gave it back, better than before! Giving Precious and Tanya a chance to own the new plan is so much better than me getting all self-righteous about my "rights." Oh, Jesus! Help me to trust You more . . .*

Another tap at my door interrupted my scattered thought-

prayer. Edesa stuck her head in. "I'm leaving now. Got studying to do. But any chance Josh and I can come over to the apartment this weekend and maybe do some painting? Or, knowing Josh, he's going to want to prep the walls. I know you haven't closed on the building yet, but . . ."

I grinned at her. "That'd be great. Just one thing . . . I forgot to tell Josh which apartment. It's the third floor. Tanya and Precious will be sharing the one on the first floor. Is that going to work for you?"

"*Sí, sí!* I like being on the top floor. No little footsteps running back and forth overhead—oh, I hear Gracie fussing. Can you believe it? She slept through the whole class." The vivacious young woman gave me a quick hug. "And *gracias* again, *mi amiga.* A larger apartment will look very, very good next time we meet with our social worker about Gracie's adoption. *Dios es bueno!*" Laughing, she shut the door behind her, but her sweet presence seemed to linger. I still wasn't used to a Spanish-speaking woman who looked African-American—her "African-Honduran" heritage, she'd told me. Edesa seemed at once exotic and earthy, sweet and salty. No wonder Josh Baxter, three years her junior, had fallen in love with her.

My spirit was nearly bursting with joy at how things were turning out. *If I trust in the Lord, He promised to make my paths straight.* Amen to that!

I turned back to my computer, looking forward to having Josh and Edesa pop over while the boys were with their dad this weekend. It got lonely when they were gone. Did I have anything else scheduled this weekend?

I clicked on the icon for my computer calendar, which

popped up instantly on the screen. My next appointment leaped out at me: *Friday, Sept. 8. Court date. 1:00 p.m.* Tomorrow. My buoyant spirit suddenly sank under the weight of Philip's last words to me: *"A judge may have second thoughts about giving you custody when he hears you left your own kid high and dry on the first day of school."*

I tried to swallow but my mouth had gone dry. Was he going to challenge my custody petition?

I wanted to talk with the boys about their dad and me going to court the following day, but it seemed like the phone rang all evening. Lee called to give me a few tips about tomorrow: Arrive early. Dress professionally but conservatively. Don't bring a big purse—keep it simple, easy for the security personnel to see what's in it. Nothing metal or sharp. Let the lawyers do the talking unless the judge specifically addresses me . . .

Estelle called from Harry's house, saying she had to drive Harry to the Medical Center tomorrow and she wouldn't be at work. She'd already told Mabel, but wanted to let me know and ask me to pray. I started to ask her to pray about my court case tomorrow, but she was off the phone already.

I called Jodi Baxter to pray about my custody petition, and she said Avis Douglass and several of the other Yada Yada sisters were at her house praying for Harry Bentley, and they'd be glad to pray for my custody case as well. "You doing okay, Gabby? Do you need somebody to go with you?"

Yes! I wanted to screech. But what was she going to do, take a

personal day off from teaching? Sounded like a bad idea. "I'm all right. I'll be fine. Just pray, okay? One o'clock."

The boys would be going to bed soon. I made a couple of smoothies out of some leftover strawberries, two overripe bananas, and the last of the orange juice, and told the boys I had a couple of things I needed to talk to them about. PJ. looked wary, but joined Paul and me on the window seat in the sunroom just off the living room. The evening was still pleasant, somewhere in the seventies, and I opened the windows to catch the breeze coming off the lake a mile away. Underneath our windows, a cricket orchestra sawed away as the boys sucked the straws in their smoothies.

Just start, Gabby. No matter how I did this, it wasn't going to be easy. I blew out the breath I'd been holding. "You both know your dad and I worked out an informal agreement about where you'd live and when you'd spend time with him after you came back to Chicago."

P.J. shrugged. "Yeah. So?"

"Well, I filed a petition for temporary custody, and the court date is tomorrow. I just wanted you boys to—"

"Why?" P.J.'s eyes sparked. "I mean, why do you have to go to court and do all that stuff? Why can't you just leave it like it is? You said yourself that you and Dad agreed how to work it out."

Paul seemed preoccupied, blowing bubbles through his straw back into his smoothie.

I chose my words carefully. "Because earlier this summer, your dad took you back to Virginia and left you there without telling me. You just . . . disappeared, and I didn't even know where you were." My voice wobbled slightly. "I'm filing for custody so that can't happen again."

Paul blew more bubbles. P.J. glowered at him. "Stop it, squirt!" Paul noisily sucked up the last of the smoothie and slumped against the throw pillows on the window seat, kicking his legs against the baseboard.

P.J. wasn't through. "Shouldn't we go to court too? We're not babies. Maybe the judge wants to ask us where we want to live."

"I don't wanna go to court," Paul piped up. "Let Mom and Dad figure it out."

"Paul's right. This is something your dad and I have to figure out." I tried to soften my voice. "But even if I have legal custody, we can still talk about how much time you spend with your dad and make changes if we all agree."

P.J. still glowered. "Don't see why you moved out in the first place," he muttered.

Why I *moved out?!* Anger spiked through my body so strongly, I half expected sparks to shoot from my hair and fingertips, like some electrified humanoid. Is *that* what Philip had told the boys? I stood up, my back to the boys, and counted to ten before turning to face them. "P.J. and Paul, look at me. Whatever your father told you, I want you to know that I did *not* move out." *Locked out, thrown out was more like it!* "I would *never, ever* leave you, especially not without saying a word." Hot tears threatened to spill over.

"So he lied, then."

Yes! I wanted to scream. *He lied! He stole you away from me!* But P.J. seemed to be fishing for something. I needed to be careful, not to tear Philip apart in front of his sons, to stick to my side of things. I breathed deeply and sat back down on the window seat, trying to calm down. "I don't know what he said or why he said it. Your dad and I had a . . . a huge misunderstanding. I

came home from work and discovered I'd been locked out and you were gone. I didn't know where! I was frantic!"

"But you called us at Nana and Grandad's. And told us to stay there."

"I guessed that's where you might be, and I was right. And it took me awhile to find a place to live so I could bring you back. But I didn't leave you, and I never will." I reached for both boys, pulling them close. "I love you too much to do that."

Paul suddenly crumpled into my lap and burst into tears. I cradled him as his shoulders shook, and to my surprise, P.J. let me pull him close as the three of us rocked together there on the window seat.

As Paul's sobs subsided, I let him sit up but kept my arms around both boys. "Hey, you know what? I have some good news."

"What?" Paul sniffed. "Is it about Dandy?"

"Mm, no. But I think you'll like it. Guess who's going to move into the House of Hope with us?"

"Ha, I know *that*," Paul scoffed, wiping his nose and eyes on his T-shirt sleeve. "Sammy told me. He and his mom, and that big girl Sabrina and her mom."

"She's big, all right." P.J. snickered and stuck out his stomach. "Big with baby."

"Well, that's true. They're going to share the first-floor apartment. But somebody else too."

P.J. looked at me sideways. "Not Miss Turner and that Jermaine kid?"

I let that pass. "No. Our new mystery neighbor taught your Sunday school class at the lake last week and he's also a pretty good baseball player."

"You mean Josh Baxter?" P.J. actually sounded interested.

I grinned. "*And* his wife, Edesa, and little Gracie, of course. Josh is going to be the property manager for this building—you know, fix stuff that gets broken, keep the furnace running, make sure the building stays up to code, stuff like that. In fact, Josh and Edesa are going to come this weekend to prep the walls and start painting the third-floor apartment, getting it ready to move in."

"But we'll be with Dad." Disappointment clouded P.J.'s face. "Wish we could help paint. That'd be fun."

I couldn't help but smile. "Don't you have a cross-country meet on Saturday? Like, waaay out in Wauconda?"

P.J. made a face. "Yeah. Buses leave from the school real early. Like six thirty."

I almost laughed. Poor Philip. "Well, the next meet that's within spitting distance, let me know. I want to see you run." I gave my oldest a teasing sock on the arm, which he shrugged off. But I could tell he was pleased.

"Okay, off to bed, you two. Tomorrow's a school day. Shoo!"

But fifteen minutes later I slipped into Paul's bedroom and sat on the edge of his lower bunk. "What about you, Paul? Think you'll like having the Baxters living here?" I tousled his curly head on the pillow, so like mine, except with a boy cut.

He snuggled under the light blanket. "Yeah, that's cool. But I'd like it even better if Jermaine and his Aunt Mabel could move in."

I hid my surprise. "And why is that?"

"'Cause"—he yawned—"then Jermaine and I could play music together whenever we wanted to . . ."

chapter 29

I didn't know what time Mr. Bentley's eye surgery was on Friday, but Mabel called a short prayer meeting in Shepherd's Fold before Edesa's Bible study for anyone who wanted to pray for "Mr. Harry." As the small group gathered, I worked up the courage to say, "I could also use prayer for my custody hearing this afternoon" without offering any details—and was humbled when two of the women who'd lost custody of their own children when they were drugged out on the street spoke up and prayed for me.

"Rev'rend Liz" Handley, the former-director-now-board-member of Manna House, showed up to cover lunch prep in Estelle's absence. I had to chuckle seeing her bustle around the kitchen, because Liz Handley and Estelle Williams were as different as chalk and cheese. Liz was short, white, and fairly round in the face, with blue eyes and short, steel-gray hair. Estelle was a large black woman, but tall and solid, her dark hair streaked with silver and usually piled in a bun on top of her head. But she

could also wear it down and wavy—I suspected Mr. B liked it that way—very womanly.

Then again, those white hairnets and big white aprons had a way of swallowing everyone's "distinctives" and turning them into look-alike kitchen blobs.

Whatever Liz was making smelled good, but I couldn't stay for lunch because my custody hearing was scheduled for one o'clock at the Circuit Court of Cook County, which had its offices in the Richard J. Daley Center in the Loop, and Lee had told me to arrive early. My stomach was in such a knot, I didn't think I could eat anyway.

Rather than hassle with parking, I took the Red Line, which had an El stop a mere two blocks from Daley Plaza. Passing in the shadow of the towering Picasso sculpture—which looked like a skinny iron horse head wearing two winglike ponytails to me—I merged with the stream of people flowing into the Daley Center and lining up at the security checkpoints. I tried not to stare, but the mix of humanity was eye-popping. Orthodox Jews with long beards and tassels hanging beneath their suit coats rubbed elbows with guys in dreadlocks and pants barely hanging on below their butts. Men in traditional suits and ties stood in line with ethnic women—Muslim?—wearing black head scarves that covered all but the face. *What if somebody showed up swathed in a burka? A person could hide almost anything under that.* Some people with ID tags were allowed to go through a special gate, avoiding the security check. Lucky them.

The rest of us inched forward. "Empty your pockets, put everything in the bin . . . Put all purses and bags on the moving belt . . . Sir, sir? You can't take that pocketknife in . . . I don't *care* if

your granddaddy gave it to you, you can't take it in . . . Well, I'm sorry. You'll have to leave it in the sheriff's holding room or get out of line . . . Next!"

I made it through security and took the elevator to the eighth floor. I had to ask two different people where to find the room number Lee had given me, but I finally found it with ten minutes to spare. Peeking through the small square window in the door, I saw the back of Lee's head. Relieved, I pulled the door open.

Lee Boyer stood up as I approached the table where he sat, giving my black skirt, black shell with an ivory embroidered cardigan, small earrings, and low heels a quick once-over and smiled his approval. "Glad you're early. Philip isn't here yet." He pulled out a chair for me.

The smallish room helped my racing heart slow down. A desk for the judge, two small tables facing it for the respective parties and their lawyers, a few chairs behind them in two short rows. No jury box. Clearly a room for a hearing, not a trial.

Philip and his lawyer came into the room with one minute to spare. He didn't look at me, just sat down at the other table, whispering to his lawyer. A door at the side of the room opened and a white woman entered, brown hair drawn back into a neat bun at the nape of her neck, reading glasses perched on her nose. A young male clerk scurried behind her and sat down with a transcription machine. That made six of us in the room. We started to stand—don't they say, "All rise" or something?—but the judge waved us back into our seats. For a few moments she didn't say anything, just studied some papers in a folder.

Finally she looked up. "I presume," she said, looking at Lee, "you are representing Mrs. Gabrielle Fairbanks, concerning two

petitions"—she glanced again at the folders—"one for unlawful eviction, the other for temporary custody of the couple's two sons?"

Lee stood. "I am, Your Honor. Lee Boyer." For the first time I noticed he was actually wearing a suit and tie. Well, slacks, sport coat, and tie.

"And Mr. Hoffman"—she eyed the other table—"you are representing Mr. Philip Fairbanks?"

Philip's lawyer, a big man with wavy silver hair and a Florida tan, also stood. "Yes. Your Honor, my client would like to—"

The judge interrupted. "I will give you time to present your client's wishes. But I haven't said my piece. Sit down." Mr. Hoffman sat.

The judge peered over her reading glasses in our direction. "Mr. Boyer. This is a custody hearing, yet you have asked that both petitions be considered simultaneously. Why?"

Lee had remained standing. "Thank you, Your Honor. The two petitions are relevant to each other. It is because of the unlawful eviction and subsequent disappearance of the couple's two children that my client is requesting custody."

The judge leaned back in her chair, took off her reading glasses, and chewed on one of the earpieces, looking not at me, but at Philip. It might have been only thirty seconds, but I felt as if I was holding my breath for thirty minutes. Finally . . . "Mr. Hoffman. *What* was your client thinking, locking his wife and her elderly *mother* out of the house—a luxury penthouse, I see—and skipping town with their sons without her knowledge?"

I smiled inwardly. *Thank you, Judge!* But Philip's lawyer must

have been prepared for the question because he stood, clearing his throat. "Your Honor, this is not an unusual happenstance when couples quarrel, though it is usually the wife who throws her husband out, along with his clothes and golf clubs, and no one thinks it strange that she has sent him packing. Just because in this case the roles were reversed"—he cleared his throat again, more for emphasis than anything else—"doesn't make it any more heinous."

The judge leaned forward. "Says who? Mrs. Fairbanks has a right to be in her own home. If Mr. Fairbanks doesn't want to live with his wife, *he* can move out."

I cast an anxious glance upward at Lee. I didn't want to move back into the penthouse! He gave me a subtle signal with his hand to be patient. Philip and his lawyer were rapidly conferring. Finally Mr. Hoffman straightened up. "Your Honor, may my client speak in his behalf?"

The judge shrugged. "Of course." But she said it in the tone that P.J. used when he said, "Whatever."

Philip stood up. Even as I tensed, dreading what he might say, I realized he seemed . . . vulnerable somehow. As usual, his handsome features were easy on the eyes, his clothes—slacks, open-necked silk shirt, summer-weight suit coat—just right. I couldn't put my finger on it—the way his eye twitched? the new stress lines in his face?—but he didn't seem his usual relaxed, confident self. "Uh, Your Honor, I know what it looks like from the outside. But the situation in our home had become untenable. My wife brought her mother and a dog into the home without consulting me, which overcrowded our space. She also took a job that prevented her from caring for our sons during their summer

vacation, and otherwise burdened the household with her unwise choices. I know what I did was drastic, but I did it to make a point. Something had to change."

He sounded so reasonable, so persuasive, I felt like crawling under the table. He made me sound like a totally unfit wife and mother.

The judge frowned. "But block her credit cards? Cancel her cell phone? I understand from what it says here"—she waved the petition—"that you left her virtually destitute with no means of support, and she ended up in a homeless shelter. A *homeless shelter*, Mr. Fairbanks."

Philip swallowed. He looked uncomfortable. "She is employed at that shelter, Your Honor. It was natural that that was the first place she turned."

The judge shook her head. Clearly she wasn't buying it. "Thank you, Mr. Fairbanks. I'm sure you think you had your reasons. But I am ruling in favor of the petitioner that she has been unlawfully removed from her home and may return immediately."

I scribbled a furious note for Lee. *No!*

Lee spoke up. "Your Honor, my client has since been able to find alternative and adequate housing for herself and her children, and has no desire to return to her former place of residence. We are requesting a financial settlement instead to help cover her alternative housing expenses."

I was watching Philip. He seemed to flinch.

The judge considered. "Hm. Do you have a statement of expenses?"

"We do." Lee strode forward with a financial statement that

included my meager salary and monthly rent for the apartment in the six-flat. The judge looked it over.

"Your Honor!" protested Mr. Hoffman. "Mrs. Fairbanks has recently come into a family inheritance that is allowing her to purchase the whole building! I hardly think she needs financial assistance—"

The judge glanced up at Lee, who was still standing by her desk. "Is this true?"

Lee nodded. "Yes. We have included that on the financial statement . . . there, on the bottom. However, Mrs. Fairbanks is still currently renting, and legally, her family inheritance—which she knew nothing about at the time of her unlawful eviction— has nothing to do with this case. The fact is, Philip Fairbanks unlawfully removed his wife from her place of residence, and in lieu of returning to that residence, she deserves financial assistance to maintain an alternative residence for herself and her children."

Lee returned to our table. I smiled at him. *Good job.* I'd managed to get by, even without Mom's life insurance, but it was the principle of the thing, wasn't it?

The judge studied the sheet of paper she'd been given. Finally she said, "I agree. I will decide the financial amount after we deal with the custody petition, since this case involves residence for the children." She took up a second folder. "I understand Mr. and Mrs. Fairbanks have worked out a mutual agreement that their two children"—she consulted the folder—"Philip, Jr., age fourteen, and Paul, age twelve, should reside primarily with their mother with weekly overnight visitation with their father. Is this correct?"

"Yes, Your Honor." Both lawyers spoke together, like Siamese twins. But Mr. Hoffman plowed on. "Which puzzles my client," he said, "why a Petition for Temporary Custody is necessary. He has agreed to his wife's wishes in this matter and the boys are currently living with their mother with weekend visits to their father."

"But as you can see, Your Honor," Lee countered, "at the time that Mrs. Fairbanks was unlawfully evicted from their home, her husband disappeared with the children, their whereabouts unknown to their mother. It is against the possibility of that occurrence happening again that my client is requesting temporary custody."

Mr. Hoffman threw out his hands. "My client simply took the boys to their grandparents, where, I might add, they had been staying previously when Mr. and Mrs. Fairbanks first moved to Chicago in order to finish out their school year. Mrs. Fairbanks was not prohibited from communicating with her sons at any time."

Sudden tears threatened to undo me. The fear and desperation I'd felt when I didn't know where they were in that first twenty-four hours rose to the surface like boils about to pop. Sensing I might break down, Lee laid a reassuring hand on my shoulder. I took a deep breath and let it out slowly. *Breathe, Gabby . . . breathe.*

Out of the corner of my eye, I saw Philip conferring with his lawyer. Was he going to bring up me leaving P.J. in the school parking lot? After a long minute, Mr. Hoffman straightened. "Your Honor, my client agrees to 'no contest' to the custody petition—provided that the financial settlement for the, uh, 'unlawful eviction' is waived."

The judge shook her head, as if she couldn't believe what she was hearing. But I motioned to Lee. "Tell the judge we accept!" I whispered. "I don't want his money. I want custody. Do it!"

"But, Gabby—"

"Just do it, Lee!"

chapter 30

Too rattled to go back to work, I went straight to my car after getting off the El at the Sheridan station, picked up Paul from Sunnyside, and took him out to McDonald's for burgers and shakes. I said, "Uh-huh" and "Really?" as Paul burbled nonstop about an annoying kid who played first-chair trumpet in the band, but I kept seeing Philip's face as we left the courtroom. For a split second, our eyes had met. He could have been gloating—Lee was angry about the deal we'd made, letting Philip get off scot-free financially—but to me, Philip seemed . . . tired. Sad.

But hanging out with Paul managed to keep me distracted until it was time to pick up P.J. and Jermaine. Paul scooted over in the backseat to make room for Jermaine and bombarded him with questions. "Hey, 'member that smokin' piece you played at my birthday party? Could you teach those chords to me? What else you been doin'?"

P.J. said nothing in the front seat, but he did look my way, questions in his eyes about the custody hearing. I tried to give

him a reassuring smile. "It's all okay," I murmured. "Nothing has changed."

Philip pulled up right at six to pick up the boys, giving a quick toot of the horn outside. I was just as glad he didn't come to the door. We hadn't spoken at the hearing either. What was there to say? The judge had given me custody of our sons and Philip had pleaded "no contest" in exchange for "no consequences" for kicking me out. Who won? I did, I guess. Except . . . for some reason, I wanted to cry.

Which I did on and off all that evening, using up the last box of tissues and half a roll of toilet paper, feeling that something was terribly wrong. I'd just secured legal custody of the boys— "temporary custody," the judge reminded me, since we were just separated, not divorced—and yet here I was, alone, the rest of my family off doing something without me. Lee had tried to ask me out, wanted to take me to dinner "to celebrate," he said, but I'd turned him down. What was there to celebrate? My marriage was in the pits, my sons had to straddle two households, had to divide themselves between mom and dad, and whatever had been good about my marriage with Philip had somehow been lost in a tsunami of . . . of what? Each of us pulling our own way until the bond that held us together had stretched too far and snapped.

Jodi Baxter called to find out how it went and said, "Praise God!" when I told her the judge had granted both petitions. So why didn't I feel like praising God?

Between sniffles, I managed to sort the boys' dirty laundry and lug it down to the basement where two ancient washing machines and one beat-up dryer sat mostly unused, but I didn't feel like going out to the Laundromat. Even as I stuffed jeans and

towels into the largest top-loader, Philip's complaint to the judge and Mabel's concerns she'd shared in her office seemed to drip down on me from the musty walls. *"Without consulting me"* . . . *"You didn't talk it over with your husband"* . . . *"No marriage can tolerate that kind of behind-the-back decision making for long."*

Frustrated, I poured laundry detergent on top of the clothes without bothering to measure and banged the washer lid down as it started to fill. Hadn't Mabel apologized for making me feel I was to blame for ending up in the shelter? And she'd called Philip's actions "emotional abuse."

But a quiet Voice somewhere in my spirit whispered, *That doesn't make her concerns any less true.*

I couldn't deal with this! Pawing through the boys' collection of DVDs in the living room, I stuck *Napoleon Dynamite* into the DVD player and zoned out in front of the TV . . . at least until I went downstairs to switch laundry loads, only to find suds had poured out of the washer and all over the floor, and the load had shut down somewhere in the middle of the rinse cycle.

Loud knocking in the front foyer the next morning sent me scurrying into the building hallway wondering who was making such a racket at eight in the morning. But I had to grin seeing Josh and Edesa Baxter on the other side of the glass-paneled door, loaded down with cans of primer and spackle, sandpaper, spackling tape, and paint rollers and brushes. I yanked the door open. "Sorry! The buzzer doesn't seem to work. Aren't you guys up kinda early?"

Josh dumped his armload in the hallway. "Unnh. Gracie woke up at five . . . Do I smell fresh coffee? Make you a deal. I'll look at what's wrong with the buzzer if you'll bring me a really big mug of joe—just black." He propped open the foyer door with a can of primer. "Do the other buzzers work?"

"I think so—at least for the two empty apartments." I headed for the kitchen, Edesa on my heels. "Wait until I tell him I flooded the washing machine in the basement," I murmured, pulling out two more mugs. "Maybe he won't want this job as property manager after all . . . Where's Gracie?"

"Grandma Jodi agreed to babysit so we could actually get some work done. She and Denny are taking care of DaShawn too. Gracie adores DaShawn! Hopefully she'll keep him distracted so he doesn't worry about his Grandpa Harry too much."

Harry! I'd almost forgotten about his eye surgery. I poured the coffee. "How's Mr. B doing? Did his procedure go okay?"

Edesa shrugged. "*Sí,* I think so. I don't really understand what they did. I just know he has to lie still for several more days—on his side, I think—and it's driving him *loco.*" She circled her finger in the air. "Or maybe he's driving Estelle *loco,* not sure which."

I laughed. "I can just imagine . . . Wait a sec, let me take Josh his coffee."

Josh had the buzzer assembly dismantled, peering into the tangle of wires, and only grunted when I set his coffee on the floor, so I turned to go. But he called me back. "Mrs. Fairbanks? I was just thinking . . . if Precious and Tanya would like to come over today, I could get them started spackling the walls in the first-floor apartment too. I think we've got enough to do both apartments."

"Which I need to reimburse you for, by the way. I'll call Manna House and see if they can come over. But when are you going to stop calling me Mrs. Fairbanks? Edesa calls me Gabby, why not you?"

Josh actually blushed. "Ah, see, it's a little awkward for me, because you're my *mother's* friend, and she always taught me . . . well, you know, it's rude to call adults by their first name. And I'm still in college, you know. But Edesa got to know my mom in that Yada Yada Prayer Group, so Edesa has always called her Jodi . . ."

I laughed. "You are so funny, Josh Baxter. You're a married man and a daddy—I think that qualifies you as an adult, college or no college. So call me Gabby, okay?"

He shrugged, giving me a shy grin. "Okay. I'll try. And thanks for the coffee." He took his first sip gratefully. "*Some*body needs to tell the Little People that the Big People want to sleep in on weekends—especially when *this* Big People had to stay up late last night writing a paper."

I left him to tinker with the buzzer . . . but that's how I ended up driving over to Manna House and picking up Precious and Tanya, who were eager to get to work on their apartment. I tied a big bandana over my hair and joined in, at which point we all decided to work on the third-floor apartment first, and then all work together on the first-floor apartment, since Precious, Tanya, and I didn't really know what we were doing, though I remembered hating the sanding part the time Philip and I repainted our big old house back in Petersburg.

I made sandwiches for everybody at noon, and then excused myself for an hour or so after lunch to go see how Harry Bentley

was doing. "By the time you get back, the spackle will be dry enough for sanding," Josh teased.

"Oh great. My favorite part," I moaned, wondering if I should change my clothes, then deciding it wasn't worth the effort to change back again.

I didn't plan to stay long visiting Mr. B—frankly, I'd never been to his apartment before and it felt a little strange to get this intimate look behind the man I'd first known as the doorman of Richmond Towers—but I was surprised to hear laughter and childish voices when Estelle opened the door. "Jodi and Denny brought Gracie and DaShawn over," she explained, but put her finger to her mouth as she led me into the small living room. "Shh, the kids are doing a 'smelling game' for Harry."

"A what?" Mr. Bentley sat on the old-fashioned couch, head bowed forward, chin on his chest. White gauze patches covered both eyes. For the first time it hit me what it must be like for him not to be able to see a thing . . . no, on second thought, I couldn't really imagine it, only knew it must be frightening.

But at the moment, the retired cop was grinning as DaShawn held a jar lid under his nose. "Guess what this one is, Grandpa!"

"Uhh . . . cinnamon?"

"Aw, that was too easy. You'll never guess this one!" DaShawn picked another lid out of a box and waved it under his grandfather's nose.

Jodi sidled up to me, a big smile on her face. "Isn't that cute? DaShawn invented this smelling game since his grandpa can't see, spent all morning at our house putting it together."

"What all does he have in those lids?" I whispered.

"Well, Harry did *not* guess Estelle's lilac perfume—he's in the

doghouse over *that* one—but so far he guessed garlic and coffee grounds and bacon grease. And the cinnamon. Not sure what's left . . . oh, apple shampoo is another one. Can't remember the rest."

"Okay, kids, that's all." Estelle clapped her hands like a school-teacher. "Mr. Harry's got another visitor, so why don't we go out to the kitchen and get a snack. Jodi girl, bring that baby with you. Harry's probably got pickled pigs' feet up in there somewhere . . . you like pickled pigs' feet, DaShawn?"

"Yuck!" the boy yelled as they disappeared out of the room.

"Don't let her pull your leg, DaShawn!" Harry hollered after them from the couch. Then, "Did she say I've got another visitor?"

"Right here, Mr. B."

"That you, Firecracker? Come here." The man reached out, feeling the air.

I pulled up a hassock next to the couch and put my hand in his. "I'm really sorry about all this eye stuff you're going through. What did they—"

"Never mind that. I gotta ask what you know about your man Philip's association with Matty Fagan."

I was taken aback. "I—I don't really know, Mr. B. Just that one time when he was on the phone, I heard him talking in the background to some guy named Fagan. That's it."

"Humph," he muttered. "It's never just 'one time' with Fagan." He suddenly swore under his breath and almost got up, then sagged back down on the couch. "Sorry, Gabby. I'm just so *frustrated* to be laid up with these stupid eye patches right now. If this Fagan is who I think he is, whatever's going down with Philip

can't be good—and could be downright dangerous. The man's always got some racket going on."

"But who is he, Mr. B?"

I couldn't believe it when Mr. Bentley told me Matty Fagan used to be his boss in the elite Anti-Drug and Gang Unit of the Chicago Police Department. Harry had blown the whistle on Fagan and his cronies a year or so ago for shaking down drug dealers and gangbangers, then reselling the drugs and weapons they'd confiscated back on the street. Internal Affairs had suggested Harry quietly retire early—he already had more than twenty years on the force—until they'd built a solid case and brought an indictment against Fagan. "Which they did several weeks ago," Harry said, "but of course he posted bail and is out on bond until time for his trial. But knowing Fagan, that wouldn't stop him from finding some other marks to go after. You think your husband is using?"

"Using? You mean drugs? No!" Whatever Philip was, he wasn't a druggie. "Only vice I know about is his gambling, which I told you about, and now he's in debt up to his eyeballs. That's why he came to me, trying to borrow money to pay it off . . ."

I suddenly had an awful thought—and it must've occurred to Mr. Bentley at the same moment, because he grabbed for my wrist and said, "That's it."

"Oh, Mr. Bentley, you don't think—!"

"That's exactly what I think. Fagan's got himself a new racket, loaning easy money to people like your husband—upstanding business types who've got themselves in trouble at the gaming tables."

"But where would this Matty Fagan get that kind of money?"

Mr. Bentley snorted a mirthless laugh. "Ha. You'd be surprised how easy it is for someone like Fagan to get his hands on fifty grand, even a hundred or two hundred—mostly payoffs from the big drug dealers in exchange for his cops looking the other way. And you can be sure the 'interest' he's charging will set your man back even more."

"So why would Philip do that?"

"Quick money, no questions asked, no check into assets, all the stuff that banks do. But it's risky, because Fagan doesn't take kindly to people who cross him."

I was dumbfounded. Should I warn Philip about this Fagan guy? Did he know the man was under indictment by a grand jury for fraud and illegal sale of weapons and stuff?

My skin crawled, not wanting to think about what Philip had gotten himself into. If Mr. Bentley was right, no wonder he'd looked so stressed at the courthouse yesterday. "But if Philip pays it back . . ."

"I hope he does, Firecracker, I truly hope he does. Because Fagan isn't a patient man."

chapter 31

For some reason, I felt all shook up after I left Harry's apartment. Not that I knew for sure what was really going down with Philip and this Fagan person, or even if it was the same Matty Fagan that used to be Harry's boss at the police department, but I had a feeling Harry's gut instincts were right on the money—pun intended.

I got back to the six-flat in time to do my share of sanding—ugh—but it was fun working with Precious and Tanya . . . until they got into an argument about what color to paint the living room, that is.

"I once saw an apartment painted all red an' black," Tanya said, dreamily sitting on the floor in the middle of the empty room, her dark hair and skin covered with a fine coat of "Tinkerbell" dust, "an' I tol' myself, if I ever get my own place, I'm gonna paint it red an' black!"

Precious nearly fell off her step stool. "Girl, ain't no way I'm gonna live in an apartment that looks like one o' them serial

killers been here." She waved her hand at the walls. "We should do somethin' classy, like silver wallpaper—ya know, the kind with fuzzy designs on it. An' paint all the trim gold . . . they got gold paint, don't they, Gabby?"

I made a strangled noise.

"Well, red an' black for the kitchen, then."

"Girl, you got red an' black for brains."

"The bathroom?"

"Hold it," I broke in. "Tell you what, since I'm the landlord—"

"Landlady," Tanya broke in.

"Landlady, then." Which sounded ridiculous, but I wasn't going to argue the point. "Since I'm the land*lady*, and since I have to pay for the paint, how about if we go with some nice muted colors in the common rooms, and you can do whatever you want for your personal bedrooms. Deal?"

Precious looked dubious. "Whatchu mean, 'muted'?"

I opened my mouth to suggest "sea-foam green" or "morning mist blue" when I glanced out the window and saw Philip's black Lexus pull up. Was it six o'clock already? "Excuse me," I said and ran outside.

P.J. climbed out of the SUV still in his green-and-gold running clothes, his sport duffel bag slung over one shoulder. I gave him a hug. "How'd it go, buddy? Did Dad just pick you up?"

"Yeah. Went okay . . . We got any orange Coke?" He took the outside steps two at a time and disappeared inside. I smiled at his back. All soft drinks were "Coke" to a Southerner. My inability to remember that back in Virginia always gave me away as an outsider. How many funny looks would it take for my boys to learn most Chicagoans called it "pop"?

Paul slid out of the backseat, squinting at the open windows on the first and third floors. "Hi, Mom! People still working? I'm gonna go see what they got done."

"Don't forget your duffel bag!" his father called through the open windows. Paul turned and grabbed a bag from the rear seat. "Not that one . . . Paul! Watch what you're doing."

Paul grabbed his own bag, slammed the car door, and ran up the walk. I started to follow, but Philip called me back. "Gabrielle? You got a minute?"

I hesitated. Wasn't sure I wanted to talk to Philip. The last time we had a "talk," I'd ended up throwing things. But I screwed up my courage and stepped to the passenger side window. "Maybe a minute. I'm in the middle of something."

Philip's eye twitched. "Just wanted to say I was, uh, out of line . . . you know, how I reacted when you turned down my request for a loan. I was just frustrated."

I hardly knew how to respond. Was Philip Fairbanks actually apologizing for saying "you owe me"? Finally I said, "Yeah, that was pretty ugly."

He looked away and the moment hung there awkwardly, like a clothesline of bras and undies flapping in the breeze. Then he cleared his throat. "Something else we need to talk about. My time with the boys. I barely saw P.J. this weekend. Had to have him at the high school at six thirty this morning, and he didn't get back until an hour ago! I didn't realize this cross-country business would be all day on Saturdays."

A flicker of irritation started at the base of my skull. My legal custody was barely twenty-four hours old, and already he wanted to change the visitation plan? But he had a point. And

he'd just apologized, hadn't he? "Well . . . okay. You want to talk now?"

Philip reached for his aviator sunglasses sitting on the dash and slid them on, hiding his eyes behind the dark, curved lenses once more. "Can't right now. I'm headed somewhere. But think about it. I'll call you, maybe Monday."

I glanced into the back. Philip's overnight bag sat on the seat. My gut tightened. "Another weekend at the casino?"

His mouth got tight, but he said nothing, just put the car in gear and started to pull away from the curb.

I don't know what got into me—my talk with Harry, anxiety, fear—but I ran alongside. "Philip! Please don't go. You're in over your head and it's only going to get worse!"

But the Lexus sped up and disappeared around the far corner, leaving me standing in the middle of the street.

Philip's request to change his time with the boys nettled me all weekend. I talked to my sisters that evening and got an earful of *their* opinions. When I took the boys to SouledOut Community Church the next morning, I realized if we moved their time with their dad—say, from Saturday evening until Sunday evening instead—they wouldn't be able to go to church with me anymore. Unless Philip would bring them . . . and that was as likely as the Cubs winning the pennant, Harry Bentley would probably say.

Speaking of Harry, I didn't see him or Estelle at church again, though I did see his grandson sitting with Jodi and Denny Baxter. Which meant Harry was probably still at home with his eyes

bandaged, and Estelle was still on his case like a Secret Service Mother Hen.

They should just get married. I chuckled silently. We all knew it was inevitable. The two of them just hadn't figured it out yet.

I corralled my thoughts and focused on the worship, letting the song the music group was singing wash over me. "The steadfast love of the Lord never ceases . . ."

Ah, a familiar song! Used to sing this one growing up in North Dakota. But the worship leader just said the song was based on a passage in the third chapter of Lamentations. Really? I grabbed my Bible, looked in the index, found Lamentations, and ran my finger down the verses . . .

Seeing the words in Scripture as the music group sang made the words seem fresh and new: *"The faithful love of the Lord never ends . . ."* It was true! God had slowly and steadily been putting my feet back on solid ground, in spite of my spiritual neglect for most of my marriage, in spite of my husband's love growing cold.

". . . His mercies never cease . . ."

Yes, oh yes! I had received a great deal of mercy in recent days. A new home, custody of my sons, a dream coming true in the House of Hope . . .

". . . His mercies begin afresh every morning . . ."

Which meant I could count on His mercy for all the loose ends still in my life! As the congregation sang, I found myself praying for something to work out about the boys' visits with their dad. I even prayed for Philip, that God would somehow untangle the mess he'd gotten himself into, gambling himself into debt and now getting mixed up with this Fagan person . . .

"*. . . Great is His faithfulness . . .*"

The song came to an end and the music group moved right into another. But the song and the Scripture still played in my heart. I'd come a long way back to faith since I'd stumbled over Lucy Tucker in the park and we'd both ended up sheltered at Manna House. But I couldn't take any credit for it. It was all God's faithfulness, never giving up on me.

My eyes got misty. Something in me wanted to kneel down and renew my vows to the Lord, like I'd done at camp one summer as a kid, giving my heart to Jesus. And suddenly it occurred to me there was something I could do—I could join this church, become a member, as a way of marking my return to faith, taking my stand publicly with the people of God in this place.

My heart beat faster with a childlike excitement. I'd speak to Pastor Clark or Pastor Cobbs as soon as the service was over.

"Gabby! That's wonderful!" Jodi said, when I told her I'd spoken to Pastor Cobbs about becoming a member of SouledOut Community Church. "Did he say when?"

"Two Sundays from now, the last Sunday in September. If I don't get cold feet before then. He gave me some papers to read about the church and a copy of the membership questions I'd be asked." I was already wondering if I'd been too impetuous. Church membership at SouledOut definitely meant something more than it had at Briarwood, where we stayed on the church membership roll even though Philip

and I had only shown up three or four times a year. Even the name—*SouledOut*, for goodness sake!—made me feel as if I was taking holy vows.

Jodi gave me a sympathetic hug. "You won't. This is definitely the right thing to do. Everyone who follows Jesus is part of the body of Christ on Earth—but those 'body parts' are a lot more effective when they're connected with the other 'body parts'!" She laughed. "Me, I'm a toe—but the foot needs me and I need the foot. We all need each other!"

I rolled my eyes, though I couldn't help grinning at Jodi's "theology." "Well, if you're a toe, maybe I'm a toenail."

"See? That's exactly it! Just think where we'd be without toenails!"

I did think about it that afternoon as I wandered through the apartments across the hall from ours on the first and third floor while the boys did homework. A lot of wall prep had gotten done just in one day with a bunch of us working together. My heart seemed to crowd into my throat. *God, I know the House of Hope wouldn't be happening if I were trying to do this on my own. Thanks for giving me other parts of the body to—*

"Yo! You de lady who buyin' de building?"

I jumped at the unfamiliar voice, a thick Island accent. A tall thin figure, dark skin, long dreadlocks caught back in a fat pony-tail, poked his head into the third-floor apartment. How stupid of me to be up here by myself with the door unlocked! I tried not to let my apprehension show, even as I moved quickly to the door and squeezed past the man into the hallway, where I could yell if need be. The door across the hall was open. Reggae music bounced within. Now that we were standing face-to-face,

I realized I'd seen the man going in and out of the building, but had never actually spoken to him before.

"Yes, I'm the new owner." The sign out front said Under Contract, even though I hadn't closed yet. "And you are . . . ?"

The man jerked a thumb at the apartment across the way. "Mi livin' dere wit me woman and me mada. Yuh still be renting dese apartments or going condo?"

I began to relax. Just a tenant wanting to know what was happening. I shook my head as I locked the door of the empty apartment. "Neither. I'm working with a shelter program . . ." It would be hard to explain. *Just cut to the chase, Gabby. You know what he wants to know.* "I'm sorry. I won't be renewing any leases. When will your lease be up?"

The man's face fell. "January." It sounded like *Jan-oo-wary.* "Dat not a good time to be wit'out a place to live."

I suddenly realized this man and his family were being put out by my plans for the House of Hope. Could I make it easier somehow?

Impulsively I said, "Tell you what. If you find a place to move sooner, you can move out without having to sublet the apartment or breaking your contract." That would work both ways, wouldn't it? It would give more options to the remaining tenants, as well as make the apartments available sooner to the House of Hope.

Or leave me with empty apartments and having a hard time paying the mortgage.

But I'd said it. And I would keep my word—to this man anyway.

The man nodded and turned to go. But I stuck out my hand. "My name is Gabby Fairbanks. You are . . ."

He shook my hand, his hand sinewy and thin. "Campbell. Maddox Campbell." Then he pointed to my hair—which was probably a frizzy mess, since it had rained as we came out of church and caught me unprepared—and for the first time a slow grin spread over his face. "Dat be a heap of curly hair—like de poodle dog."

I didn't know whether to be offended at being compared to a poodle or pleased that he was being friendly. I chose friendly. I laughed. "Yes. But did you ever see a *red* poodle?"

Now he laughed, *heh heh heh*, as he moved back into his apartment and I started down the stairs. But as soon as I got inside my apartment, I called Lee Boyer. "If the current tenants know I'm not going to renew their leases, can I allow them to leave earlier without having to sublet?"

"What are you up to now, Miss Moppet?"

I told him about my interaction with Maddox Campbell and Lee promised to do a little research. "I don't want you to get stuck with a lot of empty apartments before you're ready to fill them with your House of Hope tenants." I could just imagine him shaking his head. "You can't save the whole world, Gabby. But you *could* save a lonely guy from eating takeout again. How about dinner tonight?"

I was definitely tempted. And I'd already turned him down on Friday after the custody hearing. But . . . "I'm sorry, Lee. It sounds great. But it's a school night for the boys and I want to spend some time with them. Rain check?"

Short pause. "Is that a promise?"

I laughed. "You sound pathetic. Yes, it's a promise. Next Friday? The boys will be with their dad." I hoped. If the plan hadn't changed by then.

I'd promised the boys we could watch a movie if they got their homework done by seven, so we made popcorn, drank "orange Cokes," and watched *The Pink Panther*—the Steve Martin version—with a pile of blankets and pillows since I didn't have an actual couch yet. We laughed ourselves silly, though I winced at some of the crude humor, and ended with a pillow fight. But once they'd gotten ready for bed, I stopped in P.J.'s room to say good night. "You figure out where to catch the bus tomorrow? Better give yourself extra time. It's going to take longer."

"I'm good, Mom. It's just a straight shot down Addison." He rolled over.

I leaned over the bed and kissed the back of his head. Smooth dark hair, so like Philip's. "Good night. Love you." *Take care of him tomorrow, dear God . . .*

Next stop, Paul's room. He was propped up in the bottom bunk with a book. I sat down on the edge of the bed. "Hey, kiddo. What are you reading?" He held it up for me to see. "*Dog Stories?*" Uh-oh. I could see where this was heading.

"Yeah. Got it from the school library."

"You'd really like to have a dog, wouldn't you?"

He shrugged. "Yeah, but . . . not just any dog." He hugged the book. "Wish you hadn't given Dandy away. He was practically like my dog."

"I know, kiddo." What else could I say? We'd been through the why-I-gave-Dandy-to-Lucy scenario before. I gently took the book and turned out the reading light as Paul slid under the covers.

"I see him, you know."

"What do you mean?"

"When I go to Dad's. When I look out the penthouse window, I can see Dandy and Lucy down in the park. Sometimes she's looking up at the penthouse. Seems like it anyway."

"Really?" That was curious.

"Yeah. Why is she always in that park? I mean, it's not that close to Manna House. Doesn't she stay at the shelter too?"

"Sometimes. Usually when the weather's bad. Maybe that park is where she's used to hanging out. That's where I first met her, you know." "Met" being a rather loose term for how I'd run into her cart sticking out from under a bush, smack-dab in the rain, me crashing onto the muddy ground and ending up with a bloody foot . . .

"Yeah, I know. But when I saw her and Dandy this weekend, I went right down the elevator and ran outside to see Dandy—but I couldn't find them. It was like they just disappeared . . ." I heard a sniffle in the darkness. ". . . or didn't want me to know they were there."

chapter 32

True to his word, P.J. left the apartment fifteen minutes earlier the next morning to catch the bus that would take him to Lane Tech. He even remembered to take his lunch. *Well, good for him. He wants to make this work.* I tried not to think too much about the reason he'd rather take the bus than get a ride. His attitude would work itself out if I didn't make a big honking deal about it.

I hoped.

Mabel seemed a little put out now that she had to take Jermaine to school *and* pick him up, though she agreed that if P.J. didn't want to ride together, it was for the best.

I drove Paul to Sunnyside, reviewing the plan we'd made for him to walk Sammy and Keisha back to Manna House after school. He seemed upbeat, in spite of his "doggy mood" the night before. "What about Trina and Rufino?" he wanted to know. "I could walk them, since they have to go back to the shelter too."

"Yes, but they're still pretty little, you know." Trina was in second grade and Rufino just starting first. Their mother, Cordelia

Soto, had been at the shelter for a couple of months, but was hoping to move in with her brother in the Little Village neighborhood, home to many Mexican and other Spanish-speaking Americans—which would mean having to change schools. A lot of upheaval for little ones. "Their mom wants to walk with them for a while."

Much to my relief, frankly. It was one thing for Paul to walk back to the shelter with Sammy and Keisha, who were older. But round up and keep four kids out of the street? Two of whom were only six and seven? That was a lot of responsibility for a twelve-year-old.

I thought the shelter would be a bit quieter with the kids at school, but Angela rolled her eyes as I came in. "The day has barely started and already Sarge had to throw two women out who started a fight," she muttered, pushing the sign in/out book at me.

I signed in. "Over what?"

"Who knows? Somebody dissin' somebody over something."

"It wasn't Naomi Jackson, I hope." If Naomi was still here, it meant the young girl had managed to stay off the street—and off drugs—for five whole days so far.

"No, a couple of cats who came in over the weekend. I think I remember the one named Alisha from before."

I snorted. "Right. Bet it was Chris and Alisha. Figures." The two women had been on the bed list at least twice since my sojourn at Manna House—streetwise prostitutes who tended to show up whenever there was a crackdown on the "business" by the cops. But they always seemed to kick up dust, staying out past curfew or breaking some other shelter rule, then raising a ruckus

when they got tossed out. They were usually told they had to stay away at least thirty days before trying again.

"Well, at least they won't be back for another month." I gave Angela a thumbs-up and pushed through the double doors into Shepherd's Fold, hoping there would be some fresh coffee in the carafes . . . and then stopped. Naomi Jackson was curled up in one of the overstuffed chairs in the big room, arms wrapped around her knees, head down, her shoulders shaking. Tawny was crouched by her side, saying, "Hey, hey. What's wrong, girl?" but getting no response.

I walked over and touched Tawny on the arm. "Thanks, Tawny. I'll talk to her."

At my voice, Naomi jerked her head up, her face wet, her nose running, eyes accusing. "How come you ain't been around?!"

I sat down on the arm of the overstuffed chair. "Because I don't work on the weekend, Naomi. What's wrong?"

She wiped her face on her T-shirt. "Nothin' . . . I mean, ever'thing. You don't know what it's like . . ."

That was true. I didn't. "But you're still here. That's a good thing."

"I dunno," she said dully. "Dunno if I can make it. That Sarge! See, one of my homegirls—name Alisha—was here, an' felt sorry for me, was gonna give me a joint to help calm my nerves . . . but that Sarge yelled bloody murder an' threw her out." Naomi sniffed. "She was jus' tryin' to help me."

"Oh, Naomi. You don't need that kind of help." I was sure of that, but what kind of help did she need? "Who's your case manager? Are you going to see her today?"

Naomi shrugged. "That Cooper lady—but I don't got an

appointment till tomorrow." She looked up at me hopefully. "Can I hang out with you today?"

I was taken aback. I had a couple of proposals for new activities I wanted to work on before the weekly staff meeting at ten, but . . . oh, why not. "I've got work to do, but if you want to hang out in my office, that's fine with me. You got a book to read or something?"

Naomi's weepy eyes actually got bright. "For real? Don't read much, but I like to draw sometimes . . . you got some paper an' stuff?"

"Paper and stuff" I could manage. I headed for my office with Naomi on my heels. I wished I didn't feel so ignorant about how to help someone like this girl. Now Tawny . . . that girl was going to make it, in spite of her circumstances. But Naomi?

Maybe I should ask in staff meeting what kind of training I'd need to become a case manager . . . Huh! Like I needed something else to do!

It felt good to be back into the normal swing of things now that school had started—if "normal" could be used to describe a job where the clientele included prostitutes, older teens abandoned by DCFS, women trying to kick drug addictions, even the occasional professional with a college degree . . . Where three or four different languages or dialects peppered mealtimes, and the "décor" in my broom-closet office included a couple dozen stuffed-animal dogs donated by the people of Chicago . . . Where a retired female army sergeant ruled the roost at night, and

Estelle Williams—soul-food cook extraordinaire and the love of my friend Harry's life—ruled the kitchen by day.

Yes, Estelle was back, banging pots and pans with her usual abandon. Which meant Harry must be doing better.

To top off my "normal" day, Paul showed up at the shelter with his two charges right on time after school and even asked Carolyn for some help with his Algebra. And P.J. showed up at home before supper without getting lost or mugged.

But the *coup de grâce* was the call from the bank Tuesday morning, saying my mortgage loan had been approved. I was so excited, I did a Snoopy-dance in the dining room outside my office—to the snickers of several residents who'd come downstairs to "nuke" their coffee and fulfill chore duty by washing sheets from the bunkrooms.

"Normal" took a sharp right turn on Tuesday afternoon, however, when a couple of Sunnyside parents got wind of the afterschool program Carolyn was doing at the shelter, and they showed up in Mabel's office wanting to know if the program was open to the neighborhood.

After taking their names and saying we'd have to run the possibility by the Manna House board, I heard loud "music" coming from the lower level as I headed back to my office. Following the sound to the rec room, I stuck my head in the door to see Jermaine Turner's fingers flying over his electronic keyboard and Paul drumming with two drumsticks on an upended plastic bucket to the adoring audience of Dessa and Bam-Bam, Manna House's youngest residents.

"Mom!" Paul jumped up. "Look who's here! Jermaine doesn't have anything going on after school on Tuesdays and Thursdays,

so he's gonna come here. Isn't that cool?—Oh! Can you bring my keyboard to work with you Thursday? We wanna work on some music together."

Philip didn't call on Monday or Tuesday about changing the boys' schedule. But just in case, I tried to think it through as I breaded some fish to fry for supper Tuesday night. Did we even have any other options? Sunday through Thursday were school nights, and they wouldn't give Philip any more time with P.J. I was reluctant to suggest Saturday evening through Sunday evening, because then they'd miss church and the boys seemed to be enjoying SouledOut—once they got there anyway. And most of the complaining about having to get up on Sunday morning wasn't any worse than having to get up and go to school.

Holding a spatula in one hand, I stared at the kitchen wall calendar. Maybe I could offer to let the boys stay longer Saturday evening on the weekends P.J. had cross-country meets. *Which were . . . ?*

I was looking at the schedule of cross-country meets when I heard the front door slam and P.J. hollering down the hallway toward the back of the apartment. "I'm home!" A few moments later he appeared in the kitchen. "Supper ready? I'm starving! Coach worked us real hard today because we're hosting our division meet tomorrow after school. All the freshmen and varsity teams are running." P.J. grabbed a fork and speared a hunk of watermelon I'd planned to serve as a fruit salad, stuffing it into his mouth. "Can you come?" he asked with his mouth full, melon juice squirting six different ways.

I'd just noticed the midweek "Lane Tech Invitational" on the schedule. "If I can. What time?"

My oldest speared another hunk of watermelon and shrugged. "I dunno, four o'clock I think. Hey! I'm gonna call Dad, see if he can come too."

I almost told P.J. his father probably couldn't since it was a workday, not wanting the boy to be disappointed. But I bit my tongue and served up the golden-brown catfish, some plain rice, a heap of hot peas, and the rest of the watermelon while P.J. was on the phone. By the time I'd corralled Paul and got him to the kitchen table, P.J. was off the phone, a grin on his face. "Yeah, he's coming."

"Coming where?" Paul asked. "Can I come too?"

I almost forgot to pray a blessing on our supper. *Well! This ought to be interesting. The whole family . . .*

Paul and I drove around behind the high school and found a parking space on the backstreet that ran alongside the Chicago River as we'd been instructed. The street was filling rapidly with cars pulling in between an assortment of buses from other schools. An early-morning thunderstorm had given way to a cool fall day, neither hot nor cold, the air clean and fresh. An open field lay between the backstreet and the narrow river, which was hidden in a low channel and flanked by a thick wall of trees.

We followed the general drift of parents and siblings across the field, passing numerous canopies set up by each school. Lanky teenage boys and girls in all shapes and sizes and school colors

swarmed everywhere. I tried to read the names of the schools on the sweatshirts and athletic tank tops as groups of runners warmed up. Loyola Academy . . . Whitney Young . . . Payton Prep . . . Latin School . . . Von Stueben . . . Lakeview . . .

"Oh my goodness," I muttered, "we'll never find him."

But somehow P.J. found us, running toward us in his silky green shorts and gold tank top. "Hey! You made it. Girls race first. My race is second." P.J. punched Paul playfully on the shoulder. "Wanna race me, squirt?"

Paul shrugged him off and peeled paper off a stick of gum.

"I didn't know there'd be so many people here! How'd you find us?"

P.J. snickered. "Your *hair*, Mom. I just told my teammates to look for Little Orphan Annie, and they pointed you out."

Figures. It was great to see P.J. in such a good mood. Had he grown a couple of inches since last night? Why did he look so tall and muscular all of a sudden? Like a high school athlete instead of a kid. He twisted his head around, his eyes darting here and there at the crowd of spectators. "Have you seen Dad?"

I shook my head. "Not yet. But if he said he'd be here, I'm sure he will."

"Well, just look for my number . . . 29! See ya!" P.J. ran off, rejoining the sea of green-and-gold doing warm-ups.

The girls from the different schools soon lined up, the gun went off, and their teammates cheered them on as the pack started around the field, angled onto the path alongside the river, and then disappeared into the wooded area at the far end. For P.J.'s sake, I was glad his race wasn't first. Maybe Philip would still get there in time.

Three times around the course, I was told. The first of the girl runners were just coming out of the woods across the finish line when I heard . . .

"There you are."

I turned at Philip's familiar voice. He was smiling. Gosh, he looked so . . . fine. A lock of dark hair fell over his forehead, complementing the casual tweed sport coat he was wearing over an open-necked white shirt, khaki Dockers, and the ever-present aviator sunglasses.

"Hey, Dad!"

"Hey yourself." He knuckled Paul's head. "Where's P.J.?"

"He's over there warming up with the Lane Tech team. Number 29." I kept my voice neutral. "He'll be glad you came."

"Yeah, well, traffic was a hitch as usual. What's the schedule?"

"His race is next. See?"

The Lane Tech boys' team was lining up with the teams from the other schools—four runners from each school—and a few moments later the starting gun cut the air. "I see P.J.!" Paul yelled. "Go 29!"

We kept them in sight for about two minutes, and then they swung through the stand of trees at the end of the field and disappeared. It would be several minutes before the first runners came around the course and off again on the second leg. But the crowd of parents and fans faded from my awareness, and I was acutely conscious of Philip's presence, his familiar height and maleness, even that slight whiff of the Armani shaving lotion he liked. The one I'd given him for his last birthday.

"Uh . . ." I needed to fill the silence. "You wanted to talk about changing the boys' schedule?"

He didn't reply, but patted his back pocket, then pulled out his wallet and removed a five. "Paul! Go get us some Cokes, will you? Anything."

"Cool!" Paul took the money and ran off to look for a vendor.

Philip took off his sunglasses and slipped them into his coat pocket. "Guess I was thinking about the same schedule, just twenty-four hours later. Saturday evening until Sunday evening. Except . . ."

I was all set to give my objections about church, but caught myself. "Except what?"

"I . . . well, I go out of town sometimes, might be hard to get back right at six on Saturday night."

"Oh, sure. If you're having a good run at the card tables, why in the world would you want to come home in time to be with your sons?" I turned my head away.

I expected a comeback to my sarcasm, but he said nothing for a moment or two, and when he did, he actually sounded regretful. "I know what you're thinking, but it's . . . it's not like that, Gabby."

I turned back, feeling sparks behind my eyes. "Then what *is* it like, Philip?"

The crowd around us started yelling. The string of runners came out of the woods, around the field, and disappeared again. We cheered and waved at P.J., but he was concentrating on his run.

As P.J. disappeared from sight once more, Philip shoved his hands in his pants pockets and hunched his shoulders. "I told you. I'm in a jam. Trying to work my way out of it. But I was able to get a loan . . . I just need time."

The sparks sizzled and died. I stood there, looking at the man who'd been my husband for almost sixteen years. And suddenly I felt afraid—not for me, but for him. A jumble of scenarios rushed to the front of my brain. The night he was late picking up the boys . . . the phone call where he'd called out Fagan's name . . . Estelle's alarm when she heard it . . . the things Harry Bentley had said about Matty Fagan . . .

Impulsively I put my hand on Philip's arm. "This man you borrowed money from . . ." I knew I was jumping off a cliff here. This was the first time he'd mentioned that he'd gotten a loan, and how would I know it was a person and not a bank or credit union? But I plunged on. "Is his name Matty Fagan?"

Philip looked at me sharply. *Bull's-eye.* He stiffened and pulled his arm away from my hand. "It's really none of your business, Gabrielle."

"Philip! Listen to me." I was pleading now. "I don't know how you know him, or how much he loaned you, but Matty Fagan is a rogue cop who's been indicted by Internal Affairs for misconduct, fraud, shaking down pimps and drug dealers, selling drugs and weapons back on the street—you name it!"

Philip frowned. "How do you know anything about Matty Fagan? Who's been telling you a lot of scary stuff? He came recommended."

"He used to be part of the same police task force with Harry Bentley! Didn't you know Harry is a retired cop? You can find out yourself by calling the Chicago Police Department. But he's dangerous, Philip. If you can't pay him back . . . I don't know, but I've heard stories. I'm afraid for you. Please—"

"Here are the Cokes!" Paul pushed in between us, juggling

three cans of pop. "All the guy had was root beer and cream soda. Hope that's okay—hey, look! Some of the first runners are coming in! Do you see P.J.? Look for number 29!"

chapter 33

We never did decide on a workable change in the visitation schedule. Philip got tight-lipped and left soon after congratulating P.J. on a good run, even though the team from Whitney Young won the boys' race. Paul and I hung around for two more races until P.J.'s coach released the Lane Tech teams, but the unfinished conversation about Matty Fagan weighed heavily on my spirit all the way home.

Josh and Edesa were at the six-flat when we got back from the meet, trying to finish up the sanding and wall prep on the first-floor apartment, while Gracie toddled around banging a wooden stir stick on buckets, ladders, and windowsills to test their percussive qualities.

"Let me take her." I laughed, picking up the hefty toddler, who immediately went for my hair. "Ouch! Let go, Gracie . . . Anyway, she can eat supper with us. How about you guys?"

"Oh, Sister Gabby!" Edesa sighed gratefully, looking cute as a bug with her corkscrew curls tied up in a bandana. "That would

be *bueno* . . . but do not worry about us. We can eat something later."

"It's not a worry. Look at all the work you're doing! Will we be ready to paint on Saturday? We need a trip to Home Depot."

"*Sí!* We could go Friday night. We already picked up some color strips."

"Sounds good! . . . Oh, wait." I'd promised Lee I'd go out with him Friday. "Uh, no, can't do it Friday. How about tomorrow night?"

By now Gracie was squealing to be put down, so I whisked her across the hall to our apartment and let her bang on some pots and pans while I fried ground beef and chopped lettuce, onions, and tomatoes for a quick taco meal. "Mom!" Paul groused from the dining room table, where he was reluctantly tackling his algebra. "Does Gracie have to bang on those pans?"

I poked my head around the door. "Hey, if you add Gracie's drumming to your jazz duo, you'd practically have a band."

Paul made a face. "Not funny. Just don't forget my keyboard tomorrow."

I called Josh and Edesa to join us when I had the taco makings on the makeshift dining room table—I really needed to go furniture shopping!—and it was fun having spur-of-the-moment guests. As the boys teased Gracie, who was trying to mimic everything they did, I suddenly realized that living in the same building would make sharing meals like this easy to do.

For a moment the loneliness I lived with every day evaporated just a little.

"Are you okay, *mi amiga?*" Edesa asked, helping me clear the table afterward.

I nodded, but realized it wasn't true. After making sure the boys were out of earshot, I spilled my worry about Philip. "At first I was just upset about his gambling. But I think he's gotten desperate about this debt hanging over his head. Not sure why he can't just get a bank loan and pay it back the regular way, but I think he's trying to take a shortcut, some shady loan shark. I tried to warn him, but—"

"Oh, Gabby." Edesa pulled me into a chair and held my hands across the small kitchen table. "We need to pray for him. You did a good thing to try to warn Philip, but now you must leave him in God's hands." Squeezing her eyes shut, the young black woman began praying in Spanish, and then translating for my sake.

Leave him in God's hands . . . Put Philip in God's hands . . .

It felt strange to pray for Philip that way. But it felt good too. It was hard to be angry with someone I was praying for.

Lee called the next day to ask what time he should pick me up on Friday night and to tell me we finally had a closing date. "That's two weeks from today!" I squealed. "Maybe by then we'll have the apartments painted and our first House of Hope residents can move in that weekend!" I grabbed the calendar and wrote "Moving Day!" on the last Saturday in September.

Lee was quiet a moment. "I sure hope you know what you're doing, Gabby. I just don't want you getting in over your head or getting hurt."

I closed my eyes, imagining the look in his gray eyes. Gentle, concerned. "I know. I appreciate that, Lee. It's just . . . sometimes

you have to take risks to do something important. This is something I really want to do."

"Yeah, well, that's my Gabby. Just don't get so focused on saving the world that you don't save some time for me."

When we hung up I felt all a-jumble. Did he really say *"my Gabby"*? Those words made me feel warm and delicious, like eating sweet cinnamon rolls right out of the oven. At the same time I felt annoyed. Did he want me to drop everything that was meaningful to me just to spend time with him?

That had an echo of Philip to it.

Or maybe I was being oversensitive.

I shook off my annoyance and decided to work on a letter to the remaining tenants, explaining that I was the new owner, that I would not be renewing any leases, and if anyone wanted to move before their lease was up, to talk to me and we would work something out. That was being reasonable, wasn't it?

I remembered to bring Paul's keyboard to work with me on Thursday, and he and Jermaine had a "jam session" after school. I wasn't a huge jazz fan, but I had to admit they were pretty good for a couple of kids. A few of the residents complained about the noise and Carolyn had a hard time keeping Sammy and Keisha focused on their work in the schoolroom, so I had to insist that the boys close the door to the rec room and turn down the volume.

"Maybe we need to add music appreciation to the afterschool program," Carolyn said wryly, as she dragged the kids back upstairs—but I could tell she was more amused than upset.

I had borrowed the sample color strips from Josh and Edesa, and before leaving Manna House on Thursday I sat down with Precious and Tanya to choose paint for the first-floor apartment. Tanya was mesmerized by the shades of greens and blues, yellows and reds, turquoise and melon colors, leaning toward the brightest colors at the ends of the strips. "Uh, remember, Tanya," I cautioned, "a little color goes a long way on a wall."

The young mother finally chose "Strawberry Red" for one wall of her bedroom with a pale tint version of the same color for the other walls, and agreed to white for the window trim after I suggested she could paint her bedroom furniture black if she wanted. Precious chose a "Goldenrod" yellow for her bedroom with something called "Green Tea" for trim. I insisted on ivory for the long windowless hallway to lighten it up, but agreed on a couple of blue shades for the bathroom, an orangey "Melon" for the kitchen, and some pretty greens and ivory for the living and dining rooms.

But I felt wrung out at the end of our paint-color session. Was I going to have to go through this with the rest of the apartments and their new residents?

At the hardware store that evening, I left Josh and Edesa to pick out their own colors for the third-floor apartment, while I piled my cart full of the paint for the first floor. I saw Josh and Edesa arguing at one point and realized their different cultural backgrounds—not to mention the whole male-female thing—were probably clashing no less than me with Precious and Tanya. Chuckling, I pushed my overloaded cart to the paint mixing area. For some reason it made me feel better.

Until the clerk rang up both carts full of paint, that is. I had

no idea it would cost so much! *Oh, Lord, help!* I silently sent up a heavenly SOS as I handed over my credit card. *Maybe this is dumb to paint before closing on the six-flat—but I'm stepping out in faith here, believing this House of Hope has Your blessing. You know Josh and Edesa are hoping to move sooner rather than later, and the same with Precious and Tanya. But*—I gulped as the clerk handed me the twenty-inch long register tape—*I know I have a bad habit of running ahead of You, Lord . . .*

We stuffed the paint cans, thinner, brushes, rollers, and metal paint trays into the Subaru, leaving hardly any room for Edesa to squeeze into the backseat while Josh and I climbed into the front. Then we reversed the process when we got to the six-flat, unloading it all into the first-floor apartment. But I picked up my prayer again when I finally collapsed into bed.

. . . So if I'm wrong here, God, I'm asking for a little mercy. Please, just get us through the closing without any major pitfalls!

I finally got to attend one of Edesa's *Bad Girls of the Bible* studies Friday morning. About seven residents, including some of the younger ones like Aida, Tawny, and Naomi, had pulled chairs into a circle in Shepherd's Fold and were listening as Edesa read verses from the Bible about Michal, the daughter of King Saul and wife of the future King David, when I slipped into a chair off to the side. I'd always heard David the shepherd boy, the giant-killer, the psalmist, and second king of Israel taught in glowing terms. But, Edesa said, the author of this study—Liz Curtis Higgs—had a different take when it came to Michal. She

was crazy in love with the popular young man, but to David, she was mostly a political move, a way to make Daddy Saul happy.

I listened as Edesa summarized the story that was only vaguely familiar—the story of Michal wasn't exactly Sunday school material—how she helped David escape when her daddy was trying to kill him . . . how King Daddy had declared her marriage null and void and given her to another guy . . . how years later David, now the king, had demanded her back . . . and finally, how she'd watched him worshiping God and dancing with joy as he brought the Ark of God back to Jerusalem—and despised him for acting like a fool.

"So that makes her a 'bad girl'?" Tawny spluttered. "Who can blame her? He treated her pretty bad."

Ditto that, I thought. Pretty Boy David reminded me a lot of a certain man in my life who looked like a good catch at first, but wasn't exactly Mr. Charming at home. Not lately, anyhow.

The conversation got pretty hot, but Edesa was able to make a few points from the story. "*Sí*, we agree, *mi amigas*, Michal had good reason to feel abandoned and hurt—but she had let the *hombres* in her life define her, rather than leaning on God to lift her above her circumstances. And she had developed a critical spirit, which not only caused her to ridicule David but to reject the God he was worshiping."

Humph. The analogy to Philip broke down at this point, because the proper Philip Fairbanks was definitely *not* a worshiper, dancing or otherwise. But I squirmed a little at Edesa's comment that Michal had let the men in her life define her. The failure of my teenage marriage to Damien Spencer—my "Romeo" church youth group leader—had sent me running away from

God. Then marriage to suave and sophisticated Philip Fairbanks had made me decide God was irrelevant to our good life.

Only when the bottom fell out of my life did I realize God wanted to put His arms around me and pick me up . . .

For some reason I started to weep—silently, hoping the women sitting in the circle wouldn't notice. But a few moments later I felt a pair of slender arms slide around me from behind. "Oh, Miss Gabby! What's wrong? *You* can't cry. You gotta be strong so I don't cry . . ."

I wept all the harder. I knew that voice.

Naomi Jackson.

chapter 34

After Philip picked up the boys Friday evening, I felt a little guilty skipping out with Lee, leaving the young married Baxters still doing the final prep on the walls for the "paint party" the next day. But I was so glad to be whisked away in Lee's Prius—away from homeless girls like Naomi Jackson, barely out of their teens and already wasted by drugs . . . away from reminders of my own current marriage mess . . . away from a three-story building that would soon be *my* financial responsibility . . .

"You okay, Gabby?" Lee glanced over at me as he drove down Lake Shore Drive into the city. "You're kind of quiet."

"Mm, I'm fine." I leaned my head back on the seat rest, closed my eyes, and let the wind from the open windows whip my auburn curls into a welcome frenzy. "Just blowing the cobwebs out."

I heard him chuckle. "Know what you mean. I had several clients this week that made me seriously consider burning my law license."

We rode down the Drive in comfortable silence except for the

country-western music sniveling from the radio speakers. The September evening was perfect, the air balmy, the sky overhead mottled with clouds outlined in brilliant pinks and oranges from the setting sun somewhere beyond the city, the choppy lake to our left dotted with sailboats making the most of the offshore breeze. I wished we could just keep driving . . .

But when Lee finally turned off the Drive and pulled into an underground parking garage, I stuck my fingers into my hair trying to detangle my wind-whipped curls. "Ouch," I groaned, jerking at another snarl. "Now I'm paying for my wild life."

"Don't worry." Lee grinned, coming around to open my car door and help me out. "No one but you knows about those snarls. It still looks the same."

"Oh, thanks. With friends like you, who needs a mother?"

He laughed. "Hey, I like the tousled look."

I hustled to keep up with Lee, even though he had me by the hand as we climbed the stairs out of the subterranean garage. He'd told me to dress "nice but comfy" so I'd worn a flowered peasant skirt, tank top and light sweater, and flat sling-backs. "Where are we going anyway?"

"Ah. Wait and see."

We ended topside at Chicago's new Millennium Park, eating at the Park Grill, which was a lot fancier than the name implied. We started with a yummy garlic and tomato hummus, dipping baby artichoke leaves, grape tomatoes, and pita bread, followed by a chilled melon gazpacho soup to die for. I wasn't sure I had room for the main course, but ordered the rich, cheesy fettuccine while Lee had the cedar-planked lake trout.

"No, no, absolutely don't have room for dessert," I protested

an hour later, so Lee paid the bill and we wandered outside to look at the Cloud Gate sculpture—otherwise known as "The Bean" because of its shape—created by its artist to reflect the sky and lights of the city. Daylight had disappeared, but the city skyline was brilliant, creating its own stunning architectural design against the night sky.

Funny thing, it suddenly made me wonder what the Celestial City in heaven might look like. I'd never tried to imagine it before, but it had to be at least as beautiful as this night . . . only more so! A million lights sparkling like diamonds? The streets full of people singing and dancing? An atmosphere of excitement and joy and expectancy because King Jesus was in town?

I almost blurted out my thoughts. Almost. Would Lee think I was weird to say I was starting to sense God everywhere? He never mentioned God or anything spiritual. So I just breathed, "It's beautiful," as we walked hand-in-hand along the promenade.

"So are you," Lee murmured, slipping an arm around my waist and pulling me closer.

I let my head rest on his shoulder as we walked, but when we came to the Crown Fountain with its two rectangular towers projecting the faces of people who spouted water out of their mouths into a shallow pool, I couldn't resist slipping off my shoes and wading into the pool. "Come on in, silly!"

"Who, me silly? Only when I'm with you." Lee tugged off his boots and socks and rolled up his pant legs, and we splashed in the pool, along with twenty or so others waiting for the spouting mouths—at which time half of the waders ran under the streams of water, laughing as they got soaking wet. Lee pulled me over to the stone benches, murmuring, "We're too old and smart to

get a soaking at ten at night, right? Here, use my sock to dry your feet"—which made me laugh so hard I nearly fell off the bench back into the wading pool.

The Prius pulled up in front of the six-flat about eleven. "Guess Josh and Edesa aren't pulling an all-nighter," I murmured, glancing at the dark windows of both the first- and third-floor apartments. "They've done a lot of work, though. We're planning to paint tomorrow." *What now? Should I get out? Let him walk me to the door?*

Dating was awkward after you'd been married for fifteen years.

Lee came around to my side of the car, opened the door, and we walked up the sidewalk together. "It's still early," he said as I fumbled in my shoulder bag for the house key. "You got any coffee? Beer? A nice red wine? Dry socks?"

"Just coffee and dry socks." I grinned, pulling out my keys. He wasn't being very subtle. I was tempted to extend our pleasant evening . . . what would a cup of coffee hurt?

But I knew good and well coffee wasn't what Lee had in mind. He'd been attentive and affectionate all evening—holding hands, walking with his arm around me, kissing me in the middle of the wading pool. Taking our relationship to the next level . . . which was what, exactly?

Impulsively I rose on my tiptoes and brushed his cheek with my lips. "Good night, Lee."

"Gabby, wait." He grabbed my arm as I pushed open the foyer door. "I'd like to come in. The boys are gone tonight, right? What's the problem?"

I turned my head away, blinking to hold back sudden tears.

Yes, the boys were gone. Friday nights always yawned empty. Why not fill the house and my bed with someone who loved me? It wasn't like I was still married—well, technically, yes, but not really. Not "two shall be one" married . . .

That was the problem. Lee and I weren't "two shall be one" married either.

"I'm sorry, Lee. I . . . can't. Please . . ." I pulled my arm away and let the foyer door wheeze shut between us, leaving him on the steps outside. My hands were shaking so badly, I could hardly fit my key into the inner door. By the time I finally got inside my apartment, tears were sliding down my face.

I didn't sleep well, waking up early with the top sheet knotted around me as if I'd been wrestling it all night. *Ugh.* I'd forgotten to brush my teeth before falling into bed and could taste my bad breath. Swishing my mouth with mouthwash, I stared in the bathroom mirror at the bags under my eyes. *So where did it get you, Gabby, being a self-righteous prude?* Another lonely night in the single bed I'd brought from my parents' home in North Dakota, that's what.

But as I put on the coffee, I noticed the index card I'd taped to the cupboard with the verse from Proverbs I'd been memorizing, paraphrased to make it personal. "I will trust in the Lord with all my heart," I murmured, reading the card, "and will not lean on my own understanding. In everything I do and say, I will acknowledge that I'm following God, and He will show me which path to take."

I sighed, poured the first cup of coffee that dripped into the pot, and took it to the window seat in the little sunroom at the front of the apartment. Sunlight filtered through the leaves of the trees along the parkway, birds flitted here and there chirping a welcome to the day . . . and gradually the pity party I'd been having all night began to dissipate like the dew on the patch of grass outside.

"Okay, God," I sighed, "maybe I didn't exactly acknowledge You last night, but You did show me the right path. It's just . . . hard, You know? I really like Lee, and I get so lonely sometimes. I need You to walk with me and show me the way, because it's not always easy to recognize the right path."

Hide My Word in your heart, Gabby. Then you'll know the way. The words seemed so clear, I felt startled, and for a nanosecond wondered if someone else was in the room. But then I realized it was the same quiet Voice that had whispered in my spirit, *Come to Me.*

Hide My Word . . . well, I had to read it first. Fortified with my Bible and two more cups of coffee and cream, I was still curled up on the window seat in my silk lounging pants and chemise when the Baxter minivan pulled up in front of the six-flat and the whole Baxter tribe piled out, along with Estelle and her housemate, Stu. "Good morning!" I yelled out the open window. "Looks like a painting party! Give me five minutes and I'll join you!"

By the time I pulled on some old sweats and a paint-spattered T-shirt and joined the crew, more help had arrived, bringing additional brushes, rollers, and paint pans. I recognized several of the "sisters" from Jodi's Yada Yada Prayer Group . . . the spiky-haired girl they called Yo-Yo, the couple Josh and Edesa were currently

renting their tiny studio from—Florida and Carl Hickman—and the single mom who'd won all that money in the Illinois Lottery. Candy or Chancy or Chanda, something like that.

Josh took off in his folks' minivan. "Where's he going?" I asked Jodi, staggering up the stairs with a couple of buckets of paint in each hand.

"Going to pick up some of the youth group from SouledOut who said they'd be willing to help out."

Shoot. I wished P.J. and Paul were here, but even if they weren't with their dad, P.J. had another meet out west somewhere—Peoria? As soon as we got the paint distributed to the right rooms, I was going to go pick up Tanya and Precious from Manna House. I was sure they didn't want to miss *this* party.

Most of the painting crew left by suppertime, but Josh and Edesa and the senior Baxters were back Sunday afternoon after church, in spite of some threatening thunderstorms. "We can only stay a couple of hours," Jodi said, "because SouledOut is doing the Sunday Evening Praise at Manna House this evening—every third Sunday, you know."

I nodded. But to tell the truth, I hadn't been back to Sunday Evening Praise since I'd moved out of the shelter and gotten my sons back. Getting them to church on Sunday morning was a major accomplishment as it was.

Josh sweet-talked P.J. and Paul into helping him paint the long hallway in 1A, and a few curious questions got P.J. chatting almost nonstop about the cross-country meet in Peoria the day before. I

grabbed a roller and worked with them, too, just to be with the boys and eavesdrop on their conversation.

"So what do you do at a meet on a day like today—you know, rain and thunderstorms?" Josh asked.

P.J. dipped his roller in the pan of ivory paint and rolled every which way. "If it's just rain, we run anyway. But I think they call it off if it's a lightning storm. Which would have been a bummer yesterday, since it took three hours to get there!"

With four of us painting the hallway, we got it done in record time and the boys moseyed back to our apartment while Josh and I cleaned brushes in the bathtub of the empty apartment. Suddenly he stopped, listened, and turned off the spigot. "What's that?"

I chuckled. "Just Paul playing around on his keyboard."

I started to turn on the gushing water once more, but Josh held up his hand. "Wait." He listened some more and then grinned. "He's good."

"Yeah. I guess. He and Jermaine started practicing after school at Manna House."

"Really?" Josh got a funny look on his face.

As soon as we finished cleaning the rollers, brushes, and paint pans, he made a beeline for our apartment and I followed. "Hey, Paul, you're pretty good," Josh said. "You want a gig, like tonight?"

Paul just stared at him, confused.

Josh laughed. "SouledOut is doing Sunday Evening Praise at Manna House tonight and our keyboardist got sick. You want the job?"

Paul shook his head. "Aw, I don't know church music. I just fool around."

"Do you play by ear? I mean, pick up tunes you hear?"

"Well, sure. I do that all the time."

"Well, you're my man, then! We have a guitarist who can play the chords, and singers who carry the tune. You can just pick it up."

Paul was staring at Josh wide-eyed. "Uh, could I call Jermaine Turner? I mean, he's real good. Maybe between the two of us . . ."

"Sure." Josh grinned at me. "Can you get Paul there by quarter to six?"

I'd been listening to this conversation trying to keep my jaw from dropping. But it looked like we'd be going to church again tonight.

chapter 35

✵ ✵ ✵

I couldn't believe Paul and Jermaine. With each new song sung by SouledOut's praise team, the young teens developed more confidence, catching the right key and playing along with the melody at least half the time. The residents loved it, clapping to the music and giving shouts of encouragement! Most of them knew the boys or had seen them around Manna House often enough.

A heavy thunderstorm let loose right in the middle of the service, drowning out the music. But I did hear the front door buzzer and ran to let in whoever it was before they got caught in the deluge—and nearly got bowled over by a wet, yellow furball jumping all over me, whining and licking my face, followed by Lucy Tucker pulling her dripping wire cart into the foyer.

"*Oof!* Get down, Dandy! Hey there, Lucy," I gasped, trying to keep my voice hushed in the foyer. "Ohh, you're all muddy, Dandy. Get down!"

"Whaddya 'spect when it's rainin' buckets out there?" Lucy dug around in her wire cart. "Got a towel in here someplace . . ."

She rummaged in a black trash bag and pulled out a large towel that had definitely seen better days. "Here, why don'tcha dry him off while I get somethin' dry on."

"Lucy, wait! They're doing Sunday Evening Pra—"

Too late. She'd already pushed through the double doors pulling the cart behind her. A male voice was speaking—maybe one of the praise team, giving a testimony or something—but I still heard Lucy mumbling and her cart squeaking as they crossed the big room. I wasn't surprised when Paul came dashing through the double doors into the foyer to see Dandy—and the jumping and whining and licking started all over again.

"Paul! Shhh. Here . . ." I handed him the ragged towel. "Dry him off, okay?"

Somehow we got Dandy dried off and most of the wet mud on the tile floor mopped up. As the three of us slipped back into Shepherd's Fold, Dandy seemed content to just lie on Paul's feet at the back of the room as the testimonies and short teaching followed. When the praise team got up to do one last song, Jermaine beckoned wildly for Paul to come back and join him at the keyboards.

When Sunday Evening Praise was over, the shelter residents and guests from SouledOut gathered around the coffee cart helping themselves to store-bought cookies and lemonade. Denny Baxter and one of the SouledOut couples—Carl and Florida Hickman, who'd been at the six-flat yesterday helping to paint—were pushing chairs and couches back into place when Lucy came back in, dressed in a different layering of ill-fitting clothing, but at least these were dry. Coming to a halt in the middle of the room, the gray-haired bag lady squinted her eyes

and swiveled her head as if looking for something. "Where is it?" she demanded.

"Where's what?" Precious helped herself to another Oreo cookie and popped it into her mouth.

"Martha's plaque! A big mural on the wall! The name in lights . . . *somethin'*!" Lucy planted her fists on her hips. "This room got a new name, ain't it? But I don't see *nothin'* yet sayin' ya named it after Martha Shepherd."

"Oh, Lucy," I broke in. "It's only been a few weeks since we chose the name. We haven't had time—"

"Somebody say somethin' about needin' a mural on the wall?" Florida, Jodi's Yada Yada friend, poked her head into the group. The African-American woman was maybe ten years older than Precious, who was thirty, but she had the same in-your-face way of talking, as well as a scar running down the side of her face. The woman had been around.

"Well, Lucy was just wanting something in this room to let people know why we named it Shepherd's Fold," I said.

"Which was . . . ?" Florida pressed, simultaneously calling out, "Hey, Jodi, any more of that lemonade left?"

So I found myself explaining why Manna House had renamed the multipurpose room after my mother, as Precious and Lucy and several of the other residents chimed in bits and pieces of the story.

"Hm. Plaque would be nice with the lady's name an' all, but . . ." Florida Hickman surveyed the room, much as Lucy had done. "That wall there." She waved a hand at the wall opposite the double doors leading into the foyer. "As people come in, it'd be real nice to have a mural of the Good Shepherd, don'tcha think?"

"Uh-huh" . . . "That's it" . . . "You talkin' now, girl," murmured several of the residents.

Florida turned to Jodi and smirked. "You thinkin' what I'm thinkin'?"

"That's the trouble 'round here," Lucy grumbled, jerking her cart out of the circle that had formed around her. "People do too much thinkin' an' not enough doin' . . . Where's Dandy?" She stalked over to where Paul was brushing the dog's matted coat with a plastic brush from the Lost and Found. "Hey, now, that looks real good."

I followed, realizing leaving Dandy behind when we went home wasn't going to be easy for Paul. It never was.

He looked up at Lucy, his eyes challenging. "I saw you, you know."

"Did ya now!" Lucy said.

"Yeah. Saw you last week, saw you again yesterday in the park outside Richmond Towers where my dad lives. Like you're spying on us or something."

"Paul!" I gasped.

Lucy held up a hand before I could say anything else. "You got a real smart kid there, Miss Gabby. Real smart . . . C'mon, Dandy. Time fer us ta be goin'."

To my surprise, Dandy obediently got up, gave Paul a lick on the face, and followed Lucy out into the front foyer. When we left the shelter five minutes later, the rain had stopped and Lucy and Dandy were nowhere to be seen.

Paul was triumphant. "Did you hear that, Mom? Lucy didn't deny it! She even called me a smart boy, maybe 'cause I figured it out."

"Nonsense." I assured Paul that Lucy wasn't "spying" on them. Why would she? It was actually a rude thing to say, did he think of that? She probably thought his accusation was so far-fetched it wasn't worth responding to . . . but Paul had his mind made up, so I finally dropped it.

Boys!

That third week of September started to feel like fall, as the temperature dipped into the forties at night and the rain continued off and on for a couple of days. Both boys were settling into their school and homework routines—not to mention Paul and Jermaine seemed determined to practice music on Tuesday and Thursday afternoons in the shelter's rec room. It tickled me to hear snatches of the praise songs from Sunday night in their growing repertoire.

The bed list at Manna House also began to fill up because of the change in weather, meaning a new crop of residents to introduce to the various activities we were already offering—and now that fall was here, definitely time to initiate some new ones. I told the staff I wanted to schedule another brainstorming session to hear needs and ideas from the residents, and started making calls to get some field trips on the calendar. The Shedd Aquarium . . . Adler Planetarium . . . Field Museum of Natural History . . .

"Don't forget all those requests to open up the afterschool program to the neighborhood kids," Carolyn reminded me.

Expand Afterschool Program, I wrote on my to-do list. This

Saturday was the monthly Manna House board meeting. I'd try to get it on their agenda. And good grief! Had they gotten the go-ahead yet from the city for HUD's Supportive Housing partnership between Manna House and "Gabby the Landlady" to create this fledgling House of Hope? My closing was next week and people wanted to move in!

Definitely needed to meet with the board this weekend.

Estelle was back on deck for all her activities this week, including her knitting club during the nurse's visit on Wednesday morning. "Harry doing okay?" I asked, bringing her a fresh cup of sweetened coffee while she juggled the task of picking up somebody's dropped stitches while handling the clipboard with sign-ups of residents waiting to see Delores Enriquez behind the portable partition. "And how's your son?"

"Both of 'em comin' along, comin' along—if they'd both just do what they're supposed to do. *Humph*. What I got are *two* immature boys trying to be tough guys . . . Here ya go, honey." She handed a wad of knitting back to one of the new residents, and then picked up her own crocheting from the bulging yarn bag.

"What are you making?"

"Another hat for Lucy. I figure the first one is *definitely* gone and buried." She grinned at me and I grinned back. Lucy had tucked her original Estelle-creation into my mother's casket as a final farewell gift to her friend.

"So what's this?" I picked up a finished crocheted hat sticking out of her bag made of multicolored yarn with a cute wavy brim and crocheted flower on the side.

"Made that for Jodi Baxter. Her birthday was yesterday, but Yada Yada isn't goin' to celebrate it till we meet next Sunday—Oh,

hey there, Delores. You ready for the next sign-up?" Estelle looked at the clipboard. "Sunny Davis! You're up!"

I moved back toward my office to let Estelle do her job. Jodi's birthday was *yesterday*? How did I not know that? Some friend I was.

I called Jodi that night. "Happy belated birthday, you sneaky thing you. Why didn't you tell me it was your birthday?"

She groaned in my ear. "When you're closer to fifty than to forty, you're not exactly announcing it to the world. Can't believe I'm forty-seven. Sheesh."

"That's not so old. I'm going to be forty next month . . . oh, you're right. That does sound really old! Still, look at it this way— you've earned a celebration!"

"Well, Josh and Edesa and Gracie came over last night with Chinese takeout and Denny picked up a pie at Baker's Square. At least I didn't have to cook."

"Sounds like nobody cooked."

She laughed. "Hey, been meaning to ask, what's going on with Philip? Last I heard you were pretty worried he was mixed up with a loan shark or something."

"Don't know. Haven't heard from him since we talked a week ago at P.J.'s cross-country meet. Maybe I overreacted. It's probably okay. He hasn't said anything more about changing the visitation schedule either, so I'm presuming he's dropped it."

"Okay. But don't stop praying for him, Gabby. God knows what's happening, even if we don't."

I sighed. "Yeah. Thanks. Guess I need that reminder. Doesn't come natural to me to pray *for* Philip . . . but you're right. God knows."

"Oh. Meant to tell you I have to cancel my typing class at the shelter this Saturday. I've got a parent open house at school I've got to get ready for. But I'll see you on Sunday—you *are* still becoming a member at SouledOut this Sunday, right?"

"Yes—if I don't chicken out. Every time I think about getting up in front of everybody, I get jelly knees. Hey . . . will you stand up with me?"

Jodi laughed. "You're not getting married!"

"Feels like it. Please?"

"Sure. Of course I will. See you then!"

Josh Baxter showed up at the six-flat Thursday evening to do some trim work and said they were cooking up another painting party on Saturday to finish up the two apartments. "But I was wondering . . . is Paul home? I want to ask him something."

"Sure. Come on in. The boys are doing homework in the dining room. Paul! Josh Baxter wants to talk to you!"

"Thanks. This won't take long."

I hovered in the kitchen, making a snack while Josh grabbed a chair and straddled it backward, chatting with P.J. and Paul for a few minutes. Then I heard . . . "You guys coming to the Youth Jam this Saturday night at SouledOut?"

"Yeah, guess so," P.J. said. "Mom? Okay with you?"

I stuck my head around the door. "Sure. They announced it last Sunday, right? Kind of an outreach party to neighborhood kids?"

Josh nodded. "Yep. And I've got a favor to ask, Paul. You and

Jermaine did a great job last Sunday at the Sunday Evening Praise at Manna House. So I wondered if you wanted to play for the Youth Jam."

Paul seemed speechless. P.J. snorted. "You've *got* to be kidding. The electronic twins here? Oh brother."

Josh grinned. "I'm not kidding. We want as many kids involved as possible running the show. Whaddya think, Paul?"

"Well . . . sure," Paul sputtered. "But only if Jermaine can do it too. He and his Aunt Mabel don't come to SouledOut, you know."

"Doesn't matter. Lots of kids will be there whose folks don't attend SouledOut." Josh unstraddled the chair with his long legs. "Okay! I'll call Jermaine and let you know if it's a go. Bye, Mrs. Fairbanks . . . um, Gabby. See you guys Saturday night."

P.J. rolled his eyes. "I forgot. I think I'm busy Saturday."

The phone rang as I started after Josh to let him out. "Get that, would you, P.J.?" At the front door I said, "Ignore P.J. He's got a burr under his saddle."

Josh just grinned. "No problem. Maybe I'll keep him busy on the soundboard. He's a smart kid—he'll pick it up real fast."

When I got back to the dining room, both boys looked glum. "What's the matter? Who was on the phone?"

"Dad." P.J. shrugged, playing with his pen. "Says he can't pick us up this weekend, something 'important' came up."

"What?" I couldn't believe it. "He's been wanting to spend more time with you, and you don't have a cross-country meet this weekend!"

"Yeah." P.J. flipped a pen across the room. "But . . . who cares?"

chapter 36

Honestly, I considered calling Philip back and cussing him out. What was so important that he couldn't spend even twenty-four hours with his two sons this—

Jodi's voice popped into my head, urging, *"Don't stop praying for him, Gabby. God knows what's happening, even if we don't."*

Pray for Philip? *Huh.* What I wanted to do was rip Philip apart verbally for blowing off his kids, especially the one weekend this month when no cross-country meets were scheduled . . . but instead I counted to ten—slowly—and gave both boys hugs. "I'm so sorry, guys. You know your dad loves you. He must have a good reason." Though I didn't believe the "good reason" bit for a minute.

After promising we'd do a movie or something together tomorrow night, I left the boys to finish their homework at the dining room table and curled up on the window seat in the front sunroom, lights off, only a few flickering candles on the windowsills. The rain of the previous days had left the air clean and sweet-smelling and I opened a window, even though it was chilly enough to need one of my mom's afghans wrapped around me.

Pray for Philip? Well, I could try . . .

"God," I whispered, "You know what's going on with Philip. I don't understand it, Lord. But if it has anything to do with that Fagan guy, I—I don't want him to get hurt. The boys need their dad. And Philip needs You. All he's got is himself, and he's finding out that's not enough . . ."

I surprised myself at the words that popped out of my mouth. That was the prayer I needed to pray for Philip. That he would find God, or that God would find him. Whatever it took. Because it was going to take a big, big miracle to get Philip out of the massive mess he'd created.

The cell phone vibrating in my pocket interrupted my candle-light prayers. I looked at the caller ID. *Lee Boyer.* But I had an idea what he was calling for, so I let the call go to voice mail and listened to it later. *Would I like to go out Friday night to dinner and a movie?* My heart tugged. We'd had such a good time last week . . .

I waited until the next day to call him back and got his voice mail, so I left a message. "Sorry, Lee. Philip can't take the boys this weekend, so I need to do the movie-thing with the kids tonight. But I'd love a rain check; maybe next weekend?" I don't know *what* possessed me, but heard myself adding, "I'm becoming a member at SouledOut Community Church this Sunday. Do you want to come?"

Mabel put me on the agenda for Saturday's board meeting and told me to show up at ten o'clock so I could be first and wouldn't have to stay for the whole thing. I felt a little guilty skipping out on the painting party again, but left two "hostages" in

my place under Josh Baxter's supervision. The boys needed something to do anyway.

When I showed up at Manna House, the double doors into the multipurpose room were blocked with bright yellow construction tape and a ladder lying crossways in front of the door. A hand-lettered sign said, "Keep Out! Work in progress."

I poked my head into Mabel's office. "What's going on? Where's the board meeting?"

"There you are. We have to meet somewhere else. Had to schedule some last-minute work in the main room. The, uh, contractor could only come in on the weekend." The director grabbed her purse, took me by the arm, and practically pulled me out the front door and down the steps. "The rest of the board is meeting at the Emerald City Coffee Shop. Knew you wouldn't mind."

"But I left the afterschool proposal in my office! Maybe I could get in through the side door—"

"I have the copy you gave me and made copies for the board. Don't worry about it." Mabel set off for the Sheridan El Station at a good pace, dressed today in jeans, a light sweatshirt, and gym shoes.

This was so unlike Mabel Turner that I wanted to laugh. But, hey, it was good for all of us, even Mabel, to loosen up from time to time. I scurried to keep up. "What do you think about Jermaine and Paul playing for the Youth Jam at SouledOut tonight?"

"I'm glad. Really glad. I just hope . . ." Mabel's voice trailed off. "I worry about him, Gabby. He's my sister's boy, but I've raised him from the time he was five. She . . . never mind. Long story. But I worry every time he's with a new group of kids. He's different, you know. And kids can be so mean."

I wanted to give Mabel a hug, but we were crossing the street

and the coffee shop was in sight. "It'll be okay. Josh Baxter is one of the youth group leaders, and I'm pretty sure Edesa will be there tonight too. They'll look out for him. This might be just the ticket for Jermaine anyway—you know, playing 'gigs' is a big deal for someone his age. Other kids will be impressed."

We pushed open the door of the coffee shop under the El tracks and sure enough, most of the Manna House board members were there already. An assortment of chairs had been pulled into a circle near one of the front windows. Mabel and I got coffee and joined the group. I wondered if I had last night's pizza in my teeth because everyone seemed to be grinning at me.

"What?" I said.

Peter Douglass, the board chair, ignored my question and asked Reverend Alvarez to begin the meeting in prayer, which he did in a strong accented voice with no regard for the fact that we were meeting in a public place. I peeked through half-closed eyelids, embarrassed to see several people in the coffee shop frowning at us. ". . . And *gracias*, *Señor Dios*, that You have cut through the red tape and given us the city's blessing on the new House of Hope . . ."

I screeched. "Oh! Oh, sorry. I'm so sorry, but did they—? I mean, is it all—?"

". . . Amen!" boomed Reverend Alvarez. Everyone laughed. And then Mabel and Peter Douglass were both talking at once, showing me the signed papers making Manna House the official service provider for the Supportive Housing Program, along with "Gabrielle Fairbanks, Proprietor," providing housing in the six-flat at such-and-such address, and the HUD Trust Fund subsidizing rent monies . . .

I was so excited, I almost forgot to present the proposal for

expanding the afterschool program, but when I did, the board decided to take it under advisement, realizing we needed time to add more volunteer staff, equipment, and supplies, as well as look into the legalities. "Start slow, Gabby," Reverend Liz Handley advised. "You've got good ideas, but it's better to build up a program slowly and have it stick than move too fast."

Did she know me that well in such a short time? "At least I didn't go looking for this idea," I said in my defense. "It came knocking at the shelter door."

Josh managed to entice P.J. into coming to the Youth Jam in spite of the fact that his kid brother was going to play keyboard by saying they needed someone else who could learn to work the soundboard. So I picked up Jermaine and drove all three boys to SouledOut Saturday evening, and then I went to the Baxters' house to hang out until it was time to pick them up again. Denny was at the church as "designated bouncer" in case any of the neighborhood kids mouthed off or got too rough, so Jodi and I had the house to ourselves. We curled up on their couch, each of us with a cat on our lap and a big bowl of popcorn between us, and watched a golden oldie, *The Princess Bride*, laughing ourselves silly every time Vizzini lisped, "Incon*thie*vable!"

As the credits rolled, I jumped up, dumping the calico kitty off my lap. "Sorry, Patches. Gotta pick up the boys." I headed for the door. "Thanks for letting me hang out, Jodi. Too bad the Youth Jam wasn't Sunday night; then I could've brought the boys and stayed for your Yada Yada Prayer Group"—I almost said, "*since*

they're celebrating your birthday," but realized that might be a surprise. So I just said, "I could use a lot of prayer this coming week. The closing is on Thursday, and hopefully the new tenants"—I winked at her—"can move in on Saturday."

Jodi, still holding the black-and-white kitty in her arms, followed me to the front door. "Wait a sec, Gabby. Can't you come to Yada Yada anyway? After all, this is a real answer to our prayers for Josh and Edesa to find a larger place to live, and it'd be so neat for the Yadas to hear about it from you, and pray for you *and* for Edesa . . . Hey!" Her brown eyes danced. "Maybe you and Edesa could start a Yada Yada Prayer Group at the House of Hope since you'll be living in the same building. Think about it!" She gave me a hug—giving Peanut a perfect opportunity to take a swipe with claws extended at a stray curl bouncing in his face, but the cat missed and caught my cheek instead.

"Ow!" My hand flew to my face. Blood.

"Oh, Gabby!" Jodi dumped the cat and grabbed a tissue to dab at my cheek. "I'm so sorry. Are you okay? We should clean that with hydrogen peroxide or something."

I looked in the mirror in their little hallway and groaned. "I'm fine . . . I'm just going to look terrific doing that membership thing tomorrow."

And I'd invited Lee to come, of all the stupid things.

I guess the Youth Jam was a success because the boys jabbered about it all the way home. "How'd they do?" I whispered to P.J., who was sitting in the front seat with me, casting my eyes toward

the back where Jermaine and Paul were still "playing" imaginary keyboards on their knees and making "da da de da" noises.

P.J. shrugged. "Okay, I guess. Some of the kids like that kind of jamming."

I smiled to myself. *"Okay, I guess"* was pretty high praise coming from P.J.

The boys didn't even seem to notice the long scratch on my face, but I was pretty self-conscious about it when we walked into SouledOut the next morning for Sunday worship—especially when Harry Bentley, wearing a black patch on one eye, looked me over with his good eye and mused, "So what does the other guy look like, Firecracker?"

"Ha! You should talk, Mr. B. Where'd you get the pirate outfit? It's not even Halloween yet." Then I relented. "Are you okay?"

"Oh, yeah, yeah, I'm fine. If Estelle would just give me back my car keys. That woman! Thinks I can't drive with one eye." He moved off, muttering.

I hadn't heard from Lee whether he was going to come today or not, but I kept looking around during the first part of worship when the whole congregation was standing and singing, half-hoping he'd show up and half-hoping he wouldn't. Then I didn't have time to worry anymore because Pastor Cobbs announced they were going to receive new members into SouledOut's fellowship that morning and would Gabrielle Fairbanks and Harry Bentley please come forward?

Did the pastor say Harry? We both made our way to the six-inch high platform at the front of the wide half circle of chairs that made up SouledOut's "sanctuary." "You didn't tell me!" I whispered to him as we met at the front.

"You didn't ask!" he whispered back, but gave me a big grin.

Jodi joined me on the platform, giving me an encouraging hug, but I was surprised to see her husband, Denny, come up and stand alongside Harry. *Not Estelle?* Okay, maybe that would have been too obvious.

SouledOut's pastoral team stood together, smiling broadly at Harry and me. I tried not to think of Jodi's offhand comment once that the two men reminded her of the "Mutt and Jeff" cartoons—Pastor Cobbs, short and sturdy, Pastor Clark, tall and gangly—and made myself pay attention to Pastor Clark's homily on the meaning of church membership.

"Just as baptism," the older man was saying, "is a public declaration of one's personal faith, receiving fellow believers into church membership is not only a recognition that this brother and this sister are members of the worldwide body of Christ, but they are an essential part of *this* church family—similar in many ways to a family adopting children, who become just as much part of the family as anyone else. And as the apostle Paul tells us in his first letter to the church in Corinth, the family of God is made up of many different kinds of members, with different gifts and different roles, but *all* the parts need each other."

He picked up a hammer, grinning mischievously. "And as we know, the different parts of the human body are organically interconnected. I hit my thumb with this hammer the other day"—he held up a bruised thumb—"and you better believe the rest of my body knew about it!" The congregation laughed. "Same when I eat a really good piece of April Simmons's chocolate cake—the rest of me is *really* happy." More laughter.

Pastor Clark was beaming now, full of spirit in spite of his

wrinkles and thinning hair. "So Sister Gabrielle and Brother Harry, we are excited that you have both decided to become members of SouledOut Community Church. We pray that God will meet you here and that you will grow closer to Him—because in the end, it's about Jesus, not us. But we also want you to know that you're family now. When you cry, we will cry with you, and when you're happy, we will laugh with you, not at you . . . Let's pray."

I barely made it through the rest of the membership service without blubbering. Pastor Cobbs took over and asked each of us questions, affirming our faith in Jesus Christ as Savior and Lord, confessing and receiving God's forgiveness for our sins, and inviting the Holy Spirit to release our spiritual gifts in service to others . . .

The membership questions replayed themselves over and over in my mind the rest of that day, sinking deep into my spirit. I had "accepted Jesus into my heart" at an early age back at Minot Evangelical Church—it pleased my parents to no end—but I'd drifted so far from Him after the failure of my teenage marriage. Since coming to Chicago and falling into the arms of Manna House, both as staff and as a resident, my faith had been fanned back into a burning ember in my soul.

But it felt so good to *say it*. To say it publicly! *Yes! I believe! I'm taking my stand with God's people, a follower of Jesus!* It felt so good, I wanted to celebrate my new relationship with "God's people" somehow, to end the day with a bang, not a whimper.

And I knew just the thing.

Grabbing the phone, I pushed a speed-dial number. "Jodi? . . . Yeah, it's me, Gabby. Is it still okay to show up at your Yada Yada Prayer Group tonight?"

chapter 37

❋　❋　❋

Jodi gave me directions how to get to Ruth Garfield's house where the Yada Yada Prayer Group was meeting that night. "Don't worry if you're a little late," she assured me. "I'm so glad you're coming! Everyone will be so excited to see you."

I left the boys with money for a pizza and strict instructions to finish their homework before watching TV or playing video games, and then stopped at Dominick's to pick up a mixed bouquet of gerbera daisies, tinted carnations, and fall leaves for Jodi's birthday. For some reason, the yellow, orange, and red colors of the sturdy flowers made me smile—they were so like Jodi. Down-to-earth, bright, seemingly ordinary but comforting just by being there. And the colors would complement her brunette coloring . . . which didn't work for *my* reddish hair and fair skin, even though I had a fall birthday too. *Next month.*

My smile turned to a grimace as I headed up Lincoln Avenue toward Ruth's address. *Mercy!* Philip had thought it was such a hoot to put thirty-nine candles on my cake last year and light

all of them. Now I was going to turn forty . . . forty and newly single.

I hadn't seen it coming.

Get a grip, Gabby, I scolded myself. *This is a glad day! You're going to the Yada Yada Prayer Group to celebrate your new spiritual family.* Yes, my life had felt like a train wreck only a few months ago, but I'd somehow come through having found myself—and God—again.

Ruth's house turned out to be a classic Chicago bungalow—a tidy one-story brick with a tiny front yard and a neat flower bed of mums beneath the two bay windows on either side of the two-stair stoop. No porch. I rang the bell, and a moment later Ruth Garfield appeared at the door, dark hair dyed and frowzsy. "A guest, it had to be," she announced, waving me in. "Everybody else just walks in. Oh! Flowers . . . very sweet of you." Beaming, she reached for my bouquet.

I held on. "Uh, they're for Jodi. I thought . . . I mean, Estelle said—"

"Well, of *course* they're for Jodi." Ruth dropped her voice to a stage whisper. "But leave them here in the foyer until we bring in the cake."

I wasn't sure if she'd been kidding or just covered up her little blooper, but I carefully stuck the bouquet in the umbrella stand and followed my hostess into the compact living room, which was alive with chatter.

"Yay, Gabby! You made it!" Jodi Baxter jumped up from where she'd been sitting on the arm of the overstuffed sofa and glanced around for an empty seat. The small room was crowded, with every chair and couch seat taken. Several of the welcoming

faces I knew well—Edesa and Estelle and Jodi—and most of the others I'd met at one time or another—Estelle's roommate, Stu, and Adele the beauty-shop lady—or recognized from when I'd visited the group once before.

The twentysomething white girl with spiky hair and wearing overalls—Yo-Yo, that was her name, I remembered—jumped up from a folding chair and said, "I'm good." She plopped down cross-legged on the floor.

"Sit! Sit!" Ruth urged me. "And you two—out! Out!"

Bewildered, I wondered who she was talking to—then saw two round, impish faces peeking into the living room from the doorway. Ah, Ruth's three-year-old twins. Some of the women laughed and I heard a familiar voice call out, "Isaac! Havah! Come give Auntie Estelle a goodnight kiss."

The two children ran into the room, dressed in matching yellow-and-green footed pajamas, and jumped into Estelle's lap. Isaac, I noticed, had a large, strawberry birthmark on his face.

Ruth rolled her eyes. "Kids, schmids, their mother they ignore and obey total strangers. Ben! . . . Ben? Where *is* that man?" Huffing, Ruth disappeared to look for the mysterious Ben.

By now, the twins were scooting from lap to lap, getting good night kisses . . . until they got to me. Then they just stood like Dr. Seuss drawings of Thing One and Thing Two, staring at me. The little girl—Havah, I presumed—pointed an accusing finger at my hair. "Is that a clown wig?"

Estelle chortled right out loud. Taking my cue, I grinned too, and pretty soon everyone was chuckling. "Yep," I teased. "I just forgot my clown suit. Sorry."

The twins' eyes got big—but just then an older man with

silvery hair and a rather bulbous nose scurried into the room, scooped up a twin under each arm, and hustled out again. Their father? If so, the twins must have been "late-in-life blessings."

I didn't have time to figure out the family dynamics, because Avis Douglass was saying, "All right, sisters, we need to get started. It's already five thirty. We want to have enough time to hear praise reports and prayer requests—but first let's worship our awesome Savior, just for Who He is . . . Oh, Jesus, You are wonderful! We're so glad to just sit at Your feet and be in Your presence . . ."

And just like that, Avis slid into talking to God as though He'd come walking through the door. Others joined in, sometimes several at once, murmuring prayers of thanks and praise. I closed my eyes and drank in the atmosphere of these women worshiping together, not asking God for anything, just focusing on being grateful for His love and faithfulness.

Someone started singing, "O come let us adore Him . . ." —which surprised me, because I'd only thought of that song as a Christmas carol—but I loved the fact that the chorus was so simple, I didn't need to look at any words, I could just let my heart sing. Then people added other phrases: "For You alone are worthy" . . . "We give You love and honor" . . . and back to "O come let us adore Him . . ."

The song died away and Avis finally opened the conversation for praise reports and prayer requests. Edesa was the first. "Oh, *mi amigas*, I am so excited. God has answered your prayers for me and Josh and Gracie in a mighty way! Not just for a bigger place to live, but—" She suddenly turned to me. "Sister Gabby, *you* tell them. Because God answered both our prayers!"

All eyes turned to me. I shrank slightly into my chair. I'd wanted to come tonight to share the good things God had been doing in my life with these sisters, but I'd hoped to listen to others first. "Uh, that's okay, Edesa. Go ahead."

To my relief, Edesa burbled on, telling the Yada sisters how the new House of Hope needed a property manager on site and how I'd offered the job to Josh, and what a wonderful answer to prayer it was since it meant living on the premises.

"What's dis 'House of Hope'?" the Jamaican woman named Chanda demanded. "How come all you talking tings mi not hear about?"

"Humph," Yo-Yo snorted. "If you'd stay put 'stead of flyin' to Jamaica or Waikiki to lie in the sun, you woulda heard about it too."

Realizing some of the women hadn't heard the whole story, I started at the beginning and told how the idea for the House of Hope had come to be, with Jodi and Edesa jumping in from time to time to fill in details. "But I've got more good news!" I said, grinning with excitement. "I met with the Manna House board on Saturday, supposedly to bring a proposal about an expanded afterschool program, and—"

"Wait a minute," Florida Hickman interrupted, frowning. "You met with the Manna House board on *Saturday*? At Manna House?" She glanced anxiously at Jodi and Jodi returned a slight shrug and shake of her head.

"Well, no . . . not *at* Manna House. Some kind of construction was going on, so we met at a coffee shop nearby. Why?"

A grin replaced Florida's frown. "Oh . . . no reason. Now what was you sayin'?"

What was *that* all about? *Weird.* But I went on, telling how the board casually let slip that the city of Chicago had approved the House of Hope as part of their Supportive Housing Program, with the HUD Trust Fund subsidizing rent monies and Manna House providing the needed social services. "The House of Hope is now official! Well, as soon as we close on the building this Thursday," I added. "Which I'd like prayer about, that we wouldn't run into any hitches. If all goes well, Edesa and Josh and the first two moms from Manna House can move in this coming weekend."

The room erupted into a joyous cacophony of clapping, "hallelujahs," and laughter. After a few minutes of congratulations and happy tears from Edesa, Jodi piped up, "And that's not all the good news! As some of you know already, this morning our sister Gabby, here, became a member of SouledOut Community Church!"

"And Harry too!" Estelle said. "An' I'm not talkin' 'bout no 'transfer of membership' neither. For both Harry and Gabby, we're talkin' 'bout two people comin' back to God after a long time out in the cold. Am I right, Gabby girl?"

By this time, I was all choked up and couldn't speak, but I nodded . . . and Florida just started thanking God for "our new sister in Christ" while Jodi pressed a tissue into my hand to take care of the tears and my runny nose.

After the prayer, Chanda crossed her arms across her chest, looking puzzled. "Mi know mi been gone a few weeks, but, Sister Gabby, you keep saying 'we' when you talking 'bout closing on dat building. Is 'we' you an' dat husband of yours? You two back together again?"

The room went silent and some of the Yadas looked at one another as if embarrassed by her question.

"Uh, well, I guess I said *we* because my friend, Lee Boyer—my lawyer, I mean—has been helping me with this whole process. He's really been there for me." I could feel myself blushing, remembering that kiss . . .

"Uh-huh." Chanda looked at me critically. "So what happened wit de husband? You still married?"

"Good grief. Shut up, Chanda," Yo-Yo muttered from her spot on the floor. "So what if she is? The jerk kicked her out, left her high and dry. Ain't like she's really got a husband anymore. Heck, if this Lee guy wants to be her friend or her boyfriend or whatever, I say more power to him!"

"Mi just asking," Chanda protested. "You all be on *mi* case when mi be wit a man mi not married to. Mi jus' trying to figure it out, what be okay walking de Jesus walk and not just de Jesus talk."

I squirmed helplessly. Fortunately, Avis spoke up, her voice calm but authoritative. "That's a good thing to think about, Chanda. Our actions *should* line up with the Word of God—walk the talk, as you say. But Gabby's situation might be better shared with some of the sisters she knows personally. However, we can certainly pray . . . Gabby, are there some things you'd like us to specifically pray about?"

I nodded, grateful to be off the hot seat. "Uh, well, just what I already mentioned, the closing on the six-flat this coming week. That's the last step to making the House of Hope a reality. And"—I decided to claim some high ground—"I do want prayer for my, um, husband, Philip. He's gotten himself into a lot of debt gambling at the Horseshoe, and I'm afraid he's trying to fix it in

ways that only make the situation worse. To be honest, I'm really concerned about him. In spite of everything, he *is* my kids' dad and I don't want him to get in trouble."

Avis nodded, and even though there were others who still needed to share, she suggested they pray right then about the closing on the six-flat, and then she prayed for Philip. "Lord Jesus, You know everything about this man—his past, his present, his future. From our point of view, it's easy to be angry at what he's done, kicking Gabby out of her home and basically abandoning her. But You died for all our sins, including Philip's. You know his heart, his hurts, his weaknesses—and right now, we're praying that You will touch his heart and bring him to his knees. Help him to realize that what he needs is You. Protect him from the evil one, who is using him not only to hurt Gabby and his family but himself . . ."

I could hardly believe Avis's prayer. It seemed so . . . right. She admitted being angry at what Philip had done, as if God really understood, and still prayed that God would "touch his heart" and "protect him from the evil one."

When others had had a chance to share and pray—Estelle did a short update on her son, Leroy, who was still in the burn unit at the county hospital, and asked the sisters to keep praying that she'd know what to do with him once he got released—Ruth bustled into the room with a pineapple upside-down cake and a tray of hot tea and lemonade while everyone sang "Happy Birthday" to Jodi. When Estelle gave Jodi the crocheted hat she made, I rescued my flowers from the umbrella stand and gave them to her.

"Oh, Gabby. They're perfect!" Jodi grabbed me in a hug. "I'm so glad you came tonight. The things you shared, your membership at SouledOut this morning—those are the real things to

celebrate. But . . ." She pulled me away from the others into the front hallway, lowering her voice to a whisper. "Do you want to talk about Lee sometime? I'm sure it can be confusing where another guy fits when you're separated but still married. I promise I'll listen and not jump in with instant answers. But I *am* your prayer partner, remember?" She smiled. "It might help to pray together."

I nodded and gave her a wordless hug. Yes, yes, yes, I needed to talk about Lee. And pray. About Lee and me. About how to "walk the talk" when things felt so mixed up right now.

Sunday had been such an amazing day, I was still grinning when I pulled open the big oak doors of Manna House the next morning and walked into the cool foyer, with the stained glass reflections falling on the floor in sparkling colors. "Hi, Angela!" I beamed at the young Asian receptionist as I signed in. "Good morning, Mabel!" I called into the director's office, whose door stood open. "Great day, isn't it?"

I barely noticed when Angela came out of her cubby and Mabel stood up from her desk to follow me as I pushed open the double swinging doors into the next room, and I was halfway across the room before I saw it . . .

A large, colorful mural had been painted on the wall directly across from the doors. The figure of Jesus the Good Shepherd was surrounded by a flock of sheep that He was bringing into a sturdy enclosure, a long staff in one hand and a tiny lamb tucked into the crook of His other arm. Over the top of the mural flew a long open scroll with bright blue script lettering that said, "Shepherd's Fold."

I felt as if the breath had been knocked out of me. Slowly I walked closer to the mural, hardly aware that many of the residents were standing around the room in little clusters, because no one was talking. As I stood looking up at the mural, I noticed that the sheep weren't the fat, wooly kind populating most biblical pictures, but they were all different colors and shades of white, brown, and tan, some with scraggly, dirty wool, some thin and starved looking, some with bleeding or bandaged wounds. But the look on the Shepherd's face was pure love.

"Who did this?" I croaked.

Mabel came up alongside me. "Florida Hickman's son, Chris— he's an art major over at Columbia University. Got his 'training' tagging walls and underpasses around the city before the law caught up with him. Now . . . well, you can see for yourself."

I smiled. So this was the "work" being done over the weekend behind the yellow construction-taped doors. No wonder Florida had almost freaked out last night when she thought I'd met with the board here over the weekend.

Only then did I see a little brass plaque over to one side. I bent closer to read it:

In memory of Martha Shepherd,
fondly known as "Gramma Shep."
A resident of Manna House
from June 19—July 10, 2006.

Tears streamed down my face. "Lucy should see this," was all I could say.

chapter 38

Speaking of Lucy, she showed up during lunch and it wasn't even raining.

"Wonkers!" she said, appearing in the dining room on the lower level with Dandy in tow. "Now *that's* more like it." Her gray eyes glittered as she jerked her thumb upward toward Shepherd's Fold.

The tables erupted in clapping and whistles. "Ya shoulda seen Miss Gabby's face when *she* came in this mornin'!" Hannah laughed. I had to smile. I rarely thought of the young woman as Hannah the Bored any more, because Adele's Hair and Nails had increased her afternoon hours to four days a week, Wednesday through Saturday.

Lucy loaded up a plate with Caribbean rice and beans and Mexican sausage at the lunch counter and sat down with an "*Oomph!*" at the table where Mabel, Estelle, and I were sitting. "So who done it?" She grabbed the bottle of hot sauce on the table and liberally sprinkled her rice and beans. "That wall thing, I mean."

Mabel told her about Florida Hickman overhearing her complaint after Sunday Evening Praise a week ago—

"I seen the lady. Who is she?"

"One of my Yada Yada prayer sisters," Estelle put in. "Her family's been renting half their second floor to Josh and Edesa, place no bigger'n a shoebox. Guess Flo was here when SouledOut came to Sunday Evening Praise last week."

"Yeah, yeah, yada, yada . . . whatever. Go on." Lucy poured on more hot sauce.

Mabel picked up the story. "So that's when Florida got the idea to ask her son, Chris, about doing a mural for Shepherd's Fold. The young man is in a special art program for talented teens at Columbia College and he jumped at the chance."

Lucy guffawed when she heard the boy had first used his artistic talent "tagging" the walls of buildings and elevated train underpasses . . . but Estelle jumped in with even more juicy details. Even Mabel hadn't heard the story of Jodi Baxter volunteering to be a drama coach at the Juvenile Detention Center when the regular JDC English teacher got sick, which is where she saw Chris's talent come alive painting the large backdrop for a dramatic piece the kids wrote themselves and acted for staff and parents.

That was the first time the Hickmans realized their son had *real* talent, since up to that point all it had gotten him was doing time at the JDC.

"That's a fantastic story," I murmured when Mabel and Estelle were done. "I hope we get a chance to thank this young man in person one of these days."

Lucy shoveled more rice and beans into her mouth. "Well, maybe we oughta have some kinda dedication or somethin' for Shepherd's Fold, now that ya got a decent plaque an' ever'thing."

"Good idea, Lucy. A *really* good idea." I slipped my last bite of sausage under the table to Dandy, who was parked by my knees, collected my empty dishes, and started to get up. "Well, time to get back to work."

"Hey, don't run off, Fuzz Top. You the one me an' Dandy come here to see. Just got sidetracked by that mural thing upstairs." The old woman pointed her fork at me. "You an' me gotta talk. But somewhere private like."

I raised an eyebrow at her. What in the world was this about? "Well, okay. When you're done, just come into my office." But by the time I'd scraped my dirty dishes and sorted them into the heavy plastic dishwasher bins, Lucy and Dandy were already parked in my office.

I closed the door and sat down at my desk. "So what's up?"

Lucy narrowed her eyes. "Your boys okay? I didn't see 'em up at Richmond Towers all weekend. Not their dad, neither."

Now I raised both eyebrows. "You *are* spying on them!"

Lucy pulled herself up indignantly. "So? Just makin' sure they all right when they not with you. Can't seem to forget how I found you that night when that mister of yours kicked you out, cryin' your eyes out on that park bench . . . an' don't forget who found Dandy here, wanderin' 'round the park after bein' lost all night an' all day. So you got a problem with me keepin' an eye on your boys? Huh?"

I shook my head with a rueful smile. "No . . . no, I'm grateful, Lucy, really I am. But I think it freaked Paul out a little. He doesn't know why you're 'spying' on them."

Lucy leaned forward. "Well . . . I ain't tellin' you the whole truth, neither. Fact is, I been seein' some strange characters

hangin' around Richmond Towers, overheerd 'em askin' 'bout the mister, where he lives an' stuff."

My breath caught. "What kind of strange characters?"

She shrugged. "Don't belong there is all. One was an under- cover cop, 'nother was a man in a suit . . ."

I blew out my breath. Why would a cop and a man in a suit be asking around about Philip? Had he done something illegal? "How do you know it was an *undercover* cop? I thought the whole point was not to look like a cop."

Lucy snorted. "Huh. When you live on the street long as I have, you can smell an undercover a block away."

I frowned. "Are you sure they were looking for Philip? Though I suppose it could be one of Philip's creditors trying to find him. He's, uh, run up some big debts. But I appreciate you keeping an eye on my boys."

"Yeah, well . . ." Lucy pushed herself out of the chair. "Mostly wanted to know the boys was okay since I didn't see 'em this weekend up at the Tower."

"That's because they stayed with me this weekend. They're okay." I grabbed a pen and scribbled on a notepad. "But here are my phone numbers—both home and cell phones. Call me if you're concerned about anything, okay?" I held out the note.

"Now, Fuzz Top, whatcha think I'm gonna do with that? You know I ain't got no cell phone."

"Just take it, Lucy. If you need to call me, you'll find a way."

When Paul showed up at the shelter after school, I told him he was right after all, Lucy and Dandy *were* keeping an eye on

them when they were staying at Richmond Towers, just wanting to make sure they were okay. When I said Lucy *and* Dandy were keeping an eye on them, he seemed to feel better about it. But I made a mental note that I should probably talk to Philip about the "strange men" Lucy had seen. Who were they? What did they want? Or was she just imagining things?

But it seemed as if Thursday showed up on the calendar before I even had time to blink. Closing day! I was so nervous Mabel told me not to bother coming in to work that day until it was over, because I'd be virtually useless. Lee had called me at work several times during the week to let me know what to expect at closing and to make sure I brought the necessary bank draft to cover the down payment, title fee, and other expenses. *Whew.* Taking out that bank draft sent my savings account plummeting to a low water mark. I'd be barely wading in my inheritance money now instead of swimming.

As many times as we'd talked that week, I thought it was strange that Lee didn't say anything about my invitation to come to church last Sunday, so I finally asked if he'd gotten my message. "Oh gosh, Gabby. I'm sorry. I did, but I thought . . . well, obviously I didn't make it. To be honest, I'm not really a church kind of guy. But I hope it was everything you wanted it to be."

"What do you mean, you're not a church kind of guy? I wasn't asking you to join the church, just come to something that was meaningful to me."

"Hey, down, girl. Don't jump all over me. It sounded like an afterthought when you turned down *my* invitation to go out to dinner last Friday. I didn't think it was that big a deal."

I'd hesitated. "You're right. It was an afterthought. But it was

a big deal—to me anyway. Becoming a member of the church, I mean. But . . . never mind. What's the address of the title company where we're doing the closing? Eleven o'clock, right?"

"Don't worry about finding it. I'll pick you up at your house."

After we hung up, I'd picked up one of the floppy stuffed dogs still hanging around my office and went nose to nose with it. "Hey. Remind me next time not to mix business with pleasure. There're probably plenty of blogs out there about not getting romantically involved with your lawyer."

Still, I was glad it was Lee who sat beside me at the big conference table at the title office Thursday morning at eleven. He squeezed my hand before the owner of the building and his attorney and the title company rep came in, giving me an encouraging smile. I squeezed back. Lee Boyer had helped me through one of the roughest periods of my life, and the fact that he knew it all and still thought I was special, well . . .

An hour later we all shook hands, the attorneys and title guys packed up their briefcases, and we headed out into the parking lot to go our different ways. I started to lean against Lee's Prius to regain my equilibrium, but it set off his car alarm and I leaped away in shock as the horn began blaring. Grinning, Lee used his clicker to shut off the alarm and then we both collapsed against the car.

"Uh, Lee? Did I just hand over a check for two hundred grand?"

"More. All those fees, remember?"

"And all those papers I signed. You read them, I hope."

"Uh, they're pretty standard. I have read them at one time or another."

"Uh-huh. And now I own a very large building."

"Mm. Medium I'd say. Just a six-flat. But if you want, now you can move out to the suburbs and join the fine tradition of Chicago's absentee slumlords—ow!" He threw up his hands to defend himself against another slug on the arm. "Just kidding."

I looked at him sideways. His easy grin, wire-rim glasses, and brown hair falling over his forehead gave him a perpetually boyish look that made me feel like kicking off my shoes and running barefoot in the grass—except the parking lot was concrete.

"Let's go buy a kite," I said suddenly.

"What?" Now he started laughing.

"I feel like flying a kite! Come on!"

"You're crazy, Gabby Fairbanks, you know that?"

I was still glowing and windblown when I finally got back to Manna House at three o'clock. We almost didn't find a kite, since all the stores were already stocked with Halloween costumes and Thanksgiving decorations. But we finally found a big, black bat-shaped kite in the Halloween section of a discount store and took it to Lincoln Park along the lakefront. The wind off Lake Michigan had been nippy, but it sent the kite flying high and gave us rosy cheeks and red noses.

"Friday?" Lee said hopefully when he dropped me off at the shelter.

For some reason Chanda's snippy comment at Sunday's Yada Yada meeting niggled at me. *"Just trying to figure out how to walk the talk . . ."* But I'd already blown Lee off last weekend. What could it hurt? "Sure, Friday," I promised and ran up the steps.

Precious and Tanya took one look at the grin on my face when I came in the door and started screeching with joy. "We can move! We can move!" . . . "We got us a real apartment! Oh, thank You, Jesus!" They both grabbed me and dragged me down the stairs to the lower level. "C'mon—Estelle's got somethin' for ya!"

"Something" turned out to be a large sheet cake Estelle and her Thursday afternoon cooking class had made and decorated with "Congratulations!" The cake and fresh coffee brewing drew residents and staff from all corners of the building, and by the time the schoolkids joined us, we had a regular party going. Even eye-rolling, pregnant Sabrina finally seemed excited that she was going to have her own bedroom at last.

I called Josh and Edesa on their cell phones and told them the move was a "go" on Saturday. But it wasn't until the boys were climbing into their dad's Lexus at six o'clock Friday evening that I realized I hadn't called Philip about Lucy's report of "strange men" hanging around Richmond Towers. I didn't want to say anything in front of the boys, so I just asked Philip to call me later that evening when he had a chance.

His call came when Lee and I were slow-dancing to a live band at one of the popular country-western venues around the city. *Okaay, this is awkward*, I thought, trying to find a corner of the room farthest from the band. Plugging one ear I held the cell phone to the other. "Philip? Thanks for calling. Just wanted to

tell you that, uh, Lucy Tucker said she's seen some strange men hanging around Richmond Towers asking for you. She wanted me to tell you." I felt silly even as I relayed the message.

"Lucy? The old lady who's got your mom's dog?" I heard him snort in my ear. "What's *she* doing snooping around here? Look, tell her to mind her own business . . . Where are you anyway? I can hardly hear you with all that racket in the background."

"Good-bye, Philip." I flipped the phone closed and moved back across the dance floor to where Lee was waiting for me, a welcoming grin on his face.

It wasn't any of Philip's business where I was.

The second call came at six thirty the next morning.

I almost didn't hear the phone ring, because I'd left the cell in my shoulder bag, which I'd tossed in a corner of the bedroom. But consciousness finally dawned and I scrambled out of bed, snatched up the purse, dumping the contents out on the bed to find the phone. "Uhh . . . hello?"

"Gabby." The voice was scratchy. Gruff. "Get over here and pick up your boys."

I was suddenly wide-awake. "Wha—? Lucy? Is that you? What's going on?"

"Dandy an' I found your mister beat up in the walkin' tunnel under Lake Shore Drive—"

"The boys! Lucy, where are they?"

"Up in that penthouse sleepin', far as I know. Your man was out joggin' early is my guess—"

"Did you say beat up? How bad is he? Did you call 9-1-1?"

I could hear Dandy barking in the background, and Lucy's voice pulled away. "Dagnabit! I'll give it back to ya. Just a minnit!" Then she was back on. "Yeah, I called 9-1-1. Now this jogger guy wants his phone back."

I could hear faint sirens in the distance on Lucy's end of the phone. I pinched the bridge of my nose and squeezed my eyes shut. I couldn't believe this. "How bad, Lucy?"

"Pretty bad, Fuzz Top. He's unconscious. Lotta blood, but still breathin' . . ."

"Stay there, Lucy. I'm coming. Just find out where they're going to take him."

chapter 39

The boys and I huddled in the waiting room of the ER. Why wasn't someone coming out to tell us how badly Philip was hurt? Lucy had gone outside to walk Dandy, who didn't understand why he couldn't come inside too . . .

The frumpy bag lady and yellow dog had been waiting for me just outside Richmond Towers when I came screeching into the frontage road and pulled the Subaru into a Visitor Parking space. She said the ambulance had left just five minutes ago and was taking "the mister" to Weiss Memorial Hospital.

"Do the boys know their dad's hurt?"

She wagged her head. "Don't think so. He was wearing them fancy jogging clothes—ya know, them silky shorts an' matchin' jacket—like he'd gone out early for a run while they was still sleepin'."

"Don't disappear, Lucy," I commanded. "I want to know what happened—but right now I've got to get my boys. I'll be back as soon as I can."

Muttering thanks to God that I still had my security pass and keys to the penthouse—once management had insisted that Philip replace the original locks—I rode the elevator to the thirty-second floor and let myself in. All was quiet. Trying to ignore the schizophrenic feeling of walking around in the high-priced penthouse that used to be my home, I found the boys sprawled in discount store twin beds in one of the bedrooms, dead to the world. Waking them gently, I told them to get dressed quickly. We had to go to the hospital . . .

I couldn't answer any of their questions. Lucy rode in the front seat with me, Dandy between the boys in the back. "Now tell me, Lucy! What happened?"

"Like I said . . ." She and Dandy were taking their early morning walk in the park, staying close to Richmond Towers. As they came through the lighted pedestrian tunnel that gave joggers and residents of the luxury high-rises along Lake Shore Drive access to the beach, Dandy suddenly started to whine and pull on his leash. A man was crumpled on the ground in the tunnel. "Thought at first it was just a wino passed out on the ground. But when I saw them fancy jogging clothes, I knew this wasn't no wino." Then Dandy had stiffened and started to growl. The light wasn't that good in the tunnel, but when Lucy got close, she realized who it was.

"Another jogger came along an' let me use his cell phone, so I called 9-1-1, then I called you." She'd snorted in disgust. "The guy didn't want to wait around till the ambulance got there. Had to finish his run. Made me give the phone back."

"Did the paramedics tell you *anything* about how badly Philip was hurt?"

"Nope. Cops came, asked me a couple of questions since I was the one who found 'im. Never let on I knew who he was, though."

When we came flying into the emergency room, I'd rushed to the desk and asked if a Philip Fairbanks had been brought in by ambulance. The receptionist looked at a clipboard. "Relation to the patient?"

I hesitated a nanosecond, then blurted, "His wife. These are his children."

"Have a seat."

Now we sat in the waiting room . . . waiting. Two uniformed policemen came out of the double doors marked Hospital Personnel Only and spoke to the receptionist, who nodded at me. They wanted to know what I knew about what happened. I shook my head. "Nothing! We're . . . separated. Someone called me, told me he'd been found beaten unconscious while he was out jogging. I . . . the boys were with him this weekend. I picked them up from their dad's place and came here."

The police treated it as a routine mugging, jotted a few notes. Left.

Who to call? I should call somebody! I called Jodi Baxter . . . Wondered if I should call Philip's parents but decided to wait until we knew something about his condition. I asked the boys if they'd like to get something to eat. Both of them shook their heads. The clock's second hand labored toward 7:40 . . . 8:05 . . . 8:30 . . .

The move. My new tenants were supposed to be moving into the six-flat this morning. But I just sat. They'd have to figure it out for themselves.

Jodi and Denny Baxter pushed through the revolving doors

into the ER waiting room at nine o'clock. "Gabby! What happened? Is he going to be all right?"

I shook my head. "Don't know yet . . . Oh."

A young doctor in a white coat flapping open to show his pale blue shirt and blue striped tie, stethoscope sticking out of one coat pocket, came through the double doors and looked at our little group, the only people standing. "Mrs. Fairbanks?"

I nodded. The doctor motioned us into a nearby conference room, and I insisted that the boys and the Baxters come too.

"We've done our preliminary exam. Whoever worked him over did a bang-up job." I winced and glanced at my boys. A crude choice of words. "Your husband has several broken ribs, a broken arm, possible internal injuries from being punched in the stomach, a severe laceration on his head caused by striking concrete, a badly broken nose that will cause a lot of bruising, a possible concussion . . . but the good news is, none of it is life-threatening. We need to do more tests to determine the extent of any internal injuries, and he'll have to be hospitalized for several days. Maybe a week. But"—the young doc actually smiled—"he's going to be fine."

Paul drew his legs up onto the chair with his arms, put his head down on his knees, and started to cry. P.J. put his arms around his brother and murmured, "Hey, hey. It's okay. He's gonna be okay, didn't you hear?"

"Thank you," I said to the doctor. The words barely came out in a whisper.

Jodi and Denny took the boys to the hospital cafeteria to get some breakfast and brought me a bagel and a large coffee. "With cream," she pointed out with a sweet smile. Then she and Denny left, taking Lucy and Dandy with them, to check on the move.

"They should just go ahead," I told them. "Josh has the build-ing keys. They've waited long enough."

It was almost three before Philip was moved to a private room. They'd sedated him to set the broken bones and deal with the pain, so he wasn't aware when the boys and I tiptoed into the room to sit with him. He seemed swathed in bandages—his rib cage was bound, his right arm had been set and was held away from his bruised body with some kind of contraption, and his head had been shaved and was wrapped in bandages except for his face, which was a mess—swollen nose and eye, scrapes and cuts.

He looked awful.

Estelle Williams and Harry Bentley peeked into the room. "We're not stayin', honey," Estelle said, sweeping me into a big hug. "Just wanted to let you know there are a whole lot of people prayin' for Philip right now. An' if you need anything—*anything*—you let us know, you hear?"

I blubbered into her soft bosom and nodded, even though I could hardly breathe, she was hugging me so tight.

Harry motioned me out into the hall. "You know who did this, don't you?"

I shook my head . . . then slowly nodded. "If you're right about Matty Fagan." I fished for a tissue and blew my nose.

"I know I'm right. What's it been . . . four weeks since Philip met with Fagan? Fagan never gives anybody that long to pay back what he loaned 'em. I've got my ex-partner on the case, seeing what she can find out." Harry shook his head. "The sooner Internal Affairs gets that rogue off the streets, the better for everybody."

Harry and Estelle left. We sat some more. "Look, Mom!" P.J. cried. "His eyes are open!"

Philip's eyes were mere slits. I leaned close. "Philip? It's me, Gabby. And the boys are here."

"What . . . where am I? . . . What happened?" he croaked.

I told him briefly. He closed his eyes and seemed to think about it a long while. Then he opened them again. "Are . . . boys okay? I—I left them alone, just going for a short run . . ."

"We're fine, Dad." P.J. bent close into Philip's line of vision. "Don't worry about us. You're going to be fine too. Doctor said."

Philip raised his left hand and crooked a finger at me to come close. I bent over him. "I don't . . . want . . . boys . . . here. Don't want them . . . to see me like . . . this."

Too late for that. But I nodded. "They're going home soon."

Jodi and Denny Baxter returned later that afternoon and said the move was done—including picking up household and personal things Precious had stored here and there with friends. But everyone was worried about her and the boys and Philip. The Baxters offered to take the boys back to our apartment and stay with them until I came home. "Not a hardship for us," Jodi assured me. "After all, Josh and Edesa and Gracie are right upstairs now! I'm sure they can use some more help getting settled. But . . . why don't you come home for the night? Get some sleep. You can come back tomorrow."

We were standing out in the hallway. I looked back into the room where Philip lay on the hospital bed attached to all kinds of wires and tubes and IVs. I shook my head. "No. Think I'll stay here tonight."

Jodi looked ready to argue, but I held up my hand.

"The thing is, Jodi, he doesn't have anyone right now . . . except me."

chapter 40

I dreaded making the call but couldn't wait any longer. Once the boys had left with the Baxters, I found a family waiting room and dialed the Fairbanks' number in Virginia. Marlene Fairbanks went ballistic when she heard we'd been at the hospital since early that morning and I was just now calling them.

"I'm sorry, Marlene. We didn't know for a long time what his injuries were, and I knew you'd want to know. The boys needed my attention; they're upset, of course, and—"

I don't think she heard me, because she was still calling me every name she could think of while telling me this was all my fault.

"Get off the phone, Marlene!" snapped Philip's father. I heard the senior Fairbanks arguing, then one extension went dead and Mike Fairbanks came back on the phone. "Now. Tell me again what happened, Gabby. He got mugged while jogging? Of all the—!" Mike Fairbanks let loose with a few choice expletives, and then checked himself. "Sorry. But I *told* that bull-headed

son of mine not to move to Chicago. So, what are the doctors saying?"

When I finished rehashing the doctor's report, Mike just said, "Look, we'll get the earliest flight we can, be there sometime tomorrow." Then his voice softened. "Thanks for being there, Gabby . . . after, you know, everything."

After we hung up, I pinched the bridge of my nose, trying to stave off a wicked headache threatening the back of my head. There was another call I needed to make—to Henry Fenchel, Philip's business partner in the commercial real estate firm they'd established together last spring. He wouldn't be expecting Philip to come in until Monday . . . maybe I could wait until late Sunday. By that time Philip's parents would be here and *they* could deal with Henry and Mona Fenchel . . .

I sighed. No, better to let Henry know sooner rather than later that Philip was going to be laid up awhile. That was only fair. Henry would have to cancel meetings, follow up on clients, fill in for Philip—whatever it was the two of them did during a week to keep Fairbanks and Fenchel Development Corp running.

Sucking up my courage, I dialed Henry's cell, but only got his voice mail. Not surprising on a weekend. I left a brief message, saying Philip had had an accident and was at Weiss Memorial, and to call me as soon as possible.

I looked at my watch. I'd been out of Philip's room half an hour already. Should probably get back soon. He was basically helpless right now if he needed ice chips or lost the call button for the nurse. But there was one more call I wanted to make before I lost the battery on my cell phone . . .

I called Lee.

I sat in the recliner in Philip's hospital room the rest of that day, listening to the beeps and ticking of the half-dozen machines attached to his body, wondering what in the world I was doing there. I wished I had somebody to talk to! But all I got when I called Lee was his voice mail. Frustrated, I'd left a cryptic message and hung up. Where was he when I needed him?

Maybe it was just as well. He'd tell me Philip had brought this down on his own head—which was probably true, if Mr. B was right about that guy Fagan—and I should just go home. Still, I knew, somehow, I'd made the right decision to stay. I turned on the TV and watched some mindless reality show so I wouldn't have to think, and actually welcomed the parade of nursing aides who came in and out to check Philip's vitals, change his IVs, and give him more pain meds, which kept him zoned out most of the time.

But I was surprised when Pastor Joe Cobbs and his wife, Rose, from SouledOut came by that evening, bringing a tote bag Jodi Baxter had packed for me with some of my toiletries, a few sandwiches and fruit, my Bible . . . and my cell phone charger. "You know Jodi." Rose Cobbs smiled. "Thinking of everything." The African-American couple didn't stay long, but Pastor Cobbs did pray for Philip in his strong voice that I'm sure carried down the hall clear to the nursing station.

When they left, Philip muttered through his swollen lips, "Who was that?"

I was startled to hear his voice. He'd seemed basically out of it when they were here. "My, um, pastor and his wife."

A long silence. "You asked him to come?"

"No. They just came."

"What? Uh . . . Whole world knows I'm laid up here?" He winced with pain.

I decided not to answer. "You're hurting. I'll call the nurse—it's probably time for more pain meds."

I reached for the call button, but Philip grabbed my hand with his one good one. "Just . . . don't tell my parents. Or Fenchel."

I gently pried my hand from his grip. "I'm sorry, Philip. They needed to know." I tensed, expecting him to get angry—but all I heard was a groan escaping his dry and swollen lips.

I had dozed off in the chair when my cell phone rang. I squinted at the caller ID: *Henry Fenchel.* Slipping out of the room, I closed the door and hit Talk. "Hello?"

"Gabby! What's this about an accident? What kind of accident?" I'd expected Henry to be worried, concerned, anxious. But his words slammed through the phone like a challenge. I told him briefly. "How bad?" he demanded.

Again I kept the details brief. "They need to monitor him for a while. Could be a week."

Henry spat out a curse word. "Gabby, this is the last straw!" He was practically shouting into the phone. "Philip has taken money from the business account to cover his gambling debts, thinks I don't know because he transfers money to cover it from . . . *somewhere*, who knows! He's distracted, he comes in late on Monday, he's missed some important meetings with clients . . . Ever since you left him, Gabby, he's been going downhill. Now this. How are we supposed to run a business, tell me that!"

"Since I left him? Since *I* left *him*? Henry Fenchel, you know good and well—!"

"Whatever. Since the two of you broke up. But I've had it! I'm going to sue him, break off the partnership. You tell him that, Gabby!" And the phone went dead.

My heart was pounding so hard I had to lean against the wall to get my breath. When I finally went back into the room and saw Philip lying there looking like a wreck, knowing it was going to get worse—a lot worse—before it got better, I fell into the chair and put my head in my hands. *Oh, Jesus! You're the only one who's going to be able to turn this around for Philip. Please, God . . .*

The night was long, but I must have finally fallen asleep, because when I woke up sunlight was slipping long fingers through the blinds, making pretty patterns all around the stark hospital room. I looked over at Philip . . . and realized he was staring at me.

"You're awake," I said.

He just looked at me for a long moment. Then he croaked, "You've . . . been here all night. Why did you . . . stay?"

Good question. Wasn't sure I could answer it. I pushed off the blanket the nurse had given me and got out of the recliner, standing uncertainly at the end of the bed. But finally I took a deep breath and blew it out. "Because, Philip, I'm still your wife and you needed me."

He kept staring at me. I could hardly stand to look at his bruised and battered face and looked away . . . but when I looked back, tears were running down his face. "Oh, Gabby . . ." he

moaned. And then he started to weep, big deep sobs racking his body, mixed with pain with every move. His sobs sounded almost animal-like, a guttural wail I'd never heard before. I didn't know what to do. What was going on?

I almost reached for the call button to call the nurse, but his free hand flailed, motioning to me to come closer. Tentatively, I moved around to the side of the bed and he grabbed my hand. "Gabby!" he gasped. "Gabby, I've . . . I've messed everything up so bad. I don't know what to do! You . . . you were the best thing that ever happened to me, and I . . . I drove you away. Please . . . please, don't leave me. You have every right to . . . to walk out of here, but . . . can you forgive me? I'm begging you! Please . . ."

Out of the corner of my eye, I saw the door open slightly and a man's face appeared for a moment, and then disappeared again.

Lee Boyer!

I gently slid my hand out of Philip's grasp. "Just a minute. Someone's here."

"Gabby, please . . ."

"I said just a minute."

I hurried out of the room into the hall, closing the door behind me. Lee Boyer had walked several yards away, but he turned back when he heard the door close. His eyes flashed and his body was rigid.

"Lee?"

He strode toward me, almost shaking with anger. "I heard. Heard everything that—that con man was saying to you! You know it's all a lie, don't you? He'll say anything right now, because he's in trouble. What are you doing here anyway, Gabby? I called your house and they said you were still here at the hospital."

The absurdity of the situation made me want to laugh—or cry—or something. I could still hear Philip's voice in my head—"*Can you forgive me? I'm begging you!*"—and now Lee was hissing at me between clenched teeth, "*It's all a lie!*" But for some reason a strange calm settled over me, like standing in the eye of a storm with the two men in my life swirling like hurricanes around me.

Lee threw his hands out in frustration. "You don't owe that man anything, Gabby Fairbanks. I . . . I love you, don't you know that? We could have a good life, you and me. We're the same kind of people. We get along great. We like the same things . . ."

For the life of me, I don't know why I said it. "Except church. And God."

I don't think I could have startled him more if I'd slapped Lee in the face. His mouth dropped open and his eyes widened behind his wire rims. Then he found his voice. "Church? God? What do church and God have to do with *us*?"

A sudden sadness settled over me. "Maybe . . . everything."

Lee looked totally bewildered. Then the anger rose in his voice again and he pointed a shaking finger toward Philip's hospital room. "And you think that . . . that self-centered jerk in there is your churchgoing, God-praying type?"

I shook my head. "No, that's not what I meant." The sadness weighed heavily on me. Part of me wanted to fling myself into Lee's arms and run away with him, disappear from this hospital and leave Philip to wallow in his own mess. I had no idea what to say or do, but the strange calm seemed to surround me and hold me up.

Lee's diatribe finally ran out. He paced back and forth a few steps, then stopped. "Gabby, I don't know what's going on here.

But I want to know if you feel for me what I feel for you . . . because if you do, then come with me. Don't listen to him. But if you go back in there, we might as well call it quits."

"Lee. Don't make me choose. Not now. This isn't the time."

"Yes it is. Leave him. Come with me." He held out his hand.

My calm threatened to shatter into little pieces, to be sucked into the hurricanes swirling around me in that hospital hallway and the room just steps away.

I wanted to go.

But I couldn't.

My eyes filled with tears. "I'm sorry, Lee," I whispered. I slowly turned, opened the door to Philip's room, and shut it behind me.

chapter 41

I slipped into the bathroom of Philip's private room and cried silently into a skimpy white towel. *What have I done?* Lee said he loved me! But to insist that I leave with him now when Philip was hurt and broken, to say if I stayed we might as well call it quits . . . it was so unfair!

I heard a nurse come into Philip's room. "Well, look who's awake already. How are we feeling this morning? . . . Let's see, which thigh did they use to give you the Heparin shot last night? . . . Okay, turn over, we'll do the other thigh this morning."

Turning on the faucet in the sink, I let the water run so she'd know I was in there. What would I say to Philip when I came out? *"I forgive you"*? No, no . . . it wasn't that simple! He'd nearly destroyed me! Was saying he was sorry just a big lie to get my sympathy, like Lee said?

But . . . what if he really was sorry?

That possibility was so beyond comprehension, it would have to be a miracle. But I'd seen some pretty impossible miracles in

my own life the past few months. What if God hadn't given up on Philip yet? What if . . . what if God had allowed Philip's life to spin out of control to get his attention, like Avis had prayed at Yada Yada? Was Philip paying attention? What he'd said to me not fifteen minutes ago wasn't the self-confident man I'd married, or the cruel egomaniac who'd washed his hands of me.

He'd sounded like a broken man. A Humpty Dumpty who'd had a great fall . . .

But if God was working on Philip, where did I fit into the picture? Was I ready to take responsibility for my part in our broken communication? To ask Philip to forgive *me*?

Oh, God, I groaned. *I can't do this. I need time. Time to think. Time to pray. Time to talk to someone who isn't going to give me an ultimatum.*

Washing my face, I took several deep breaths and came out of the bathroom. The nurse was exchanging the IV bag and doing readouts from the machines. She smiled pleasantly and said the doctor would be doing rounds shortly, they'd probably want to do more tests to determine the extent of internal injuries . . . and then she was gone, leaving Philip and me to deal with our unfinished conversation, like a sticky spider's web filling the room.

His head was turned away, his face still twisted in misery. But as I approached the bed, that Voice seemed to speak to my spirit. *Gabby, take the time you need. You don't have to figure it all out right now. Can you trust Me with all your heart? Can you lean on Me instead of your own understanding?*

Startled, I stopped beside the bed. Was God telling me that promise I'd been memorizing was for *now*? This moment? I *didn't* understand how all this craziness was going to work out—so it

might as well be now. I took a big breath, then breathed out a silent prayer . . . *Okay, God, I'm going to trust You. But I'm going to need a lot of help.* But even as I prayed, the "sticky spider's web" seemed to shrivel and disappear, and the anxious knot in my stomach began to loosen.

I laid a hand on Philip's leg covered by the thin blankets. "Philip? I'm still here. But I can't answer you right now. I need time to think . . . and pray."

He turned his head toward me and his tortured eyes met mine. He nodded slowly. "I know."

I finally left the hospital late that afternoon, after Philip's parents arrived. They hadn't been able to get a direct flight to Chicago and had to wait for a connecting flight in New York. Marlene Fairbanks had rushed into the room crying, "Oh, my poor baby. Who did this to you?!" ignoring me completely.

I'd greeted Mike Fairbanks briefly, gathered up my things, and slipped out as unobtrusively as possible. As I walked to my car in the parking garage, I felt as if someone pulled a plug from the bottom of my feet and all my energy drained out. I couldn't wait to get home, crawl into my bed, and take a long nap.

Except . . . I'd promised P.J. and Paul I'd bring them back to the hospital this evening after their grandparents arrived. They'd called that morning, wanting to spend the day hanging out at the hospital, but I'd told them their dad had been taken to radiology for some tests and I didn't know how long it would be. "You can come this evening, I promise."

Paul had seemed alarmed. "Nana and Grandad are coming all the way from Virginia? Dad's not going to die, is he?"

"No, no. Didn't you hear the doctor? Once his injuries heal, he'll be fine."

"So why are they coming?"

"Because he's their son and they love him." I thought about this and realized it was true. "If *you* lived in another city and got hurt, I'd come to see you in a heartbeat."

"Oh." I could almost hear Paul smile. "Okay. But I miss you, Mom. When are you coming home?"

Now, buddy. I'm on my way.

Turning south on Sheridan Road after pulling out of the parking garage, my mind drifted to the way God's Spirit had spoken to me in that hospital room. And I realized I'd been right to tell Lee that my relationship with God and my decision to become a member of SouledOut did have everything to do with my relationship with him—and with Philip too. The second part of that promise in Proverbs was that if I kept on putting God *first* in the decisions I had to make, He *would* lead me in the right path.

That was His promise.

As tired as I was, a smile crept onto my face as I turned into my new neighborhood. In the thirty-five hours since I'd rushed out of the apartment Saturday morning, the six-flat had surely gone through a transformation. Josh and Edesa and little Gracie would be settling in on the third floor . . . Precious and Tanya and their children would be right across the hall . . . and when Sabrina delivered, there'd be a new baby to fuss over!

And that was only the beginning. In the next several months, the other tenants would move out and more Manna House moms

would be assigned to the House of Hope so they could create a home for their children . . .

"Oh, Jesus," I murmured aloud. "What have we started here?" I knew I was in over my head—waaay over—but a sense of excitement and expectancy pushed my weariness aside and I hiked up my speed a few notches, eager to get home and see the beginning of the dream come true.

As I turned the corner onto my street, I saw a cluster of people gathered outside the six-flat, some standing or sitting on the steps, others on the flat concrete "arms" that hugged the steps leading up to the front door. What was going on?

I pulled the Subaru into a parking space along the curb, sorting out faces. Jodi and Denny Baxter sat on the steps, holding their granddaughter Gracie . . . Josh and Edesa Baxter had their arms around each other, laughing about something with P.J. . . . oh my goodness, there was Harry Bentley and his grandson . . . couldn't miss Estelle, sitting on the "arm" in her latest homemade caftan, braiding Sabrina's hair . . . and Mabel Turner, of all people, talking with Precious and Tanya . . . and was that Lucy Tucker?! The elderly woman sat like a boulder in the middle of the steps while Paul and Tanya's Sammy chased a yellow dog in circles around her . . .

Paul spotted me first. "There she is!" he yelled, galloping toward the car, Dandy fast on his heels, tongue lolling.

I climbed out of the Subaru laughing as Paul grabbed my hand and started pulling me up the walk toward the building, while the rest of the crowd started clapping and cheering. "Look up, Mom! Look up!"

"Look up where?" I said . . . and then I saw it.

A large, curved wooden sign had been fitted over the stone arch above the doorway of the six-flat. In twelve-inch high wooden letters, it said . . .

HOUSE OF HOPE

Tears sprang to my eyes. "Who . . . ? How . . . ?" I gasped.

Jodi Baxter came to my side and slipped her arm through mine as I stood looking up. "Denny and Josh made it—been working on it a couple of weeks. I tried to get them to call it The Yada Yada House of Hope—to remind the moms who come to live here that God knows everything about them, like Psalm 139 says—but I was voted down. 'Three words is enough!' Denny told me." She shrugged and laughed. "That's okay. *We* know it's a 'yada yada' thing, don't we, Gabby?"

"Hey!" Lucy yelled from the steps. "Ya gonna stand there all day? Some of us got stuff to do, places to go!"

The people around her cracked up. "She's right!" Precious waved me in. "Come on! See what the House of Hope looks like from the inside, now that some of us be livin' in hope again!"

With Paul hanging on one hand and Jodi on the other, I moved through the grinning crowd of friends and family, up the broad steps and through the front door that Harry Bentley— ex-doorman but never ex-friend—held open for me.

And I knew I was coming home.

reading group guide

1. In chapter 6, Gabby's lawyer, Lee Boyer, tells her the House of Hope idea, while noble, doesn't seem like a wise use of her inheritance money while she's in the middle of a custody case and possible divorce. What do you think—is she being impetuous? Acting in faith? How can we tell the difference in our own lives?

2. In the same chapter, Mabel Turner says, "If this [House of Hope] is God's idea, then it's going to happen. God's timing is perfect. You don't have to rush it." How do we know when something is "God's idea"? If we run into roadblocks, how do we know when that's the work of Satan trying to stop it and we should press on—or God allowing circumstances to show us it's *our* idea, not His?

3. In chapter 17, what did Mabel mean when she says it's not enough to "believe in God," you have to "*believe God*"? What would it mean for you to *believe God* for something in your life situation today?

4. Do you think Gabby contributed to the downfall of her marriage as Mabel suggested in chapter 18? Why or why not? Why does Gabby have such a difficult time hearing what Mabel said? How do you understand Mabel's apology in chapter 23? Do you think "taking responsibility" for mutual problems in a marriage helps or hinders when one is dealing with emotional abuse?

5. In chapter 27, Gabby offered one of the available apartments in the House of Hope to Josh and Edesa Baxter before talking it over with Precious and Tanya (to whom she'd already promised the two apartments). In what way was she "leaning on her own understanding" (see Prov. 3:5–6)? Now she's in a bind! . . . What are the implications for Josh and Edesa if she tells them they can't move in after all? For Tanya and Precious if they do? For Gabby either way?

6. Are you sometimes tempted to "run ahead of God" with *your* good ideas? What kind of pitfalls have you fallen into?

7. Gabby's solution to the above fiasco: "Suddenly it seemed simple: Just own up to my mistake. Start over." How would Gabby's solution help in *your* situation?

8. Why do you think Gabby held back from telling her sons the stark, bald truth when P.J. implied that his mom was the one who "moved out" (chapter 28)? Do you agree with her reasoning for not vilifying Philip? How would you have responded in that instance?

9. Do you think Gabby did the right thing not making "a big honking deal" out of P.J.'s negative attitude toward Jermaine (chapter 32)? What is she hoping to accomplish? How would you handle a similar situation?

10. Gabby gradually changed her prayers from praying *about* Philip to praying *for* him. In chapter 33, she said, "It was hard to be angry with someone I was praying for." Is there someone you're angry with right now? Have you thought about praying *for* this person (not just *about* him or her)? What would your prayer be for this person?

11. On her date with Lee Boyer in chapter 34, Gabby was starting to "sense God everywhere." Has that happened to you? Where or when was the last time an experience or place made you actively aware of God or spiritual reality (outside of church or reading your Bible)?

12. When Gabby attended the Yada Yada Prayer Group in chapter 37, Chanda challenged her about her relationship with Lee while still married to Philip. What do you think about the way Avis handled the awkward situation? How would you have handled that situation? What do *you* think about Gabby's relationship with Lee?

13. After Philip is mugged and ends up in the hospital, do you believe he is sincere when he asks Gabby to forgive him? Why or why not? If you were Gabby, how would you have responded to the choice Lee presented to her at the hospital?

14. Do you think there is any hope for Gabby and Philip's marriage in the future? What would you like to see happen with Philip? With Lee? Why?

15. What are your thoughts and feelings about emotional abuse in marriage? How can sisters support one another when some form of emotional abuse takes place in a marriage? How can the church be more active in addressing this often hidden problem?

reading in 3-D

In this and the previous House of Hope novels, Gabby Fairbanks often depended on her friend Harry Bentley, but you've seen Harry only through Gabby's eyes and may not realize he is a retired Chicago cop who put himself on the line by blowing the whistle on a corrupt and dangerous colleague.

He and Estelle are "an item," but have you been on a date with them?

He's raising his grandson, but why?

He saves Gabby's estranged husband from being shot, but how?

He's found faith through the Yada Yada Brothers' Bible study group, but can it carry him through the most frightening experience of his life?

The Yada Yada Brothers novels by Dave Jackson parallel Neta's House of Hope novels and represent a different kind of reading enjoyment, three-dimensional literature, if you will. It's something that only a husband and wife writing team could pull off.

Each novel stands alone but takes place in the same time frame, same neighborhood, involving some of the same characters living through their own dramas and crises but interacting with and affecting one another . . . just the way it happens in real life.

This is why readers of *Harry Bentley's Second Chance*, the first Yada Yada Brothers novel say . . .

- "Got it, read it, loved it, will recommend it! Can't wait for the next book."
- "I LOVE, LOVE, LOVE the idea of parallel novels! This is absolutely amazing!"
- "*Harry Bentley's Second Chance* was just as exceptional as *Where Do I Go?* and the whole Yada Yada series."

Enjoy the following Prologue to the second Yada Yada Brothers novel, *Harry Bentley's Second Sight*. It corresponds primarily to events in *Who Do I Lean On?* Neta's third book in her House of Hope series (the book you're holding in your hands), with a tiny peek ahead into Neta's fourth book, *Who Is My Shelter?*

An excerpt from
Harry Bentley's Second Sight

By Dave Jackson

prologue

···•◉•···

DaShawn Bentley was tall for a nine-year-old, but to rest his knees on the dash of his grandfather's SUV, he still had to slide way down in the front seat while he texted his friend Robbie. "R U g-o-i-n-g 2 c-a-m-p t-o-m-o-r-r-o-w-?" He hit Send. Except for that brief stay in a foster home in the suburbs, DaShawn had never been outside Chicago, especially not way out in the country, in the woods, by a lake with canoes and horses. So he was counting on some of the other guys from SouledOut Community Church going with him.

"You ever been to camp, Grandpa?"

When Harry Bentley didn't answer right away, DaShawn looked over to see his grandfather turning from side to side as if he were trying to read the address numbers on the passing storefronts. He kept closing one eye and then the other with exaggerated winks that contorted his face like a rubber mask.

"Grandpa?"

"Yeah, what?"

"I said, did you ever go to summer camp?"

"Uh . . ." The searching and winking continued. "No. We only had day camps down on the Southside. But they were pretty good."

Realizing his grandfather wasn't watching where they were going very carefully, DaShawn sat up just in time to see them closing too fast on a stopped truck.

"Grandpa, LOOK OUT!"

Harry Bentley hit the brakes. Tires screeched, then *WHAM!* The little RAV4 slammed into the back of a huge red pickup.

There was a moment of silence, like dust settling, as DaShawn realized he'd just been in his first-ever car accident. He turned to look at the baldheaded black man next to him. "You okay, Grandpa?"

DaShawn's grandfather was staring straight ahead. "Yeah. You all right?"

"I think so. What happened?"

Grandpa shook his head. "I was just . . ."

His response was cut short by the cursing of two burly white men getting out of the pickup. They both wore sweat-stained T-shirts, yellow hardhats, and looked to DaShawn like twin construction workers.

"Wait here!" Grandpa said as he opened the door and went to meet the men inspecting the damage. But a few moments later DaShawn was surprised to hear the construction workers' cursing turn to laughter as they pointed to the back of their truck and then the front of the little SUV.

"So what happened?" one said as he threw up his hands. "Are you blind or something? Isn't this truck big enough for you to see it?"

"Yeah," said the other man. "We were stopped at a red light, for Pete's sake! What's the matter with you?"

DaShawn relaxed a little. At first the men had seemed really angry at his grandpa, but now it was more like they were making fun of him.

In a few moments, the loud voices quieted as the drivers got down to the business of exchanging licenses and insurance cards. The other driver began shaking his head as if he didn't care about all of that, and DaShawn heard him say, "We can report this if you want, but my truck ain't even scratched. That big hitch can take a hit and keep on truckin', know what I mean?" He pointed at the RAV4. "You're the one with the messed-up bumper, and it was your fault, so reportin' it'll only raise your insurance rates. Do what you want. But if it were me . . ." He shrugged.

"You sure neither of you are hurt?" Grandpa asked.

The two men looked at one another. "Nah. We're good." Then with a smirk, the driver added, "But run into me again, and I'll claim whiplash and sue ya dry."

"Hey." Grandpa held up both hands in surrender. "I'm really sorry, guys. Thanks."

"No problem. Just watch where you're goin' next time."

The men returned to their truck and drove off as DaShawn's grandfather came back to the car and got in. He sat there in a daze until a car behind them beeped its horn.

"You okay, Grandpa?"

"Yeah, yeah." He blew out a lung full of air as he wiped a hand over his head and stepped gently on the gas to cross the intersection and pull to a stop behind some parked cars along the curb. He sat there staring out the front window, then glanced

momentarily over at DaShawn. "Can you read that parking sign up ahead there?"

"Sure. Says, 'No parking when snow is over two inches deep. Tow zone.'"

"But . . . none of the letters are smeared or anything?"

"Uh, no. But you don't have to worry, Grandpa. It don't snow in July."

"'Course not." Harry laughed as he continued "winking" at the sign, then began rubbing his eyes with the back of his hands. "Musta got somethin' in my eye. Left one's all blurry. But . . . hey, it's probably nothin'."

"That why you didn't see that truck, Grandpa?"

"No . . . well, maybe. I was distracted, I guess, tryin' to read signs."

DaShawn grinned. "I know. I know what you were doin'. You lookin' to find some nice restaurant to take Miss Estelle to for dinner tonight, huh?"

"Hey, that's none of your business." His grandfather grinned and put the car in Drive as he pulled away from the curb. Then he turned back to his grandson and arched his eyebrows while pursing his lips. "Actually, I already got plans for tonight." He bobbled his head from side to side. "Big plans."

"Oh yeah? What's up?"

"Promise you won't tell?"

"Promise."

"I'm gonna ask her to marry me." He slapped his breast. "Got a ring in a little box, right here in my pocket."

"Really?" DaShawn's eyes got huge.

"Yep. After dinner I'm gonna take her sailing on the Tall Ship

Windy. And right during the Chicago fireworks, when they're lighting up the whole sky, I'm gonna pop the question. Whaddaya thinka that?"

DaShawn didn't answer. He just sat there grinning like he'd witnessed Santa coming down his very own chimney.

"Harry, this place is too expensive," Estelle Williams whispered as she scanned the menu for Riva's Restaurant on Chicago's Navy Pier. Their table looked out over the harbor as the sun's golden rays ricocheted off the glass and steel of the city's magnificent skyline.

"Don't worry 'bout it. Just order what you want."

Estelle shrugged and returned to the menu. But there'd been an edge in Harry's voice. In fact, ever since he'd picked her up this evening, he'd seemed uptight. She glanced at him again. "Harry Bentley . . . you tryin' to wink at me?" She closed her menu and lowered her head to position herself more in his line of sight.

"No, I'm not trying to wink at you. Why would I be doin' that? Haven't we been seein' enough of each other to be beyond flirting?"

"Well, I should hope so. Harry . . ." She reached across the table and pushed his menu down, forcing him to look at her. "What's the matter with you?" The frown lines in his forehead were deeper than usual. "DaShawn told me you were in a car wreck this afternoon, but I didn't see any damage. You okay?"

Harry leaned back in his chair and stared out at the boats. Then he closed his eyes and rubbed them with the knuckles of

both hands. "Yeah, I'm okay. It was nothin', Estelle. No one was hurt. Just messed up my bumper a little."

"Hmm." She studied the man she'd come to love. Something wasn't right. "Harry, what's the problem? Come on. Somethin's troubling you. Is it Mother Bentley again?"

"No, she's doin' fine. You know that. You take care of my mom more than I do. It's just . . ." He closed his eyes for a moment. "My eyes been bothering me a little. Think I'm getting allergies or something."

"Your eyes?" The implications clicked through her mind like a calculator. "Is that why you had a wreck? Maybe you shouldn't be driving, Harry."

"It wasn't a *wreck*, Estelle. Just a little fender-bender. And I can see quite well enough to drive. Besides, it's just my left eye. Probably got something in it." He flipped open his menu and squinted at it. "Now, come on. Let's put that behind us and have a nice dinner."

"Maybe you need glasses, Harry. You know most people our age do need glasses, at least to read. I should get some myself."

"I already have a pair of reading glasses, Estelle."

"Then why don't you use them? I've never seen you wear them."

"Estelle . . . don't worry about it, okay? Just order."

She stifled her next comment and opened her menu again. The man was nothing if not stubborn. Well, if he insisted on paying for it, she'd enjoy her meal. "I think I want to start with some lobster bisque and one of these salads—baby greens with balsamic vinaigrette and sliced almonds."

When the sun had finally set and they'd finished their

dinner, Estelle was so full of scallop fettuccine and asparagus Parmigiano—not to mention the bites she'd snitched of Harry's double-cut pork chop with black current sauce and his garlic mashed potatoes—that she passed on the dessert, and they just lingered over coffee. But their conversation mostly involved brief answers from Harry every time Estelle tried to introduce a new topic. She noticed he'd actually turned his chair slightly away from her and spent most of his time looking out at the boats as they came and went across the lights of the city shimmering off the water. Occasionally, he checked his watch as it approached nine o'clock and then, resting an elbow on the table, he held his head in his hand for a moment, shaking it back and forth slightly as though he were deciding the course of the universe.

She had to do something to pull him out of this funk.

"Harry . . . Harry, let's top off the evening with a ride on the Ferris wheel. I've always wanted to do that, and it's such a beautiful night. I bet we could see the whole city from up there."

He looked at her blankly for a moment, then nodded. "Yeah, yeah. Why not?" He sat up in his chair as though relieved. "Let's do it. I'll call for the check."

Harry felt bummed. His special evening with Estelle had crashed and burned . . . at least in terms of what he'd planned. Why hadn't he taken her for a sail on the Windy? Why hadn't he given her the ring?

It was that episode of *Grey's Anatomy*—the one where they discovered that a guy who was going blind in one eye had an

inoperable brain tumor. Memory of it had popped into his mind just as he was turning into the Navy Pier parking garage with Estelle. He wished he'd never seen that show, but he had, and all evening he couldn't get it out of his mind.

What if that was happening to him?

It was nearly eleven by the time he'd taken Estelle home and picked up DaShawn from his mother's. He'd been tempted to let the boy spend the night at Great Grandma's, but tomorrow was Sunday, and Harry had to have him packed and over to SouledOut Community Church an hour early to catch a ride in the van with the other kids going to summer camp. If it was a church camp, why did it start on Sunday? It made no sense to Harry.

Harry dumped the boy onto the bed, pulled off his shoes, and let him fall back to sleep in his clothes. He could take a shower in the morning.

Harry knew he should go right to bed himself, but he couldn't . . . not yet. Not until he had more of an idea what he might be facing. He couldn't ask Estelle to marry him if he was going blind! Or what if he died of a brain tumor? The ring in his pocket nearly burned a hole in his chest. Passing up his plans for a romantic proposal on that sailing ship tore him up. He wanted so badly to declare his love for her, but he couldn't go through with it, not until he knew.

He sat down at the table in the living room where he and DaShawn shared a computer and turned it on. When the browser came up, he typed "blind spot in eye" into the search engine and clicked the Return key.

One Web site said everyone has two blind spots, one in each eye, but they were over to the side and corresponded to where

the optic nerve connects to the eye. There was even an on-screen demonstration: "Close one eye and position your face close to the screen while focusing on the large 'x.' Then move your head slowly back away from the screen." When Harry tried it, the three large letters a few inches to the side disappeared and reappeared, one after the other as his natural blind spot passed over them. *Why haven't I noticed that before?* he thought. "Because the other eye compensates and fills in the missing image," the Web page explained.

Cool, an interesting distraction . . . but it didn't account for the blind spot right in the center of his vision. He tried another Web site . . . and another . . . and another. Just as he feared, several mentioned the possibility of a brain tumor as the cause of a blind spot. And he couldn't find anything to rule it out in his case.

By the time he finally shut down the computer at one o'clock in the morning, his mind was spinning with other scary possibilities: a detached retina . . . macular degeneration . . . diabetes . . . a stroke. On the other hand, he found a few less frightening causes of temporary visual problems . . . stuff like migraine headaches or excessive fatigue and certain medications.

As he finally crawled between the sheets, he tried to relax. Maybe he was getting worked up over nothing. In fact, he'd probably feel better after a good night's sleep. Maybe something blew into his eye and scratched it without him noticing it. It had to be something like that . . . didn't it?

But sleep wouldn't come. *Please, God. I don't want to lose my sight. How would I take care of DaShawn? Didn't You give him to me? And Estelle . . . don't You know we've got a good thing going? I couldn't saddle her with me as an invalid. In fact, God, I don't think I could*

stand myself as an invalid. I'm too old to learn Braille. I couldn't adjust, not at this age.

His heart pounded as he stared up into the gloom of his bedroom.

If it were a tumor, what other havoc would it wreck inside his skull before it killed him? How long would it take? Would he suffer? Would the doctors shoot him so full of morphine he'd be a zombie by the time he died? In his mind, he already had himself in the hospital, pin-cushioned with tubes and monitors. *Huh! At least they won't have to shave my head before operating!*

But who would care for his elderly mother? He couldn't leave that responsibility to Estelle. In fact, he probably ought to break off his relationship with her completely. He couldn't entangle her in something like this. She already had enough problems, like that schizophrenic son of hers. She deserved a life of her own, not the burden of looking after a blind man. He couldn't do that to her.

Harry turned over on his side and stared at the window, covered by venetian blinds. Fine strips of light from the city glow outside shone between each blind. He closed his right eye. At the point of focus for his left, the otherwise straight lines of light detoured around his blind spot like water flowing around a rock sticking out of a river. Yeah, now he was calling it *his* "blind spot," not just blurry vision. He squinted, trying to evaluate what he could see. Maybe it wasn't as bad as it'd been earlier that day. He was tempted to sit up, turn on the light, and see what happened if he tried to read words from a book. Would the "missing" letters have returned? Maybe there'd be only a slight fuzziness. Maybe he was getting better.

But Harry resisted with all his will power.

Checking on it wouldn't change a thing. He needed sleep.

"O, God," he groaned, "help me! Help me calm down and just go to sleep. Please!"

Order the Yada Yada Brothers novels directly from Dave and Neta Jackson at www.daveneta.com, find them on Amazon, or ask your local bookstore for ...

Book #1, *Harry Bentley's Second Chance*
(ISBN: 978-0-9820544-0-6)

Book #2, *Harry Bentley's Second Sight*
(ISBN: 978-0-9820544-2-0)

Party with the Yada Yada Prayer Group!

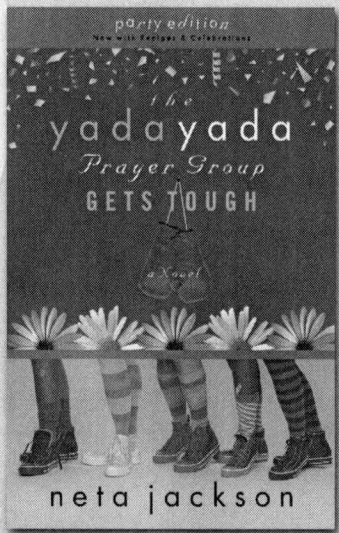

Each novel includes numerous pages of celebration ideas and recipes that flow from the story

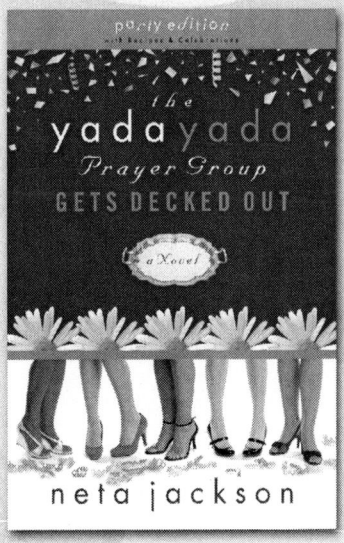

Available Everywhere

Challenges. Prayers. Friendship. Hope.
It all comes together for an
inspiring finale in

Who Is
My Shelter?

BOOK 4

yadayada

HOUSE *of* HOPE

Available March 2011

THOMAS NELSON
Since 1798